HOUSE OF JOY

Playful Homes and
Cheerful Living

gestalten

Joy Is in the Eye of the Beholder

At its most fundamental, joy is a feeling of great pleasure and happiness; it's the diametric opposite of anxiety, loneliness, and stress. Joy is often imagined to be a simple feeling, but the more you untangle it, the more complex it becomes. That's no exception in interior design, where the joy triggered by an object or space is a highly personal thing.

Today we're increasingly seeing an intertwining of different aesthetics that feel fresh, colorful, and full of play. There are many names for it: high camp, maximalism, Memphis revival. Each of these trends carries its own evolution story and is rooted in the rejection of whatever aesthetic came before it. But if we were to identify a single thread that unites the different spaces in this book—spaces that reject the somber, the vanilla, and the beige—then it would be joy.

Several ingredients can create a more joyful interior: patterns and prints in place of blank surfaces, curves and arches instead of straight lines, furniture in all sorts of whimsical shapes. And color—lots of it. There's a misconception that joyful spaces can't be elegant; that only minimalist homes or shades of greige can be sophisticated, or that rooms painted with primary colors or bright pastels are only for children. We're hoping this book will prove that wrong.

"Growing up in the '90s, I remember everything being so colorful," says the London-based artist Coco Lom, who describes herself as a pattern-seeker,

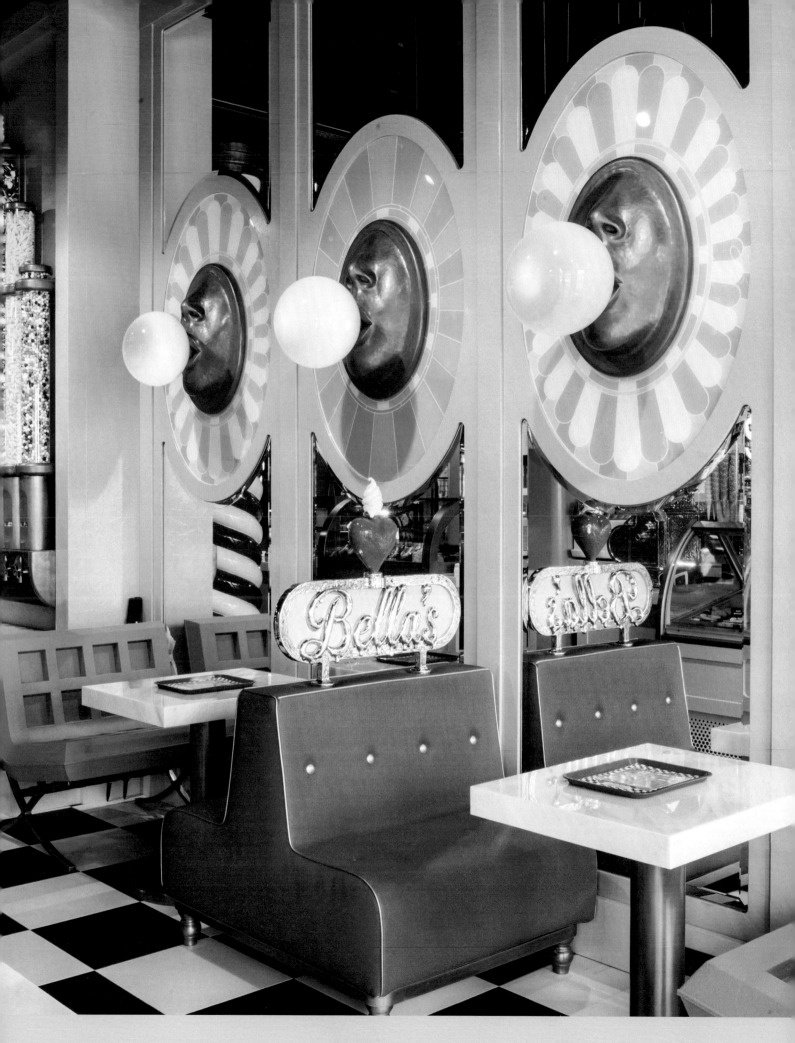

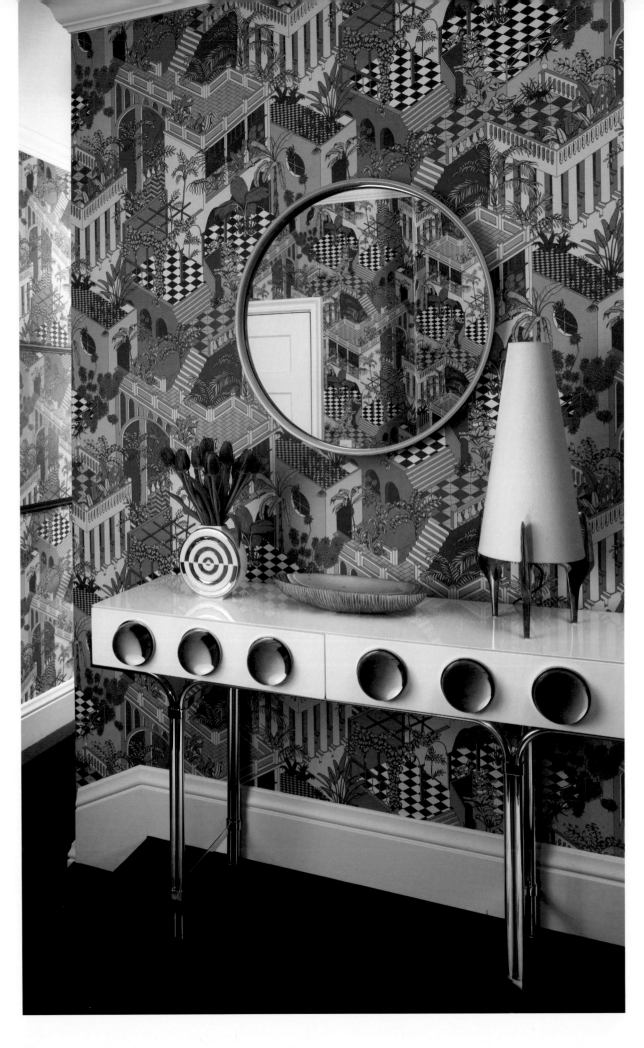

color-lover, and stripe enthusiast. "As kids, our world is curated to be full of color and playfulness, from bath time to bedtime to our classrooms. I think color triggers joy in my brain because it reminds me of all the playful and carefree times I had as a kid." She's certainly not alone in that regard. Many of the interiors in this book are laced with an element of childhood nostalgia—especially for kids who grew up in the ultra-colorful 1980s and 1990s.

Valetta House, featured on page 58, is a home in London that blurs the boundaries between child- and adult-friendly into one cohesive narrative. It's full of little stories—a staircase inspired by snakes and ladders, four yellow-framed arched windows to represent each of the clients' daughters. The architects, Office S & M, are fierce proponents of color, viewing it as a building material, not an afterthought. Co-founder Hugh McEwen describes their approach as "unapologetically joyful."

"Once you see color as an essential part of the design of a space, you start to realize how powerful it can be," says Catrina Stewart, who founded the practice with McEwen in 2013. "You can extend space, you can make space larger, you can make space smaller, you can even change the weather." That's especially true for their Mo-tel House, a London refurbishment that uses pastels to amplify natural light. The result? A ground-floor apartment that feels like anything but.

Today we're increasingly seeing an intertwining of different aesthetics that feel fresh, colorful, and full of play. There are many names for it: high camp, maximalism, Memphis revival.

When we look at color, there are often links between what we see and what we feel. Studies have hypothesized a connection between color and perception: bright, warm colors like yellow, orange, pink, and red tend to be considered "happy colors," while pastels also have the power to lift the spirits. Yellow and orange tones incite appetite, while some prison cells are painted pink in the hope that the color will reduce aggression. Tones of gray are viewed as mature, responsible choices. But as common as a neutral gray is in the built environment, it isn't necessarily known for its tendency to spark joy.

A good example can be found on Thessaly Road in London, which was a drab, concrete underpass until British-Nigerian artist Yinka Ilori was asked to intervene in 2019. As part of an initiative to improve the public realm, he installed panels in 16 different colors that, according to color theory, have a positive impact on happiness and well-being.

Ilori is part of a movement that the artist and designer Adam Nathaniel Furman coined New London Fabulous. Furman, whose home accessories and public installations come in dazzling palettes, noticed the streets of his home city were changing, as artists and designers increasingly injected color into a notoriously gray metropolis.

One of those artists is Coco Lom. Her work introduces squiggles, stripes, and spots to street furniture, basketball courts, and murals throughout London. Another is Camille Walala, whose polychromatic Mauritius resort we feature on page 46.

From London to Milan, it's hard to talk about the joyful aesthetic without bringing up the Memphis Group. A movement defined by its technicolor palettes and eccentric compositions, it was founded in 1980 by Ettore Sottsass, whose squiggly pink Ultrafragola mirror has spent much of the 2020s plastered across social media. The group's oeuvre responded to midcentury modernism's rational approach and mantra that form follows function. In place of rationalism and linearity, they brought a riot of color, curves, and motion.

Memphis had a brief yet powerful moment. A young Karl Lagerfeld was photographed in his Monte Carlo home surrounded by Memphis works by Sottsass, Michele De Lucchi, and George Sowden. David Bowie was a collector too. Nevertheless, the group disbanded less than a decade after its formation. Its revival has been simmering away since the mid-2010s, often seen as a shorthand for the explosion of color that came with it. Homes like Baldiwala Edge's Quirk Box in Mumbai (page 196), which cites Memphis as its defining influence, continues to follow in the footsteps of the hedonistic design movement.

These spaces play with poppy graphic patterns and prints, color blocking, and a palette that spans the whole box of crayons. Furniture is decidedly curvy, with tubular pieces, chunky proportions, and playful shapes showing that less isn't always more.

But bold colors and Memphis references aren't the only features that make the homes in this book so joyful. These spaces also play with poppy graphic patterns and prints, color blocking, and a palette that spans the whole box of crayons. Furniture is decidedly curvy, with tubular pieces, chunky proportions, and playful shapes showing that less isn't always more.

The curve motif gives way to another shape that we see over and over again: the arch. Doorways, windows, and mirrors have all done away with straight lines, a technique that's especially successful at Apartment XVII by Studio Razavi (page 136), where arches are scattered throughout the space to soften the rigid lines of the historic beamed ceiling.

The word joy is increasingly floating around. Tidiness guru Marie Kondo built her empire on the simple question: does it spark joy? The answer to this question, whether it refers to tossing away an unloved hat or painting an entire wall orange, will be as specific to you as the print on your thumb. Sometimes it's highly personal, sometimes it's universal. Most of the time, it's somewhere in between. The homes in this book explore the many ways that we can bring more joy into our homes, and into our lives.

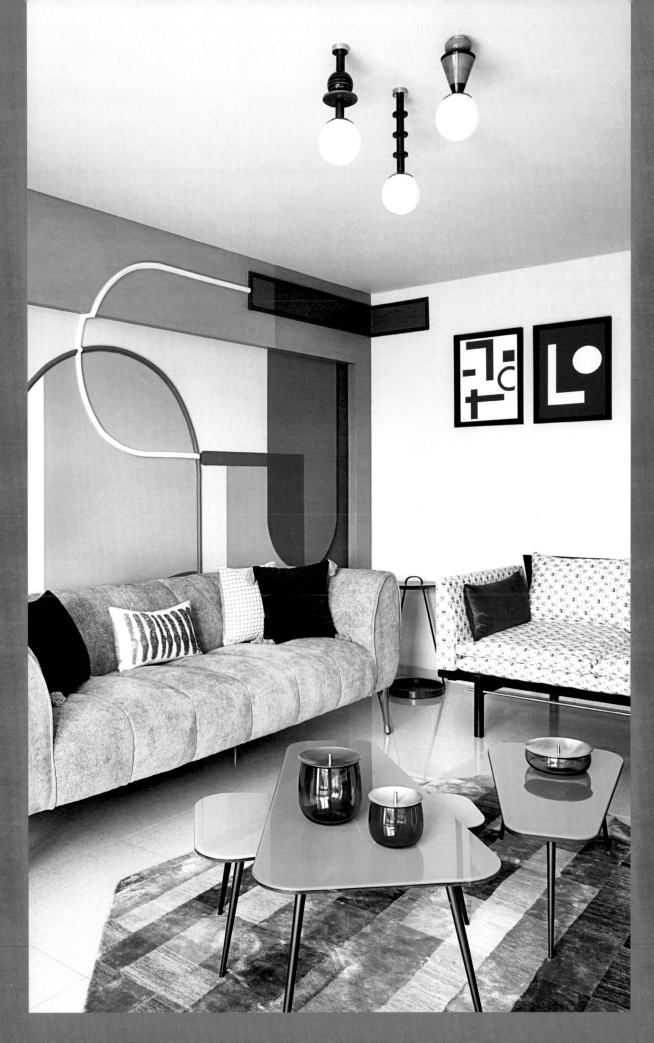

Pop Culture and a Pop of Color

Mountain View

CAN

London, U.K.

A crumbling brick wall marks the transition between a London home's extension and the rest of the Edwardian house. It also references a scene from the 1990s cult film *Trainspotting,* and it's just one of several references to pop culture in this dazzling home. Another is the eye-catching mountain feature, perched atop the extension's sliding glass door, which was informed by images of the classic Disneyland ride Matterhorn while it was under construction. The home brings together unexpected color and material combinations: recycled milk-bottle tops and chopping boards make up the kitchen cabinets in alternating colors, and their offcuts are used as facings for the new concrete lintels above the windows in the existing house. The decorative, architectural fragments in the striking blue living room are all offcuts from local plasterworks. "Waste not want not," written in tiles on a staircase off the kitchen, nods to the architect's mission to make use of as much material waste as possible. The result is a family home where color, texture, pattern, and pop culture references are all crammed together—and yet none feel out of place.

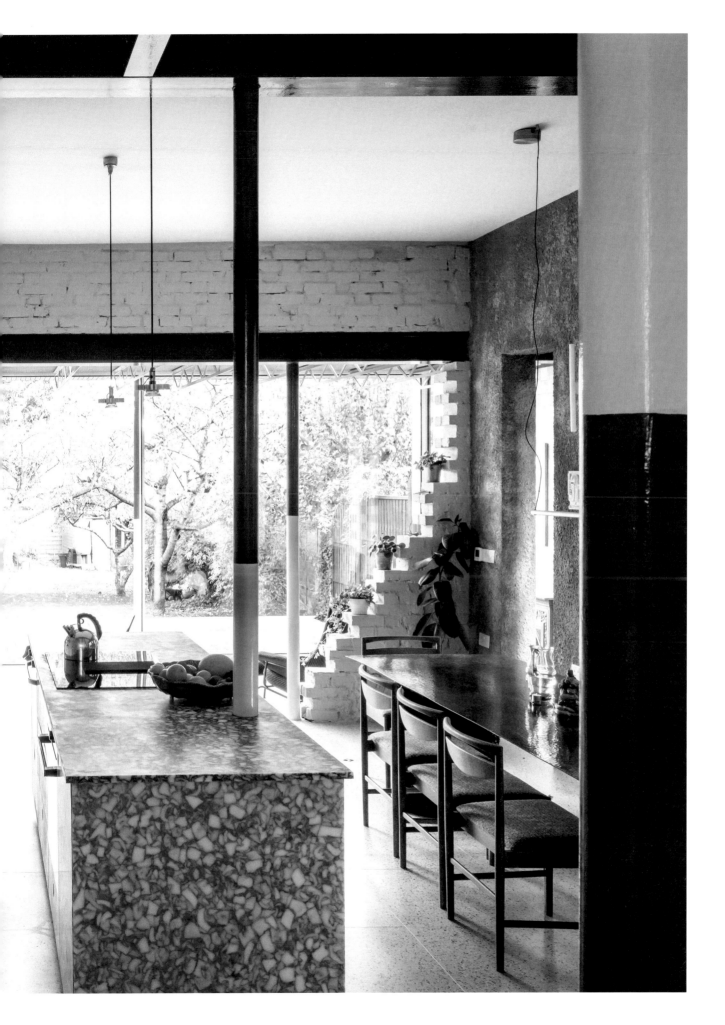

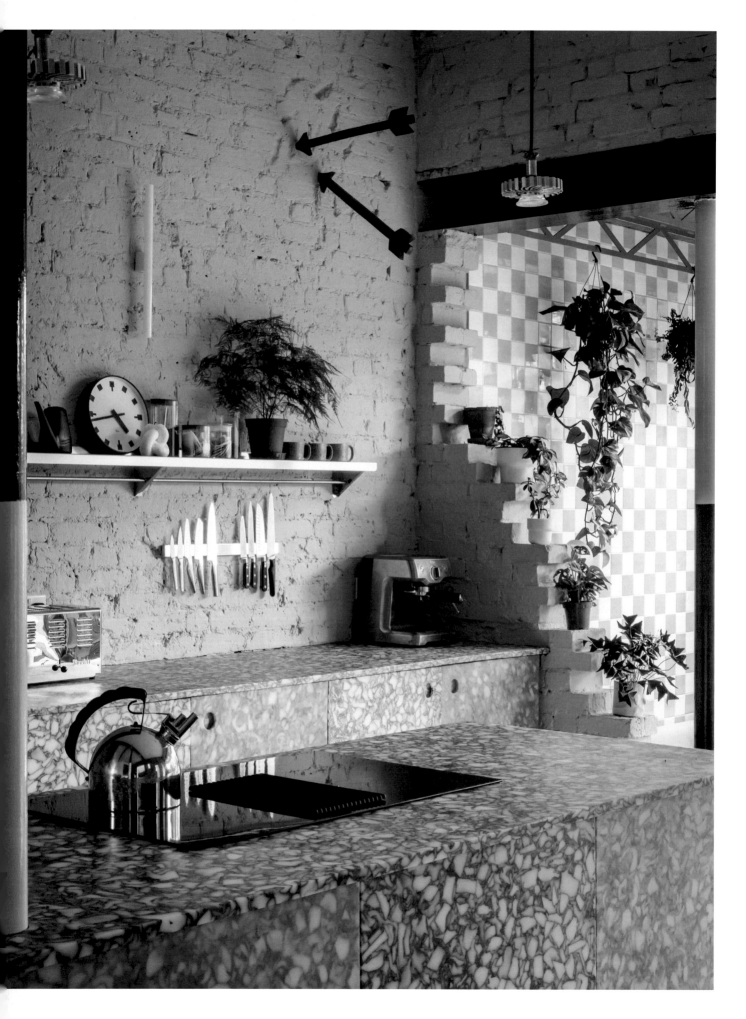

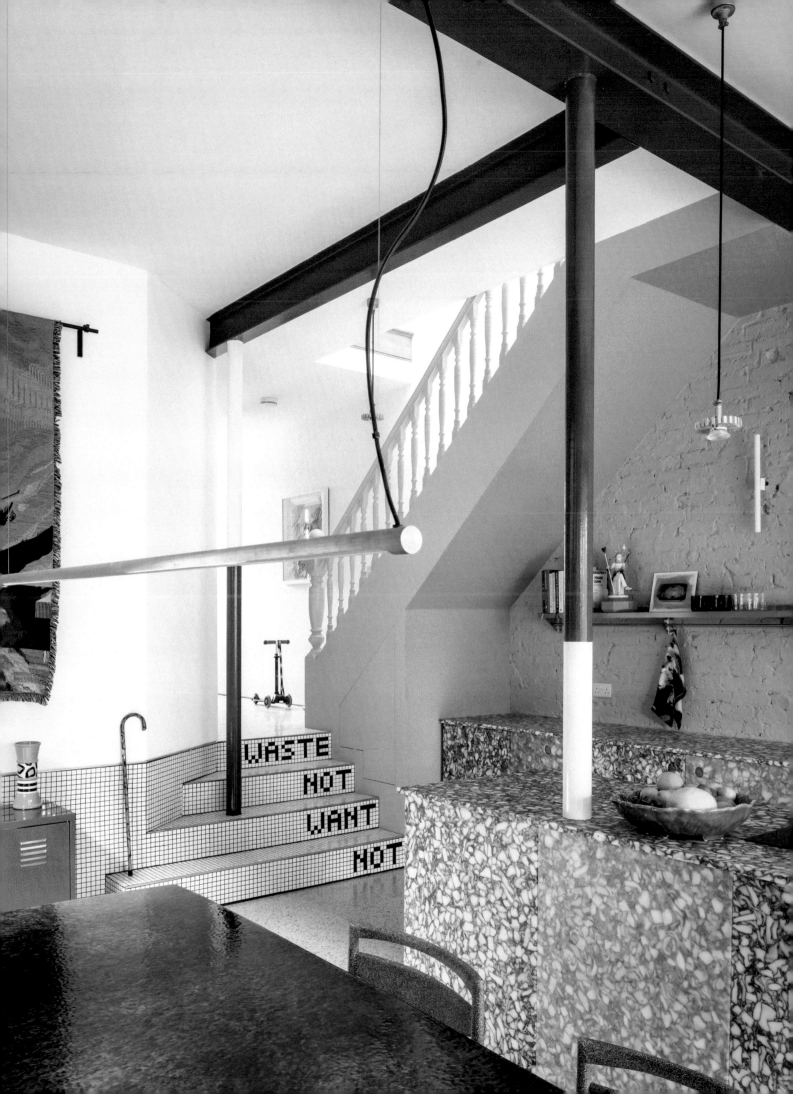

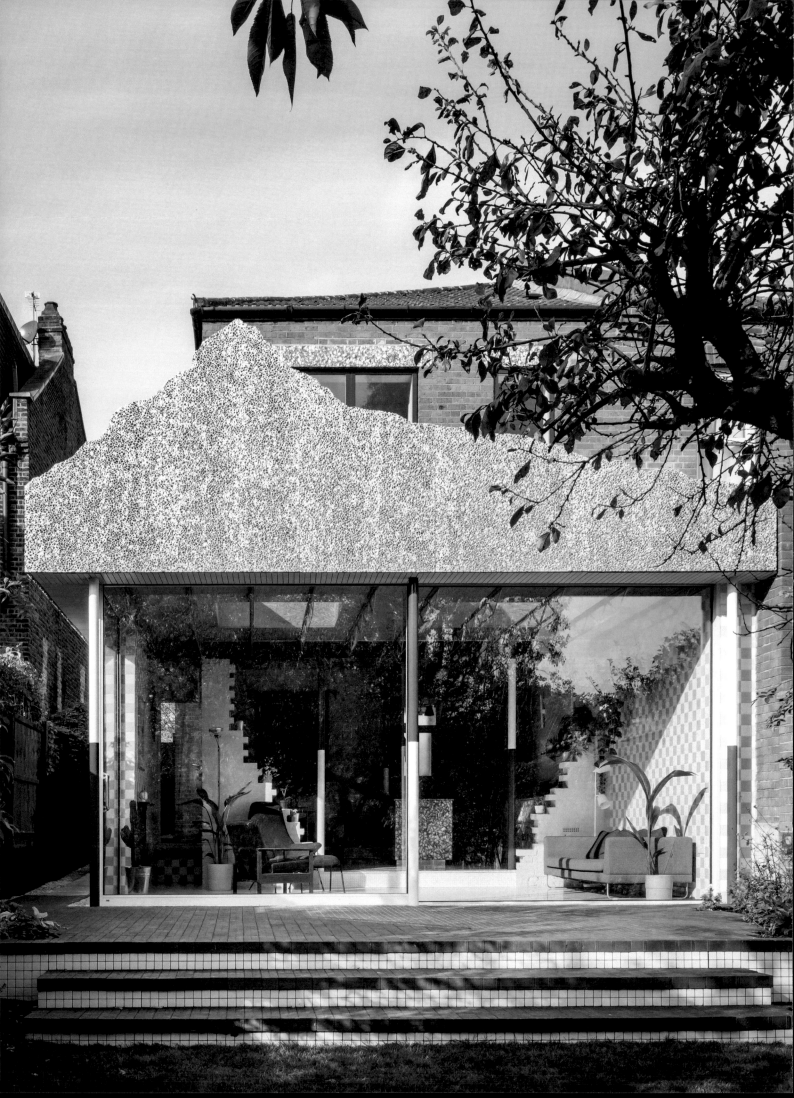

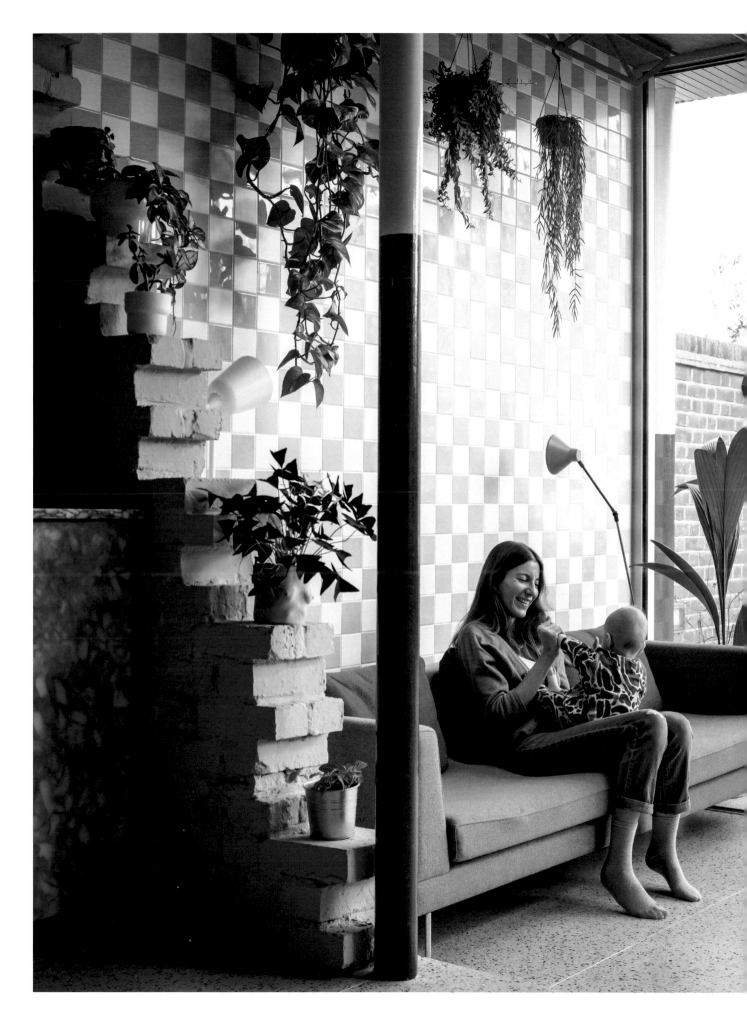

An Enclave to Rest and Replenish

Raval Hideaway

Mariana de Delás and Marcos Duffo

Barcelona, Spain

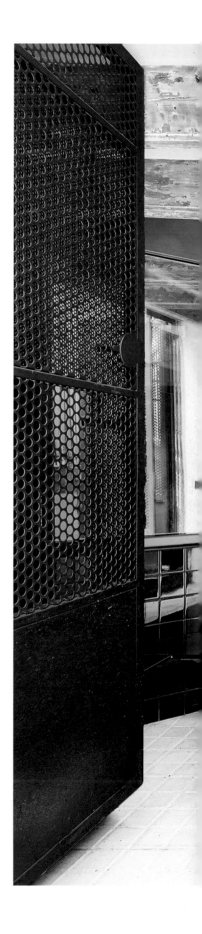

Home to a Spanish entrepreneur who spends much of his life traveling, this 590-sq.-ft. (55-m²) apartment serves as a city-center respite. Prior to conversion, the space was an old motorcycle workshop and, later, a squat. Needless to say, it needed a little love. In the process of transforming it, there were all sorts of architectural inconveniences that needed solving, starting with low ceilings. To give the illusion of space, the team went with a light, high-gloss epoxy resin floor. The apartment counts a bar and social club among its neighbors, and the architects needed to find a way to keep outside noise outside. The result is a green buffer, an acoustic and privacy barrier to the street, achieved by building two opposing layers in the facade: a perforated iron sheet and a glass and metal frame. In between the two facades, built-in seating offers a place to relax and people-watch. Inside, the color palette combines rich emerald greens with handsome black accents and the occasional pop of yellow, while the ceiling beams create a sense of pattern throughout.

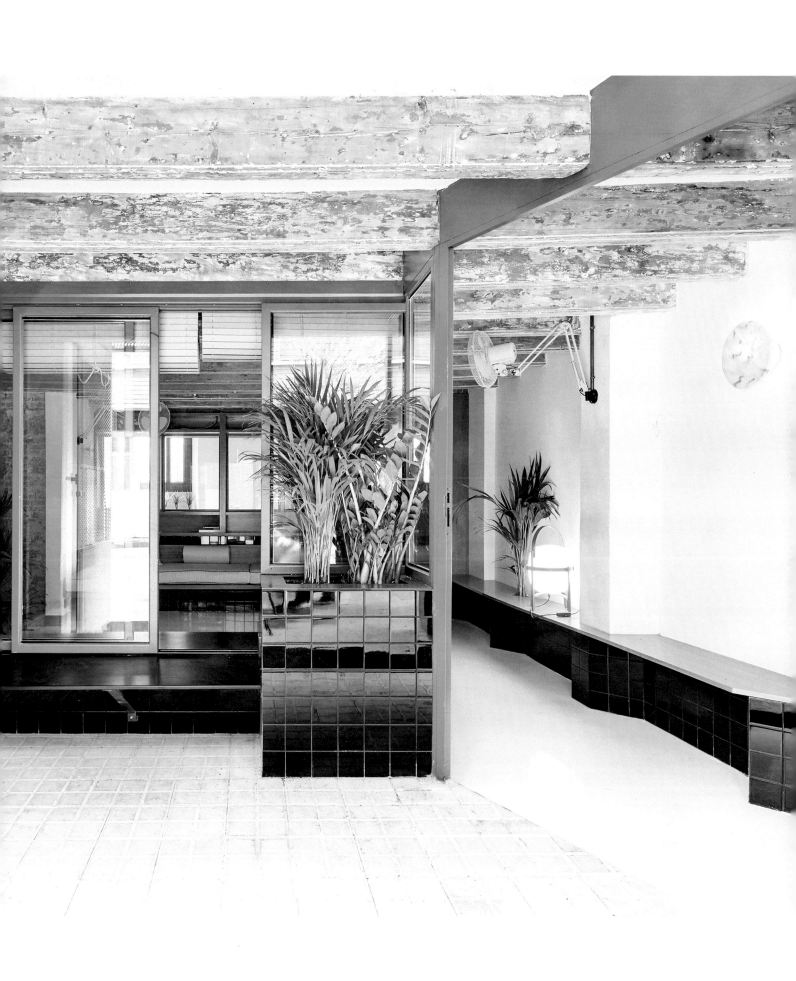

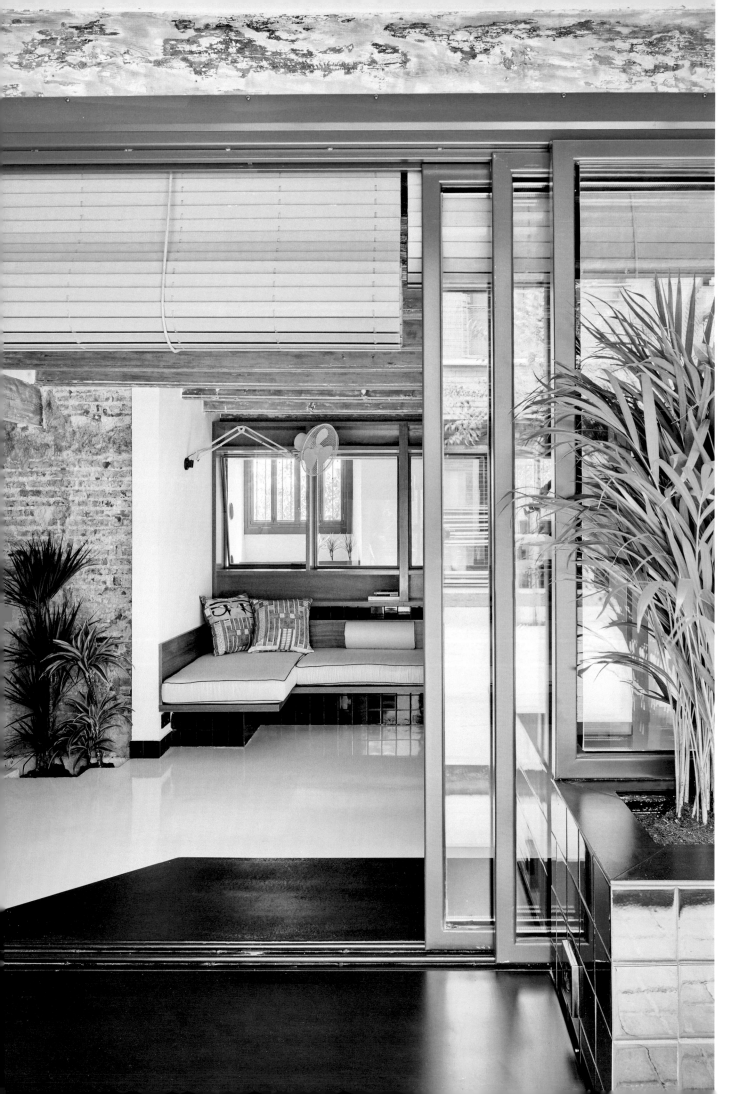

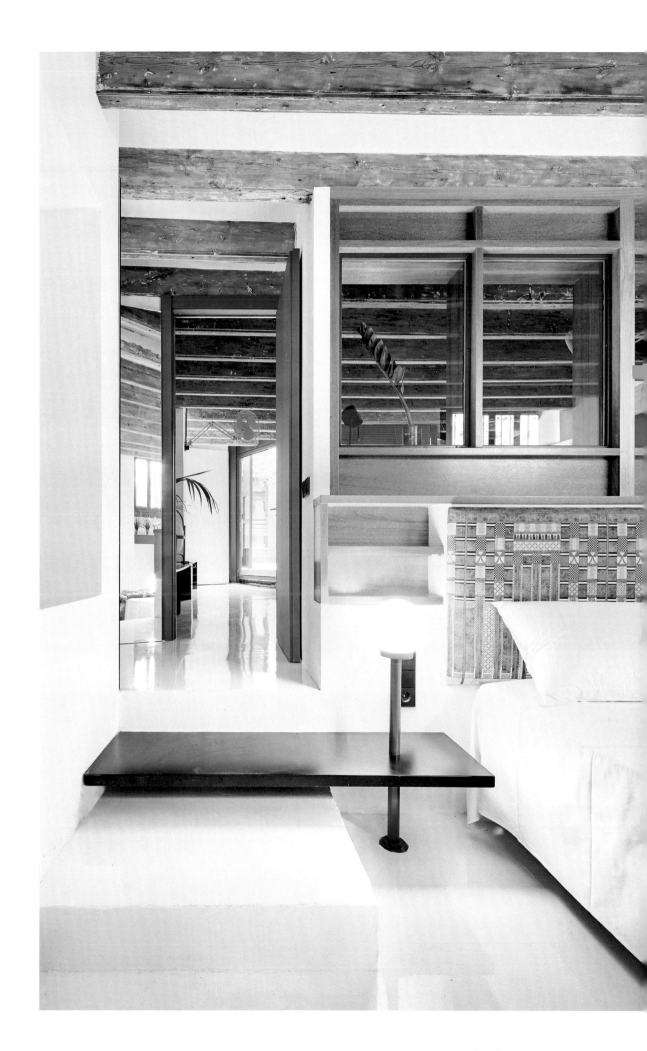

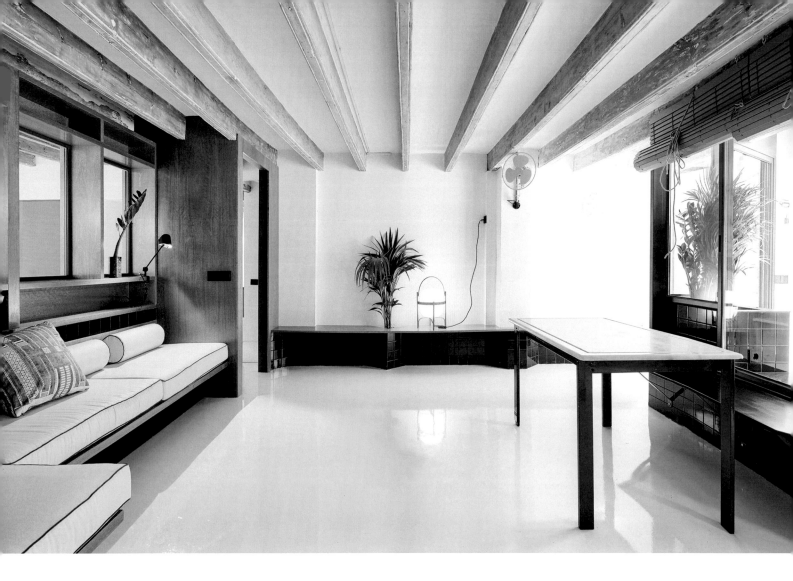

These photographs demonstrate how the glossy floor helps reflect light and detract from the apartment's low ceilings. A Cesta lamp by Santa & Cole stands beneath the bright yellow fan in the image above, its wooden frame echoing the wood paneling on the adjacent wall. The same image also reveals the small outdoor space, a threshold between the bustling street and the calm within.

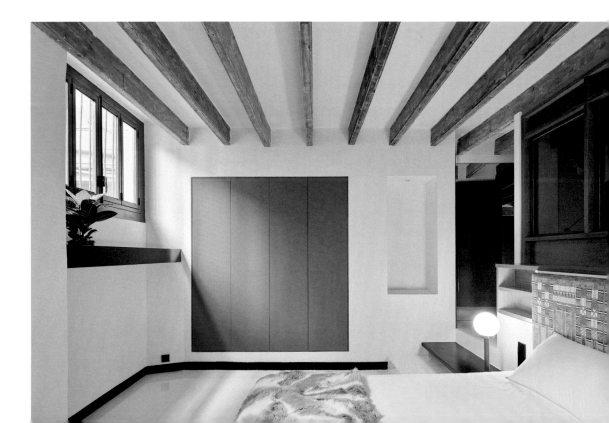

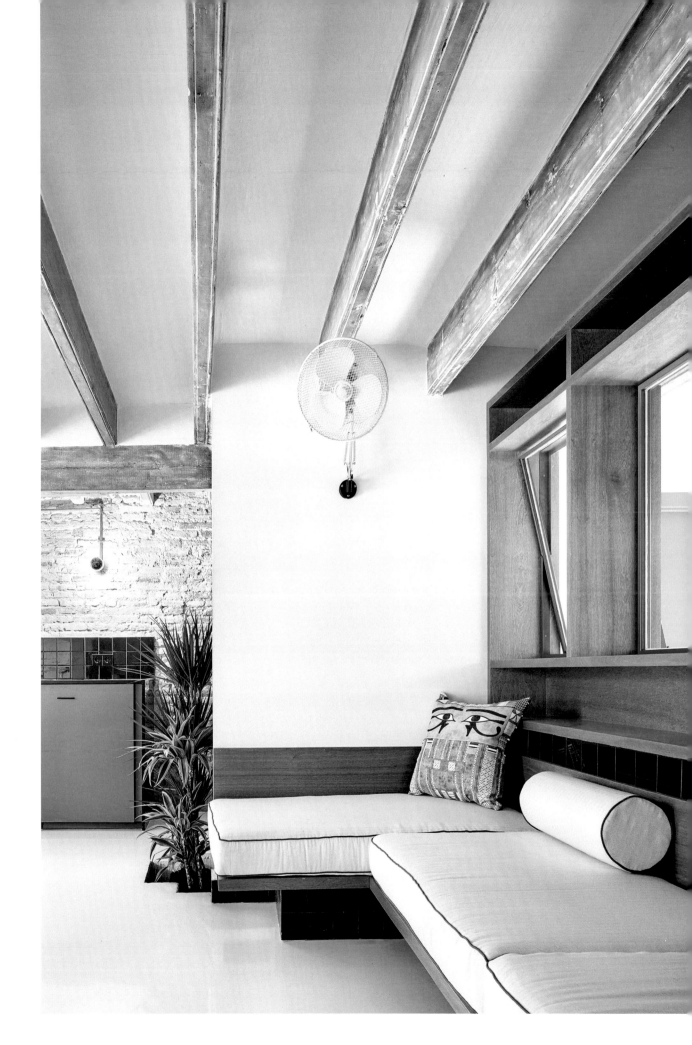

A Wine Bar That Defies Expectation

Slow Wine Bar

Dvekati

Moscow, Russia

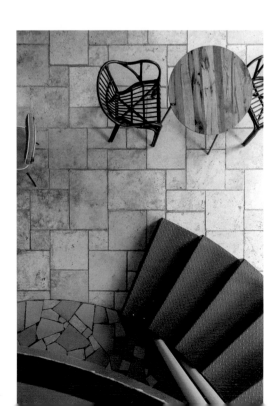

The clients behind this Moscow wine bar gave architecture studio Dvekati a clear brief: the wine bar should not look like a wine bar—no dim lighting, no dark colors, no shelves lined with bottles. Instead, the design of the finished space should surprise its clientele. Located in the cultural and business district of the city center, the raw space offered high ceilings that didn't conceal structural elements and two large windows that flooded the space with natural light. That brightness became a cue for what was to come. The architects were inspired by the modernist resort architecture of the Black Sea coast, notably the circular terraces that tower over the sea on stilts. The feeling of a seaside vacation is further articulated with a juicy color palette of coral and emerald hues. The space offers surprises throughout: wine-bottle murals, pops of color among the sandy wall tiles, and bright grout lines on the floor. It's a far cry from what Muscovites have come to expect from their wine bars—something to raise a glass to.

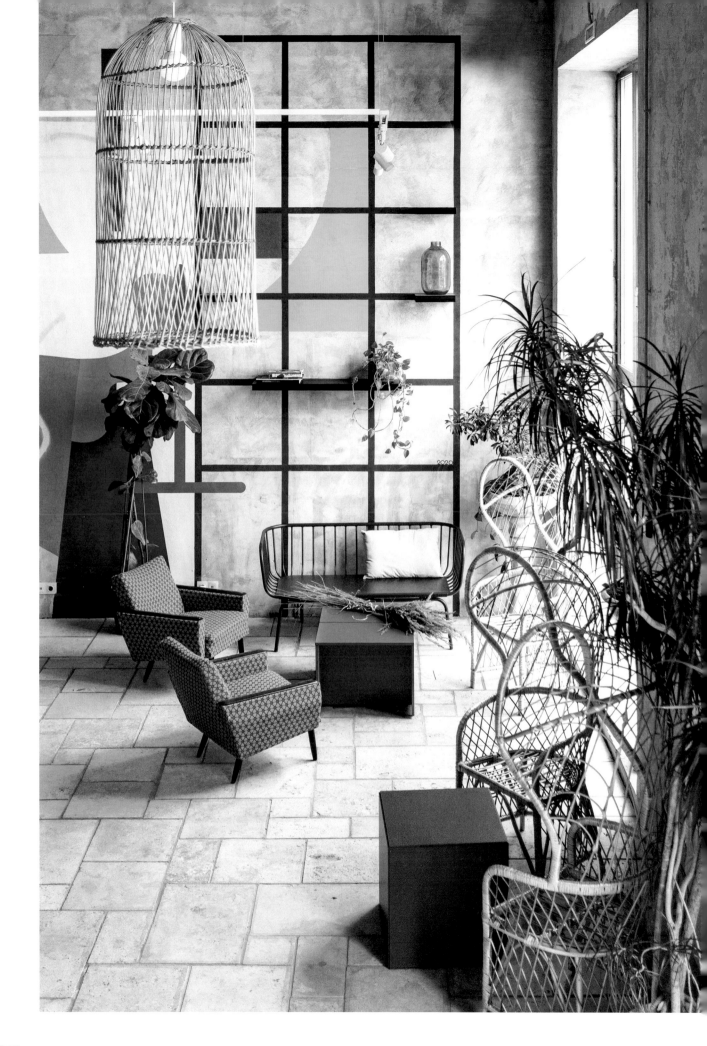

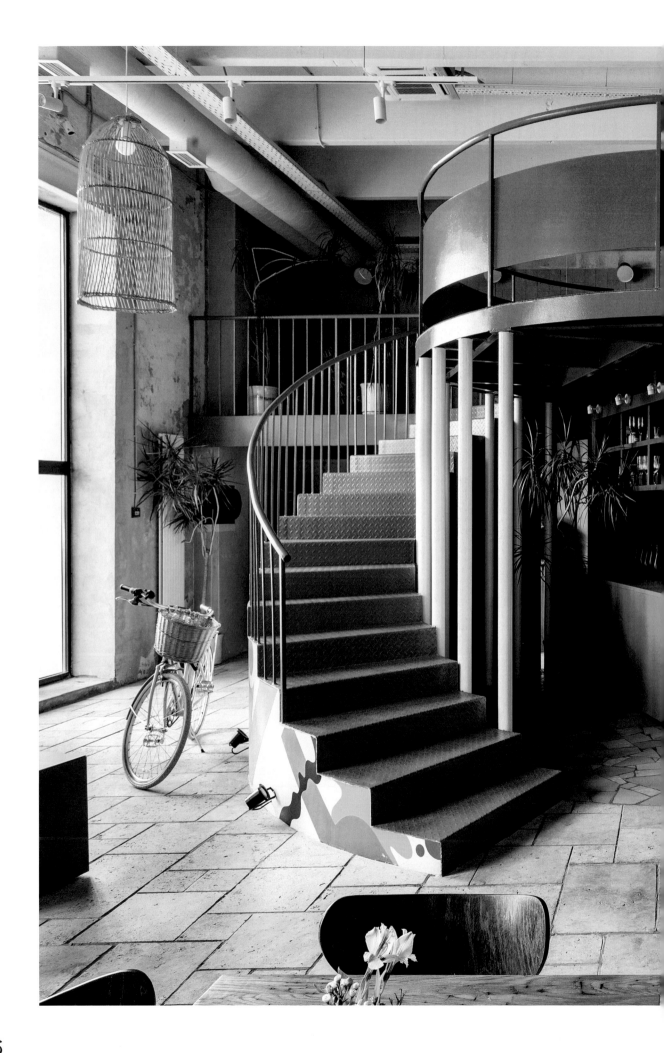

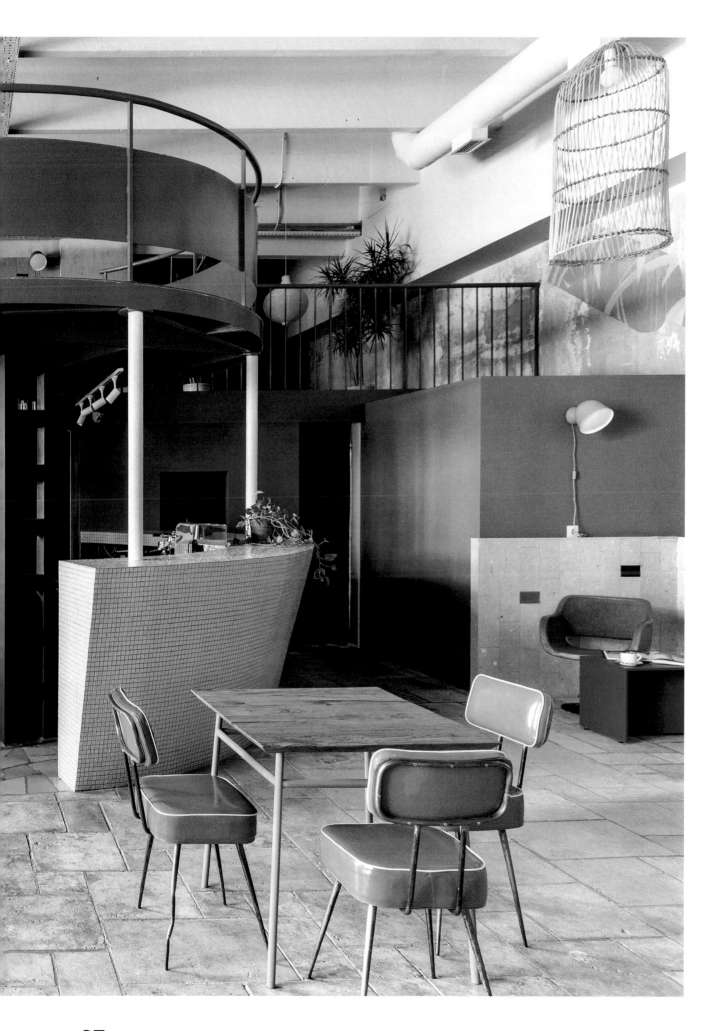

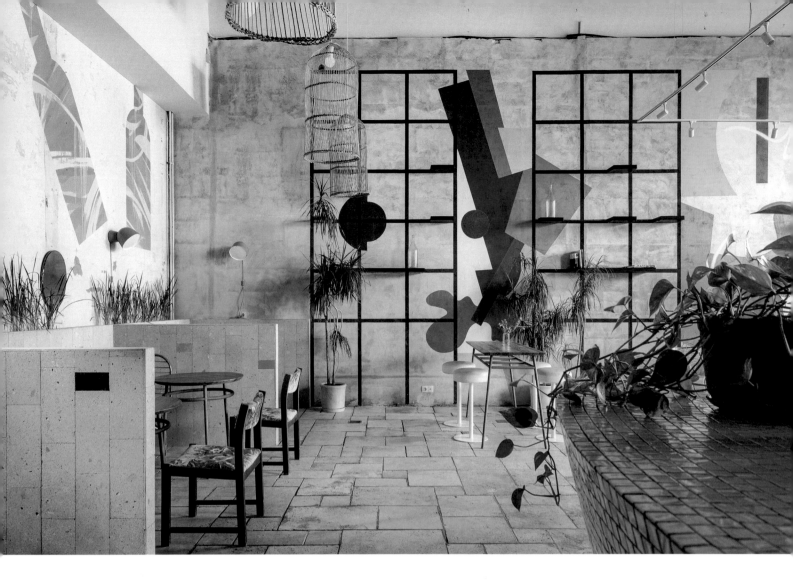

"Neutral" is not in the vocabulary of this Moscow wine bar and its crayon-box palette, where relaxation and enjoyment were top of mind for the designers. Although the Dvekati team were adamant this shouldn't look like a typical wine bar, the wine-bottle murals, pictured here, still give oenophiles something to grasp onto.

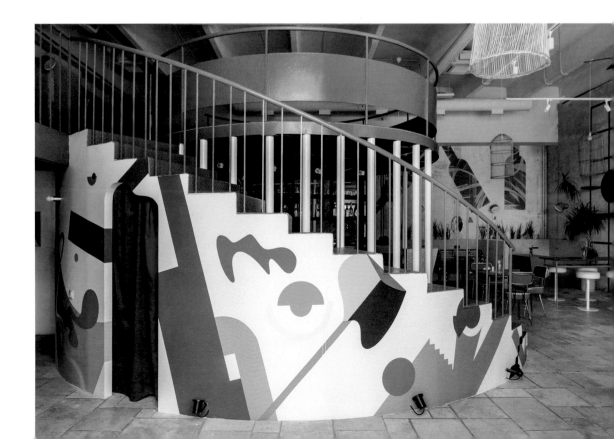

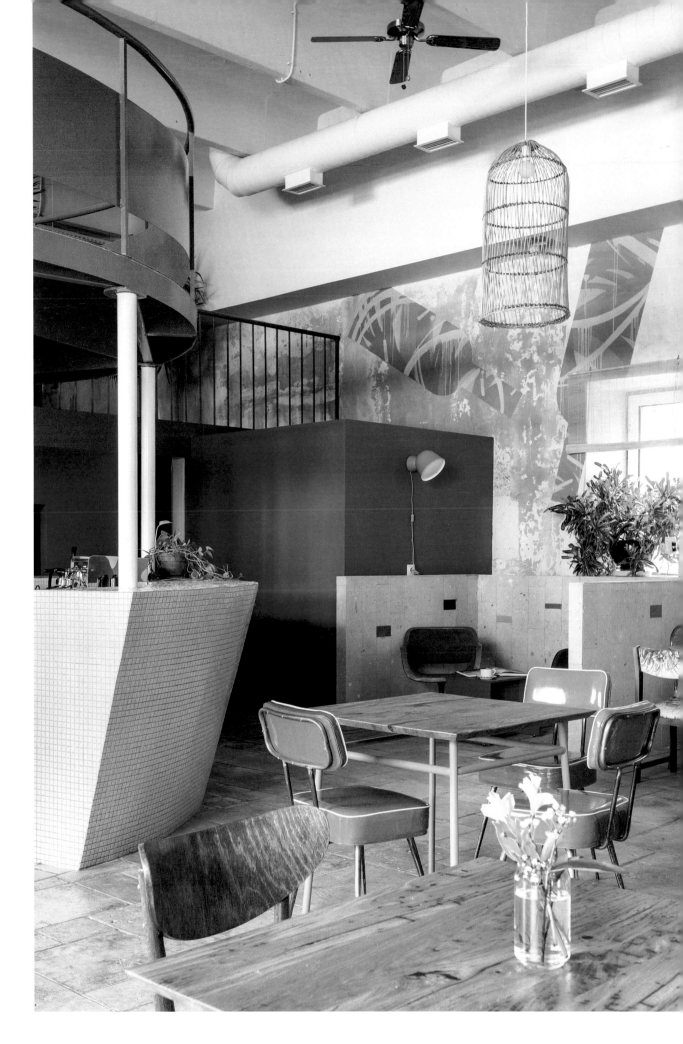

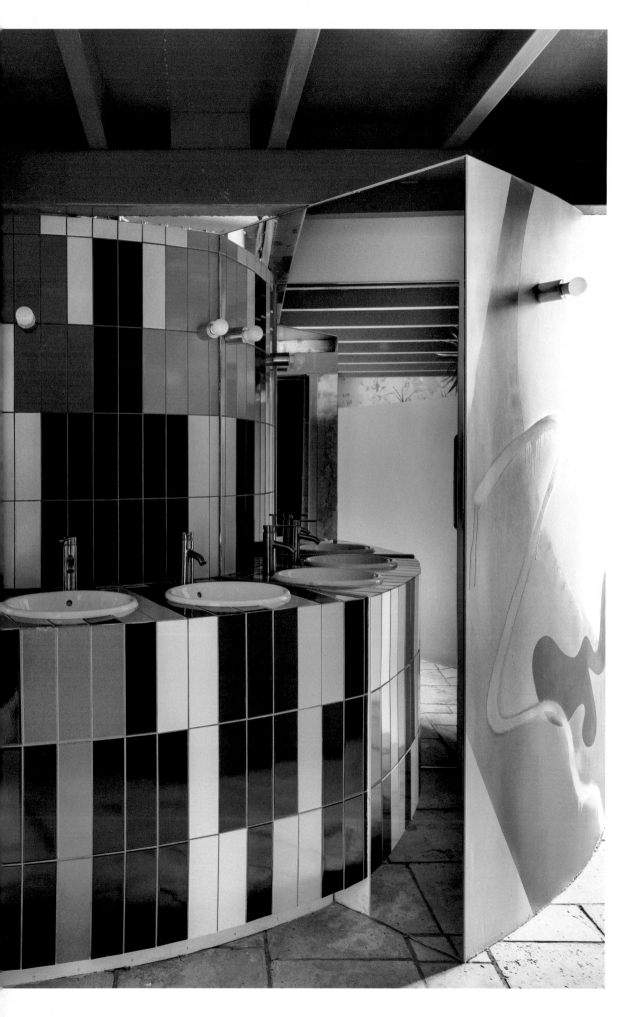

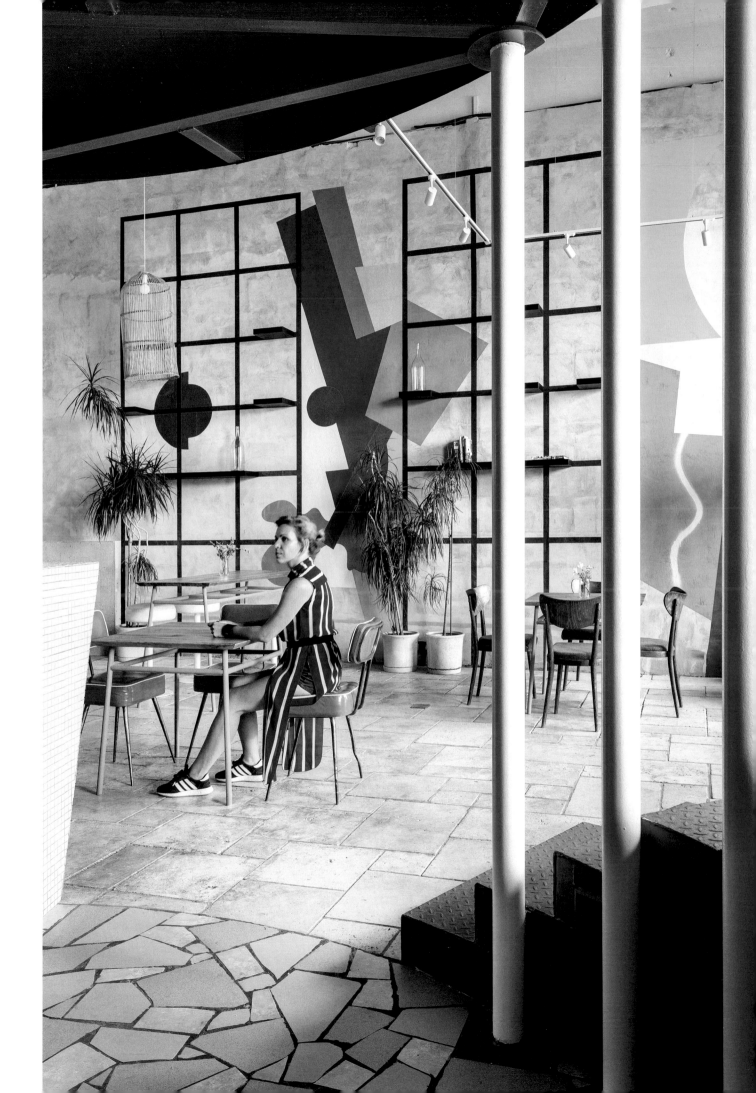

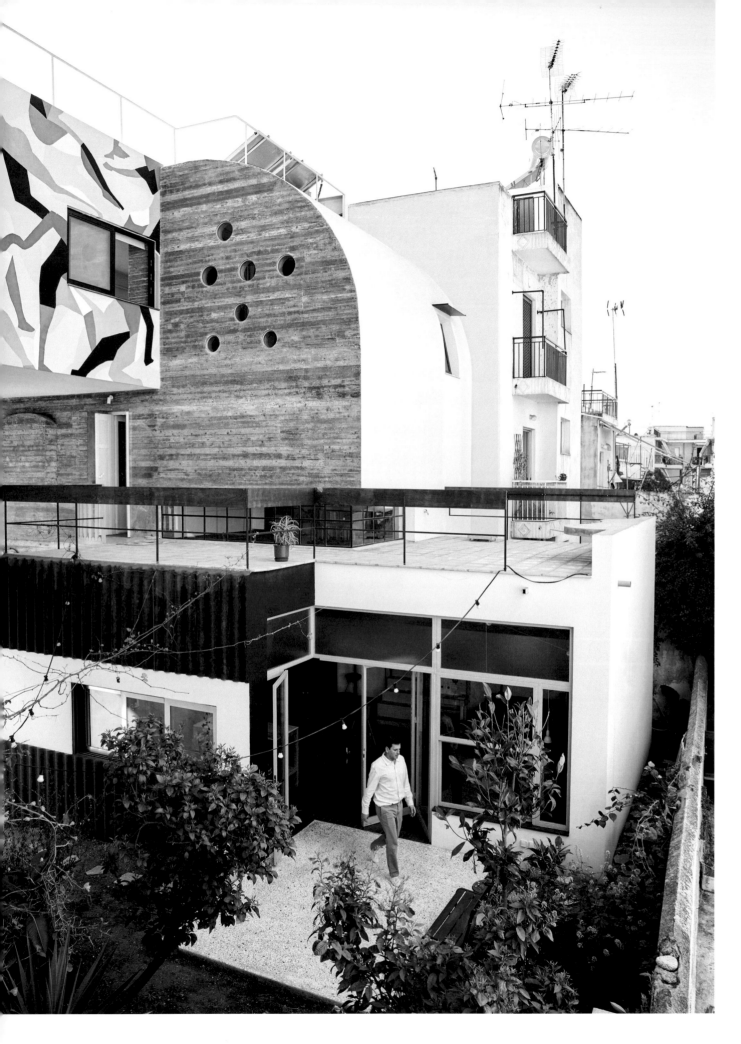

A Walk-In Collage Full of Reclaimed Materials

Petralona House

Point Supreme

Athens, Greece

Where there was once just one level, now there are three. Following the refurbishment of a ground-floor residence on a narrow street in Athens, passersby can see from the red, blue, and purple threshold that something special awaits behind the door. Inside, the home is made up of a collection of objects and materials found in local junkyards and abandoned buildings or sourced from bankrupt shops and closed factories. This approach kept construction costs drastically low and signify the sad truth of having to rethink a home renovation during a financial crisis, as was the case when this home was being built. But the circular model of reusing objects and materials that have outgrown their use is also one we can learn from regardless of the economic circumstances, and the result is dynamic and enjoyable to behold. According to the architects, bringing together a multitude of disparate elements turns the home into a living collage, combining the many details, forms, and materials of the city under one roof.

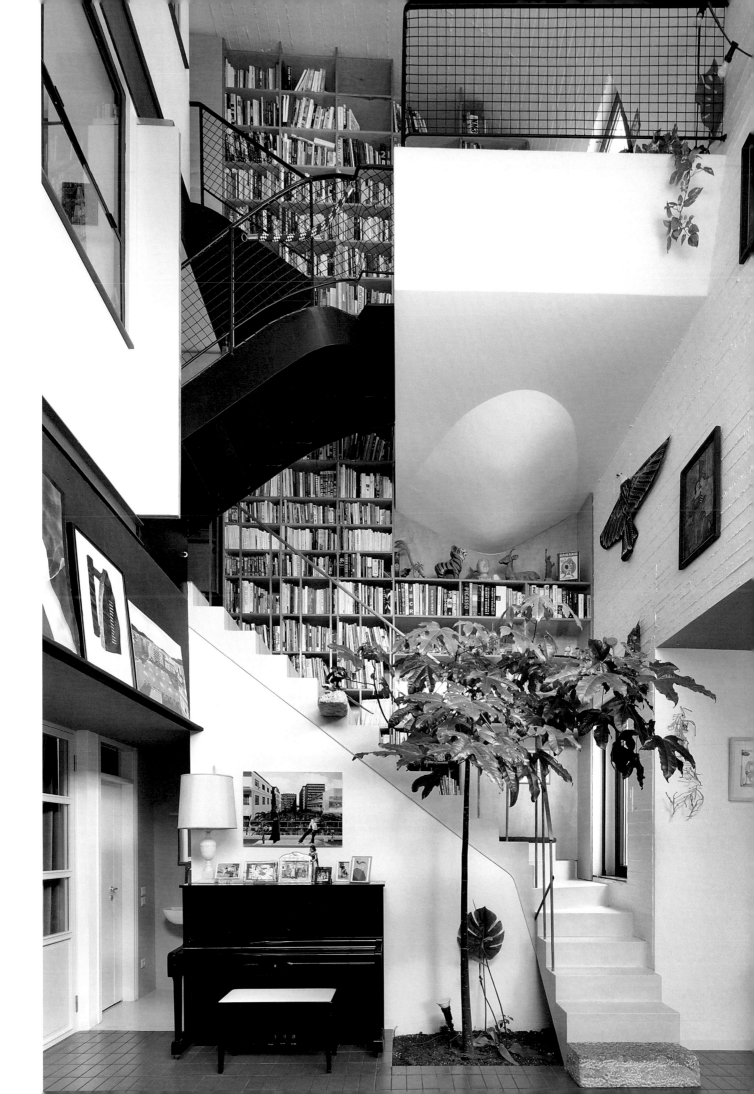

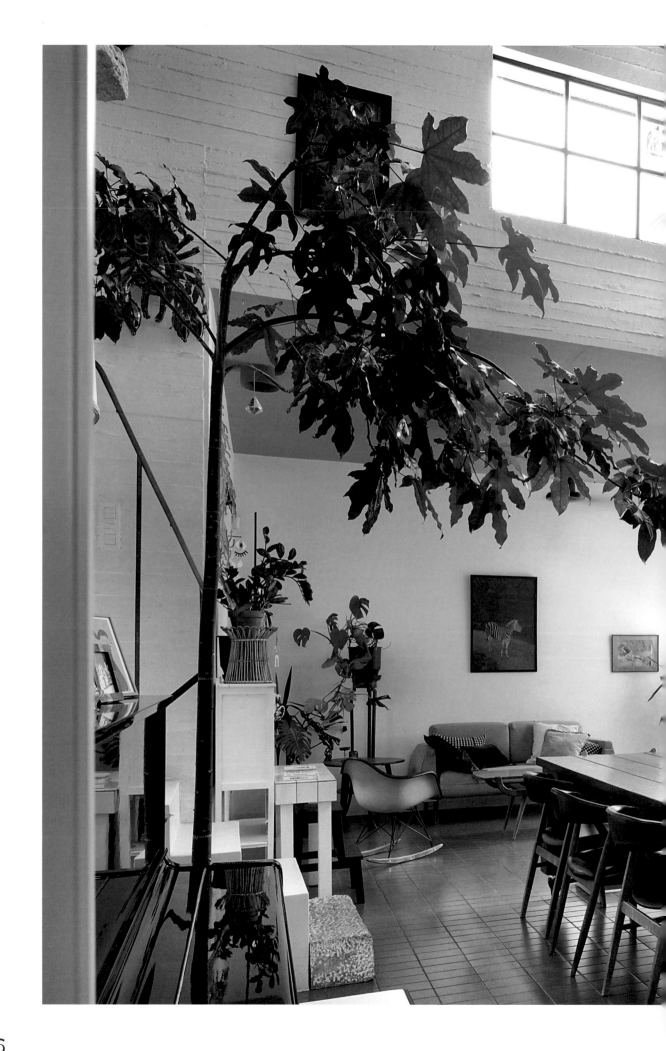

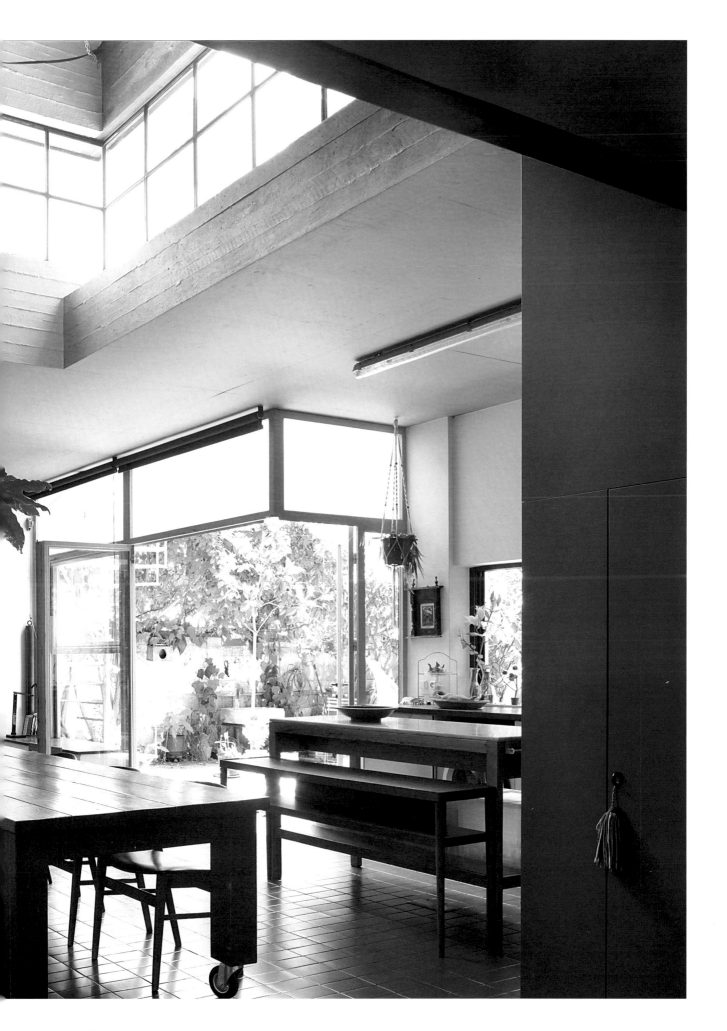

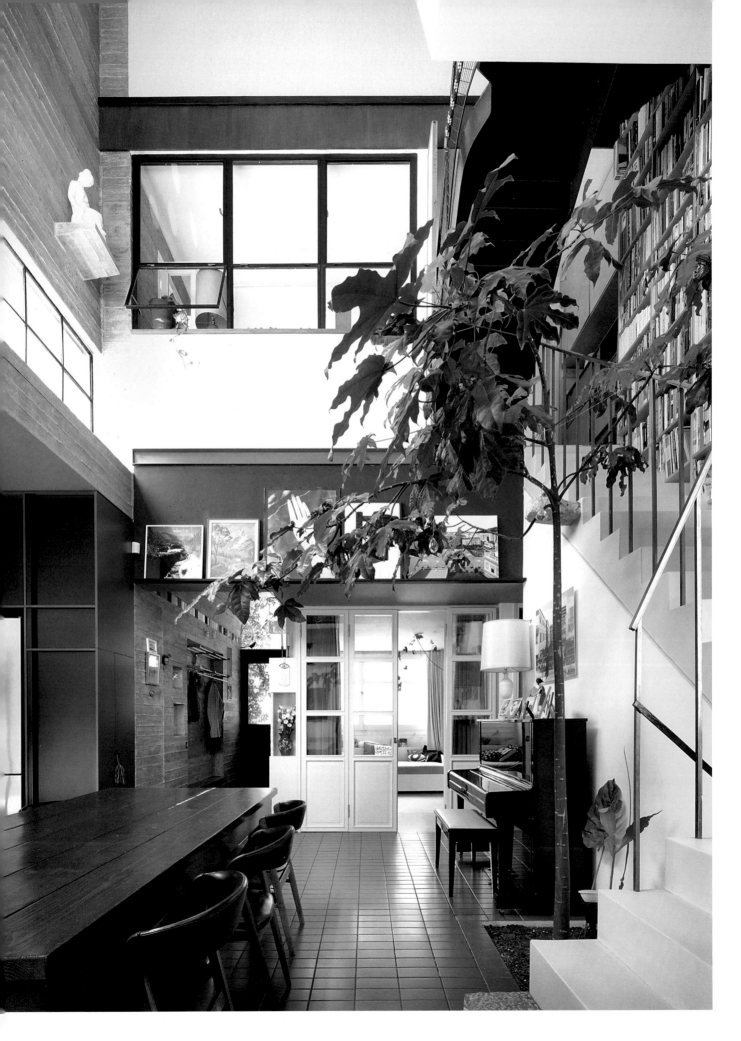

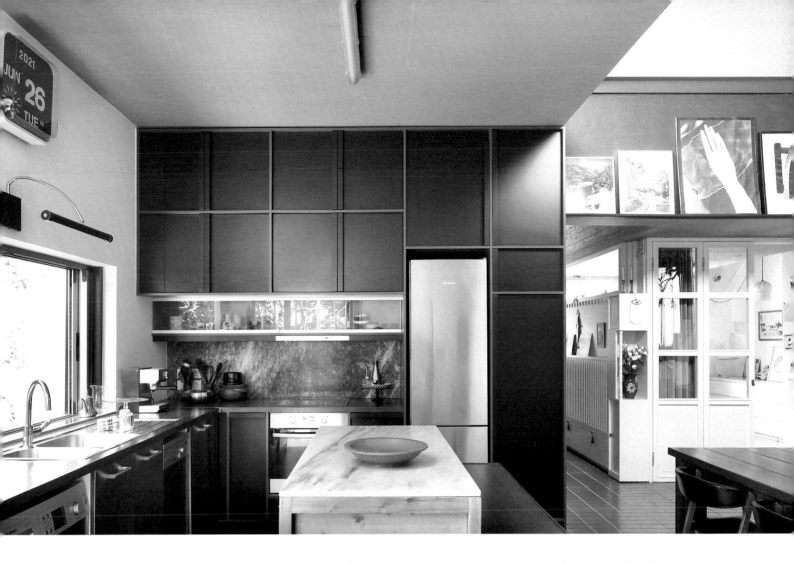

This Athenian home is built across three levels, with a void stretching above the kitchen and dining space, creating a sense of lightness and drama in the part of the home with the most traffic. This shape mimics the classic Athenian neighborhood, which is typically built around a courtyard. The architects used recycled elements throughout, picked up in disused buildings and junkyards.

Graphic Colors, *Patterns, and Prints* that Pack a Punch

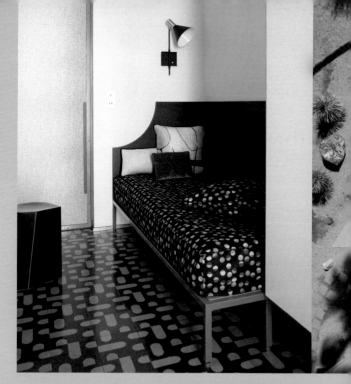

In this Milanese apartment by **Marcante Testa,** two similar-but-different patterns don't clash, but rather blend harmoniously. Here, tiles by **Bisazza** are matched with a polka-dot daybed.

Patterns liven up a space—that much isn't new. But what is new is the unexpected way some of the designers on this page mix together different patterns, along with oversized shapes and fearless color palettes. Solid, punchy colors are particularly cheerful, especially when they're arranged in graphic patterns. For added surprise and delight, apply pattern to places usually left blank: the inside of a staircase or the bottom of a pool are just two of many surprising canvases.

40

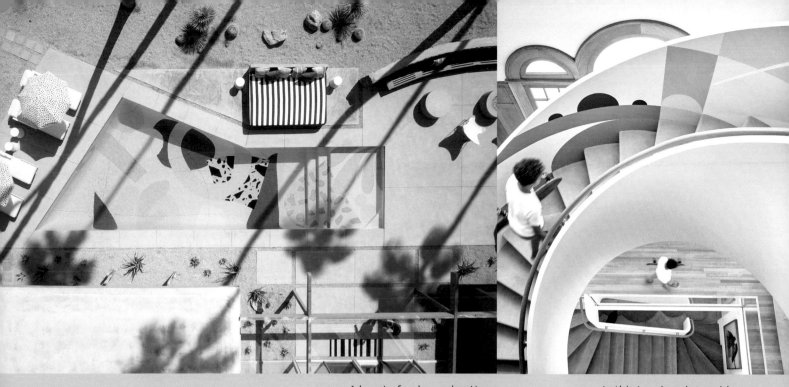

A burst of color and pattern make up this breathtaking mural by **Alex Proba** at the bottom of a swimming pool in California. The spontaneous blobs make a pleasing juxtaposition against the sharp angles of the pool.

In this Los Angeles residence, artist **Adrian Kay Wong's** mural of overlapping colors and shapes, applied along the inside of a spiral staircase, brightens the journey up to the attic.

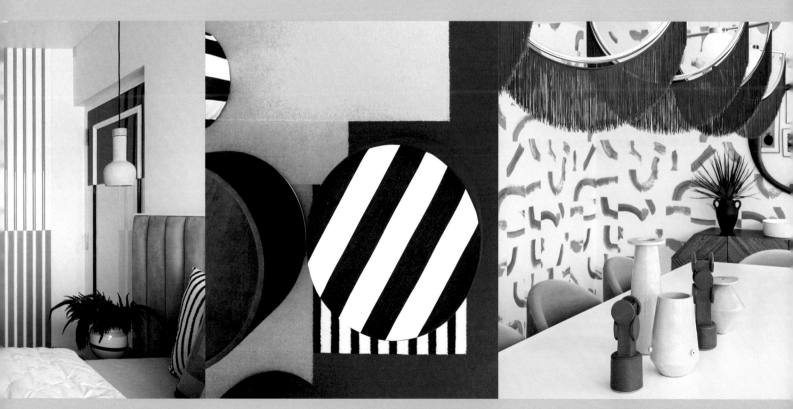

This Mumbai apartment is heavily influenced by the Memphis movement. Fluted wardrobes with brass handles from **United Trading** are matched with a carpet by **The Weaver** and an **Objectry** clock.

Color queen **Camille Walala** has decorated the entirety of the Salt of Palmar boutique hotel in Mauritius in bold color blocks and chunky patterns. From the pool to the planters to the pillows, nothing is spared.

At this Rancho Mirage residence in California, a custom dining table and pink cylindrical chairs, all from **ModShop**, foreground a brushstroke-patterned wallpaper. Fringed pendant lamps from **Manfredi Style** hang above.

A Reference-Filled Artist Residency

Villa San Francisco

Studio Mortazavi

San Francisco, CA, USA

Villa San Francisco does little to conceal that this residency is made for artists, by artists. Every decision that informed the interior can be tied back to an artistic influence, underpinning the space's wider objective to make the residents feel immersed and inspired. The walls, for instance, bear not one but three references: twentieth-century painter Wayne Thiebaud inspired the colors in the living and dining room, Nathalie du Pasquier, a founding member of the Memphis Group, informed the graphic treatment in the bedrooms, and Rome's Villa Medici influenced the proportions of how those palettes were applied. Every individual item was also selected with a story to tell, from the dining chairs designed by Yvonne Mouser, with a semicircle motif that takes inspiration from the Arc de Triomphe, to the pine-dowel living room sofa by Yves Béhar. Altogether, these elements string together a greater narrative, one that bridges France and Northern California.

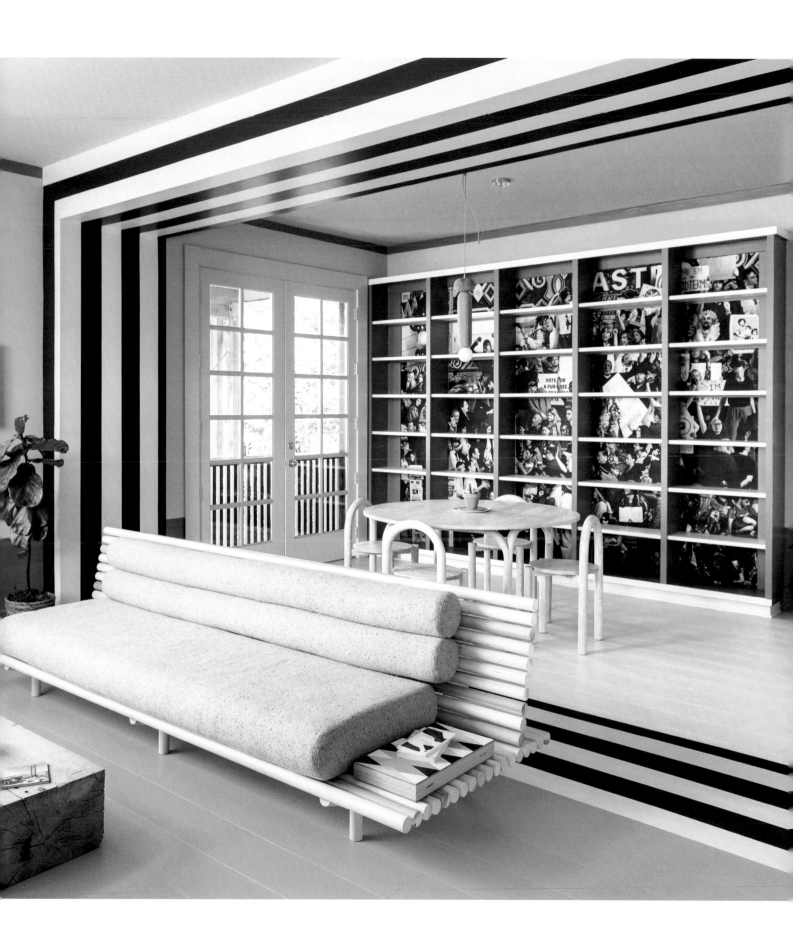

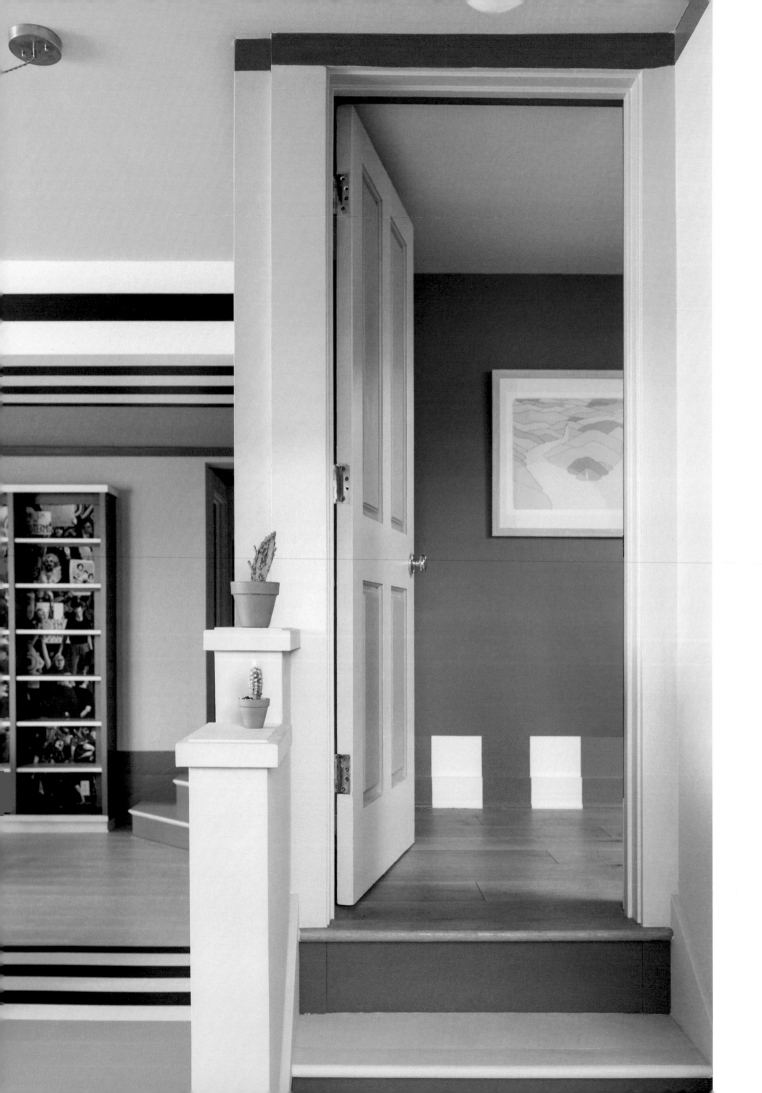

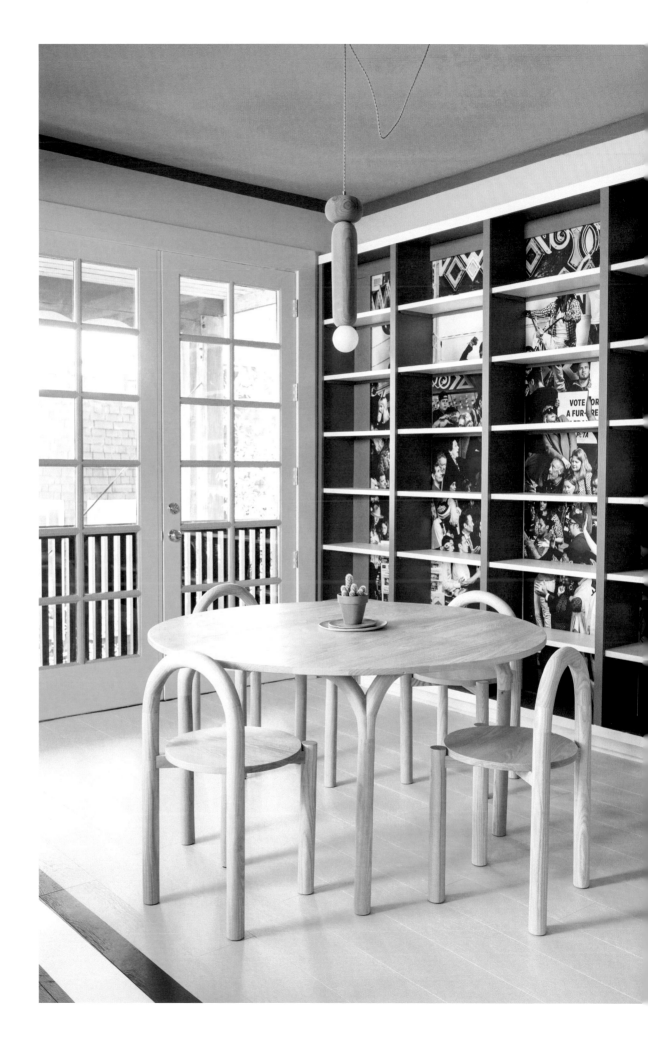

A Distinctly and Vividly Walala Resort

Salt of Palmar

Camille Walala

Belle Mare, Mauritius

There are few designers who have created a body of work that is so *them* it's unmistakable. London-based Camille Walala is among them. Be it a bouncy castle outside a London office building, a cushion, or this boutique hotel in Mauritius, her work is unified by its use of punchy colors, its graphic quality, and its vibrant patterns. That's exactly what enamored the client at the Salt of Palmar boutique hotel. Originally, Walala's involvement with the hotel group was limited to a mural at its sister hotel, but when the CEO saw the finished work, he saw the potential for more. And so, Walala received her first hotel project, with a brief to reflect the distinct identity of the island, where color plays a key role in the local culture. The hotel's palette draws inspiration from the country's architecture and natural surroundings, and incorporates the work of local artists. The optimism of Walala's work lends itself unsurprisingly well to the holiday context, where worries are washed away by color, pattern, and sunshine.

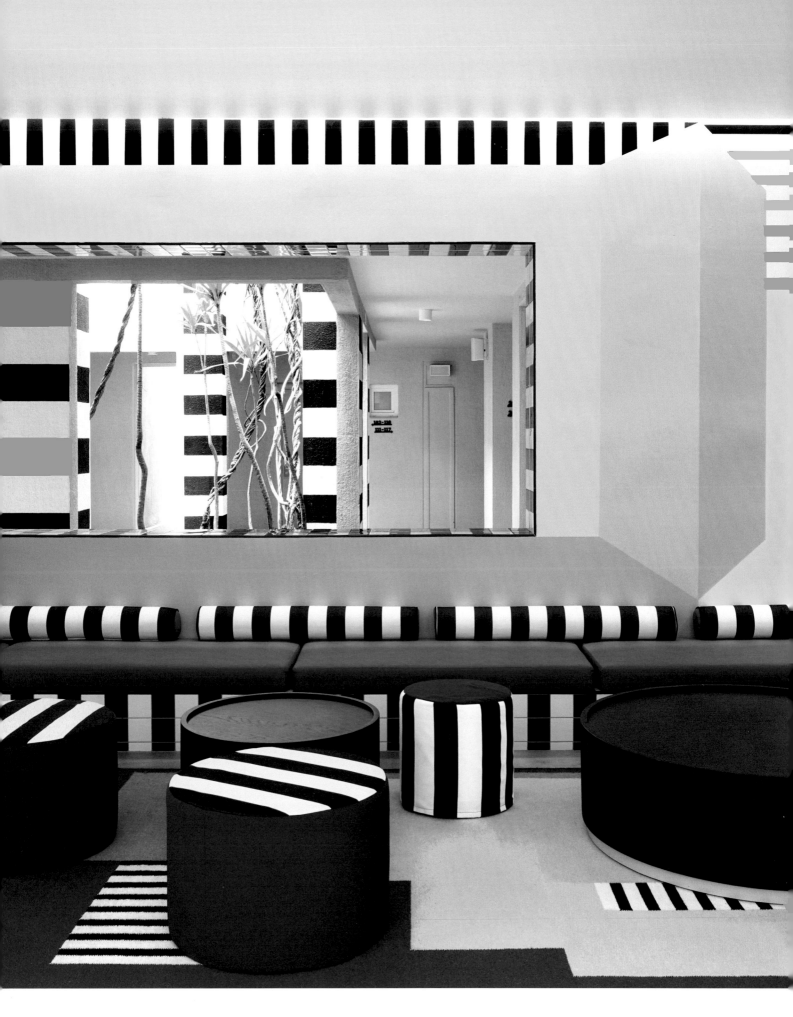

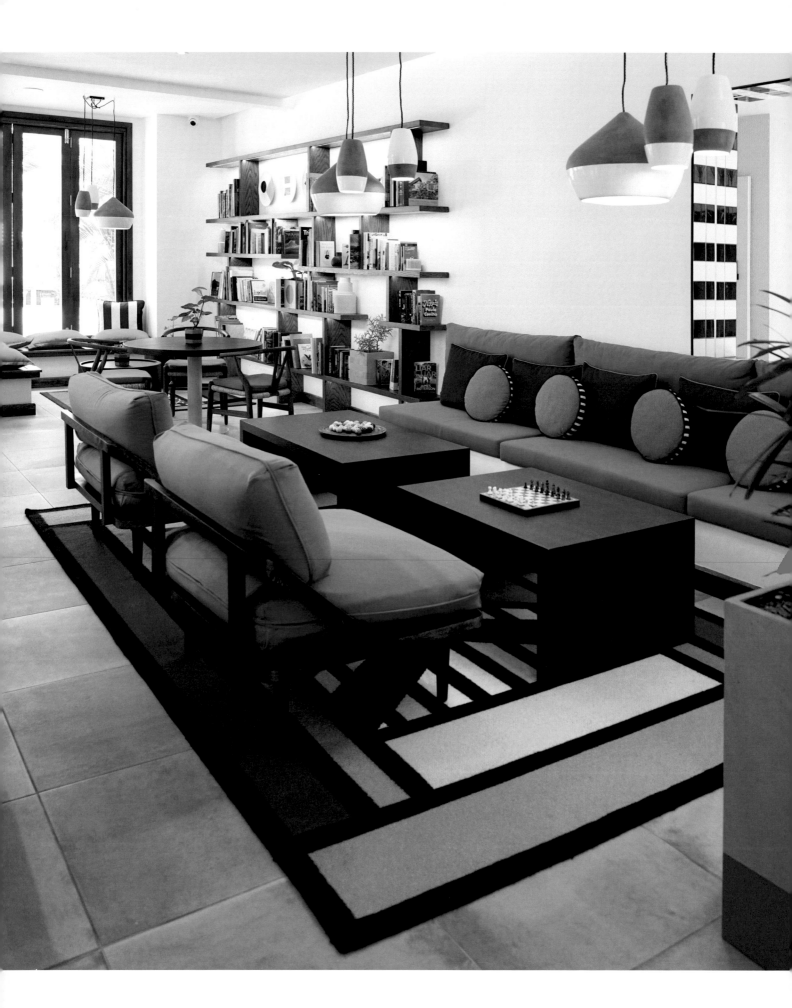

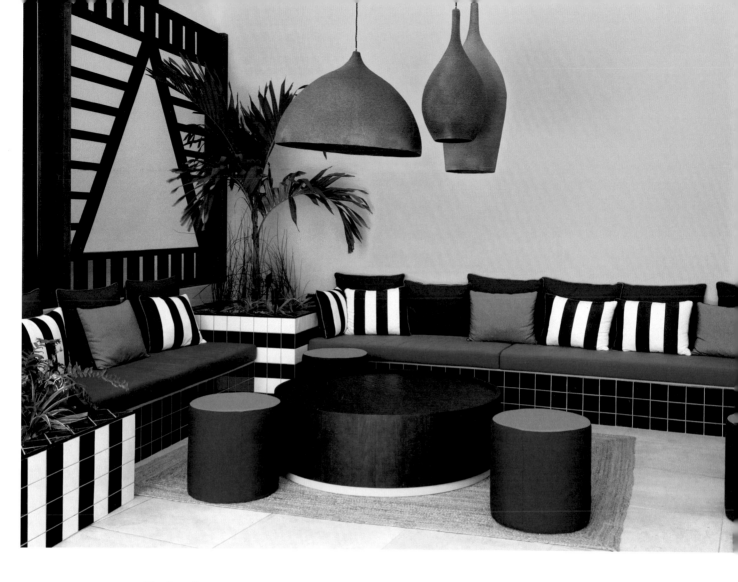

The hotel group's CEO, Paul Jones, was struck by the overlap between Walala's approach to color and pattern, and the importance of color in Mauritian culture. Her selection of punchy colors covers nearly every surface in the boutique hotel, as seen in the communal spaces shown here. The palette is directly informed by the natural and architectural surroundings of the island.

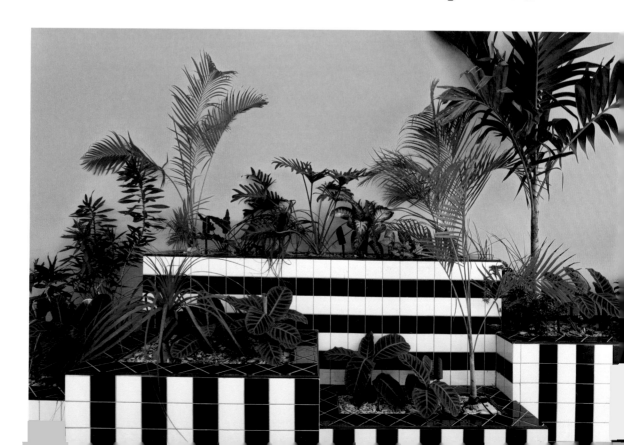

Walala worked closely with Mauritian architect John-François Adam on this project, a collaboration that was key to involving the wider Mauritian creative community. Several of the island's craftspeople, including basket-weavers, ceramicists, and rattan artisans collaborated on the interiors, forging an essential link between the hotel, the community, and culture.

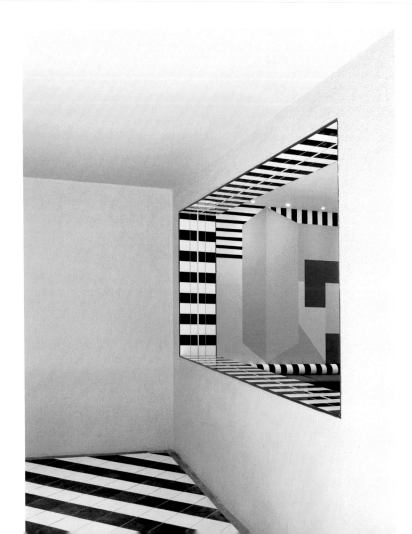

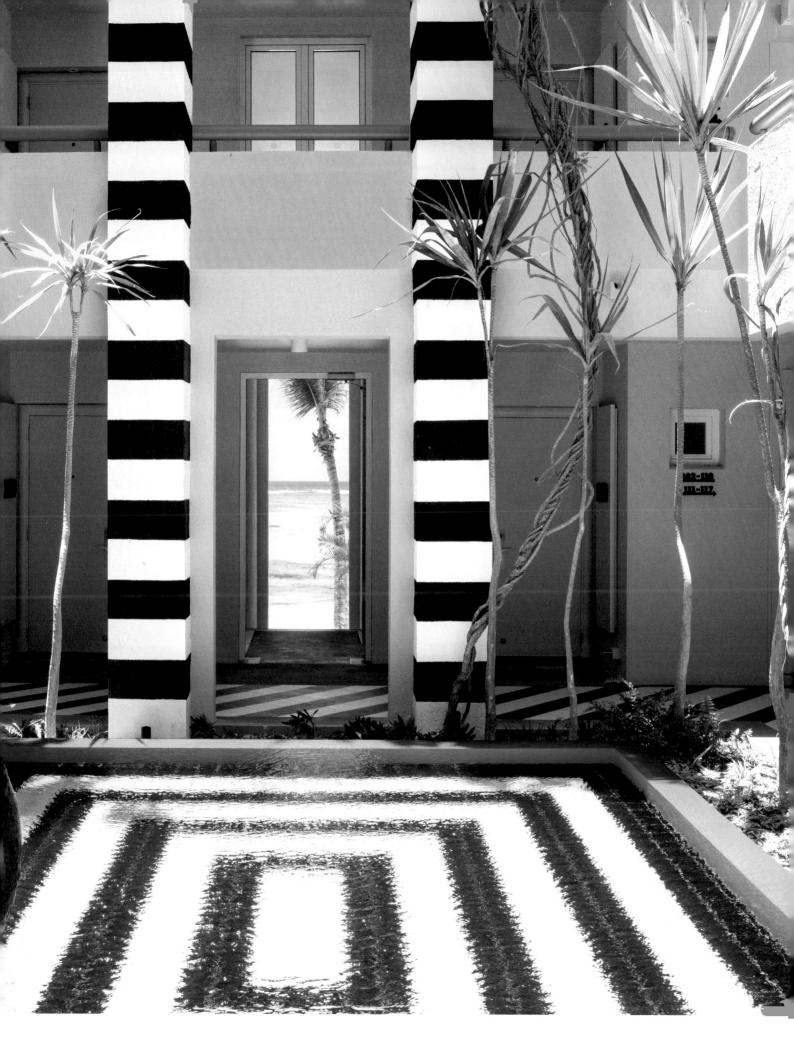

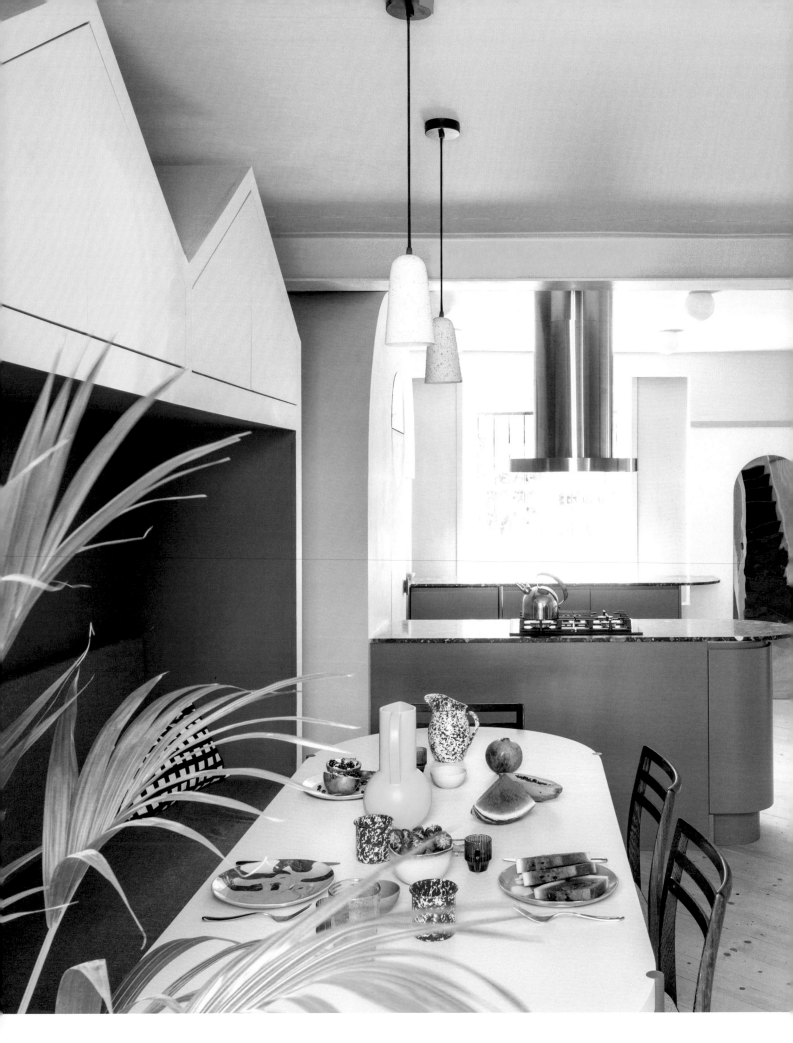

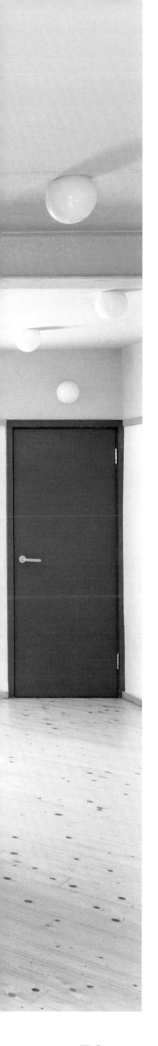

A Sunny Solution in Cloudy London

Mo-tel House

Office S & M

London, U. K.

It doesn't take much to see there's a lot going on in this house. The staircase is pink, the ceilings pistachio, and the radiators blue. The pantry is topped by a semicircle, the dining area has triangular cabinets. In a house where nothing seems to make sense, in practice, everything does. Those arches and triangles help divide the space and reference the city outside. The use of color responds to the brief, which was to turn the lower ground floor of this North London townhouse into a "not-boring" escape from the gray city. The client, Tamsin Chislett, is the founder of an online service based on lending, not buying, fashion. Those principles informed the material selection, with each one reused and repurposed. The marbled surfaces in the bathrooms and utility rooms are made from discarded milk-bottles and chopping boards. In the kitchen, the green terrazzo surface was achieved using marble offcuts. To maximize light on the lower ground level, the architects designed lighting to come from multiple angles to create a sense of brightness—a quality that's only enhanced by the cheerful color palette.

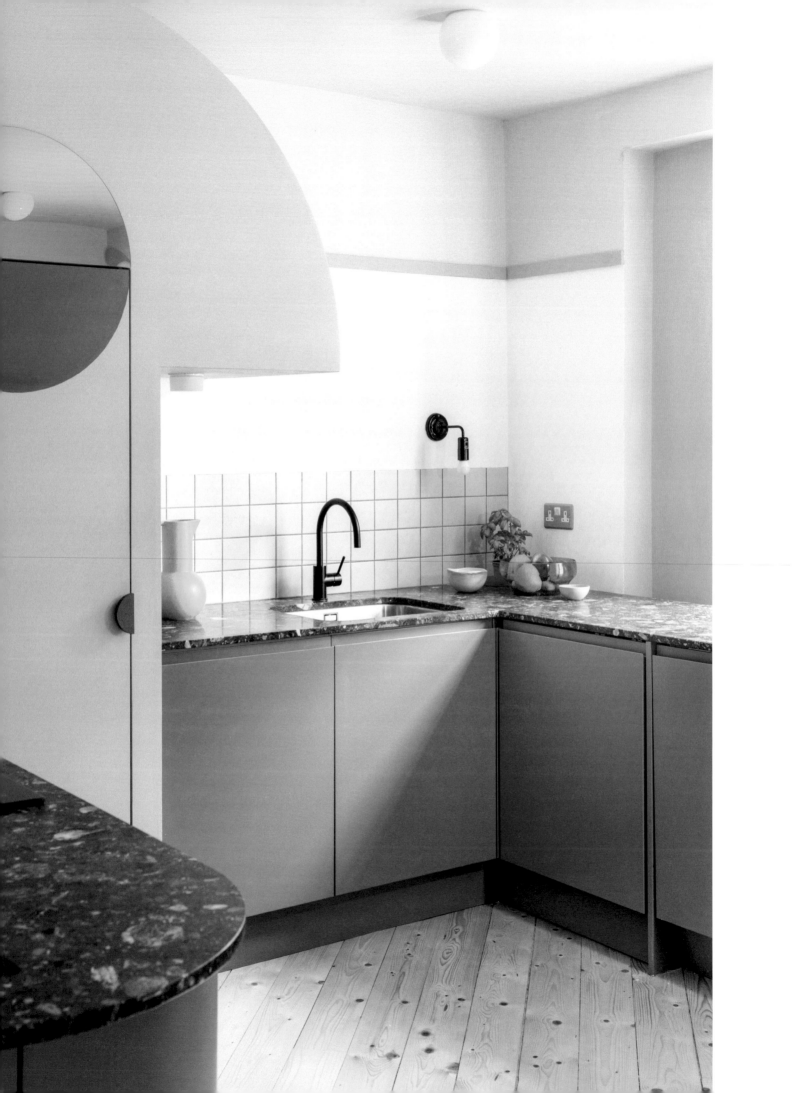

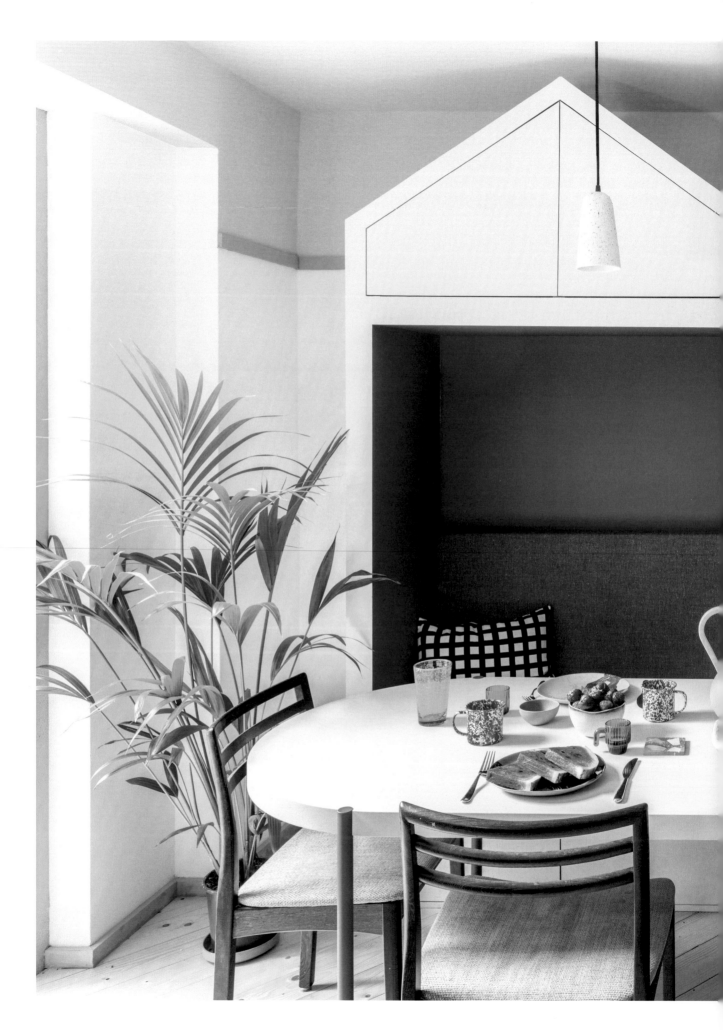

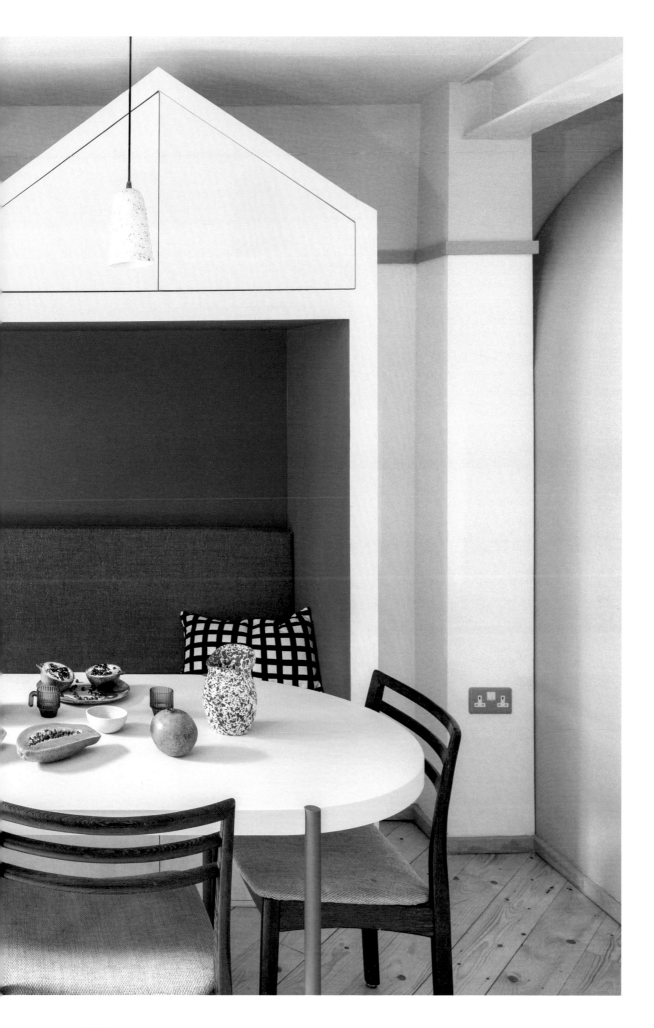

Four Eyes Are Better Than Two

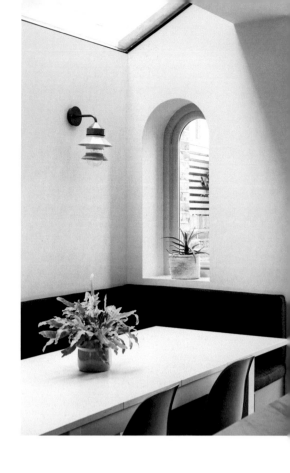

Valetta House

Office S & M

London, U.K.

They didn't have to be yellow, and they could have all been the same size, but where's the fun in that? The four arched windows represent the four girls of a London family, whose parents enlisted Office S & M to refurbish their home so that each daughter could have her own room, and to create a more child-friendly feel overall. The latter was achieved through snakes-and-ladders bannisters along the staircase and curving walls, while the overarching "adult" quality is found in glazed herringbone tiles, encaustic floor slabs, and rounded cedar shingles on the facade. In the process of designing the two extensions to the home, the architects opened up internal windows and light wells to bring more light into the home, selecting a warm color palette to reflect these new light sources. What the architects have done particularly well is create a child-friendly home that doesn't feel childish. In fact, the home will mature as the girls grow up, especially on the outside, where the cedar shingles will weather and change color with time.

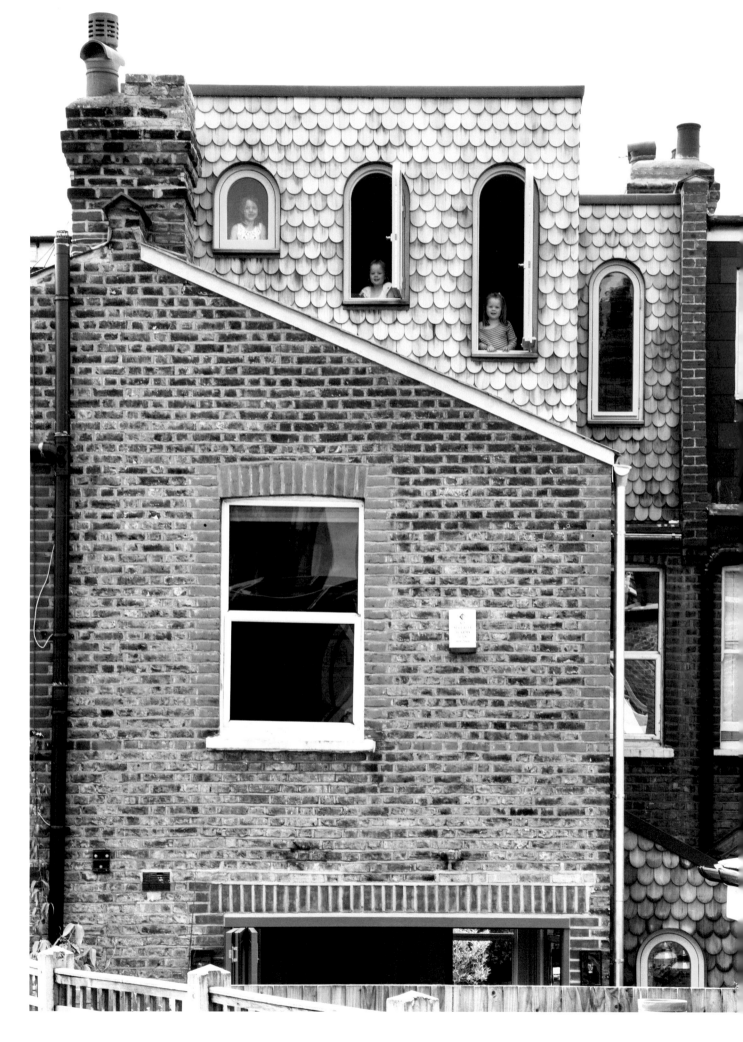

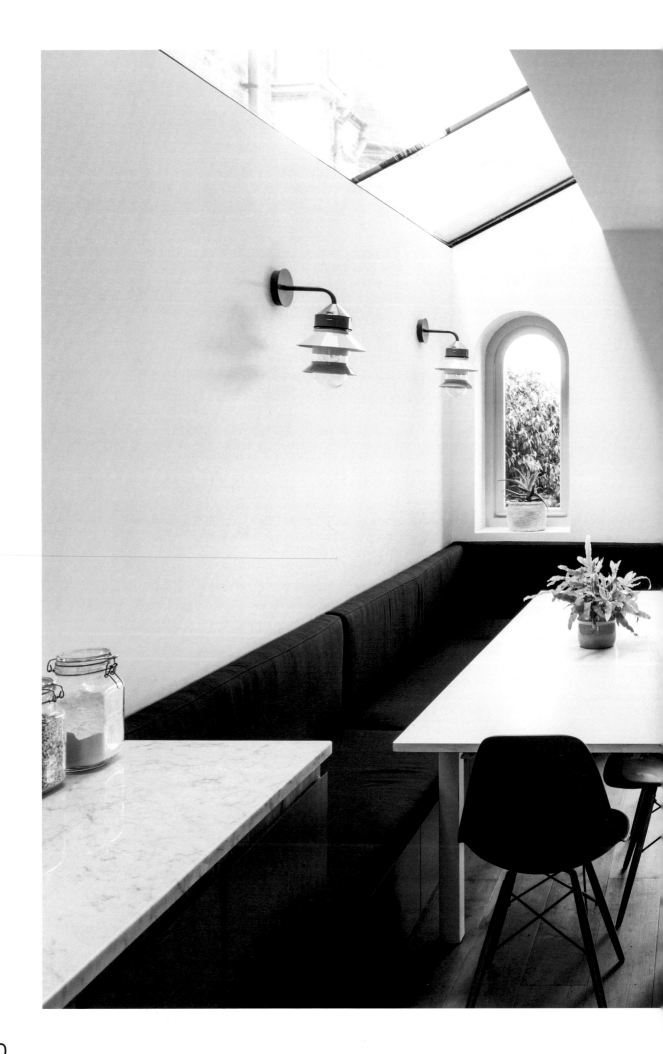

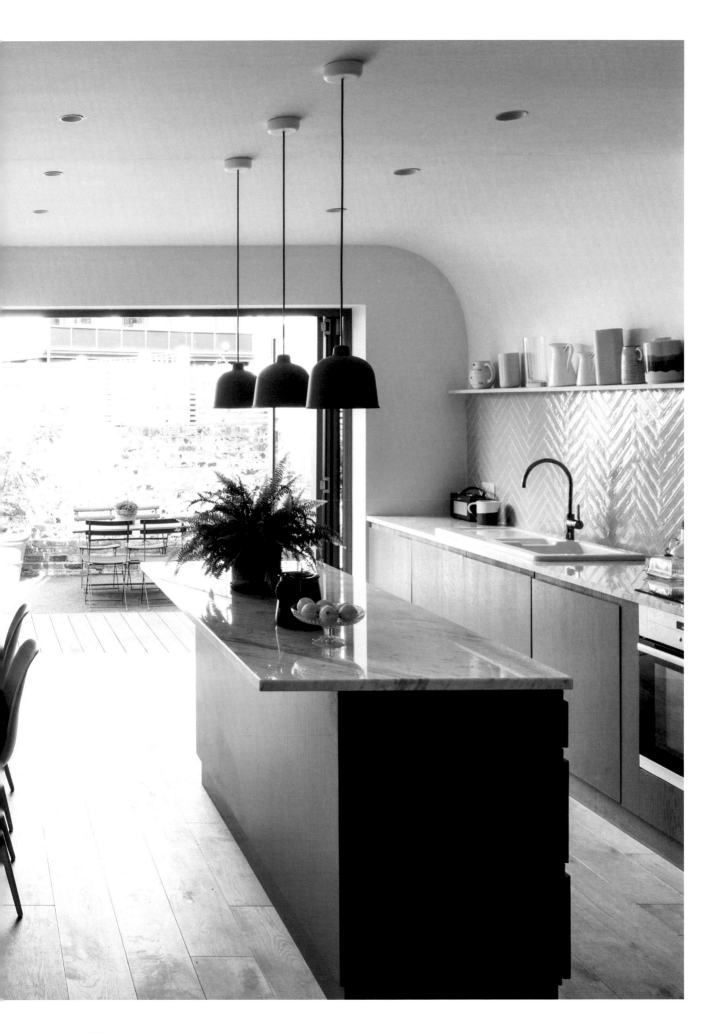

Valetta House

The home's child-friendly qualities are especially evident in these pictures, where pops of sunny yellow can be seen articulating different moments in the house, as well as creating a sense of continuity throughout. The three yellow windows are just as playful on the inside as they are on the facade.

Northerly Light in a Bright Pink Extension

Overcast House

Office S & M

London, U. K.

What otherwise might look like just another London row house has been updated with an extension in the hues of watermelon candy. The single-story add-on was envisaged to accommodate home working, while adapting the house for lifelong use by residents Keiko Cummings, a Japanese color consultant and graphic designer, and her partner Alan, an academic. One of the key requirements for the client was steady natural light throughout the day. In a climate that goes from sunny to rainy and back again several times a day, that's easier said than done. The architects achieved this with carefully shaped and placed skylights that let in natural light, but not direct sun—an approach often used by art galleries. To lower the extension's carbon footprint, they opted for wood construction, with an external skin of pigmented, scalloped concrete blocks, developed in collaboration with Mortise Concrete. Meanwhile, a green downpipe theatrically celebrates the exit of rainwater from the roof.

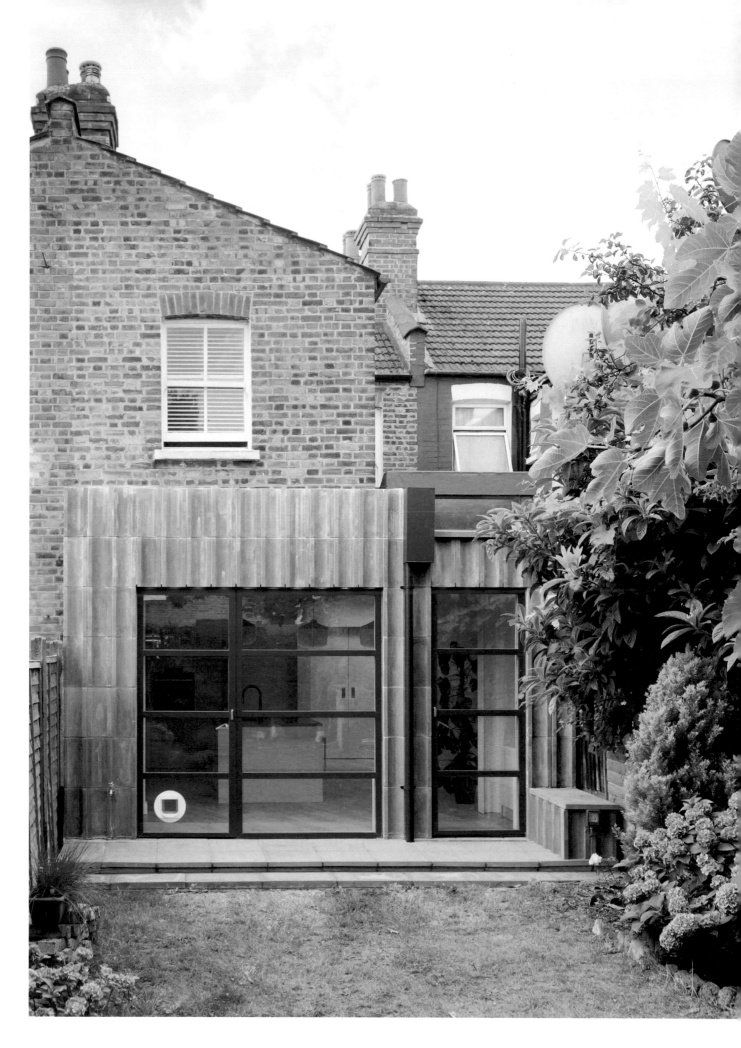

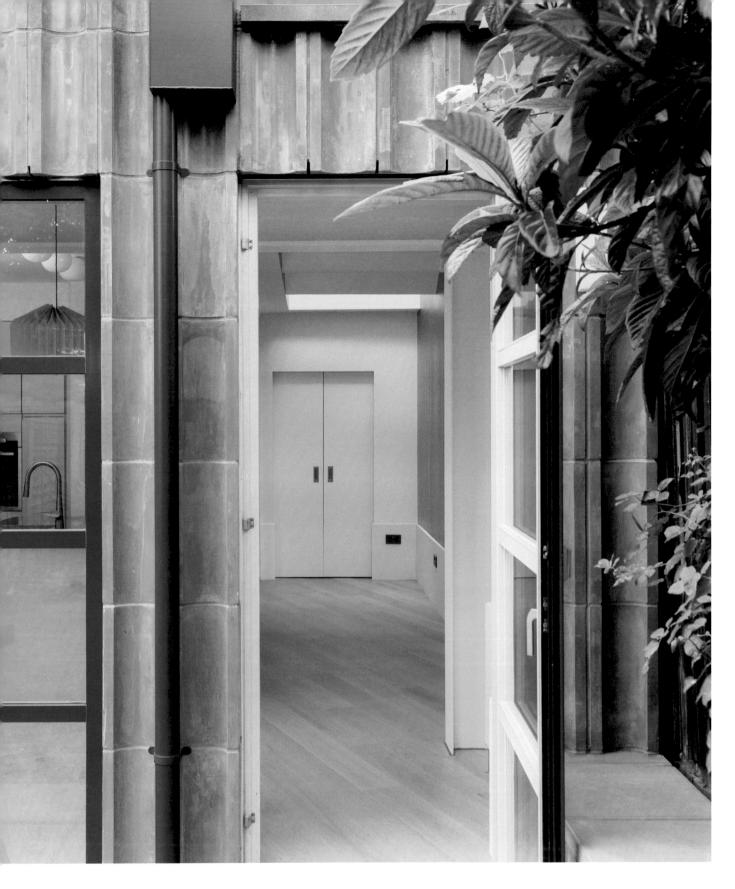

For the extension's striking scalloped facade, the architects created what they refer to as the "shadow catcher," pigmented concrete blocks that cast shadows even on overcast days. The home is far less shadowy on the inside, where techniques to maximize and evenly distribute sunlight are celebrated with a juicy color palette.

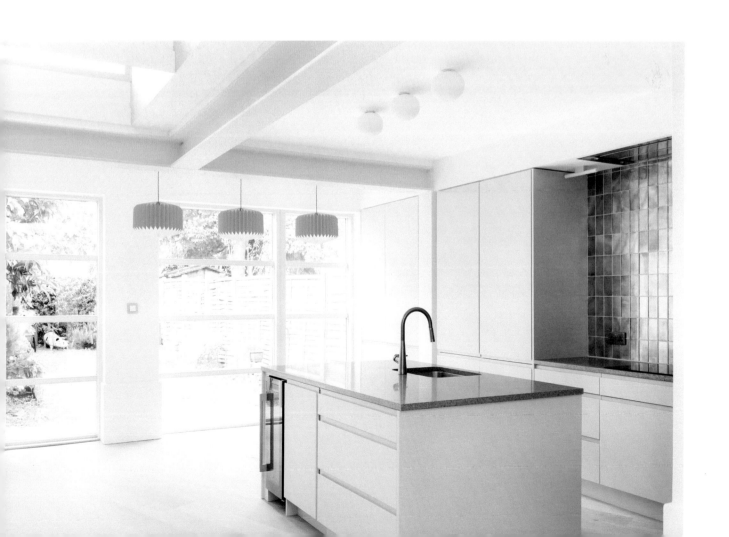

Square
Tiles and Grids
Make Playful Patterns

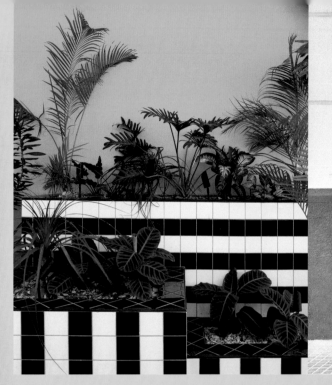

At the Salt of Palmar boutique hotel, designed by **Camille Walala,** tiles placed on outdoor planters form bold, black and white stripes, a motif that is repeated at the bottom of the pool, on textiles, and murals.

Tiles have played a leading role in our homes for centuries. But what the interiors on these pages show is that something as traditional as a tile can also appear strikingly modern; it all depends on how—and where—they are used.
To make an impact, put tiles in places other than typical zones like bathrooms and kitchens. Choose stark, contrasting colors and unique arrangements to transform plain walls into graphic, playful visuals. Arrange square tiles in a grid to give your space a sense of linear flow and geometry.

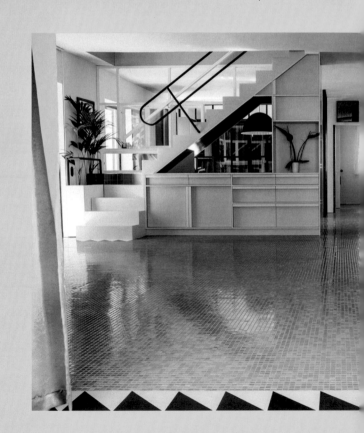

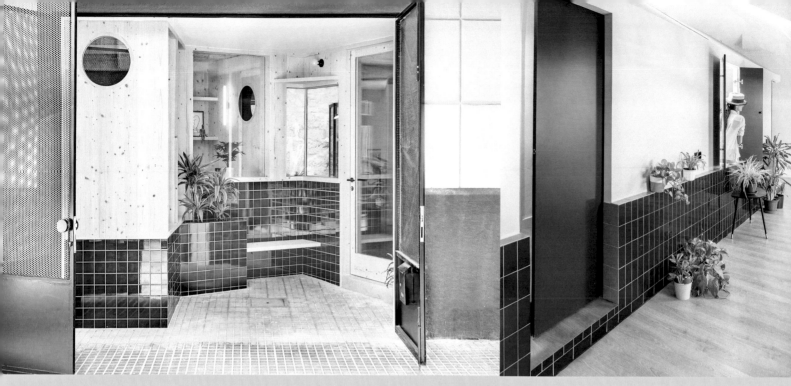

At the Palma Hideaway by **Mariana de Delás,** the entryway is furnished with built-in wooden benches and tiled planters. The tiled walls, which contrast against the muted timber, recall Mediterranean courtyards.

Designer **Mariana de Delás** goes for Moroccan flair by pairing tiles in Yves Klein blue with cheerful yellow accent tiles in this Madrid home.

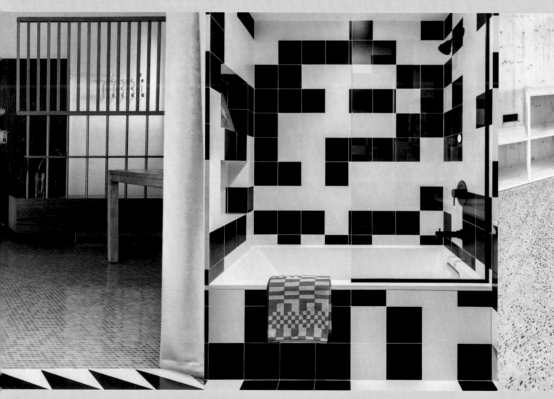

Point Supreme architects wanted the lower level of the Nadja Apartment to feel "marine-like." Small-format floor tiles catch the light like the sea's surface, contrasting against black and white accent tiles.

The tile arrangement in **Ellen Van Dusen**'s bathroom was inspired by the geometric paintings of François Morellet, who created random patterns by assigning colors to odd and even numbers in the phone book. Van Dusen used black and white tiles and the phone numbers of friends and family.

Designed by **2Monos**, the dining table at the Palma Hideaway provides a playful pop of pink to liven up the muted tones of the wood and terrazzo, and to complement the dark tabletop tiles.

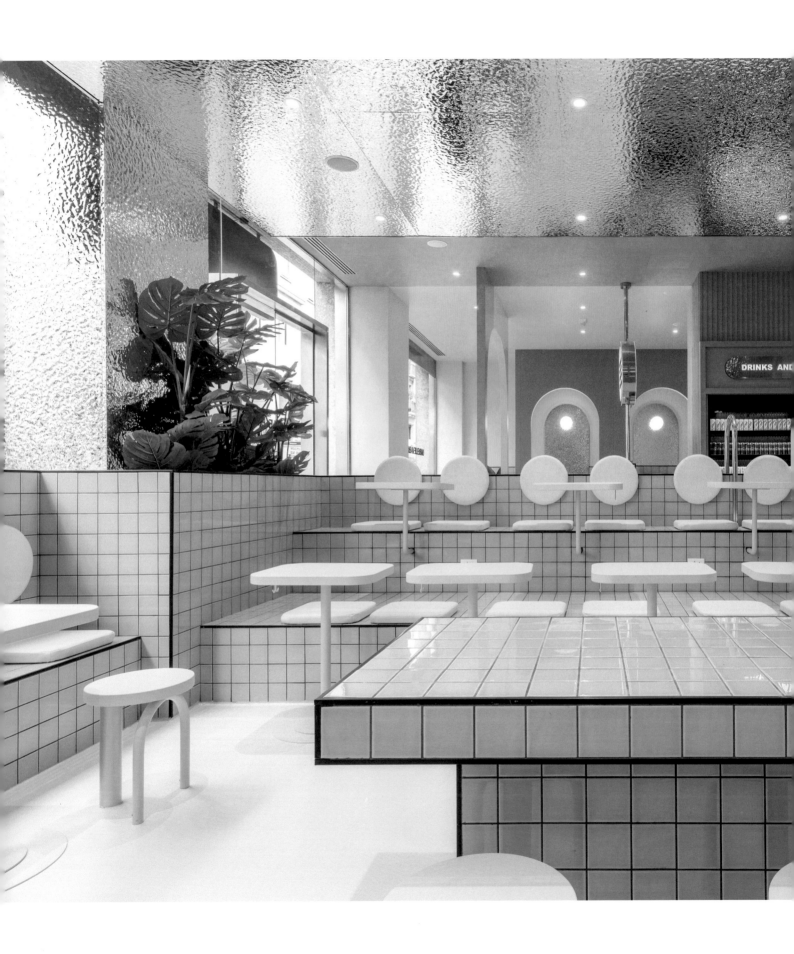

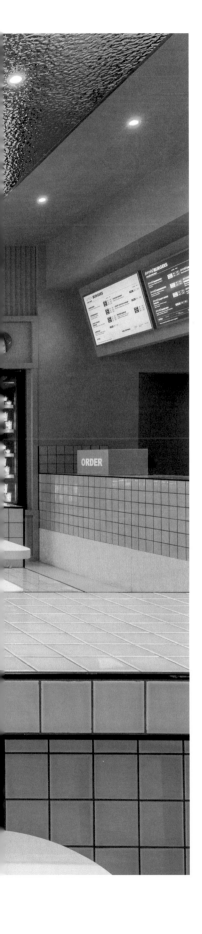

A Burger Joint Awash in Candy Colors

Bun Burgers

Masquespacio

Turin, Italy

Color drenches every surface in this Turin burger joint. Walls, floor, furniture, and fittings are awash in watermelon pink, sky blue, and pistachio green—the last a direct reference to the restaurant's plastic-free packaging. This is the second collaboration between Bun Burgers and the Valencia-based interior design studio Masquespacio, following the first location in Milan, where the studio defined the Italian chain's candy-colored aesthetic. This second iteration needed to feel consistent with the identity established in the first, but with its own spin. The Turin location introduced a third color to the mix, and each of the three colors are placed according to their relationship with the door and the two windows. The result is that passersby only see one of the three colors at a time, depending on where they stand. The stools and arches are a continuation of Milan, while the blue area of the restaurant features tiles and ladders to give customers the impression they're eating at the bottom of a swimming pool.

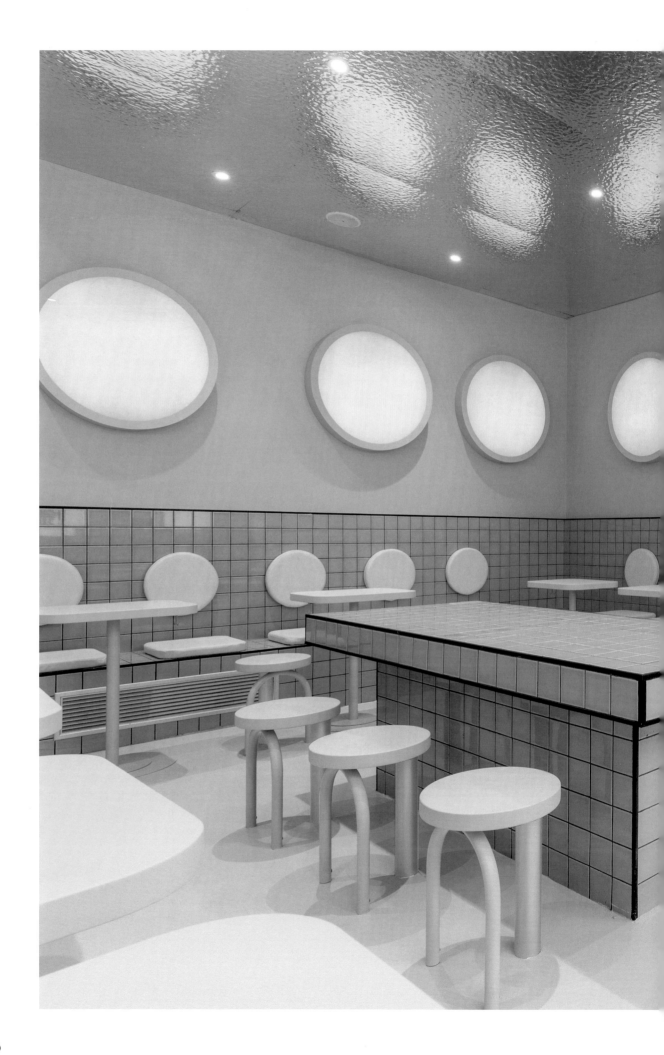

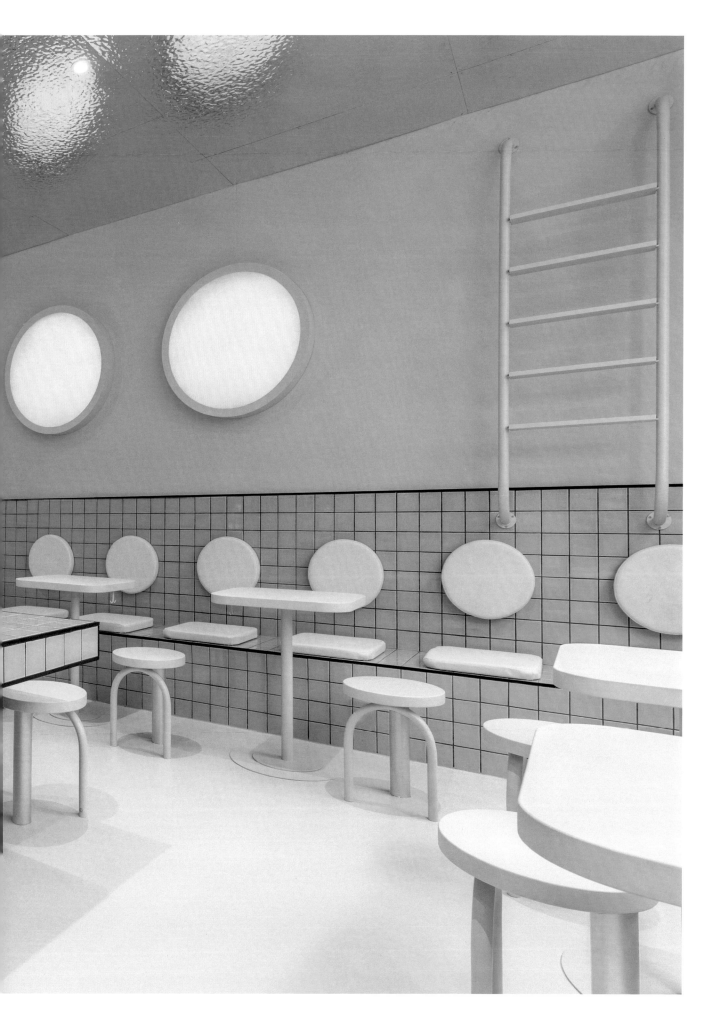

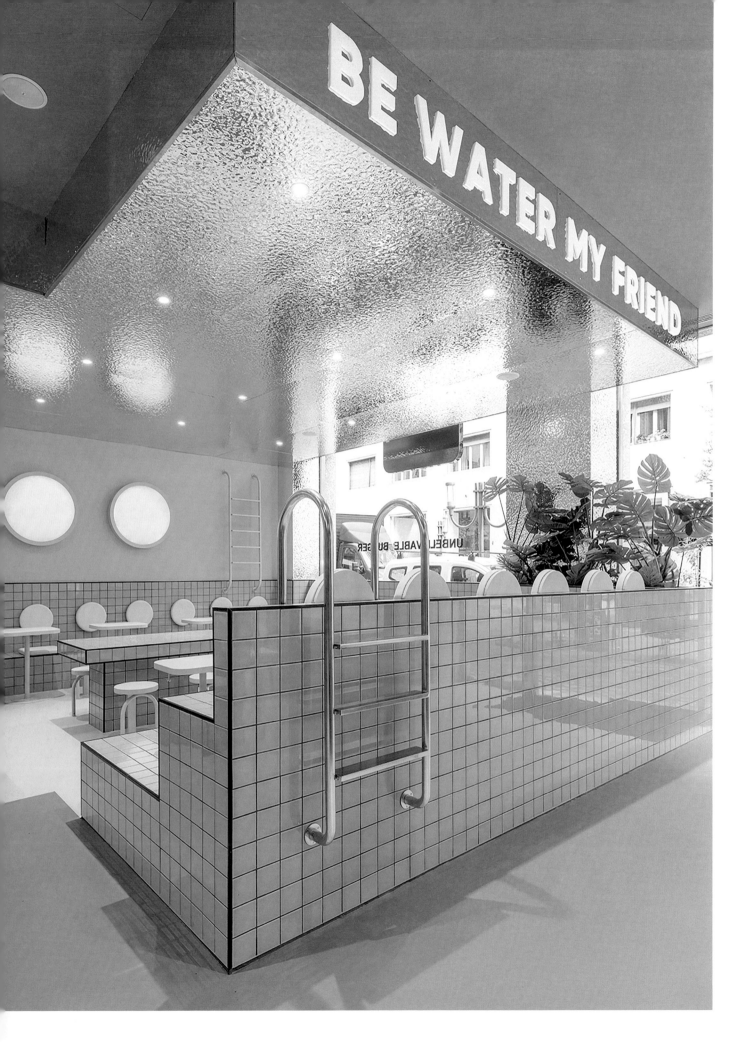

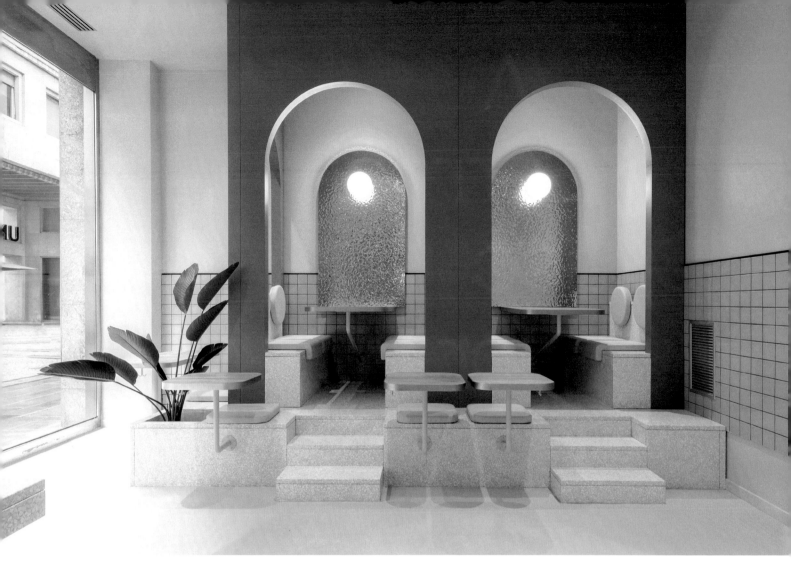

The three different parts of this restaurant are clearly demarcated by their use of color. The pistachio green, which represents the brand's approach to plastic-free packaging, welcomes the customer and directs them to the counter to order food, while the pink and blue are used for the seating sections on either side of the counter.

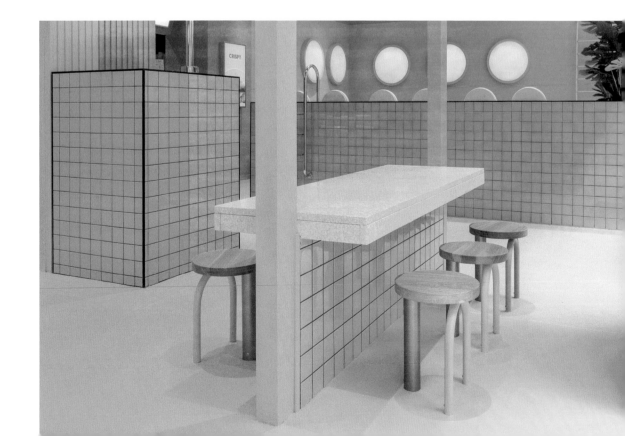

A Surreal Space for Suspension

Origin Float Experience

Bureau

Geneva, Switzerland

Origin Float Experience was designed to echo the experience of suspension. This is a place that specializes in float therapy, where guests float in a heavily salted body of water to help stimulate creativity and relaxation, and relieve muscle tension. This atypical space called for an atypical design brief, and the architects did not hold back. To the design team, it was important "to create a world [in] which one can rest and imagine: evocative, abstract yet somewhat graspable." The result is, in a word, otherworldly. Different planes of color and texture overlap with one another in a palette of babyish pastels. These planes swirl through the space and are designed to represent shifting perceptions of reality. The viewer is guided through the space by the gridded tiles and shelving, which are interrupted by the surreal organic quality of early twentieth-century *objet-trouvé* benches in the common room. A rocky installation hangs from the ceiling like stalactites, prefacing the cave-like feeling that awaits spa guests once they reach the float pods.

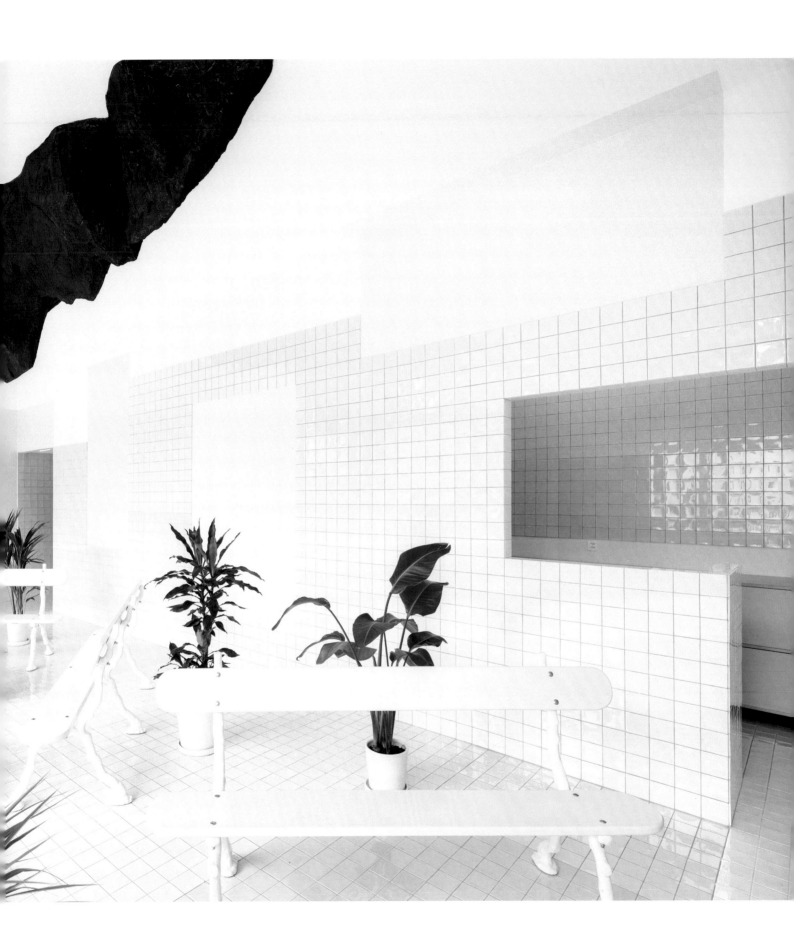

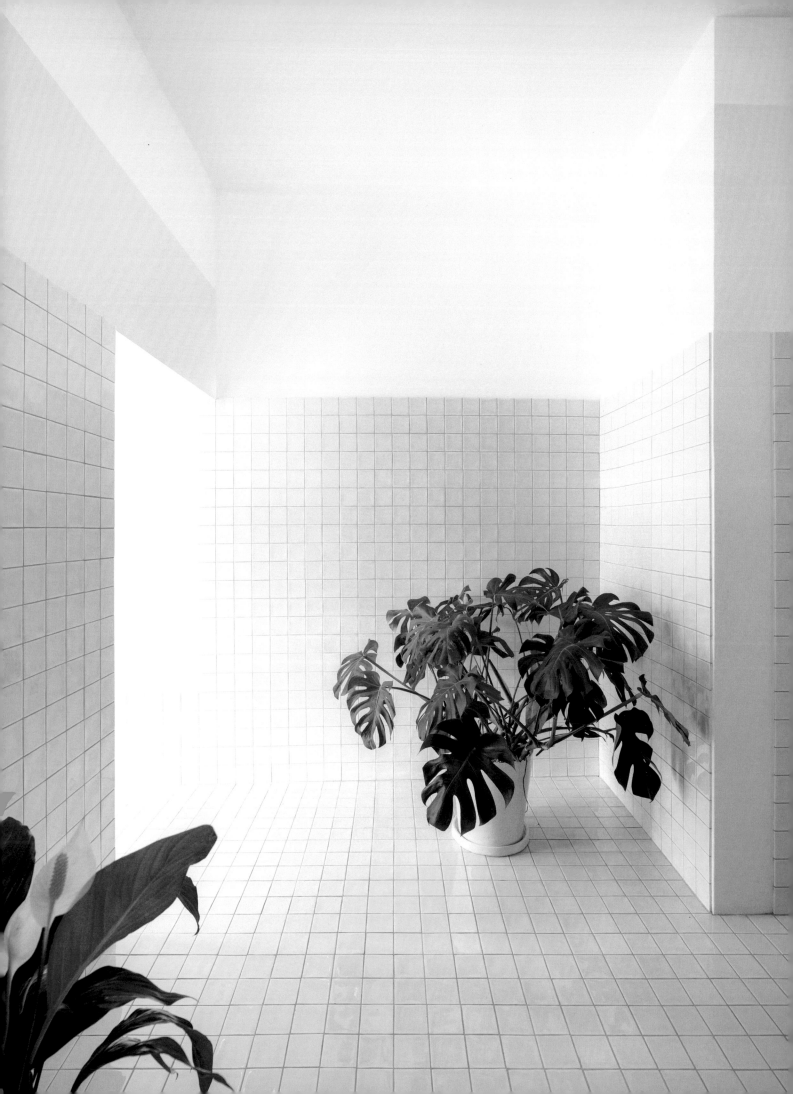

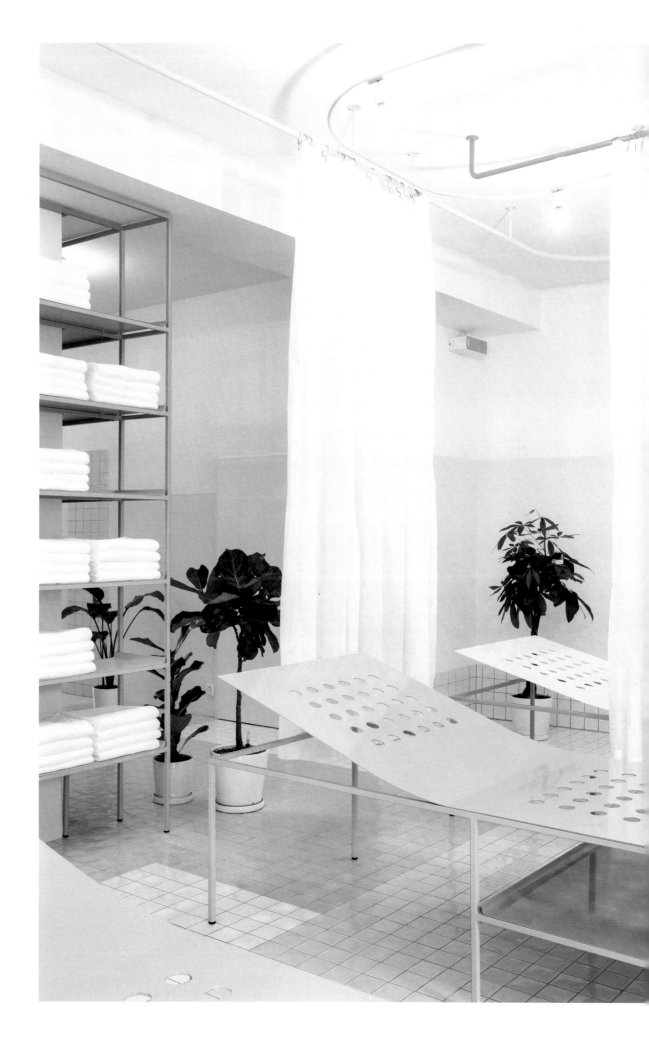

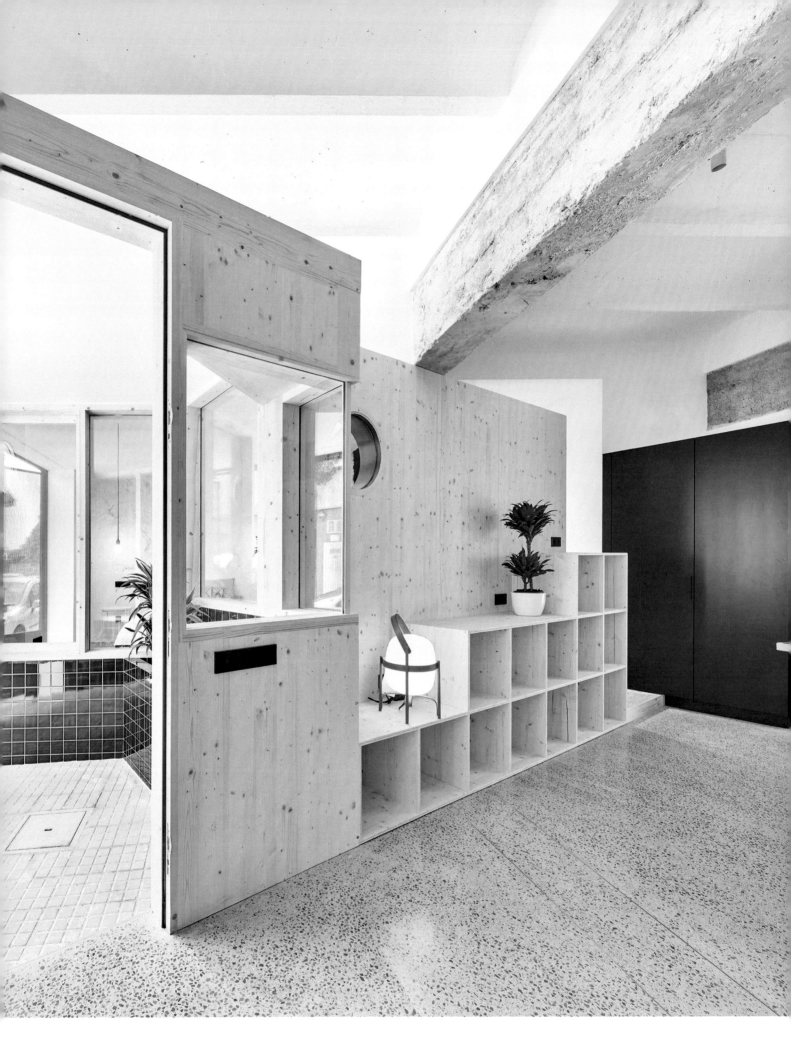

A Fresh Home in an Old Spanish Town

Palma Hideaway

Mariana de Delás

Palma de Mallorca, Spain

Is it possible for a home to feel quiet and comfortable when it's situated on the ground floor of a bustling urban street? How connected is too connected to street level? These are some of the questions that the architect explored in this renovation of a former motorcycle repair shop, located in the heart of the old quarter in Palma de Mallorca. The answer she found was to extend the threshold between home and street as much as the space would allow. Behind a perforated metal door, the entrance space offers a buffer to move from one environment to the next. Clad with tiles and bright wood, to the uninitiated visitor it's a sign of what's to come. Inside, the color is true to its island surroundings. Hues of citrus, green, and pink come together like items on a picnic blanket. Speckled terrazzo and polished concrete are cool underfoot. In the kitchen, a watermelon-colored island, designed by Mariana de Delás in collaboration with the young furniture design practice 2Monos, makes up the inviting heart of the home, placed in a way to encourage coming together over food and drink.

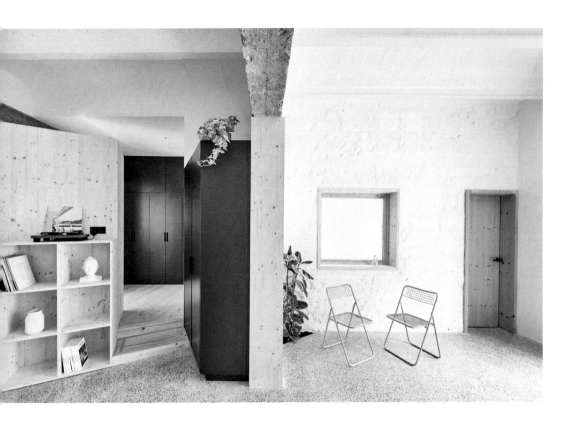

This apartment is situated on a bustling street in Palma but you'd hardly know it sitting amid the subdued concrete-and-timber palette. The architects have taken extra care in the threshold to create a sense of arrival, as well as block out street noise. The space gravitates along a diagonal axis, with a partition that serves as a room divider, storage space, and a visual tool that directs the eye toward the back exterior space.

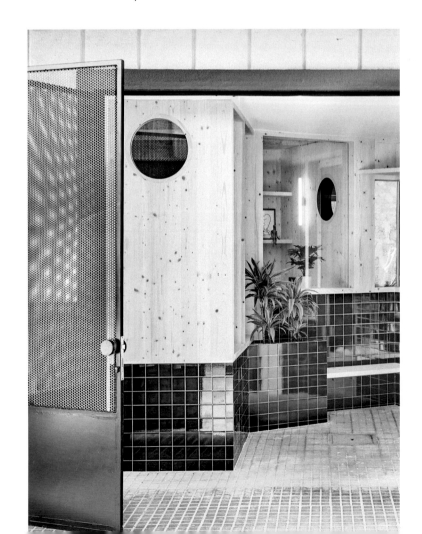

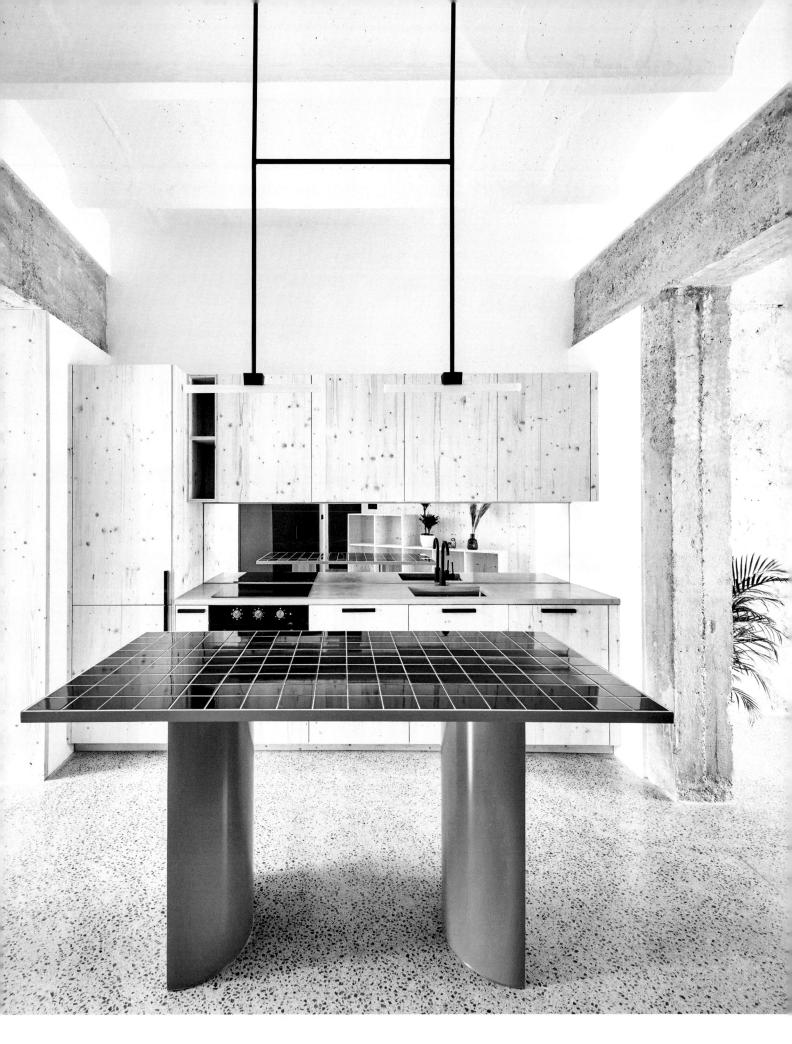

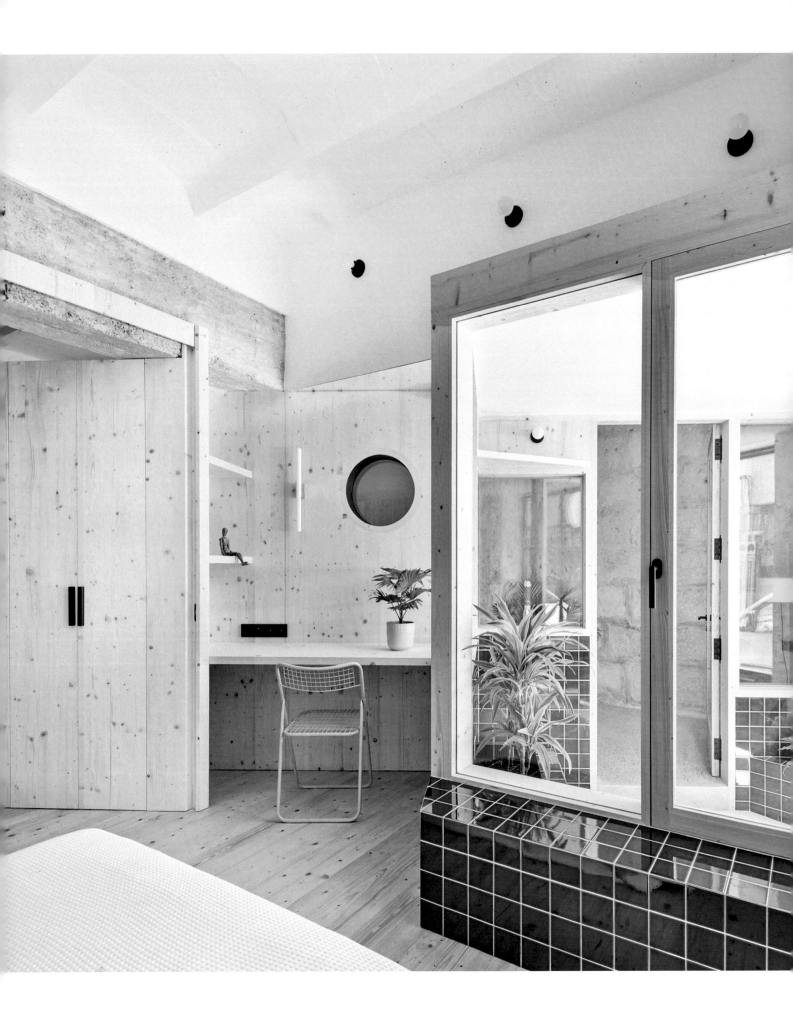

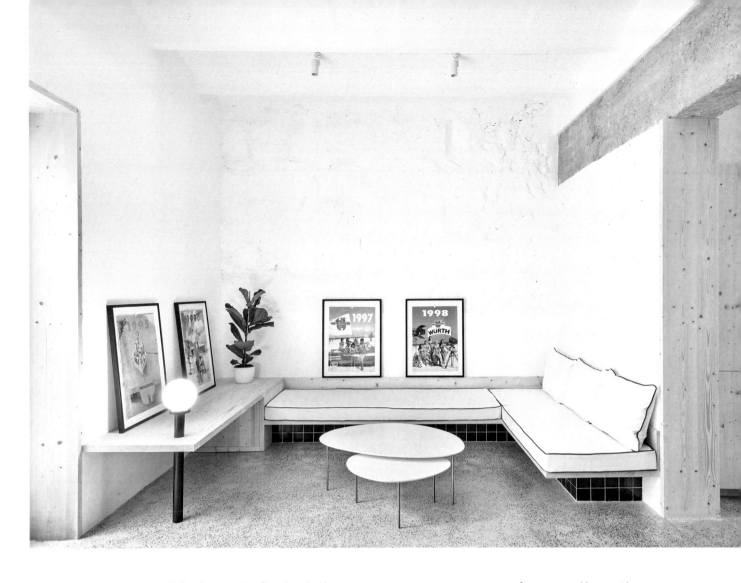

Polished concrete flooring in the common area creates a sense of space and keeps the apartment cool in the warm Majorcan summers. Wood floors in the bedroom provide tactility and warmth. A sunken plunge pool clad in the same shade of green as the tiles used throughout the home is a luxurious touch.

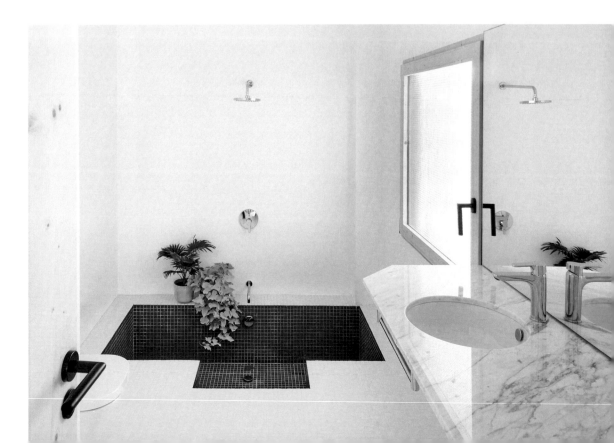

Spectacular Circles, Cylinders, and *Tubular Design*

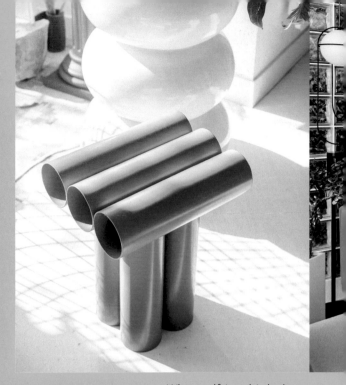

When self-taught designer **Axel Chay** renovated the Casa Calada in Marseille, he filled it with design classics as well as his own pieces. Seen here is the Septem Stool, made from aluminum tubes.

The cylinder has a certain staying power in furniture design. Its roundness doesn't intimidate, and its curves feel friendly. Unlike straight lines and angular shapes, its form suggests softness and comfort. Tubular furniture has resurfaced again and again over time, from the modernist 1920s Bibendum Chair by Eileen Gray to Terje Ekstrøm's 1970s Ekstrem Chair, an unexpected series of plush tubes that disrupted what people had come to expect from sensible Scandinavian furniture—or even from a chair, for that matter. Here are a few more recent examples of uplifting tubular design.

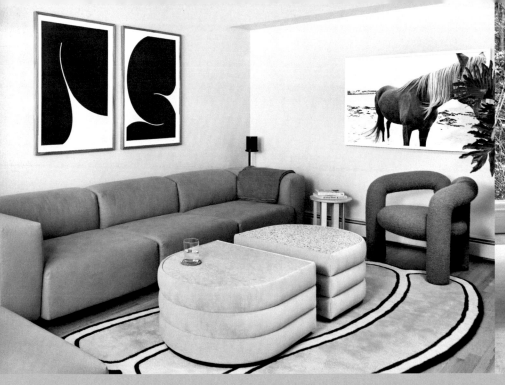

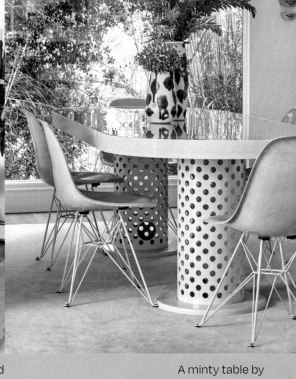

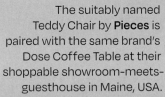

The suitably named Teddy Chair by **Pieces** is paired with the same brand's Dose Coffee Table at their shoppable showroom-meets-guesthouse in Maine, USA.

A minty table by **Ghislaine Viñas** features perforated cylinder legs and is accompanied by **Modernica**'s Eiffel chairs in this Los Angeles residence.

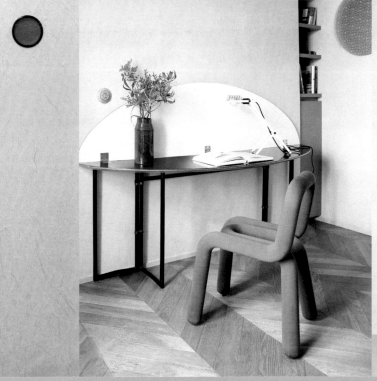

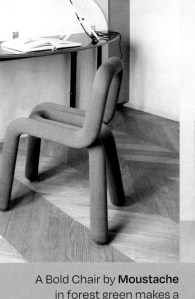

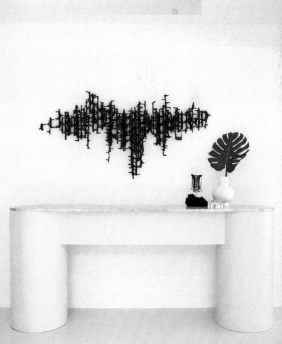

A glimpse into the meeting space at the home and office of **Uchronia** founder Julien Sebban, where a set of Chubby Chairs by Dutch designer **Dirk van der Kooij** provides striking seating.

A Bold Chair by **Moustache** in forest green makes a splash, especially when paired with a more muted but no less tubular console, in this Parisian apartment by **Marcante Testa.**

Chunky cylindrical legs crowned with a luxe marble tabletop at the Marrow Midcentury house in the Californian desert, designed by Los Angeles studio **Bells + Whistles.**

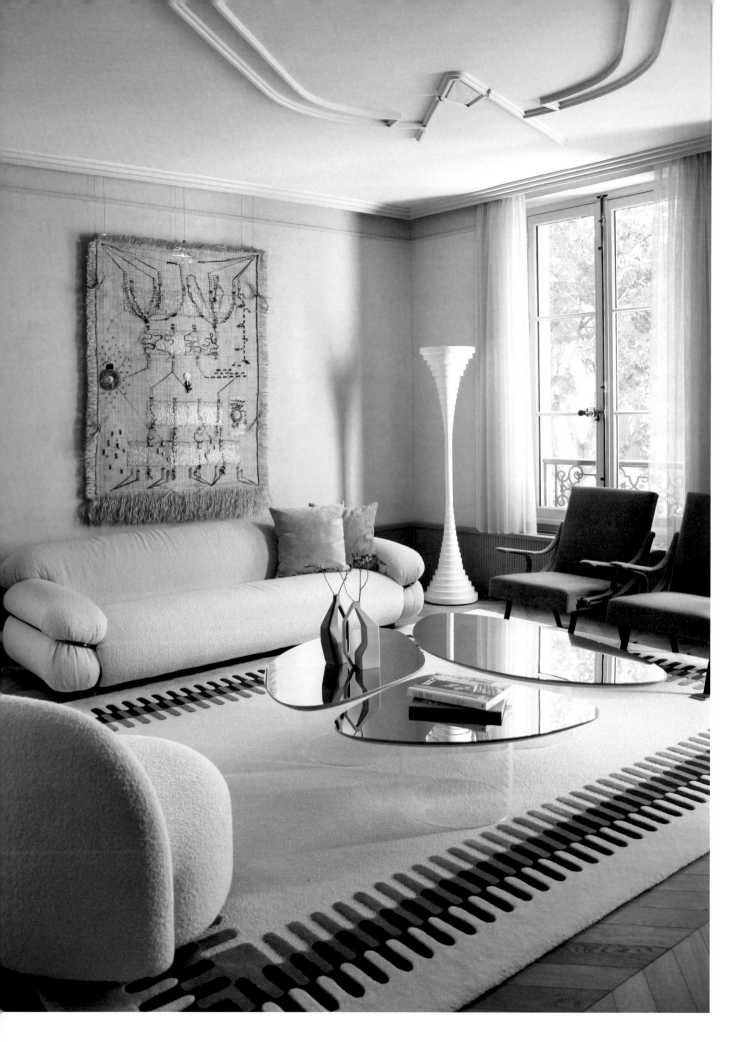

In the Shadow of Notre-Dame Cathedral

La Mesure du Temps

Marcante Testa

Paris, France

Saint-Sulpice, Paris's second-largest church behind Notre-Dame, contains a historic brass sundial, an eighteenth-century instrument used to measure the earth's orbit. The sundial is mentioned in *The Da Vinci Code,* and it's also the underlying theme of the renovation of this Parisian apartment, whose windows face the Saint-Sulpice church. To the architects, the Turin-based Marcante Testa, it was important to forge a link with the Parisian context, so they let the "feverish scene" of Paris in the 1970s inform the design. Another key influence was the client and resident, who is the director of the London-based gallery 50 Golborne, which specializes in contemporary African art and design. These disparate strands come together cohesively in the apartment, which is executed in a way that balances playful personality and total refinement. The furniture choices combine original pieces by Marcante Testa—which include built-in shelving, custom wardrobes, and specially made bathroom tiles—with classic pieces by Gio Ponti.

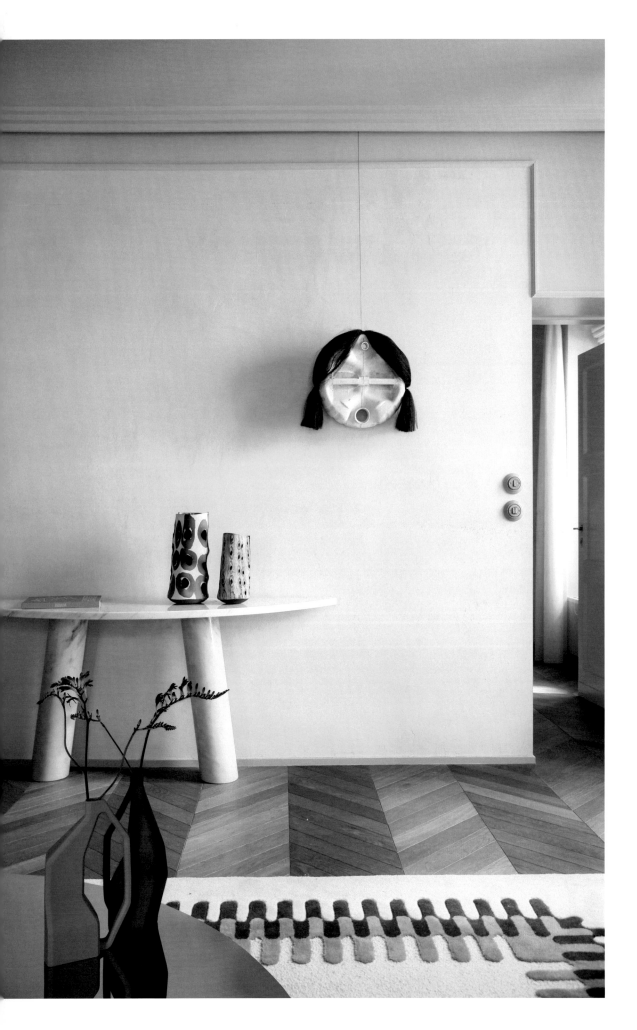

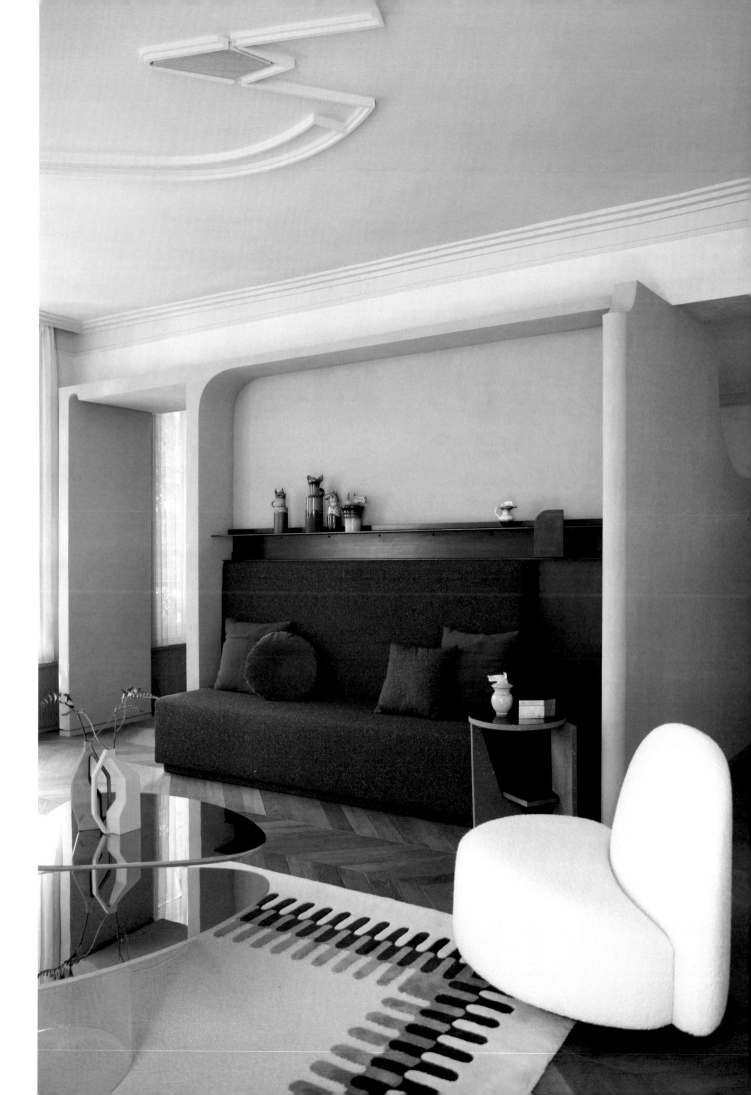

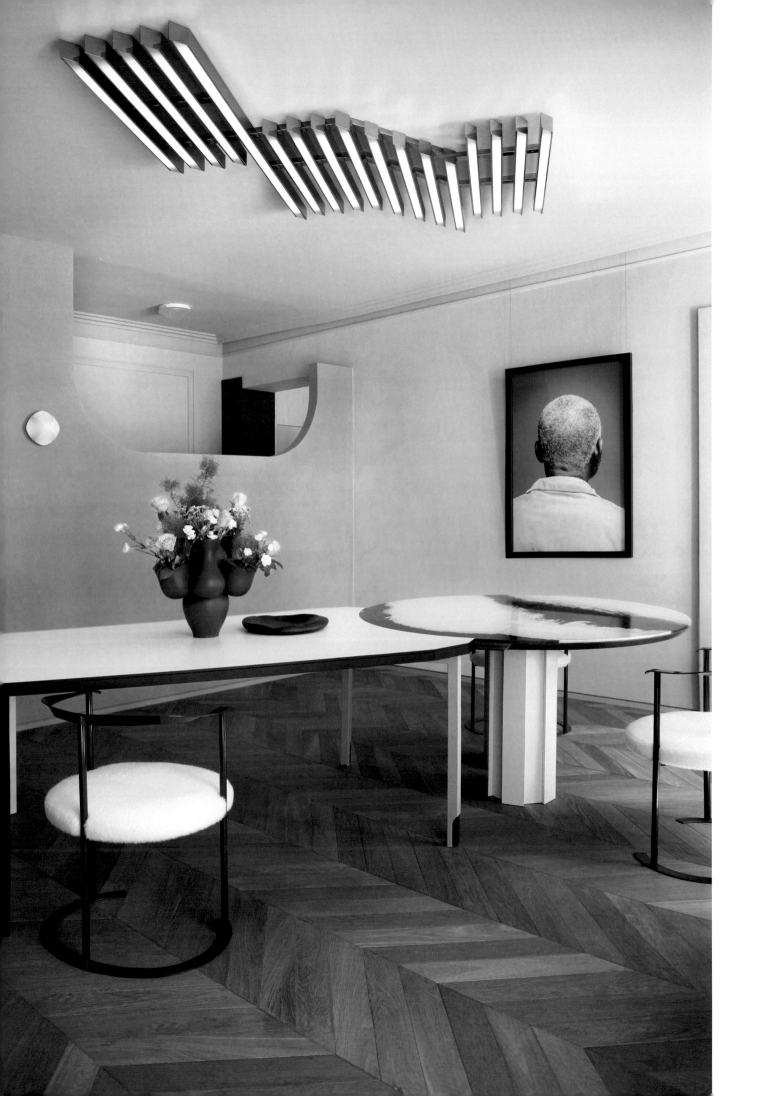

A Place for Playfulness in Paris

Uchronia Casa

Uchronia

Paris, France

Just before the COVID-19 pandemic, Julien Sebban, the founder of multidisciplinary design practice Uchronia, moved from London to Paris. Spending all hours in a confined space had its upsides, especially where the decoration of this home-showroom-office is concerned. It is filled with their own line of furniture, complemented with finds from a nearby flea market: "We built the decoration slowly during confinement with no expectations," Sebban says. The space is divided into high-traffic and low-traffic zones. A long open space offers the perfect avenue to showcase Uchronia furniture, along with a dining table for meetings, a library for material samples, and an office with room for eight. The bedroom and living areas are situated in the more private part of the house. The end result is "a place for playfulness," where Sebban and his team can experiment with colors and textures, thriving on its location in the 18th arrondissement, an area full of antique furniture, flea markets, and auctions.

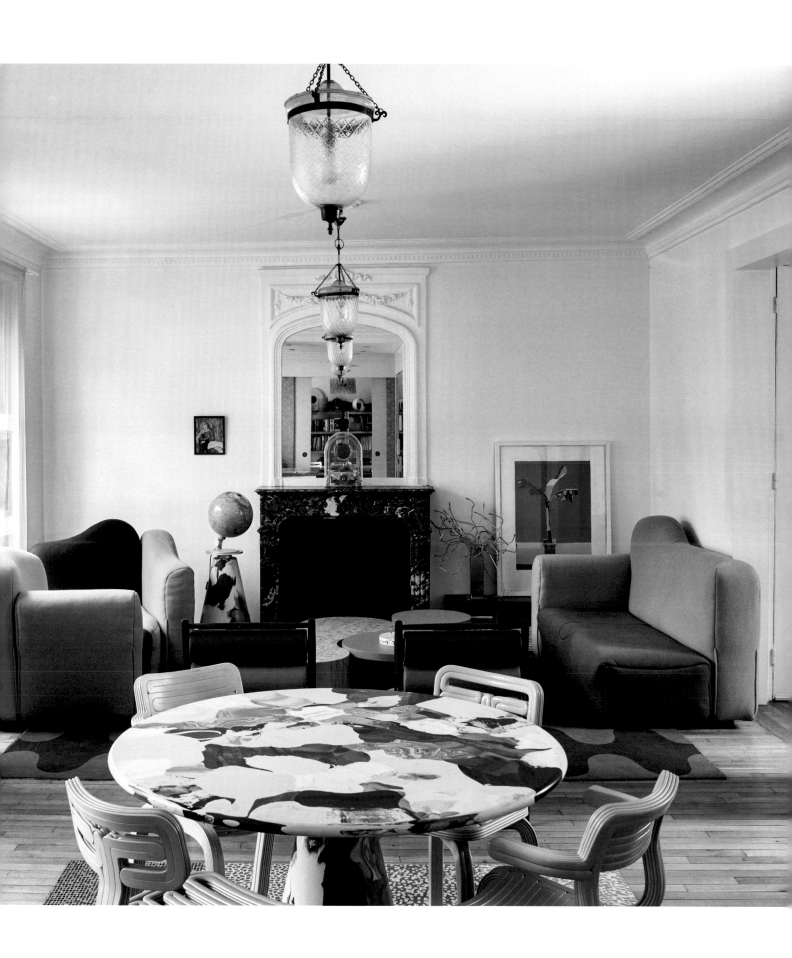

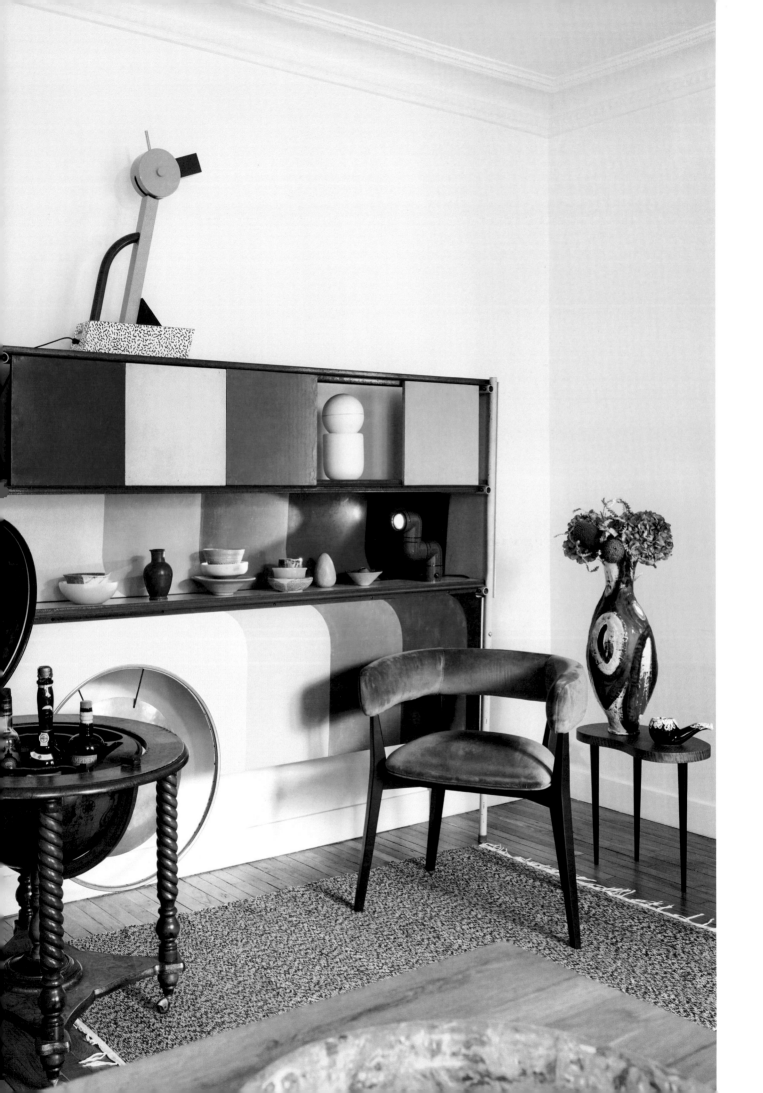

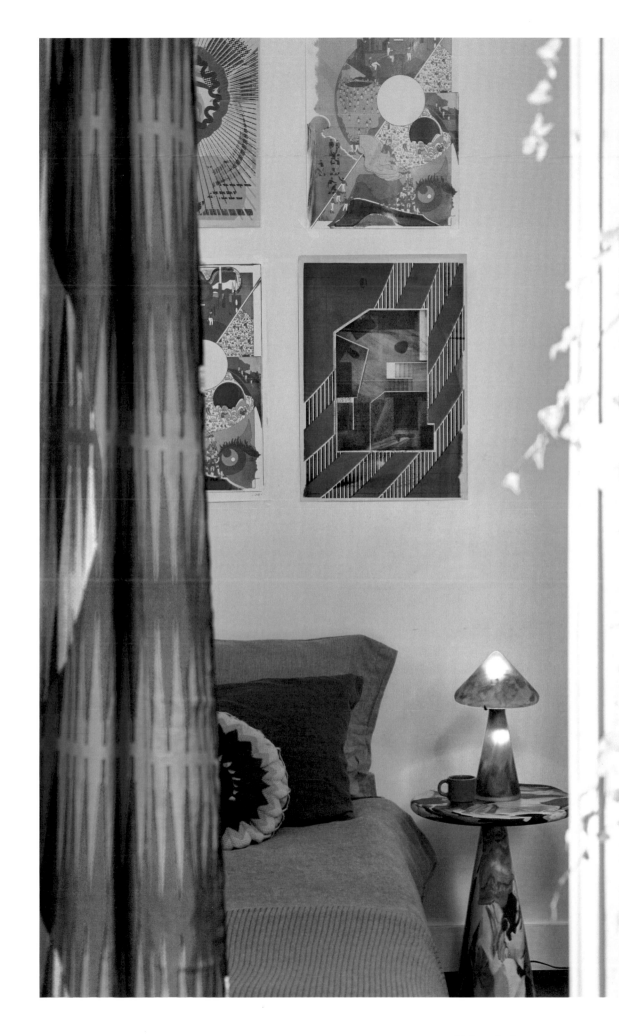

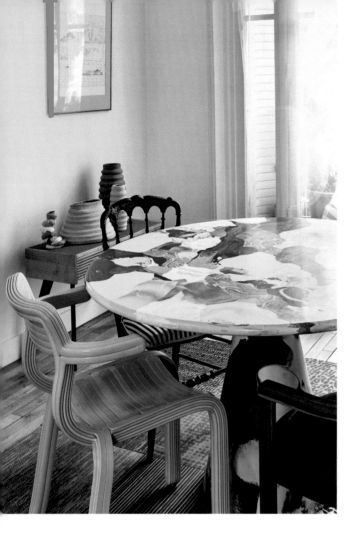

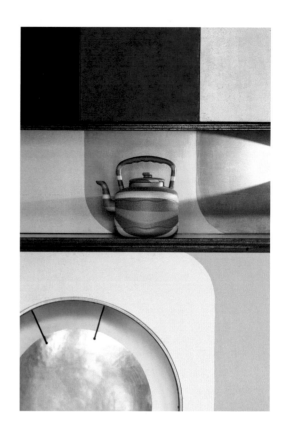

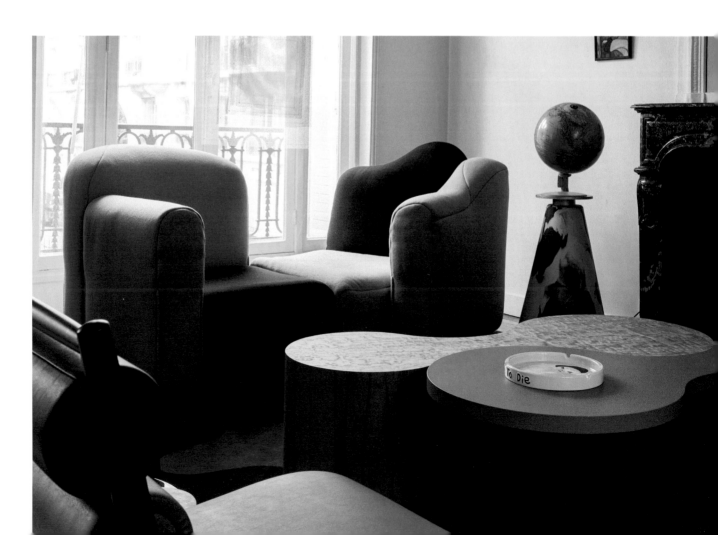

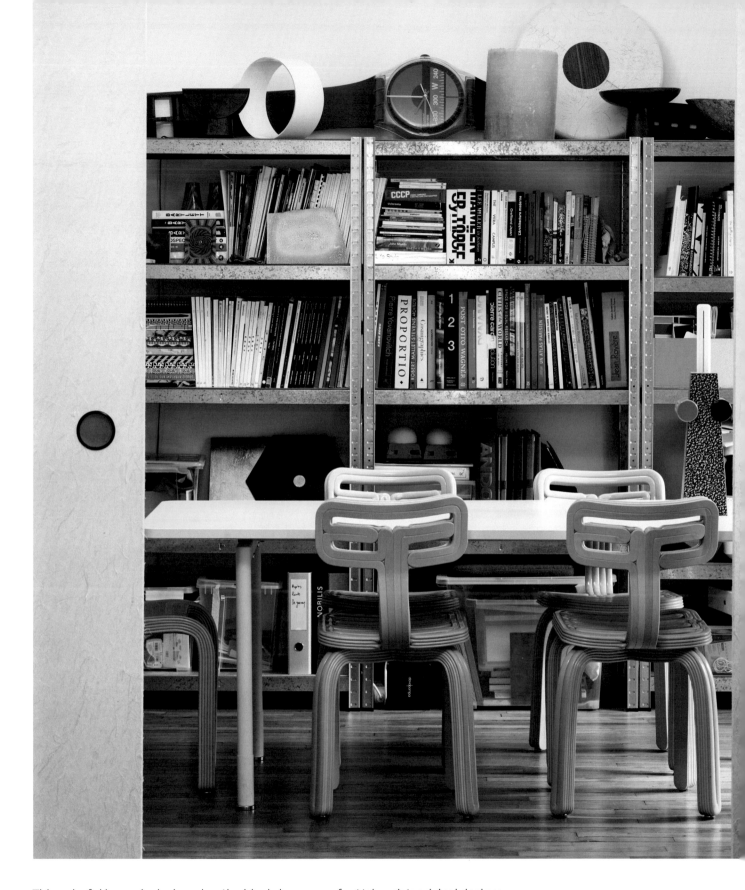

This colorful home is designed as the ideal showroom for Uchronia's original designs. On the bottom left, an early 1990s sofa by Gaetano Pesce is matched with a Uchronia carpet, curtains, and coffee table. At the top left, another Uchronia curtain is seen alongside a round table by Dirk van der Kooij. The image above shows the meeting space, where books, material samples, and other oddities are on display.

Terrific *Terrazzo* Adds a Delightful Speckle of Pattern

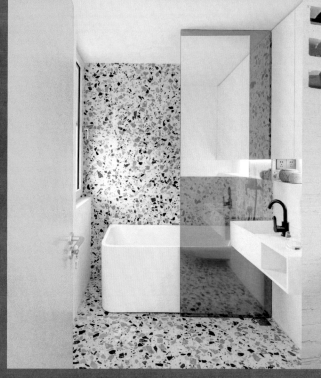

This Beijing residence by **MDDM Studio** uses a colorful terrazzo to reflect the energy of the young family who lives there. Solid-colored fittings complement the speckles, and a turquoise glass plane matches the turquoise in the terrazzo.

Although terrazzo originated centuries ago in Italy, the material has cycled in and out of favor several times in the last 100 years. It has graced the floors of art deco buildings, resurfaced again in the 1970s, and yet again in the late 2010s. Today's terrazzo and terrazzo-style surfaces have evolved to experiment with more negative space and larger fragments in punchier colors, resulting in bold, graphic surfaces. No longer relegated to flooring, terrazzo can be applied to kitchen worktops, stairways, and entire bathrooms, creating joyful environments that buzz with color and pattern.

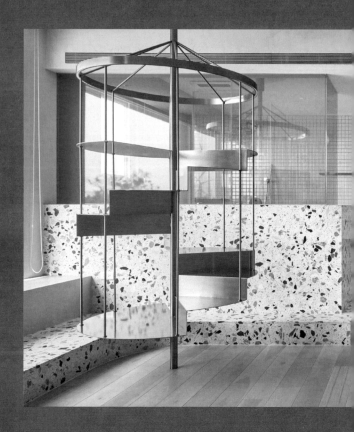

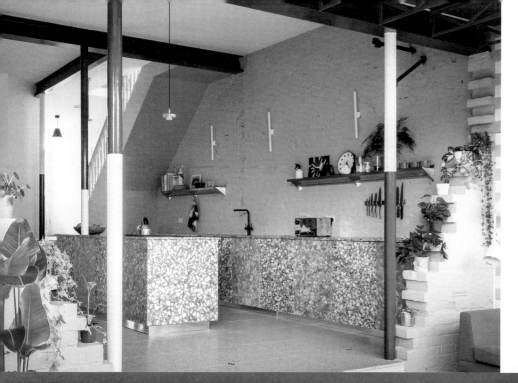

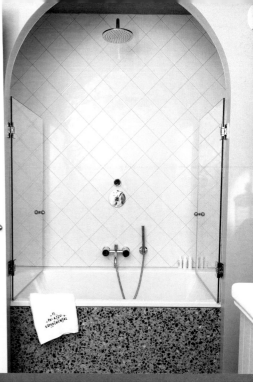

At the Mountain View House by **CAN,** the blue and gray panels are made from recycled chopping boards and milk-bottle tops. Here, big speckles match the much smaller ones in the terrazzo flooring.

A more traditional approach to terrazzo is taken in this bathroom, located at the Il Palazzo Experimental Hotel in Venice, which was designed by **CHZON** to play with the lagoon's rich design history.

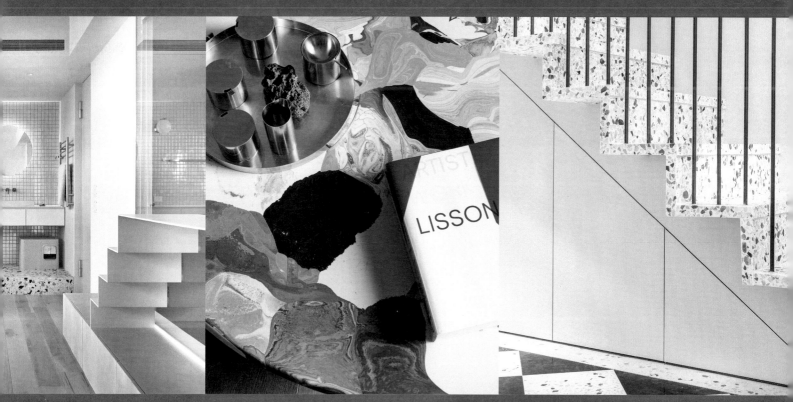

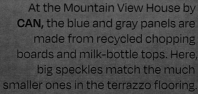

Not sure how to pull off terrazzo? This Taiwan apartment by **KC Studio** shows how to pair large surfaces in busy terrazzo patterns with solid colors that complement the colors of the speckles.

Speckled furniture takes on the appearance of marbled paper with this stunning coffee table at a Barcelona residence. The design is by **Dirk van der Kooij,** and is made from 100 percent recycled plastic.

A speckled terrazzo is used for the floor stair treads and forms a checkerboard against black floor tiles in the White Rabbit House by **Gundry + Ducker.** That same terrazzo is used on the outside facade of the house.

Terrazzo—Filled and Sunny—Side Up

House P

MDDM Studio

Beijing, China

The first and most drastic step in the total overhaul of the top two floors of this five-level terrace house in northern Beijing was to open up the space. The existing staircase was demolished, partition walls removed, and, where possible, structural walls were perforated to create continuous lines of sight. With all that natural light flowing through the now-open space, the architects went a step further with a splash of yellow throughout. Beyond the sunny walls, the kitchen island, playroom, and platform at the base of the staircase is clad in colorful terrazzo to contrast with the fresh, white built-in furniture. The shade of blue found speckled in the terrazzo is echoed in a series of teal elements throughout the home: a kitchen cabinet here, a shower door there. The energetic combination of color and pattern was, according to the architects, envisaged to reflect the energy of the young family that inhabits the space.

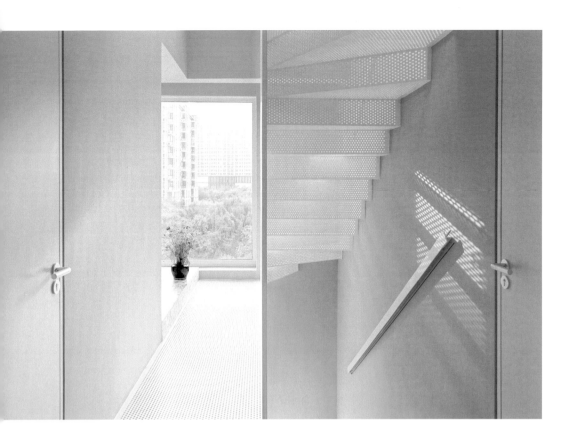

One of the key interventions in this Beijing apartment's renovation was to open it up as much as possible and let natural light fill the space. Perforated metal in particular, used for the stairs seen on the right and above, was selected to let in light from the west-facing windows, resulting in dappled light patterns on the bright yellow walls.

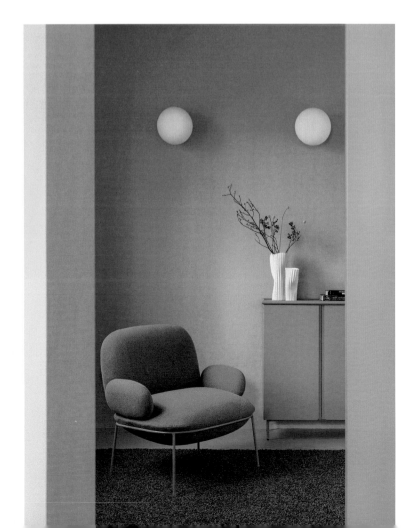

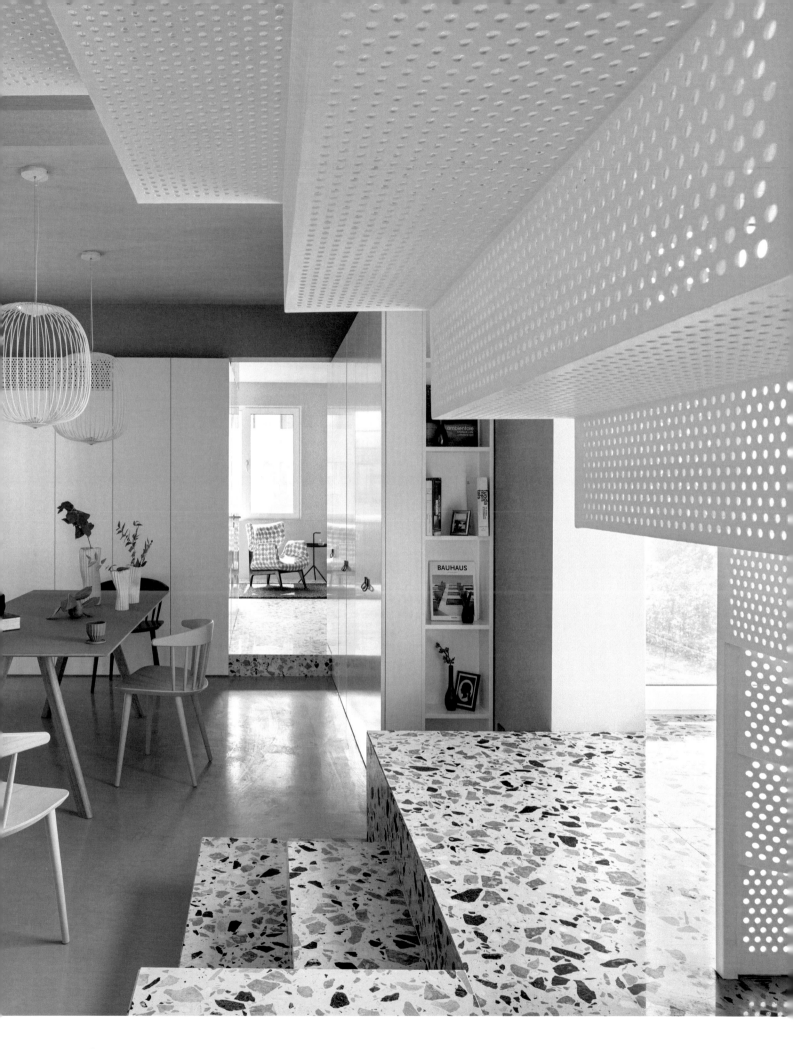

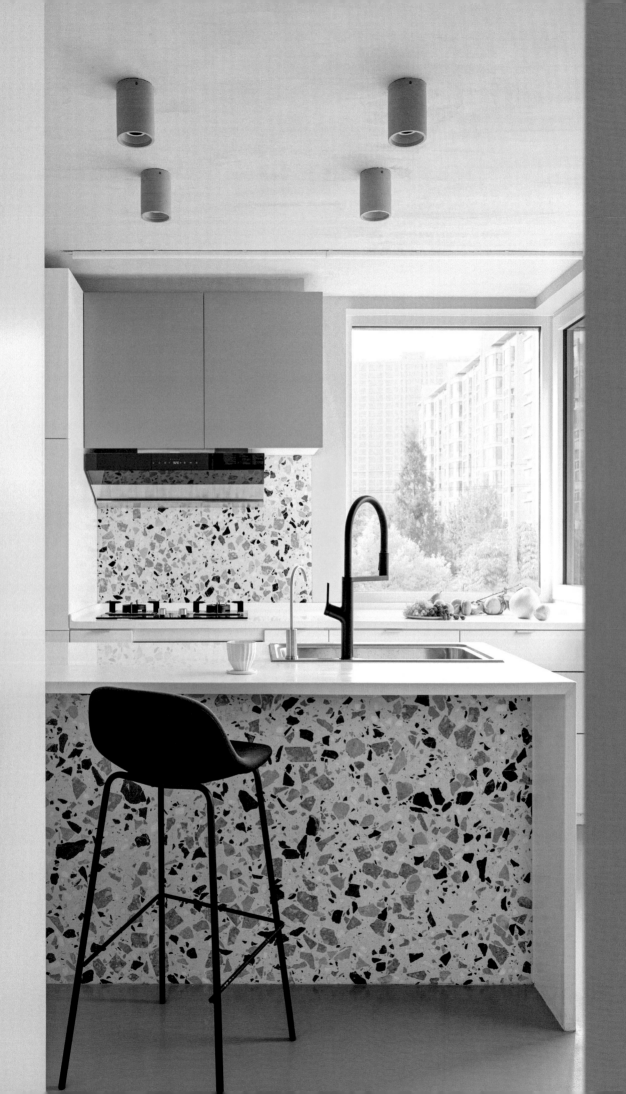

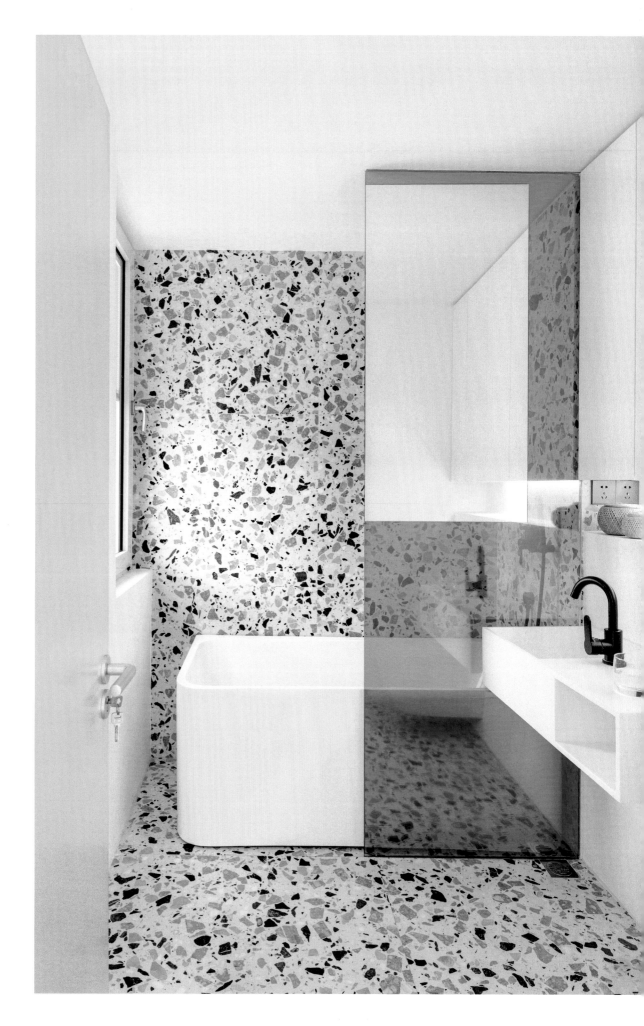

Reimagining an Ordinary Terrace House

White Rabbit House

Gundry + Ducker

London, U. K.

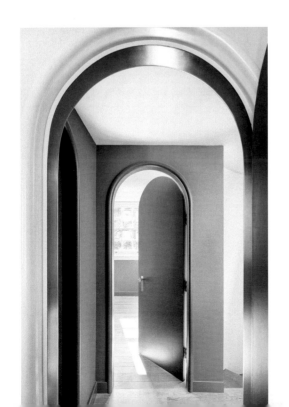

Much of what gives this home its unique identity comes down to its use of pattern. And much of its use of pattern comes down to terrazzo. Gundry + Ducker opted for two contrasting terrazzo throughout the home: speckled on the floor, stair treads, and rear facades, with a much darker and heavier pattern on the kitchen surfaces. But this is just one of many interventions the architects made. The formerly single-story 1970s terrace house now boasts three floors. Although the home sits behind a neo-Georgian facade, the interior was what the architects refer to as "generic seventies." The Kelly-green walls throughout the home were decided fairly late in the refurbishment process and were designed to disguise built-in storage. The black-and-white details contrast against the green, and the starkness of the patterns is softened by the curves of the arched doorways and spiraling staircase. These details all go back to the brief from the client: to take something that was very ordinary and make it special.

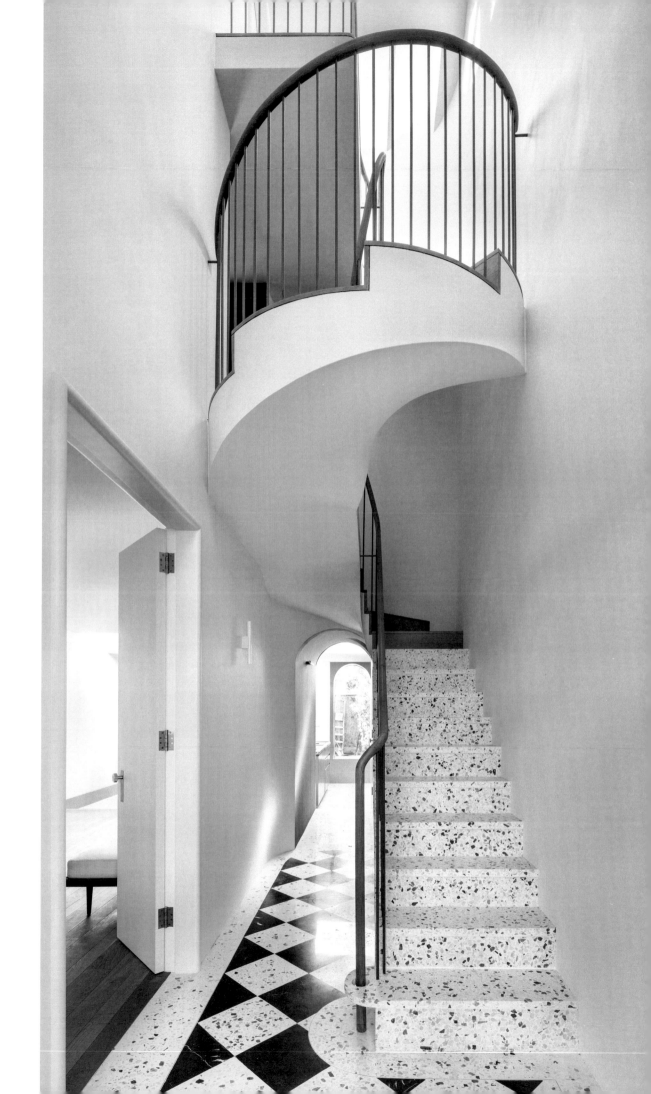

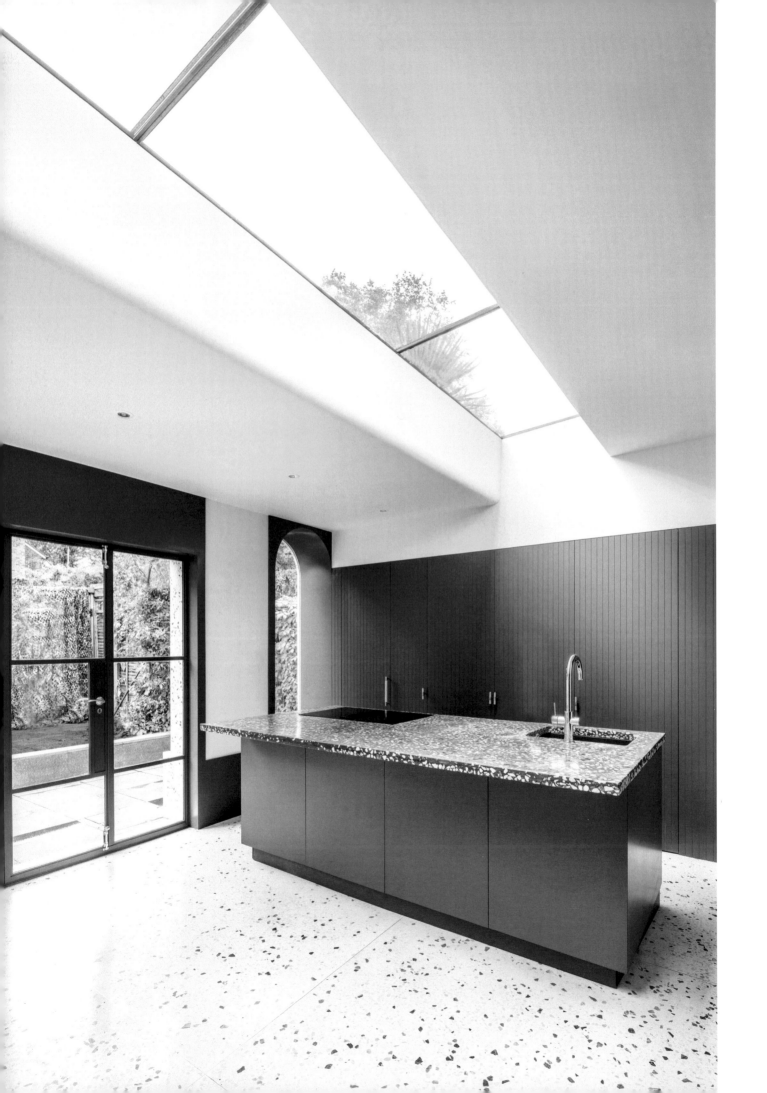

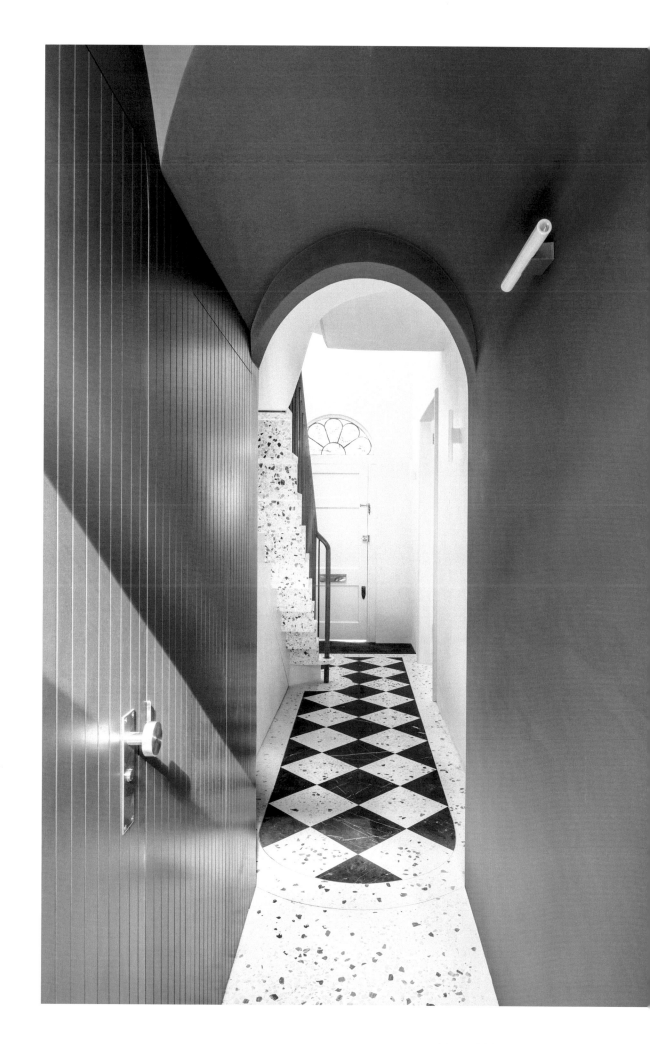

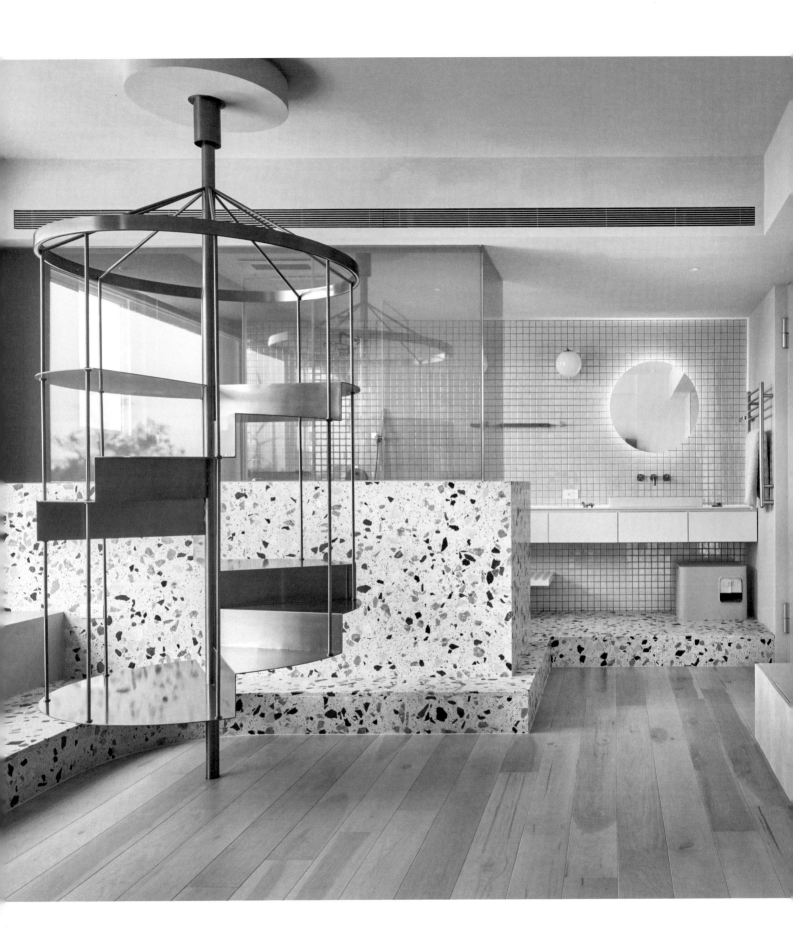

A Purr-etty in Pink Holiday Home

Cats' Pink House

KC Design Studio

Miaoli, Taiwan

The Cats' Pink House is a three-story home designed for a cat owner to go on vacation and enjoy some quality downtime with their three cats. It's full of nooks and crannies for the felines to enjoy: viewing platforms from which to patrol, walkways perfect for prowling, and a spiral staircase whose only function is as a playground for the cats. It's worth pointing out there are considered details for the human too, including a terrazzo accent that wraps around the home, providing flooring and separation between the powder room and the rest of the space. A luxurious bathtub offers a view of the trees outside, and there is even a fluffy pink swing. Infrastructure for cats doubles as furniture for humans, such as the climbable desk. The rosy color palette was achieved through a base coat of mineral paint across the walls and ceilings, complemented by pink furniture, tiles, and fittings throughout. It even extends outside the front door to a basketball court on the balcony downstairs, complete with a graphic color motif.

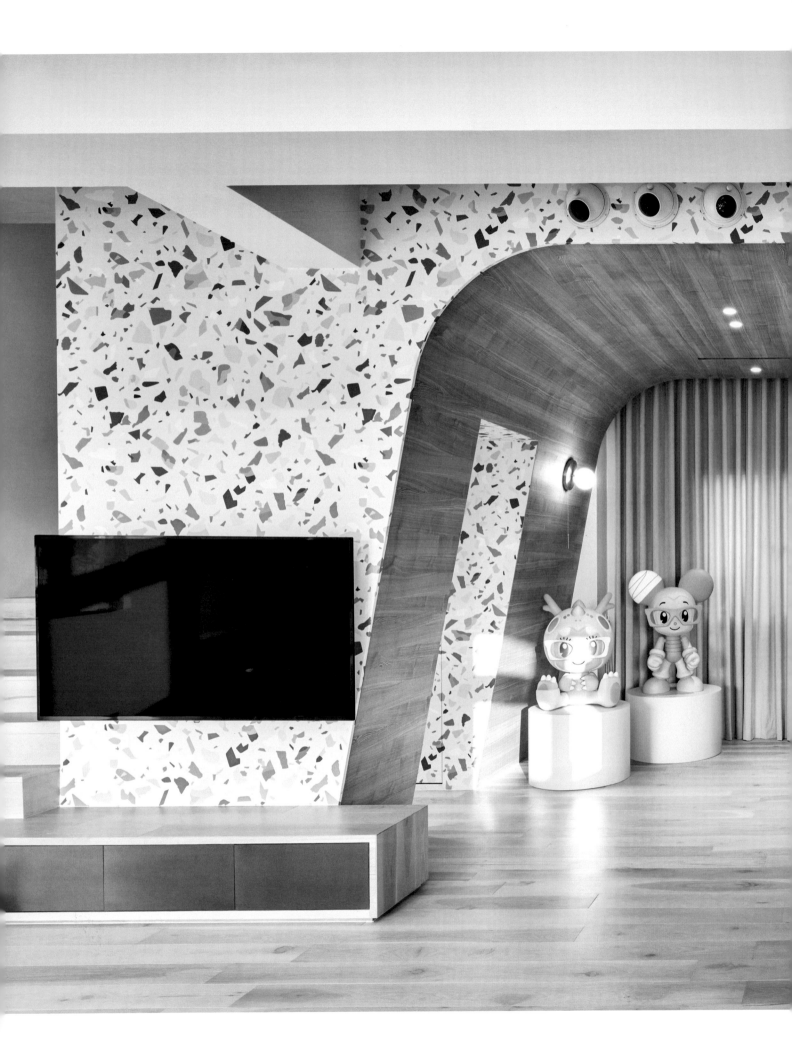

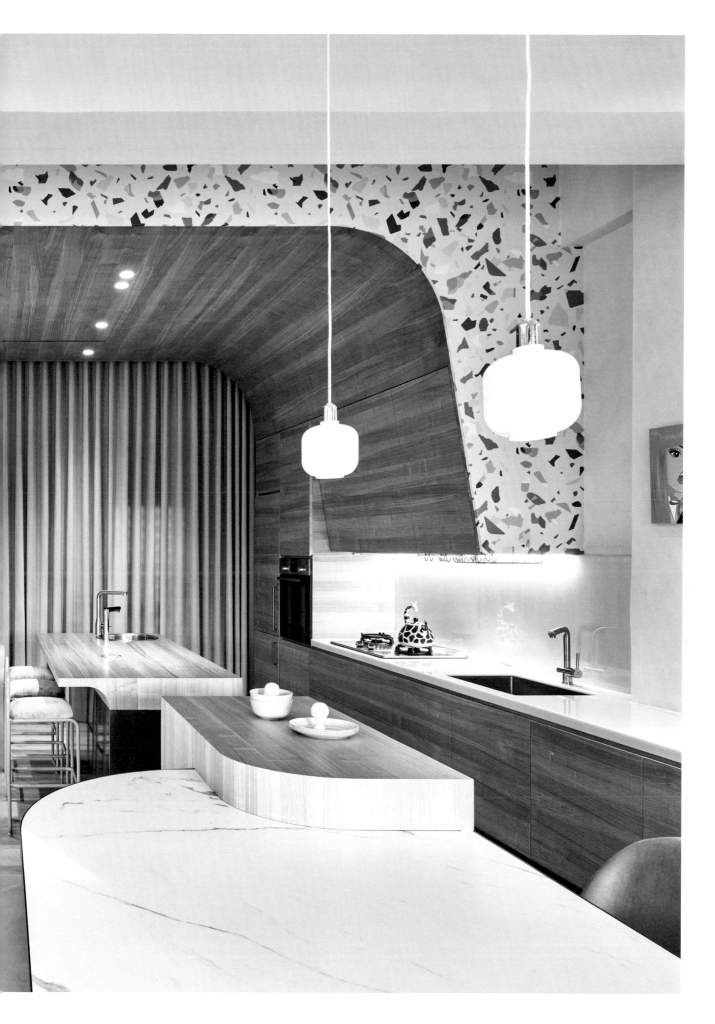

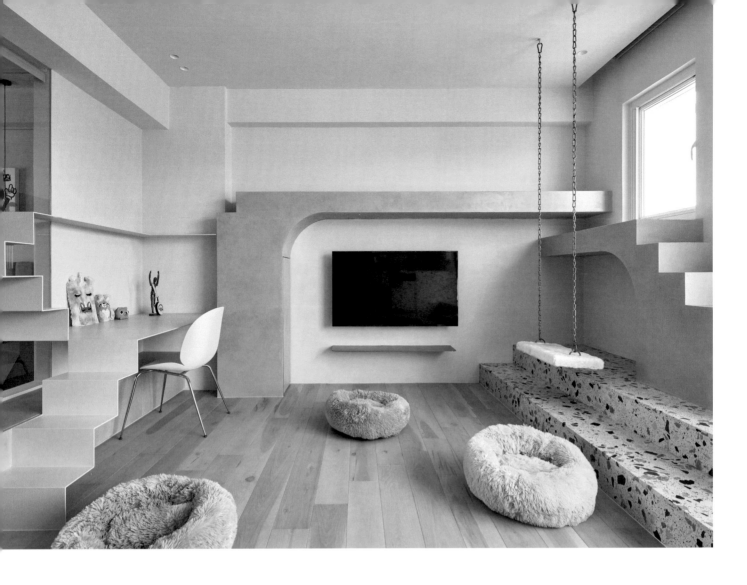

Even the cat beds, pictured above, fit seamlessly into the overall interior concept. The quirks and interests of the cat-owner is evident throughout in the proudly displayed collection of anime and kawaii characters.

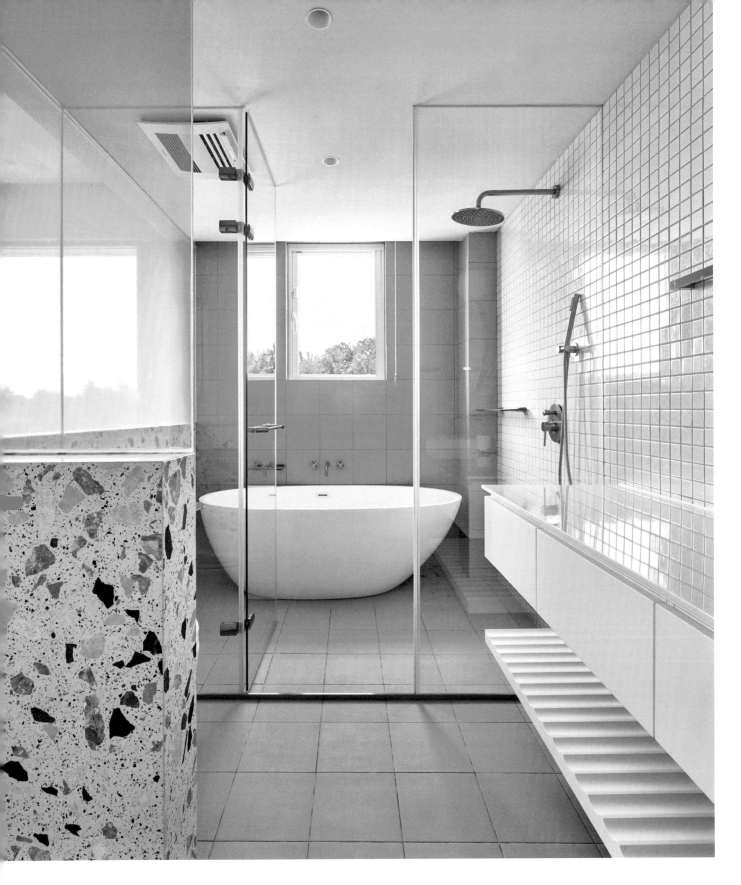

Another design feature is the prominent use of color. The blush tone that pervades the apartment can be seen here translated to large bathroom tiles, which are complemented by a terrazzo wall. The terrazzo's speckles are echoed by a matching wallpaper, which frames the vanity. Outside on the balcony, the color scheme takes on a graphic quality.

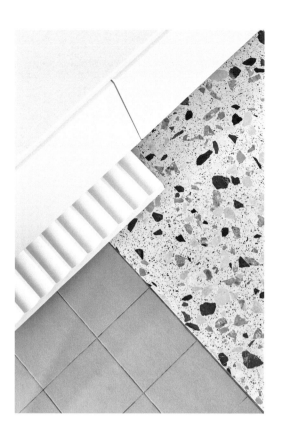

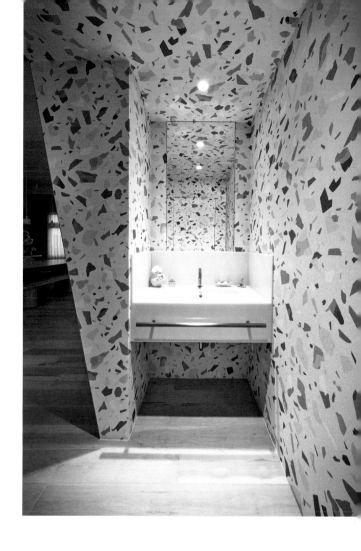

Opulent Works in a White Cube

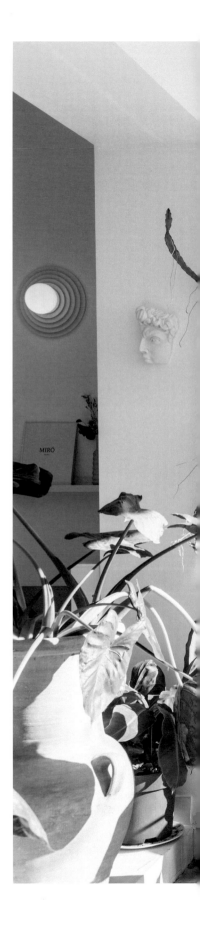

Casa Calada

Axel Chay

Marseille, France

The white cube has been in use since the early twentieth century. Groups like de Stijl and Bauhaus preferred their abstracted, modernist works to be displayed against a pure white backdrop so that unnecessary flourishes did not detract from their art, and today, most contemporary galleries follow this principle. A similar idea is at play with this house in the South of France, where Axel Chay remodeled a historic building as a family home that doubles as a showcase for a collection of designer furniture, which includes pieces by luminaries such as Pierre Paulin, Warren Platner, and Eero Saarinen, as well as his own creations. The solid primary colors of these splendid works pop against the gleaming white backdrop, where floors, walls, and ceilings are the same milky hue. To maintain the historic fabric of the home, period details like terracotta tiles in the bedroom and the marble fireplace in the living room were retained. They also provide some much-needed texture and balance the abundance of white, ensuring the space doesn't feel sterile. The result is a colorful, striking home with a strong sense of place.

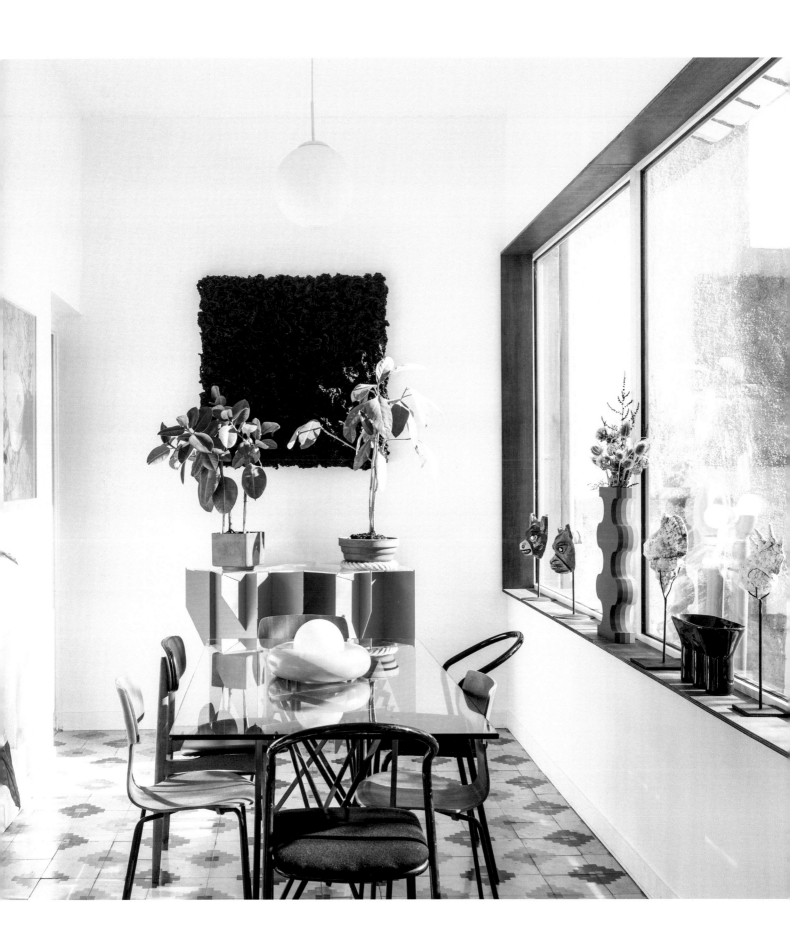

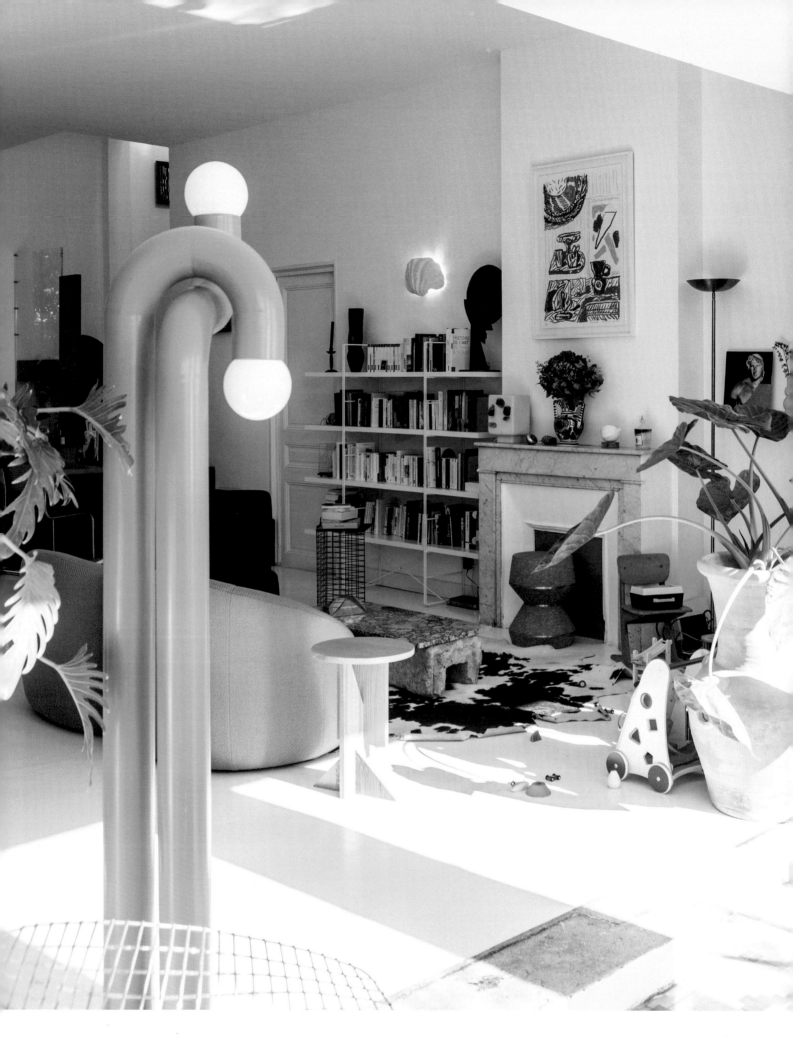

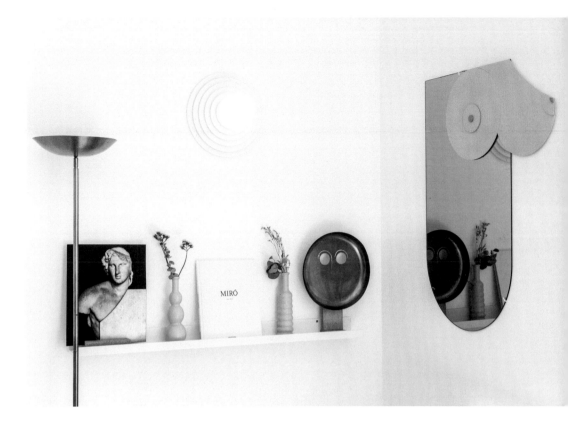

Furniture designer Axel Chay has a body of work that includes twisting tubular pieces, like the eye-catching floor lamp seen on the left. The large living room is the result of Chay's refurbishment, which consolidated the ground floor's five rooms into one. Against a white backdrop, the rich artifacts, marble fireplace, and floor tiles blend into a harmonious interior.

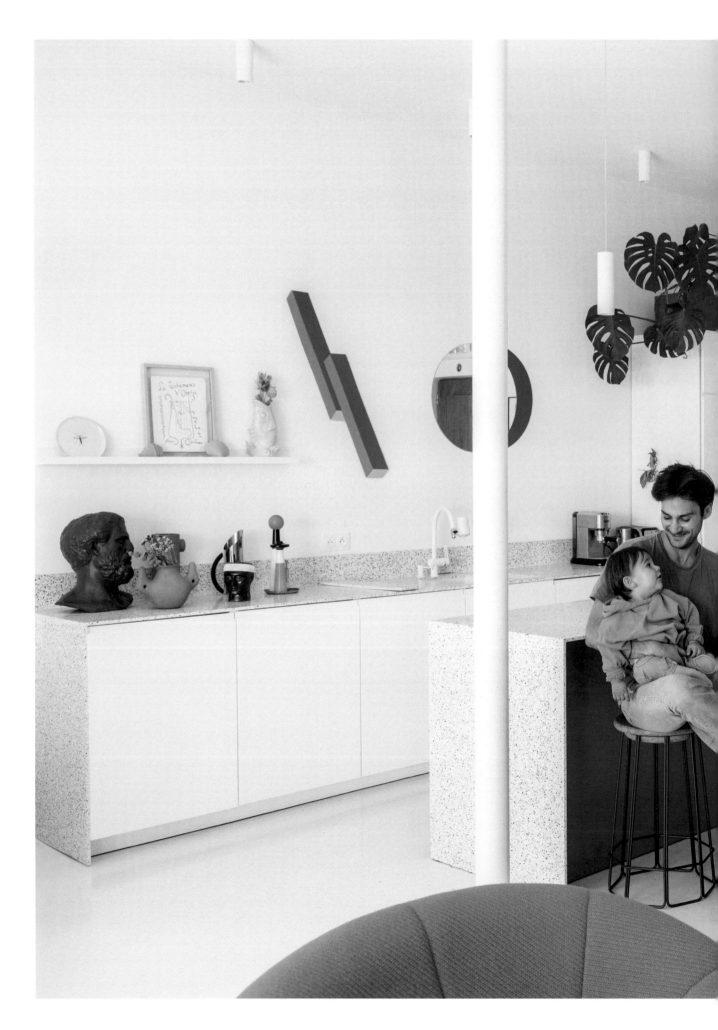

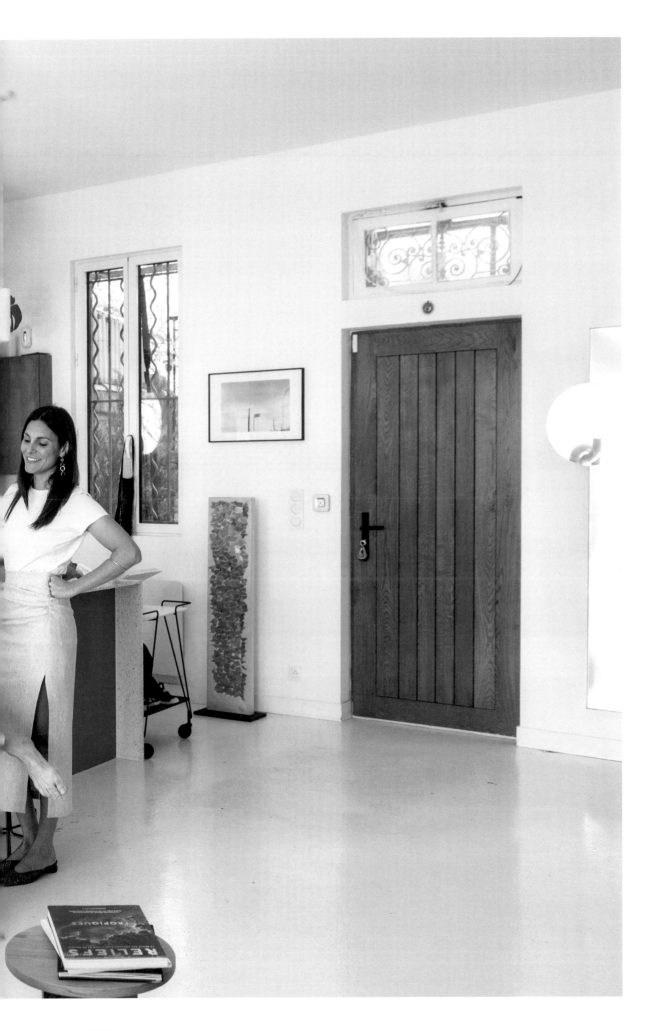

Patterns Galore in a Refurbished Brownstone

Ellen Van Dusen's Brooklyn Home

Ellen Van Dusen
and Van Dusen Architects

New York City, NY, USA

Dusen Dusen is a womenswear and home textile brand awash in peppy tones and happy patterns. It's easy to see that same spirit in the remodeled Bed-Stuy brownstone, designed and inhabited by the brand's founder, Ellen Van Dusen. When reimagining the space, there was already lots to work with. The turn-of-the-century home was bursting with period details, but the layout, with just one bathroom and a kitchen down in the basement, needed a rethink. To help, Van Dusen enlisted her father's architecture firm, Van Dusen Architects. The finished home showcases some of her own pieces, along with thrift-store finds and an Ettore Sottsass dining set, scored from Craigslist. But Van Dusen, who admits she gravitates to bright colors, knew she had to restrain the palette. Her rule of thumb: never have the full rainbow. This is achieved especially well with the walls, which are coated in a crisp white—all the better to see her bright-yellow shelving units or vintage oversized sculpture of a tulip.

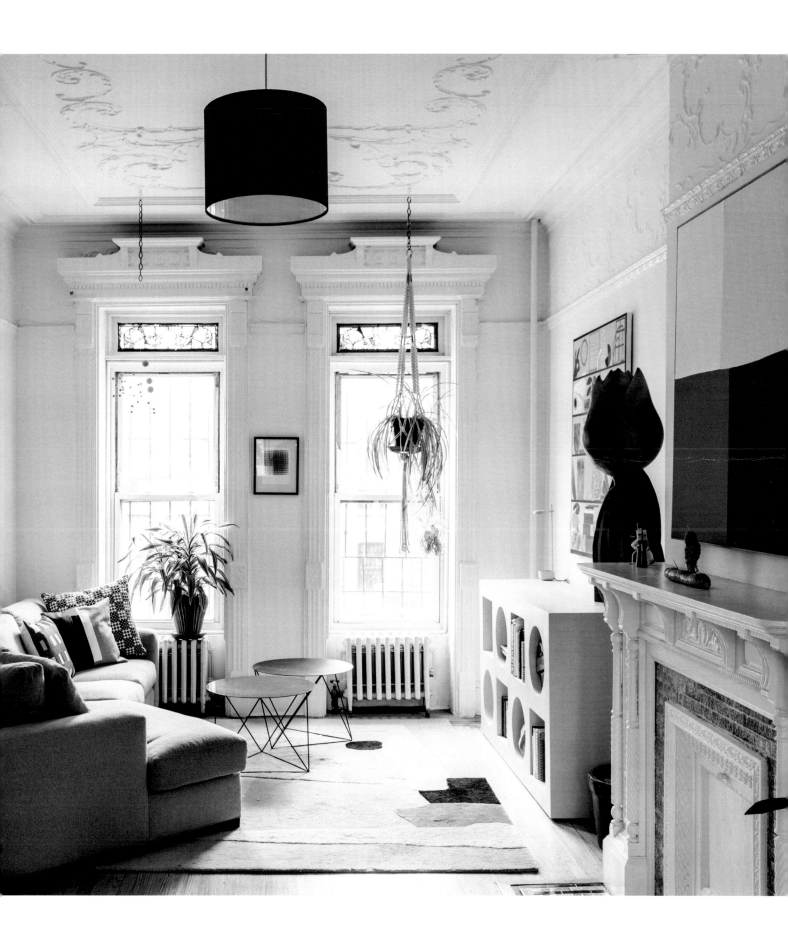

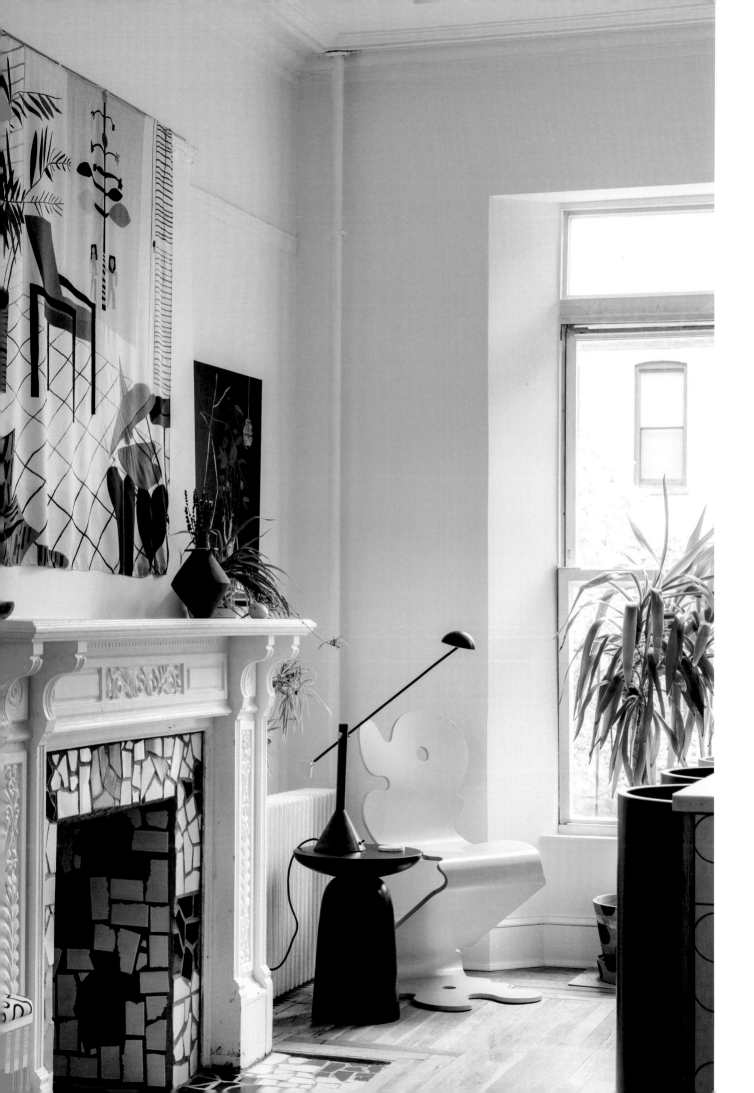

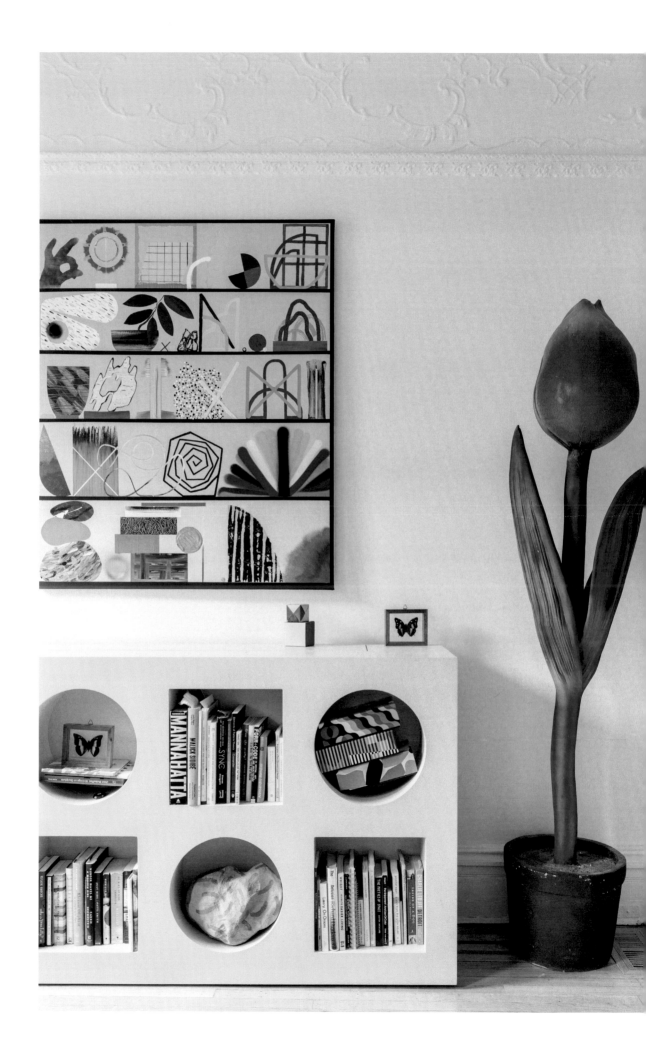

Ellen Van Dusen's Brooklyn Home

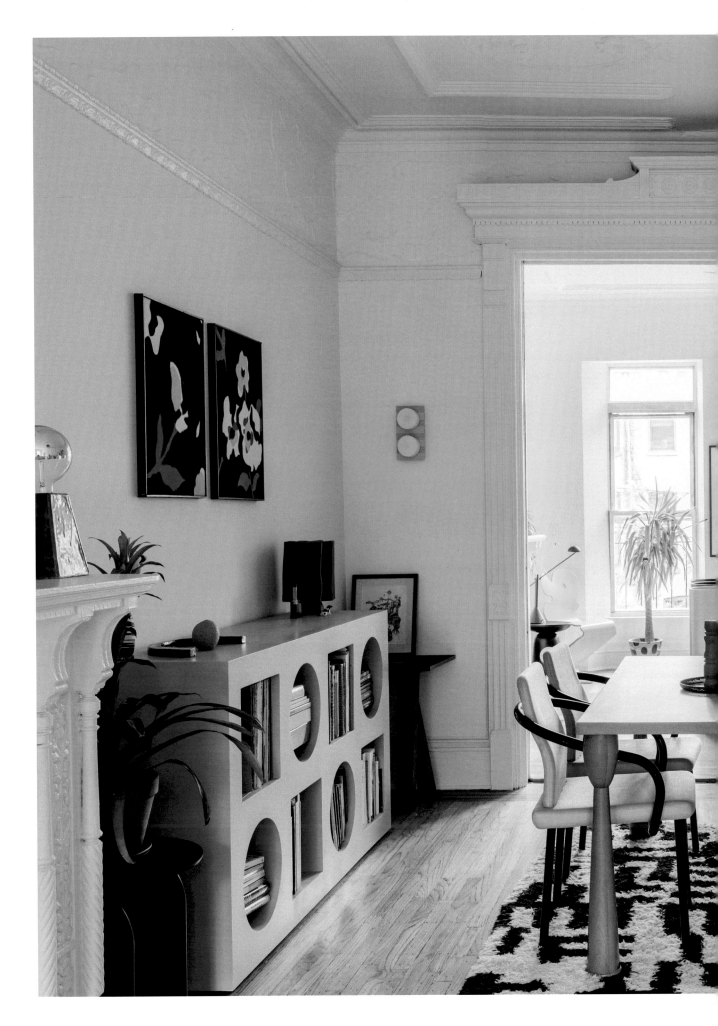

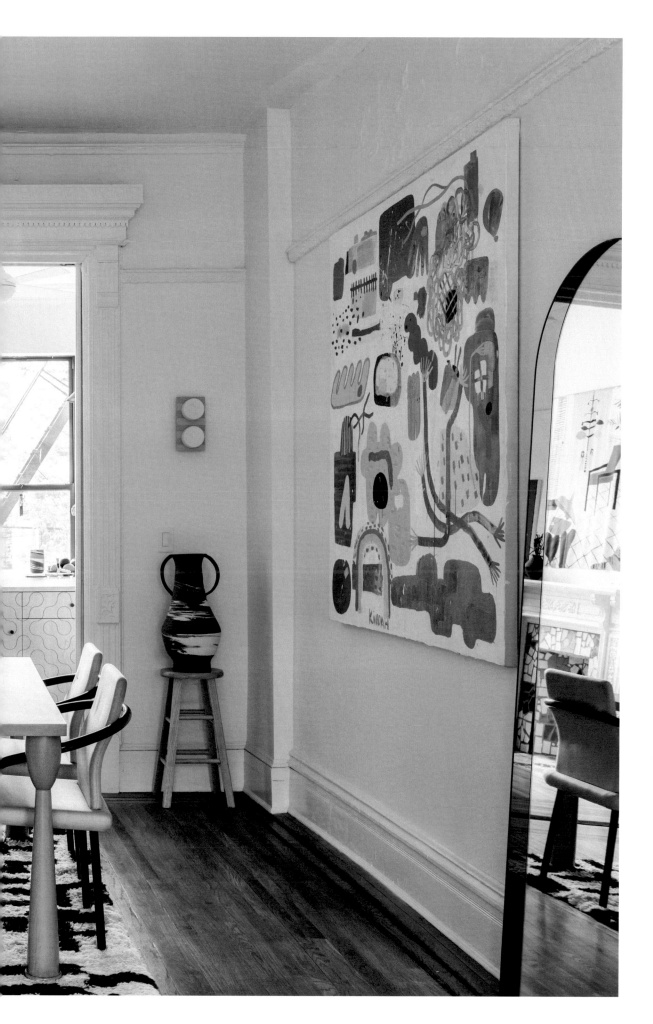

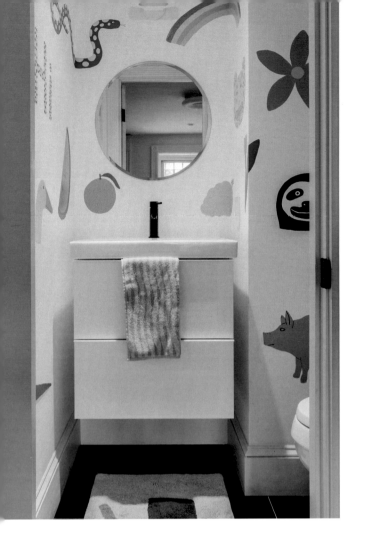

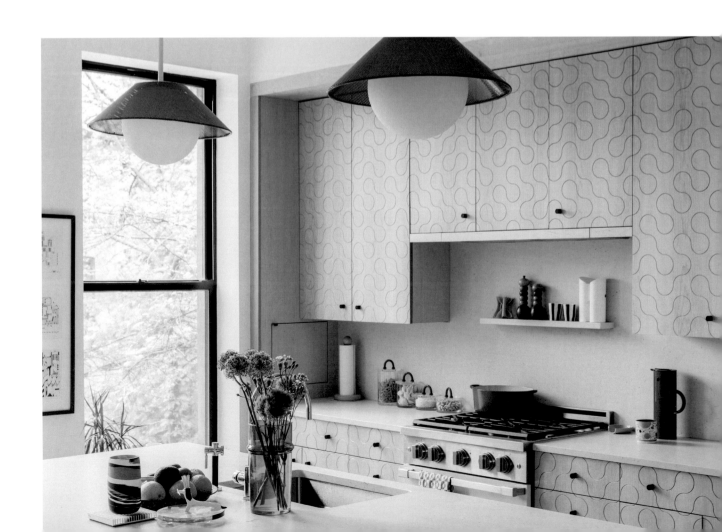

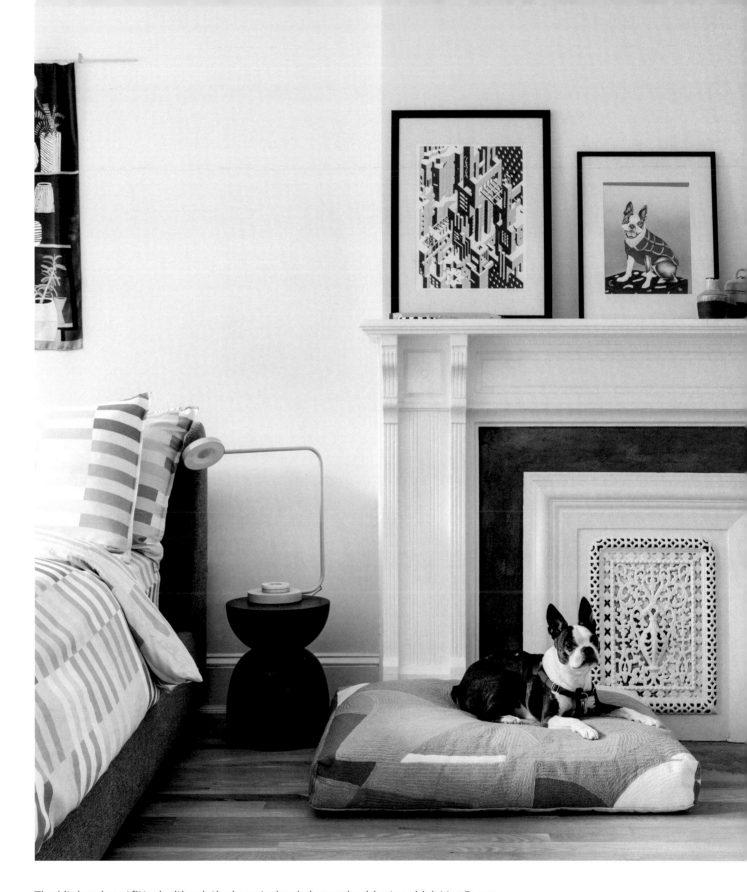

The kitchen is outfitted with relatively restrained plywood cabinets, which Van Dusen livened up by commissioning a woodworker to carve in a trail of curving patterns. This is a more subtle approach to the graphic patterns seen elsewhere in the home, including the bedding (above) and a mural in the bathroom painted by the designer's ceramicist friend, Lorien Stern.

Modern *Arches* for a Friendly and Familiar Feel

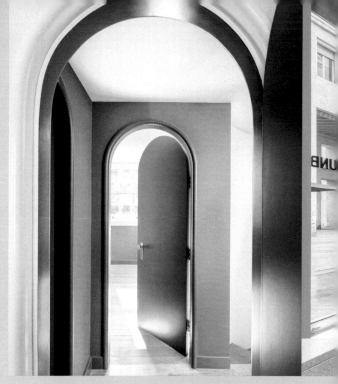

At the White Rabbit House in London by **Gundry + Ducker,** a series of Kelly-green arches articulate the space. They mark thresholds, frame windows, and, with a fanlight window above the front door, provide a warm welcome to the home.

Arches are an architectural form as ancient as they are enduring. They're a simple and effective design choice that can feel Old World, Mediterranean, or—as the spaces on this spread suggest—absolutely contemporary. In a space with rigid lines or otherwise stark features, the upside-down smile of an arch offers joyful relief. But it doesn't have to be limited to doorways. If remodeling doors, hallways, or windows to form an arch isn't in the cards, the shape can still be introduced by painting an arch on the wall or, easier still, by hanging an arched mirror.

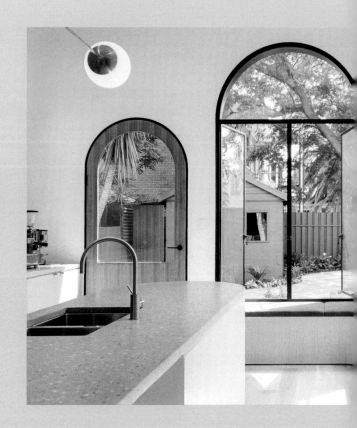

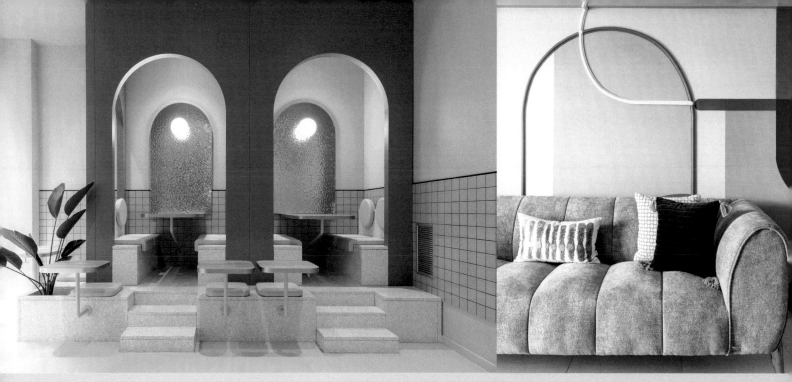

Bubblegum-pink arches lead diners to their booths at the Turin-based Bun Burgers, designed by **Masquespacio.** The shape is complemented by circular furniture and contrasted by a square grid of tiles.

At the Memphis-inspired Quirk Box by **Baldiwala Edge** in Mumbai, the color block mural overlaps an arched mirror. A sofa by Indian brand **Bent Chair** stands in the foreground.

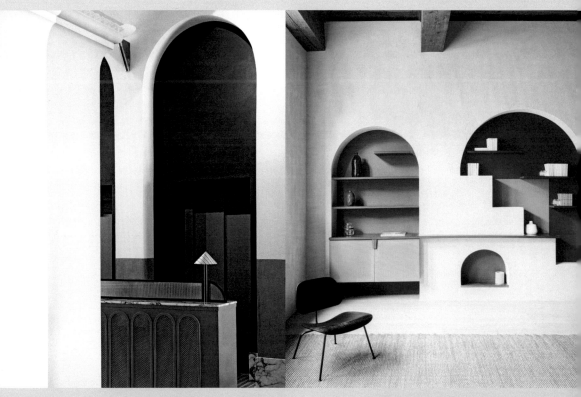

Located in the sunny suburbs of Adelaide, Australia, the art deco-inspired Plaster Fun House by **Sans-Arc Studio** uses arched windows and doorways to "give flow and smoothness to the space."

Design studio **CHZON** approaches the interior of the Il Palazzo Experimental hotel with Venetian flair, recalling the arches that can be seen around the lagoon. In the lobby, elevators are framed by arches that are echoed by the shapes in the concierge's desk.

Studio Razavi, the team behind Apartment XVII in Lyon, used arches to soften the linear quality of the oak ceiling beams, allowing "a changing dialogue across the space." Arches are used to frame doorways and built-in storage.

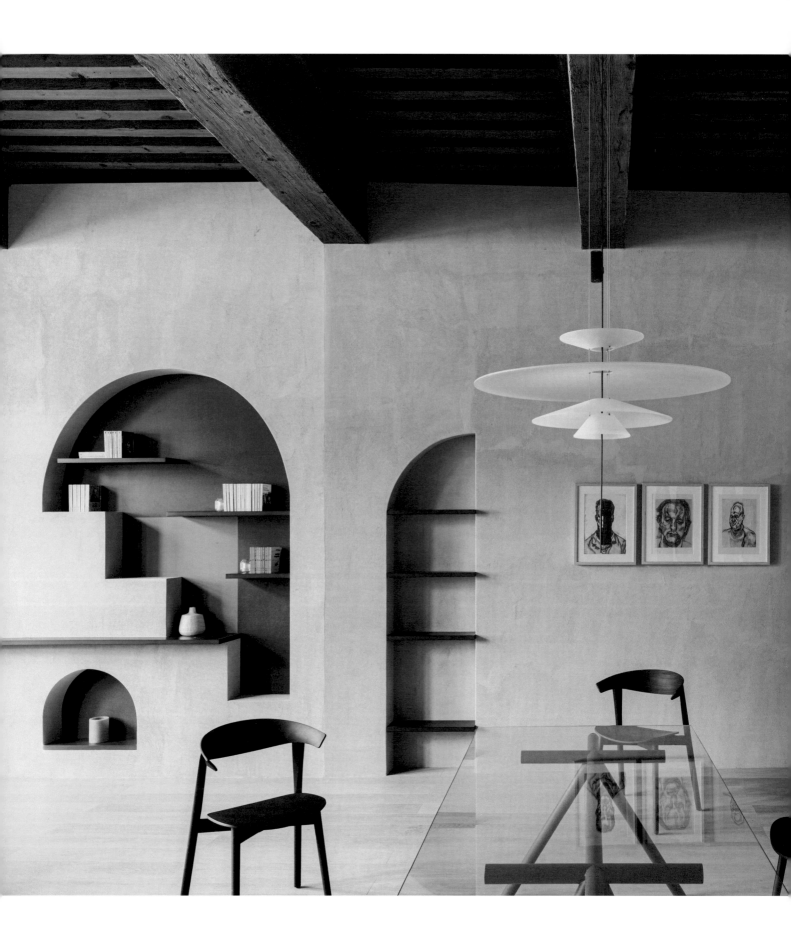

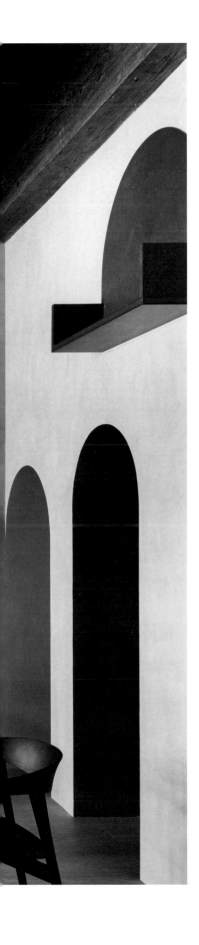

Stylish Arches in a Historic Home

Apartment XVII

Studio Razavi

Lyon, France

This home already had a strong identity to begin with; the ancient oak ceiling carries a deep sense of warmth with its overlapping beams. As far as blank canvases go, it wasn't a bad place to start. To ensure the rest of the house didn't compete with the geometric quality of the historic ceiling, the architects went with a series of arches to complement and contrast: "Arches convey a very specific feeling and are part of everybody's culture, in one way or another, hence a feeling of familiarity." That sense pervades throughout the home, where arches contain storage, frame walkways, and sometimes seem to exist for no reason other than to articulate the space around a desk. The architects avoided exuberant colors, opting instead for several tones of rich green and a textured gray calm enough to be lived with every day. The result is a home which is at once strikingly contemporary, yet more than 500 years old.

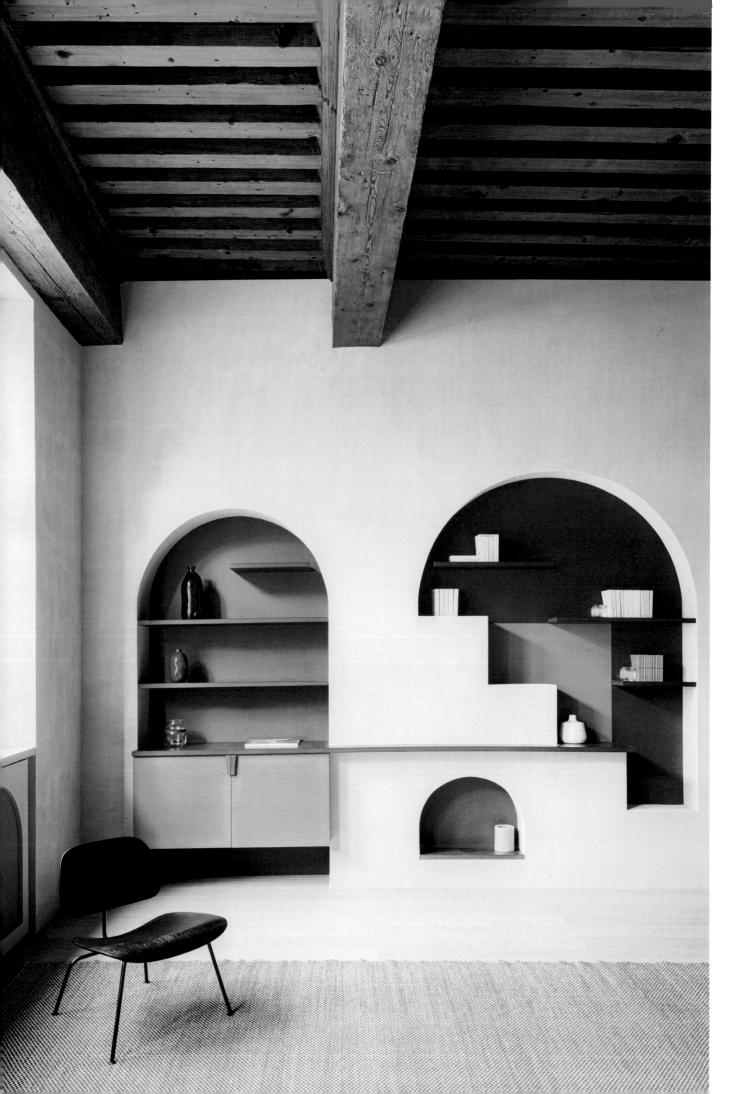

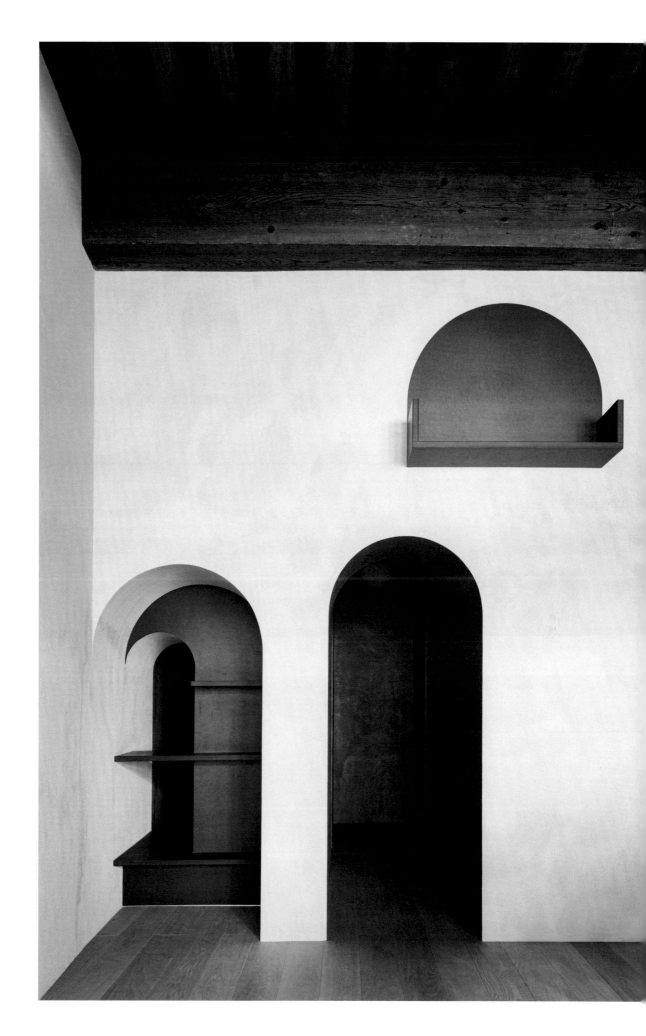

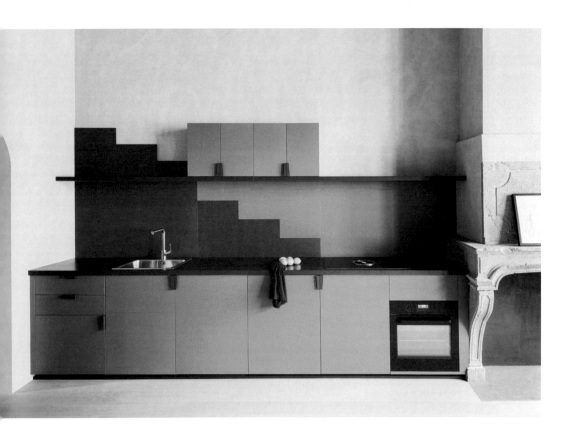

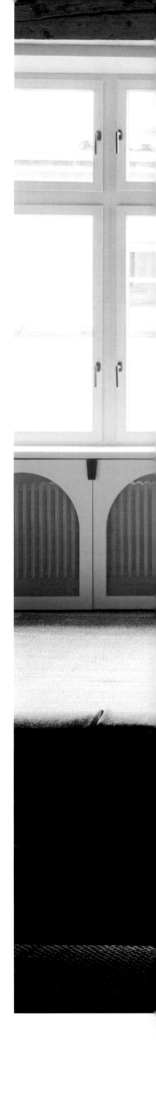

The architects were keen to preserve as much of the 500-year-old apartment's historic fabric as possible. Some elements, such as the windows and use of space, struck the architects as being surprisingly modern and worthy of being retained. The resulting intervention celebrates these old elements, rather than trying to compete with them.

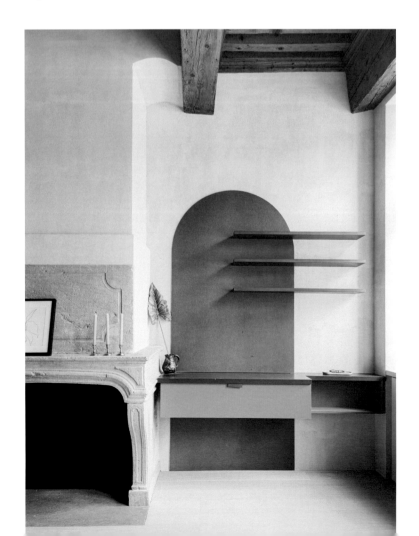

140

Classical Venice with a Memphis Twist

Il Palazzo Experimental

CHZON

Venice, Italy

The building that houses the Experimental Hotel's Venice outpost is now on its third iteration. First, a historic mansion, then the headquarters of a naval transport company, and now a 33-room boutique hotel, full of punchy stripes, chunky curves, and a gemstone palette that spans dark pastels, deep blues, and royal purples. French designer Dorothée Meilichzon, founder of CHZON design studio, is a longtime collaborator of the Experimental Hotel's string of European locations. Here, she infuses classical Venetian elements—nautical details, symmetry, a pale green ceiling to reference the color of the lagoon, and a terrazzo floor that echoes the work of Venetian modernist master Carlo Scarpa—with her own cheerful design sensibilities: nods to the Memphis movement, scalloped edges, and an unrestrained approach to color. The result feels luxurious and unmistakably Venetian, yet doesn't take itself too seriously. In a city of singing gondoliers, spritzes, and cicchetti, these interiors are just another thing to smile about.

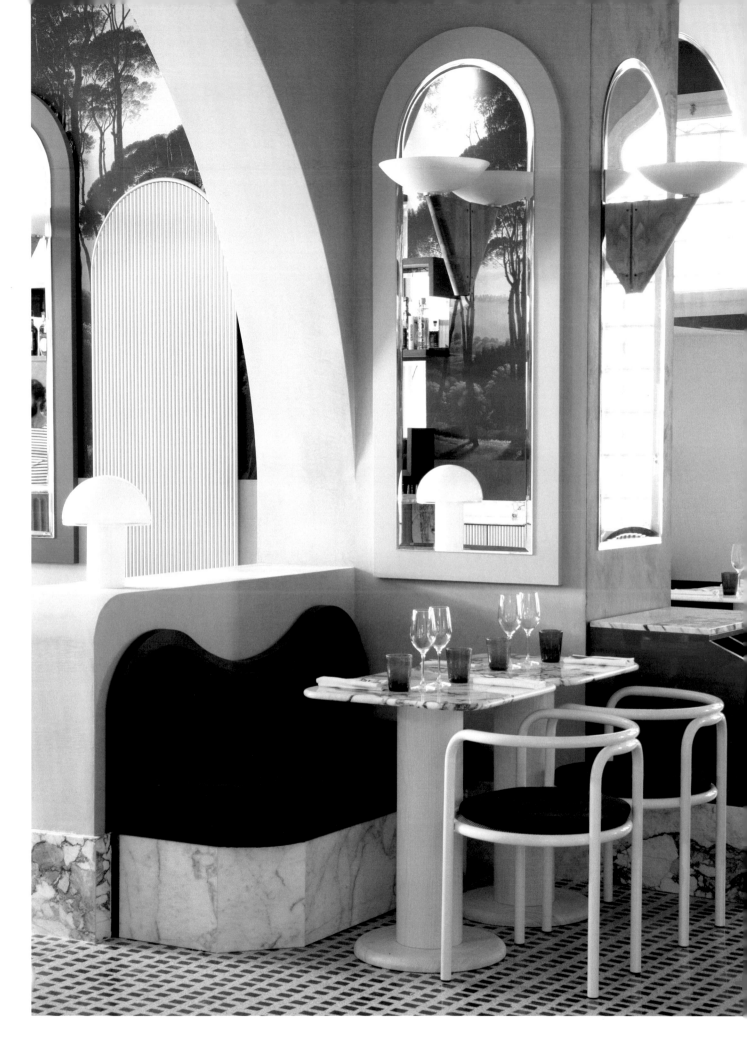

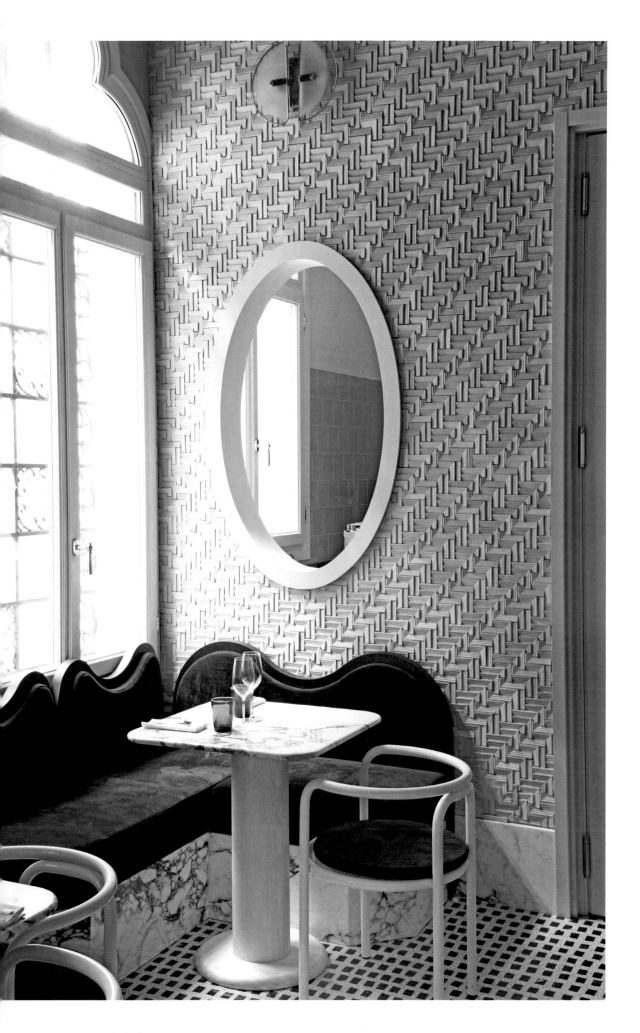

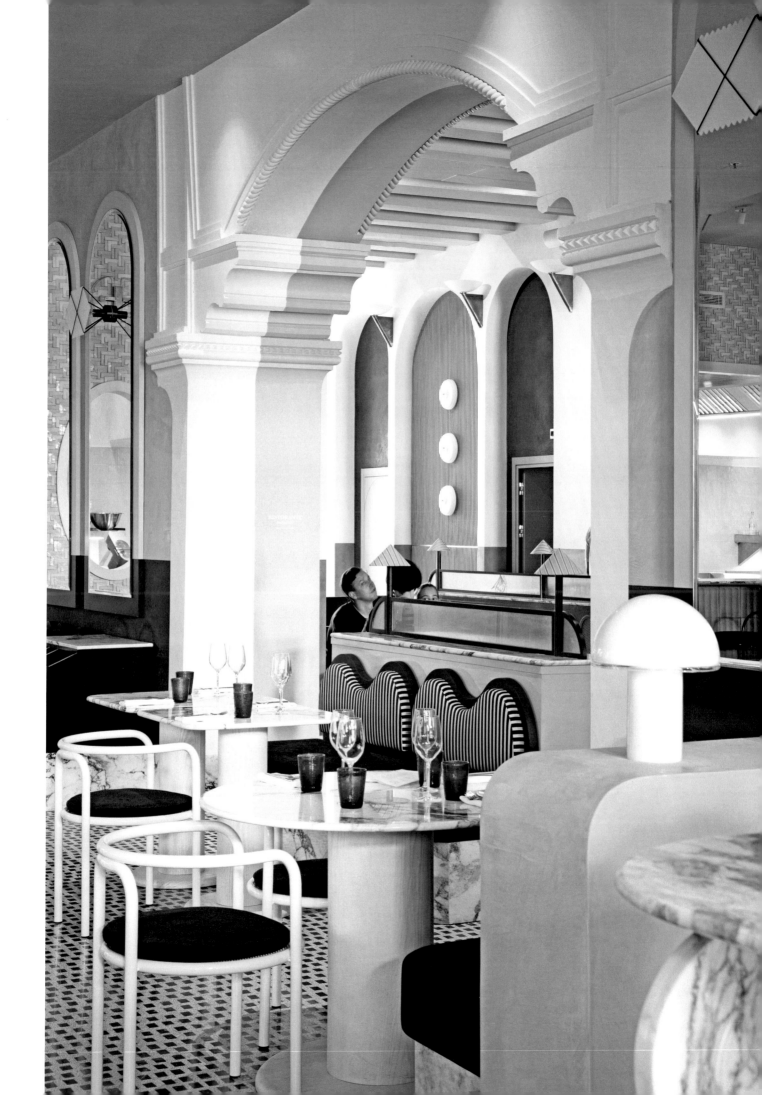

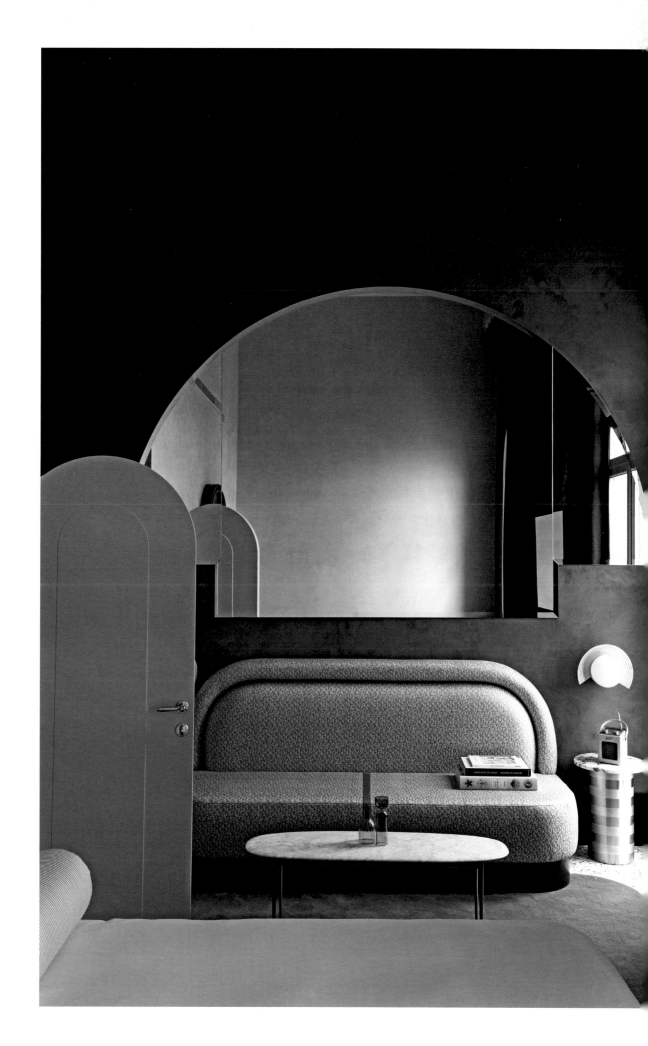

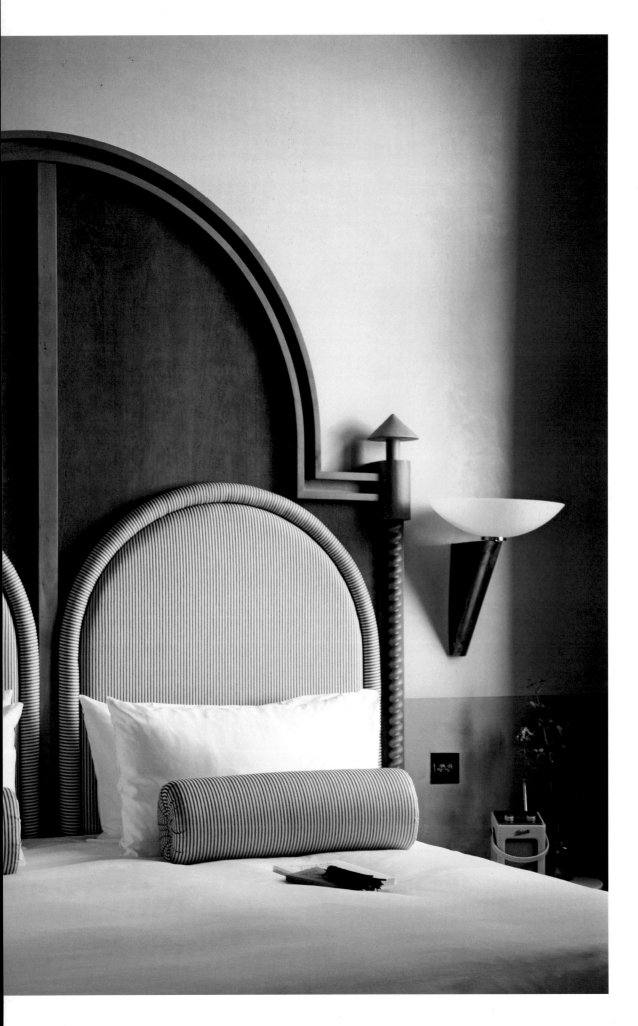

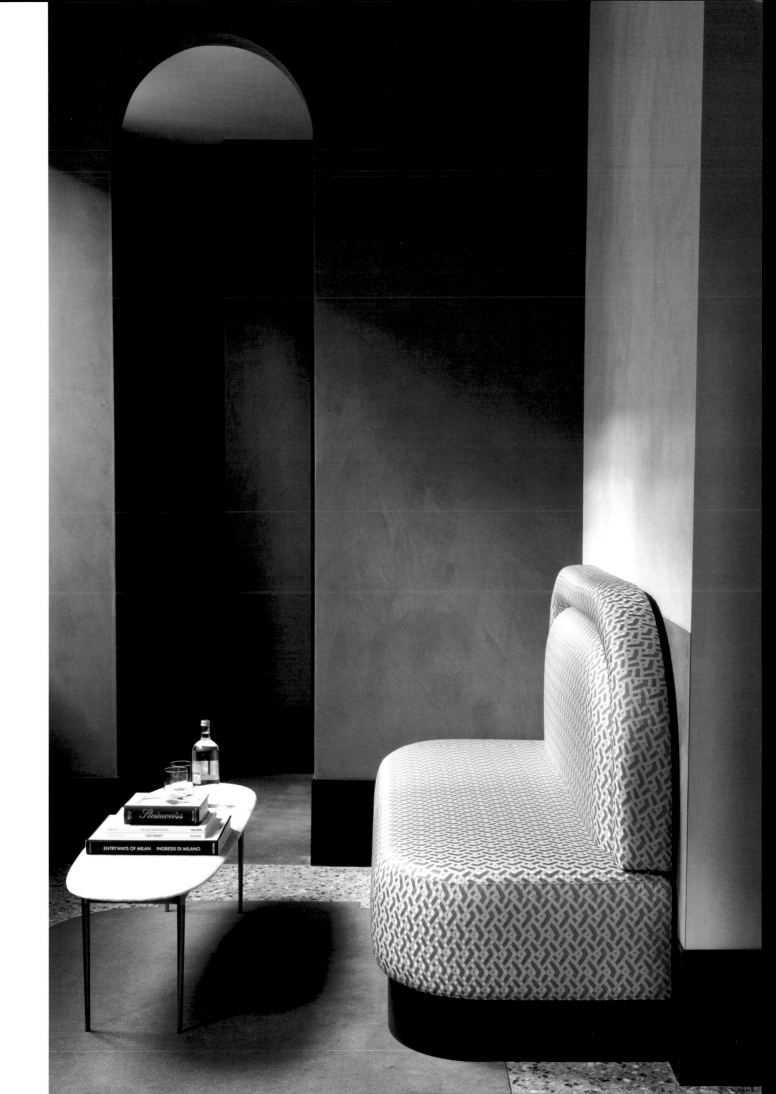

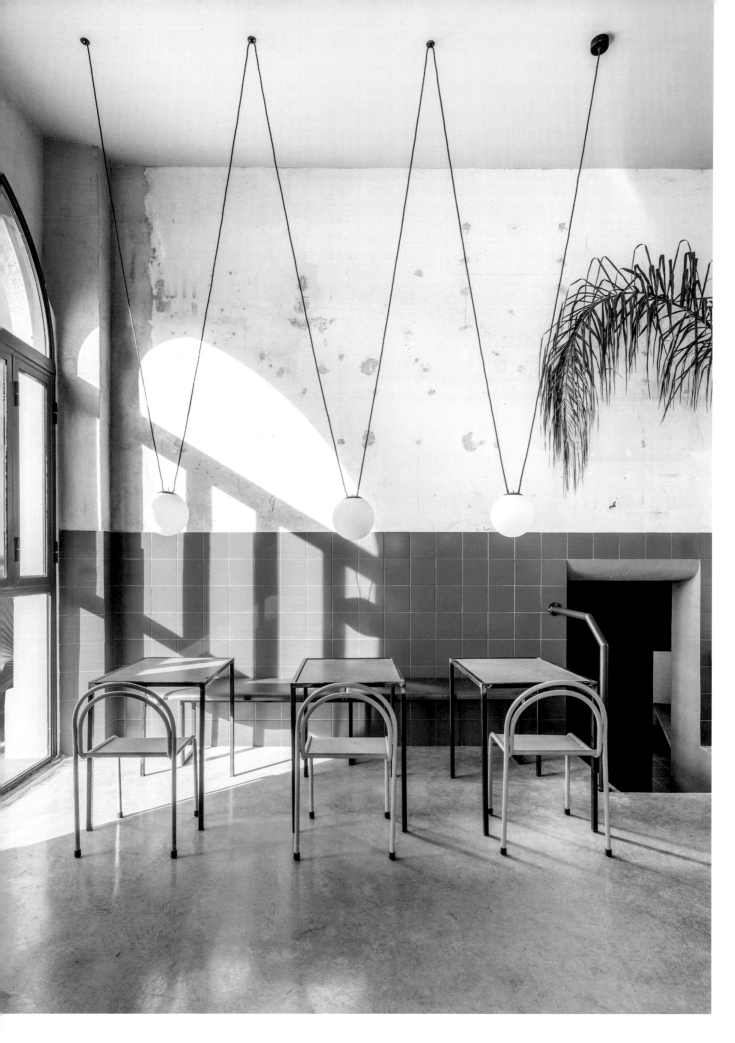

A Tutti Frutti Palette at Tre de Tutto

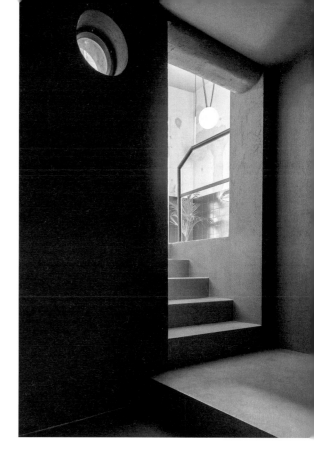

Tre de Tutto

Studio Tamat

Rome, Italy

Tre de Tutto, a restaurant in one of Rome's newly trendy neighborhoods, is built on the site of a long-abandoned bakery. Disused no more, the space has been filled with the sounds of hissing espresso machines in the morning and clinking glasses at *aperitivo* hour, all against the backdrop of a very juicy color palette. The walls have been left untreated in some areas as a nod to this building's historic fabric, but are covered with Grid wallpaper by Texturae elsewhere, perhaps as a nod to its bright future. Otherwise, it's one focal point after another: yellow chairs made from recycled iron, bold blue tiles, a neon sign at the entrance reading "How beautiful Garbatella is!" in tribute to the neighborhood, and a perforated sheet-metal panel alongside a bright-yellow staircase. The space is separated into two levels to accommodate the restaurant sitting on a slight hill. The two levels are connected by a salmon-colored staircase, a tunnel-like structure with portholes well-suited for looking out at the many characterful details of this local eatery.

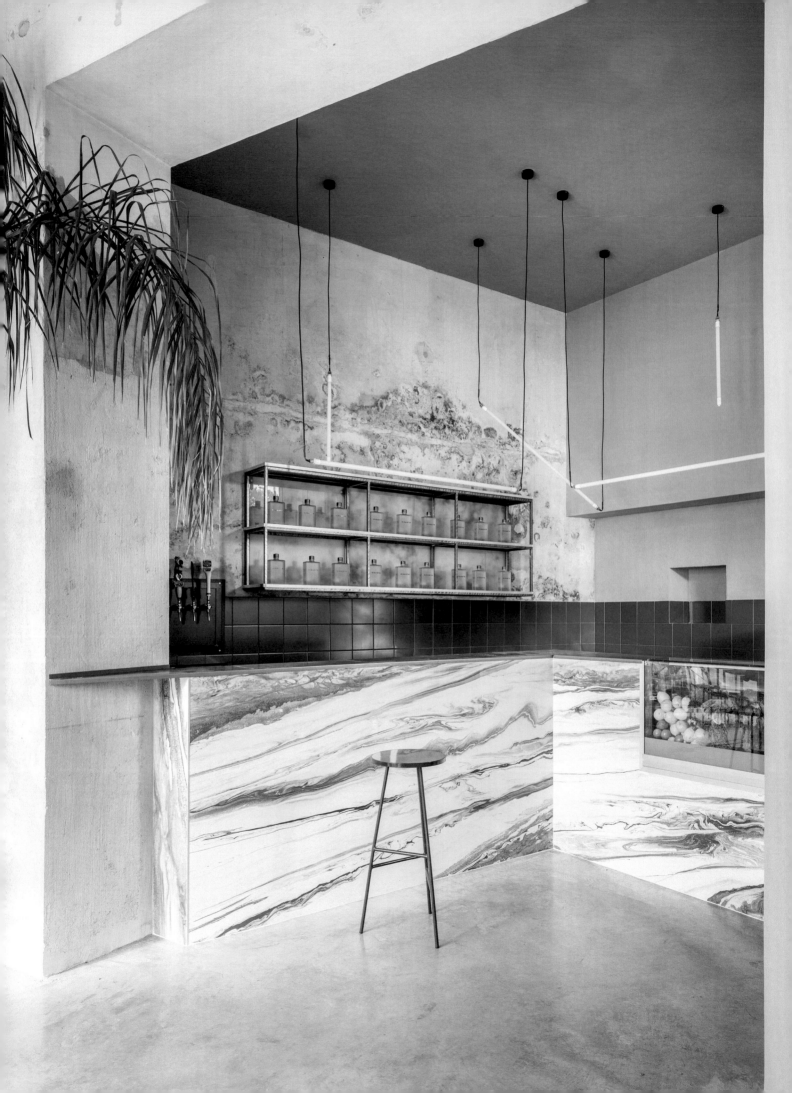

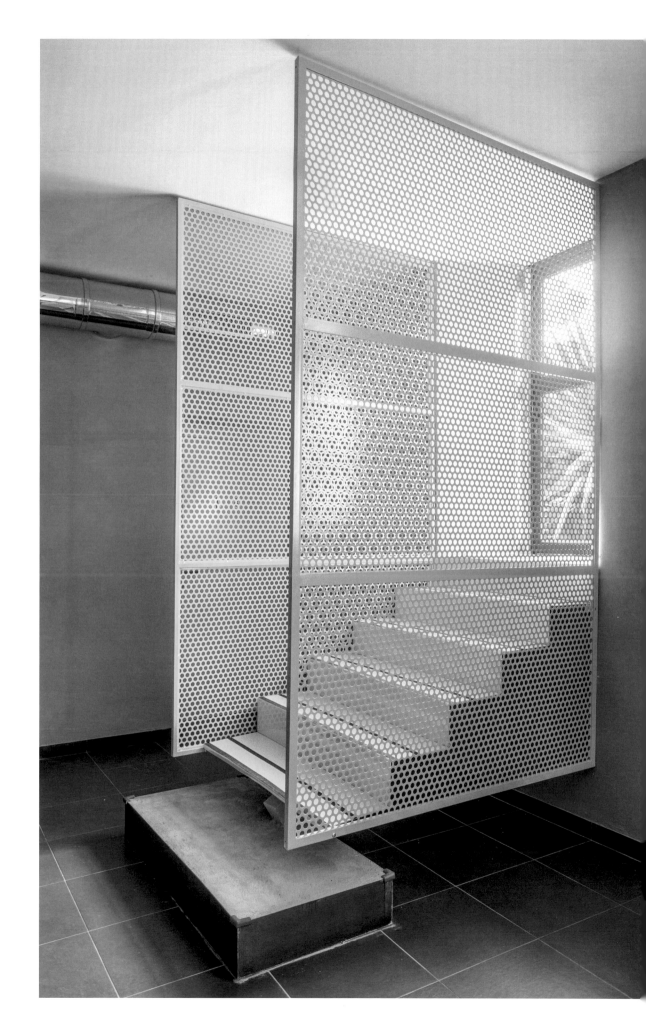

Break Away with Squiggly Shapes and *Wiggly Lines*

At the Marrow Midcentury house by **Bells + Whistles,** a squiggly mirror sets the tone of a playful Southern Californian home, made up of blobs, curves, and chubby proportions.

The best way to rebel against the tyranny of straight lines? Wiggles. Squiggly lines may have a cartoonish quality to them, but in the right setting they can add a sense of unique sophistication. Few have demonstrated this better than Memphis Group founder Ettore Sottsass, whose wavy Ultrafragola Mirror is a classic that sells for four- and five-figure sums, and embodies the movement's rejection of midcentury Scandinavian design. From blobby edges to chairs that look like they were squeezed from a tube, squiggles and wiggles are a whimsical break from the norm.

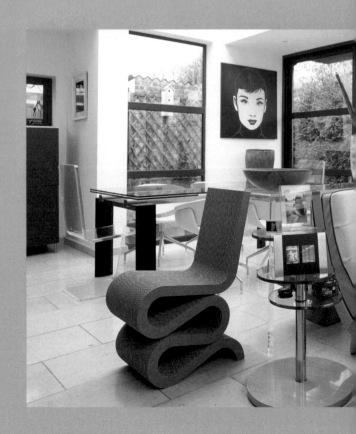

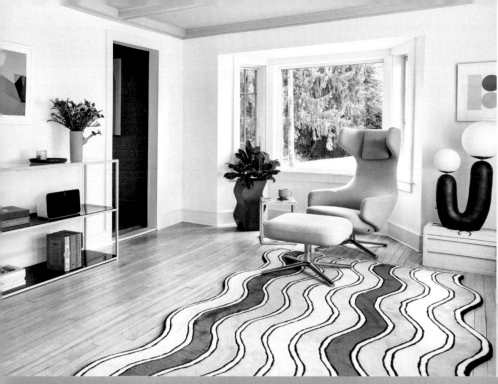

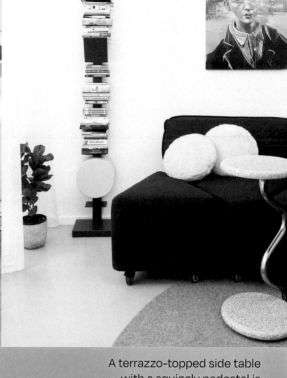

Squiggles abound in the **Pieces** shoppable Airbnb. A custom Wavy Rug snakes through the space, accompanied by the brand's Zig Zag Planter and an Oo Lamp by **Eny Lee Parker.**

A terrazzo-topped side table with a squiggly pedestal is part of **Sibling Architecture's** inclusive approach to Frenches Interior, where a circular motif is symbolic of unity, equality, and family.

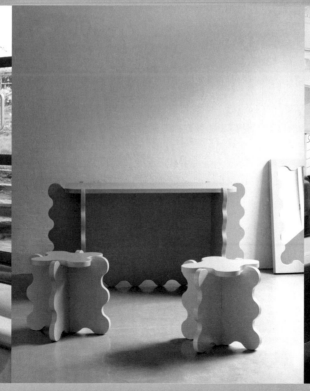

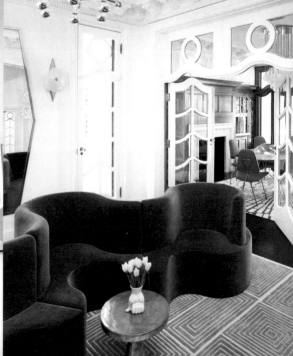

Frank Gehry's Wiggle Side Chair is part of his Easy Edges furniture series. Released between 1969 and 1973, it sought to reframe how we think about and use cardboard.

Stockholm designer **Gustaf Westman** follows in Sottsass's footsteps with his Curvy Mirror, which is framed by statement-making squiggles. The Curvy Table Mini and Curvy Desk get the same treatment.

Squiggles can be practical too. The Cloverleaf Sofa, designed by **Verner Panton** in 1969, is a modular sofa with boundless configurations. It's seen here in the Nob Hill Home designed by **Jonathan Adler.**

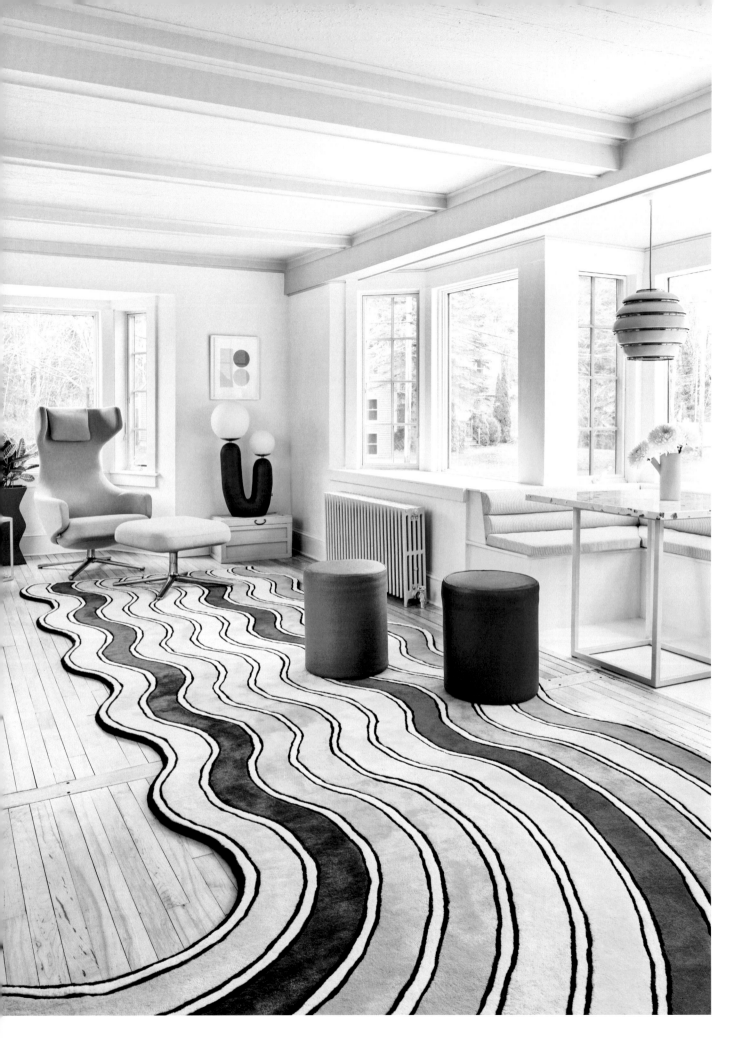

Surprises Abound in a Fun-Filled Airbnb

Pieces Home

Pieces by
An Aesthetic Pursuit

Kennebunk, ME, USA

For home-design brand Pieces, by Brooklyn-based creative agency An Aesthetic Pursuit, color is nothing to be afraid of. That stance is made abundantly clear in their showroom-meets-guesthouse. Their mission: to help people understand that with the right balance, there's no such thing as too much color. In the living room, neutral wall and floor colors don't compete with the custom, 10-color rug that flows through the space like a Technicolor cartoon river. Tucked away in verdant Maine, this space was a natural progression for the brand. It was the first time the three founders could showcase their own products, as well as a curated selection of other, like-minded design brands all together in a single, livable space. It reimagines the idea of a showroom into a shoppable Airbnb, offering their guests the chance to get up close and personal with the products: to feel the carpets beneath their feet or sink into the pastel-pink sofa—or at the very least, spend a long weekend in a cozy and colorful guesthouse.

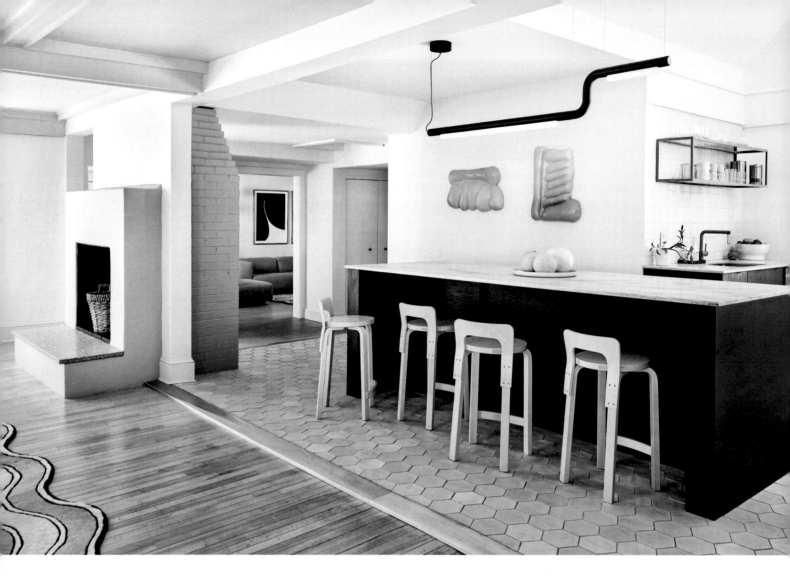

One of the many eye-catching focal points in this guesthouse is the Wavy Runner by Pieces, a cartoonish splash of color that flows through the living and dining area. On the right, it's paired with Jasper Morrison for Vitra All Plastic Chairs and a dining table also by Pieces.

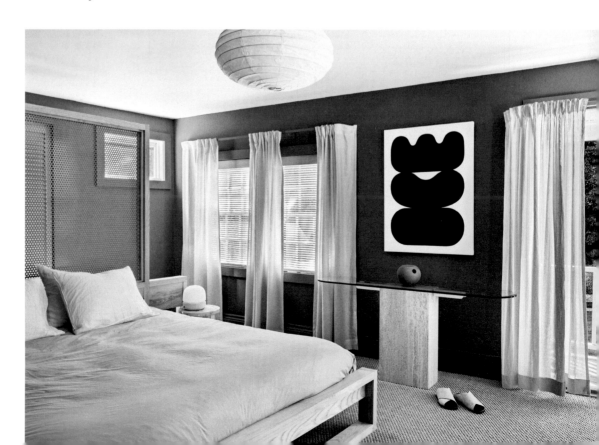

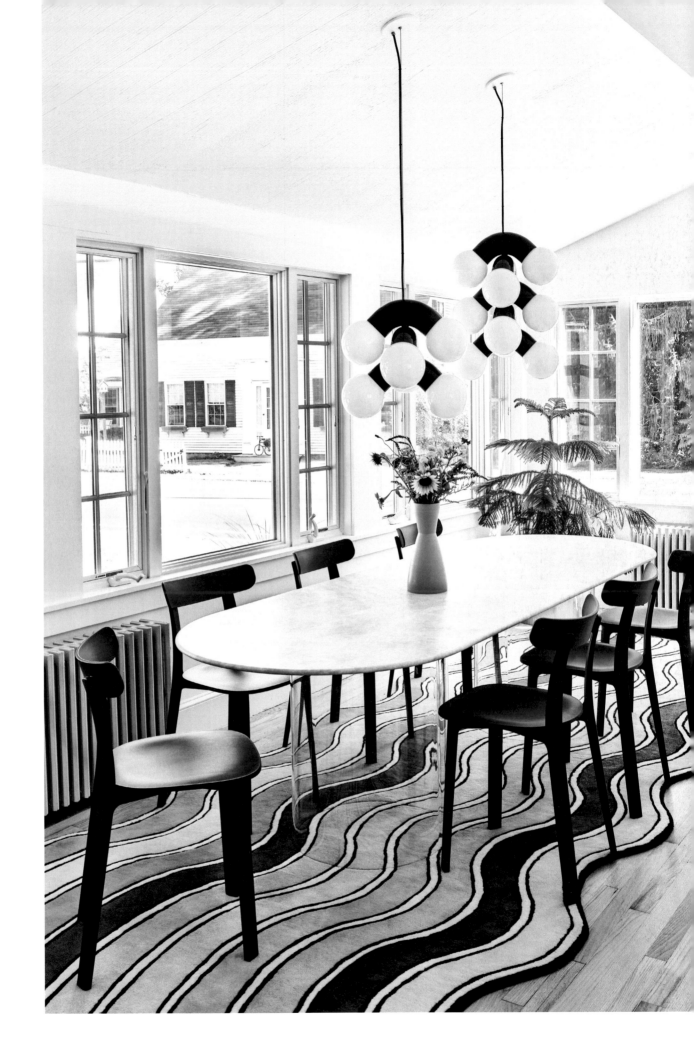

Playful Details with a Bigger Purpose

Frenches Interior

Sibling Architecture

Melbourne, Australia

In this Melbourne home, curves, circles, and squiggles come together like perfectly placed doodles on a page. But the proportions here serve a greater purpose than aesthetics—though they do it with aplomb. The residents work extensively with people who have experienced physical or cognitive injuries, and have several wheelchair-users in their immediate circle. The home therefore had to offer a high degree of accessibility. The architects were motivated "to look at accessibility in a way that was desirable, rather than a strict interpretation of the code." The furniture in the downstairs library, for instance, is all on wheels, making it easy to adapt into a guest room. The navy sofa in the living room is likened to a "cake," where slices can easily be added or removed to accommodate wheelchair-users. The pink, powder-coated handles give assistance to those who need it and the circular dining table allows for uncomplicated circulation. In fact, the circular motif is found throughout the home—a symbol of unity, equality, and family.

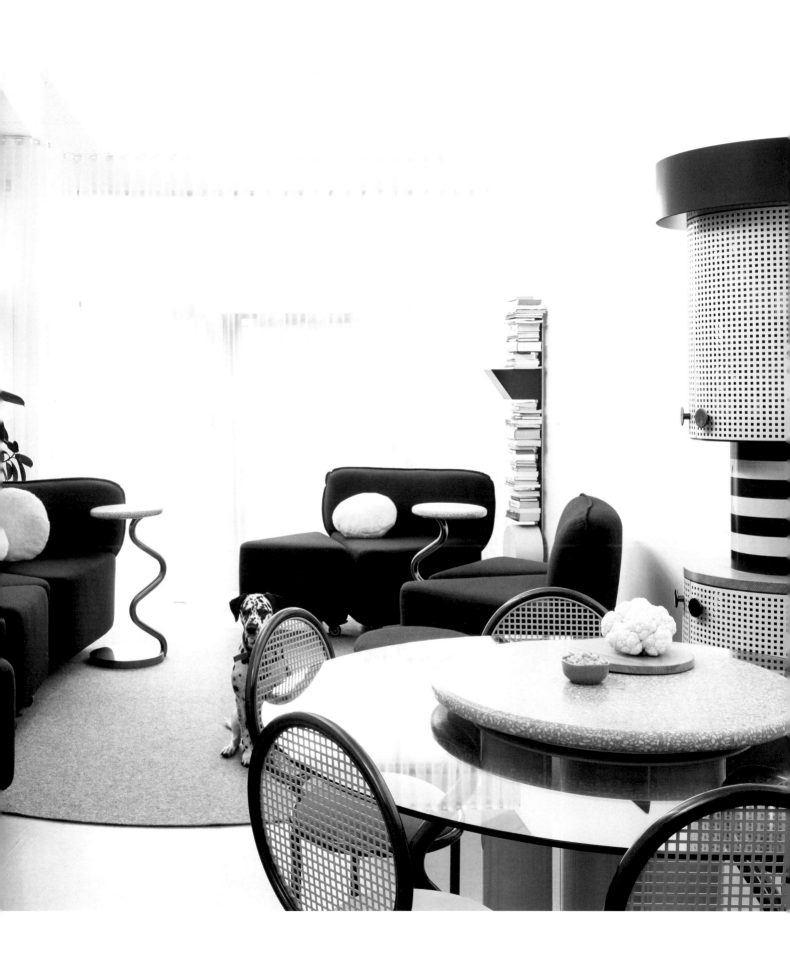

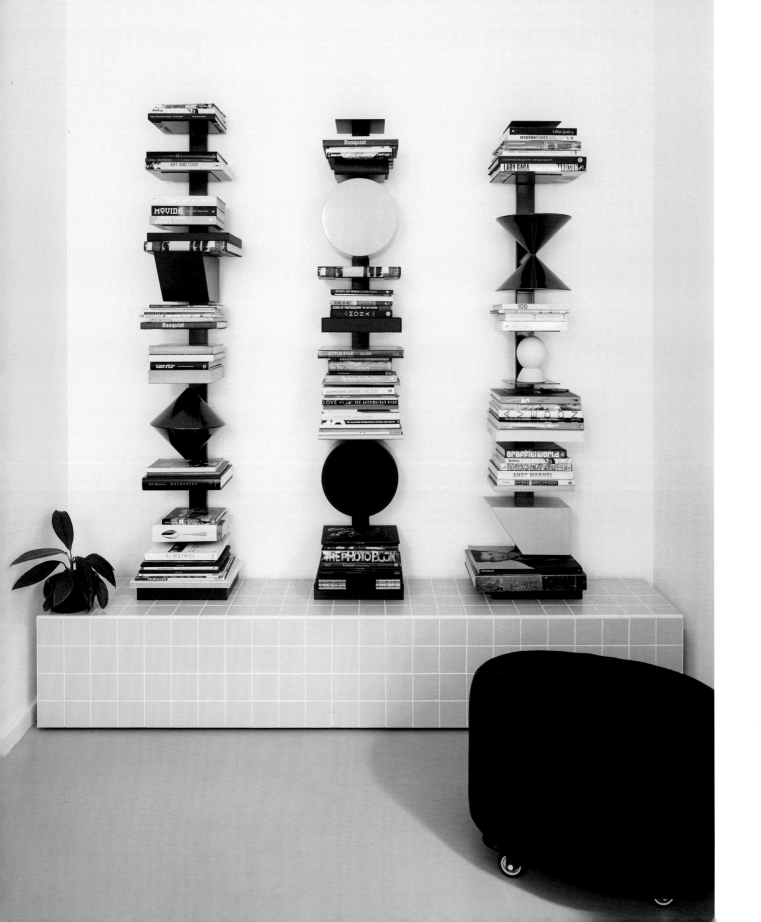

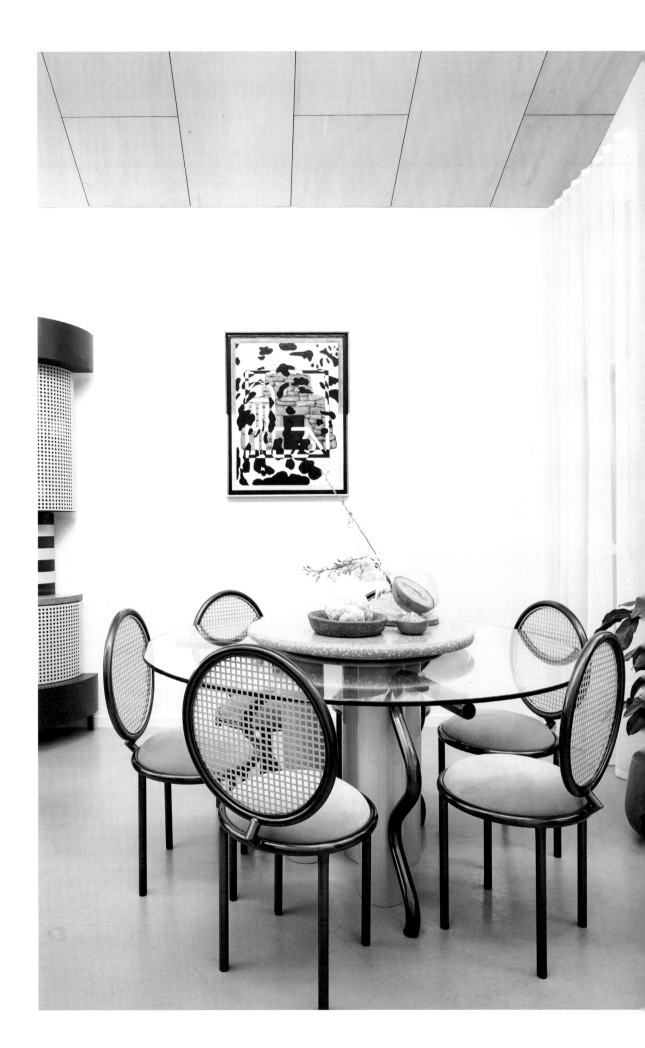

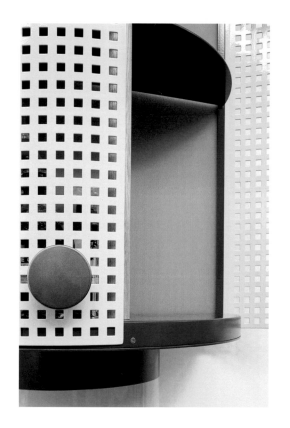
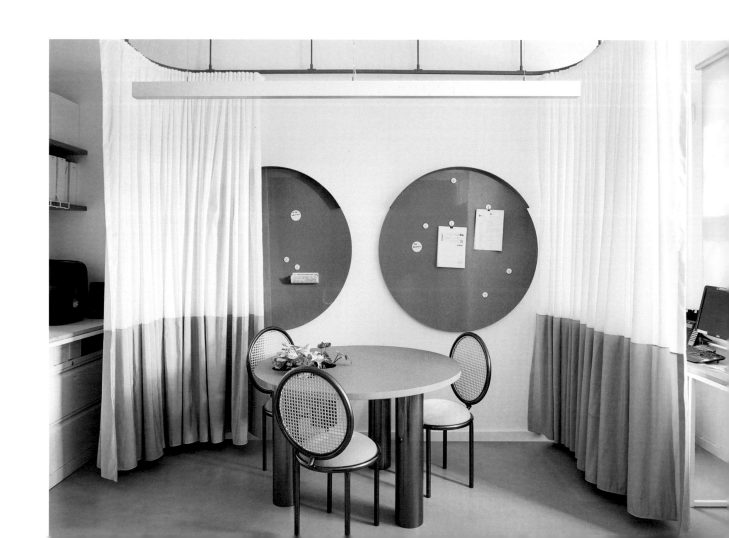

A key stipulation for this home was to make it accessible for wheelchair-using guests and friends, a factor that underpinned all design decisions. Another recurring feature is the custom-designed joinery elements, or "totems," according to the architects, where the clients can store and showcase valued possessions.

Circles and *Geometric Shapes* Are Anything But Square

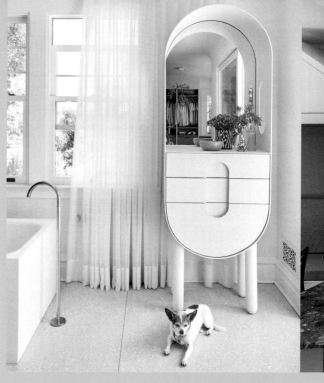

It's ovals all over in the bathroom of this Los Angeles home. **Ghislaine Viñas,** who oversaw the project's interiors, designed the cabinet with curves that are matched by the freestanding faucet.

Some of our earliest childhood lessons are based around knowing our circles from our squares. So when we see geometry reflected in interiors, especially colorful ones, there's something comforting in its familiarity. Studies have shown that circles, especially, contribute to a happier home. Simple shapes are extremely versatile to work with and boundless in their potential. The spaces in this mood board show how something so embedded in our childhoods can be reflected in the most adult of spaces.

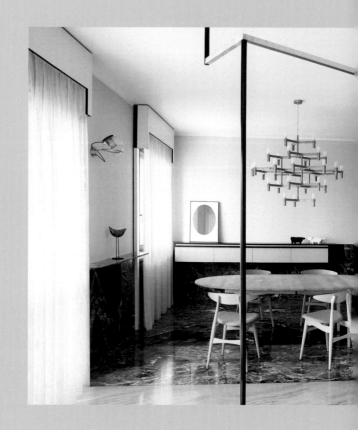

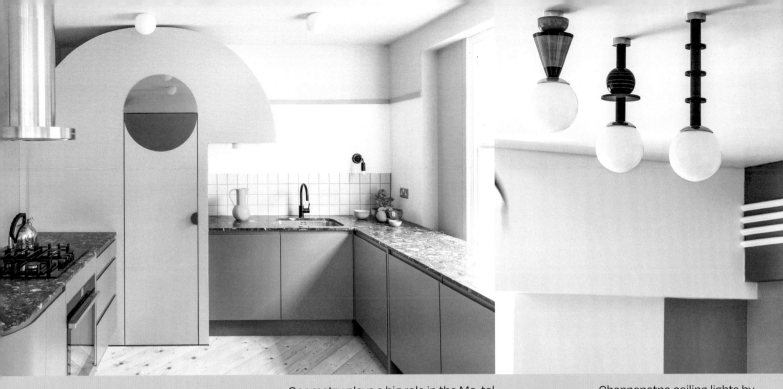

Geometry plays a big role in the Mo-tel House, designed by **Office S & M,** where peaks and arches "create notional thresholds and a sense of enclosure." The arched door conceals a guest bathroom, and the round tinted mirror is one of several placed to reflect light.

Channapatna ceiling lights by **Arjun Rathi** are named after a city in India that's especially well known for making toys. The organic vegetable colors are a direct influence, while the geometric flair is inspired by the Memphis movement.

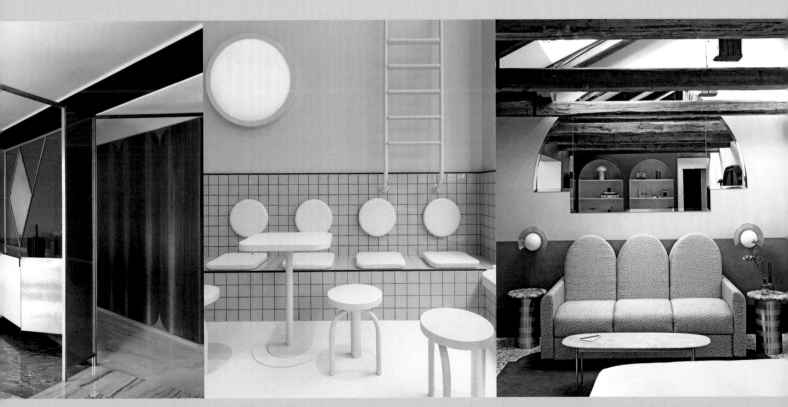

The cabinet in this Milanese apartment is designed by **Marcante Testa,** as is the brass-edged screen that distinguishes the dining area from the entrance. The dining set is by **Carl Hansen.**

At the Turin location of Bun Burgers, designed by **Masquespacio** with a millennial and Gen Z clientele in mind, circular furniture and lighting is paired with a crisp square grid of matching tiles.

It's not just circles and squares at the Il Palazzo Experimental hotel, by **CHZON.** The seating and built-in shelving forms arches, and the mushroom shape of the mirror resurfaces elsewhere as a headboard.

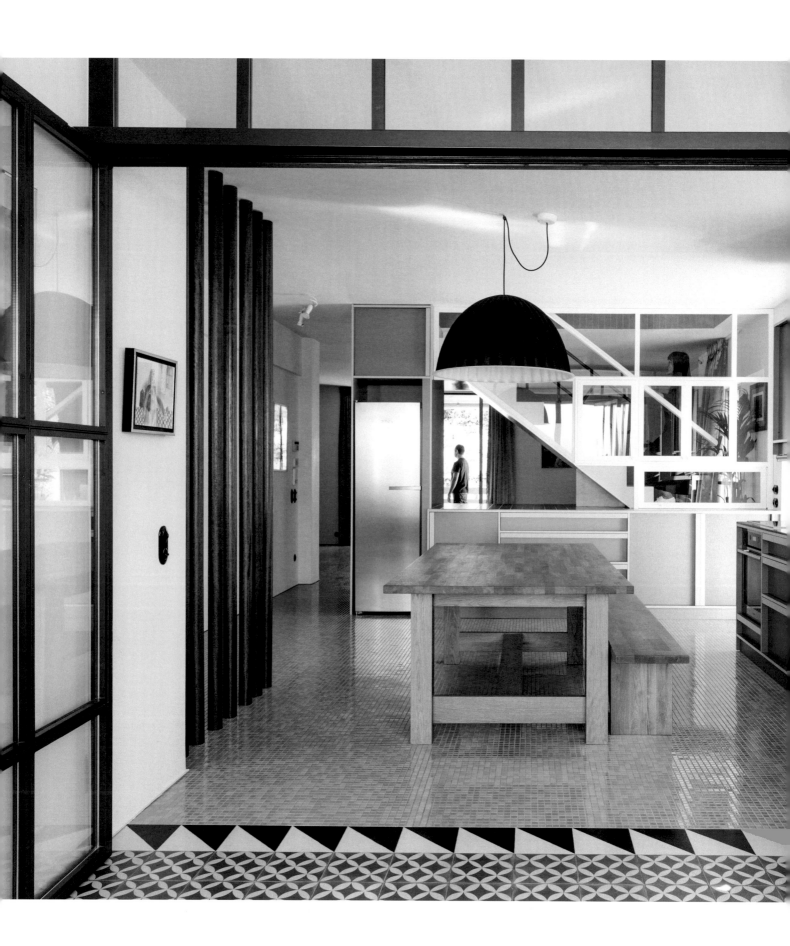

A Home in Many Shapes and Sizes

Nadja Apartment

Point Supreme
and KN Group

Athens, Greece

This home was designed to deliver two very different experiences, depending on where you stand. If you're downstairs, you find yourself standing in what the architects refer to as a "marine-like" environment, with big pieces of furniture anchoring the family's activities "like floating islands." Instead of separating out the kitchen, living, and dining areas, it's all one open-plan space, articulated by a series of custom cupboards, seating, and shelving elements—each with its own approach to color and pattern. On their own, these tiles and zigzags would already pack a punch, but seen here they form just one part of a cohesive whole. Upstairs, where the more private spaces of the home are situated, there is a calmer, earthier feel. Its graphic approach, such as the pink semicircle painted along the staircase like a rising run, complements the space and, in some areas, is inspired by the architecture of the Greek islands.

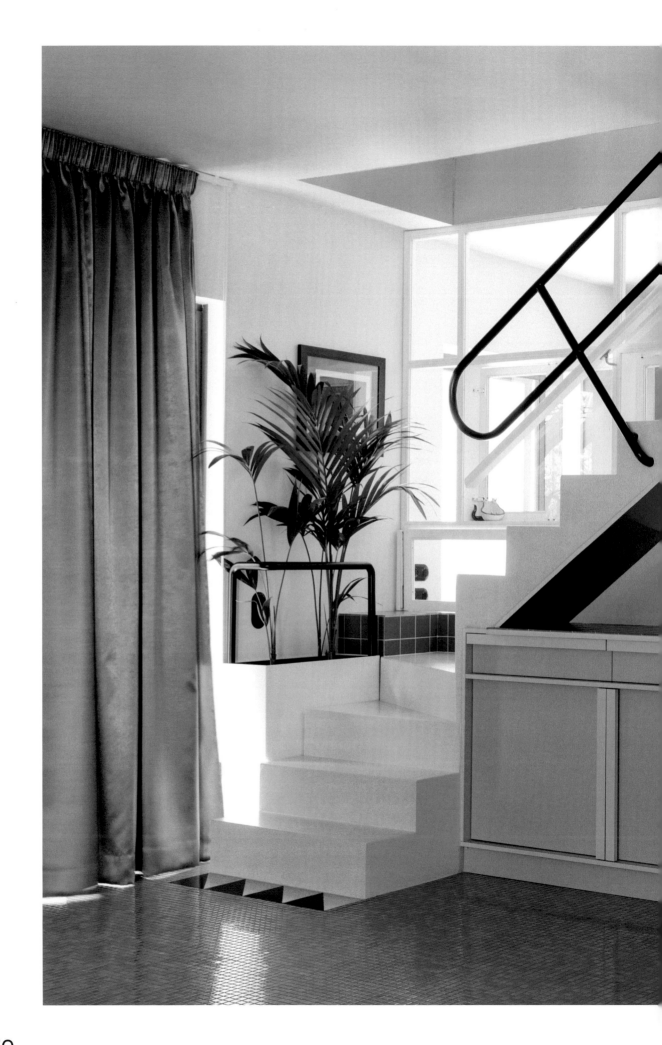

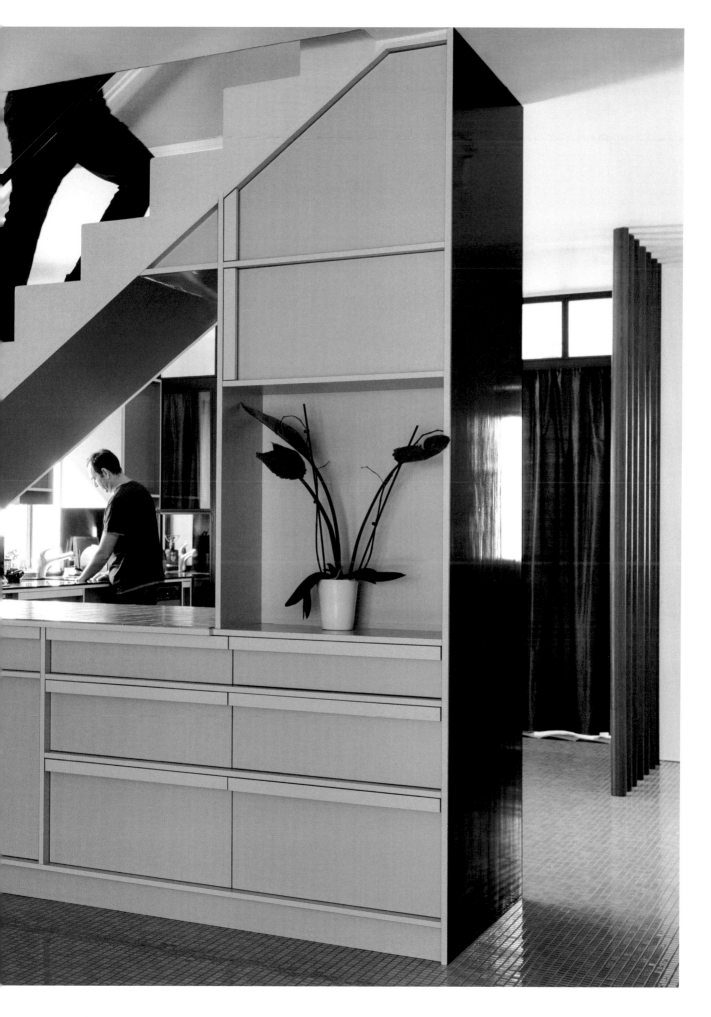

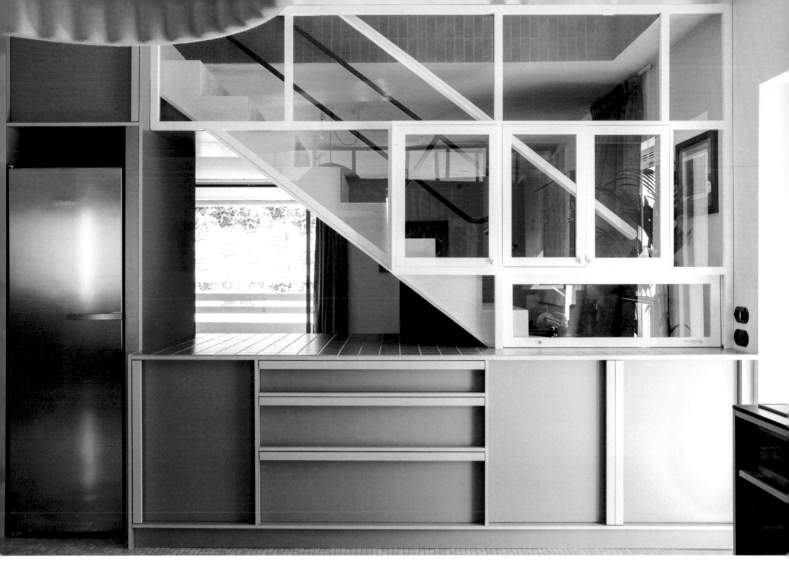

The home is divided into two opposing levels: the downstairs, pictured here, is full of vivid colors, blocky shapes, and playful geometric details. Linked by a sunny yellow staircase, the upstairs level is decorated with muted tones, better suited to rest and respite in the more private part of the home.

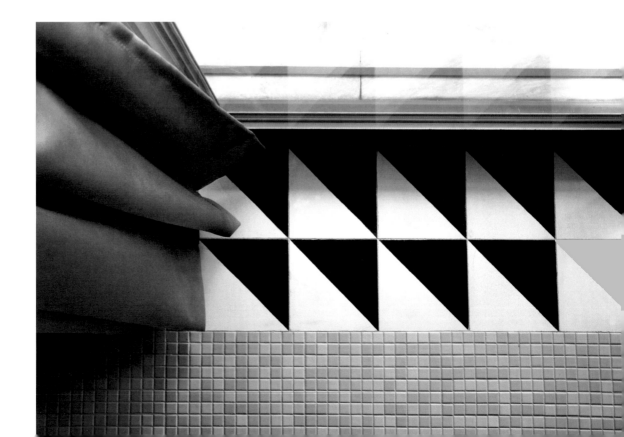

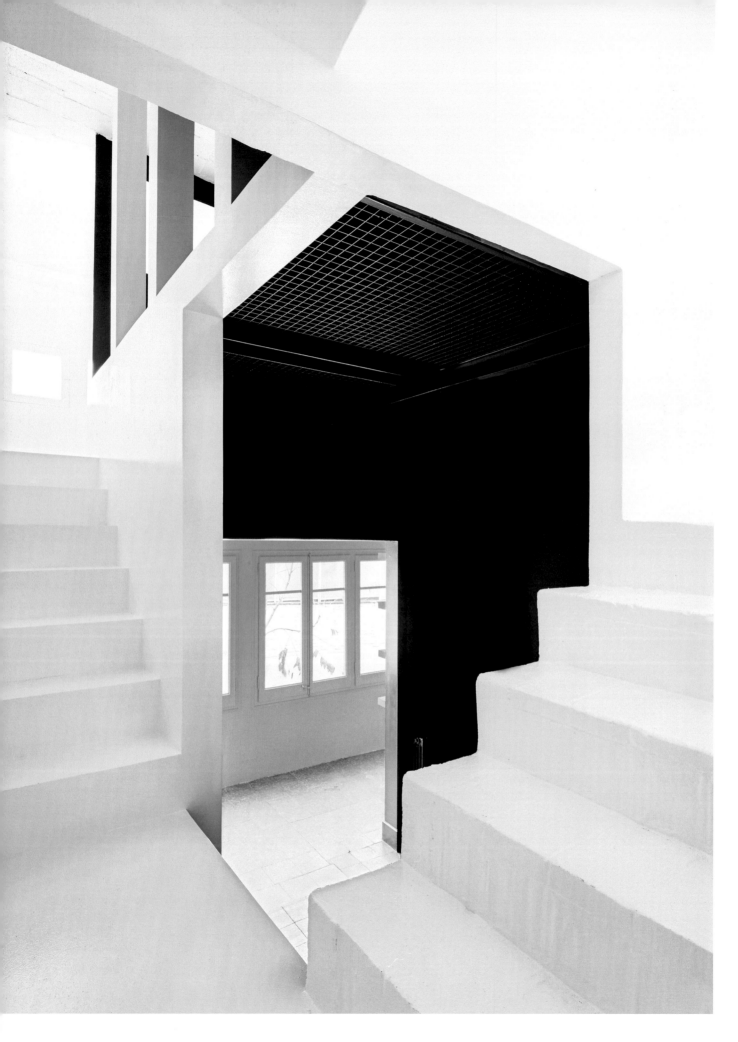

A Dazzling Masterpiece of Color and Light

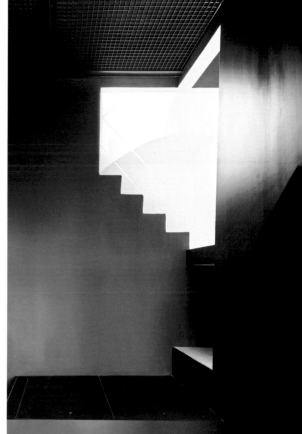

Casa Horta

Guillermo Santomà

Barcelona, Spain

When they're working with clients, designers are in a constant process of give-and-take. A small compromise here, a little trade-off there. But when they're designing a home for themselves, the story looks a little different. In fact, it might look something like the incredible Casa Horta, designed by Guillermo Santomà. The home, described by the *New York Times* as "cultivated chaos," is dominated by great swathes of color: a dark racing green, cool whites, coral pink, and a vaulted ceiling painted cobalt blue with rose-colored clouds. The staircases are treated with Escher-like emphasis, the enclosing wall removed to let light flow from the staircase into the living room, a zigzagging focal point itself. The home is composed of unexpected geometric planes: in the living room, there is a sofa enclosed by a semi-arch, the pink tile shower is triangular, and there are walkways and mezzanines throughout. And while the interior might appear thoroughly contemporary, it has maintained its historic Barcelona texture through patterned tiles and vaulted ceilings.

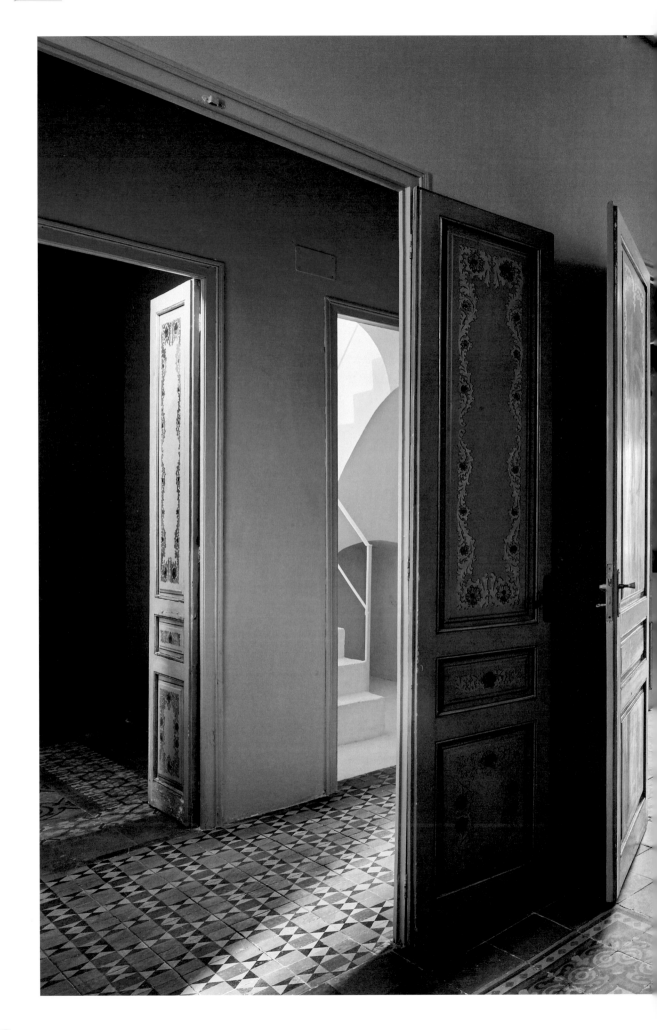

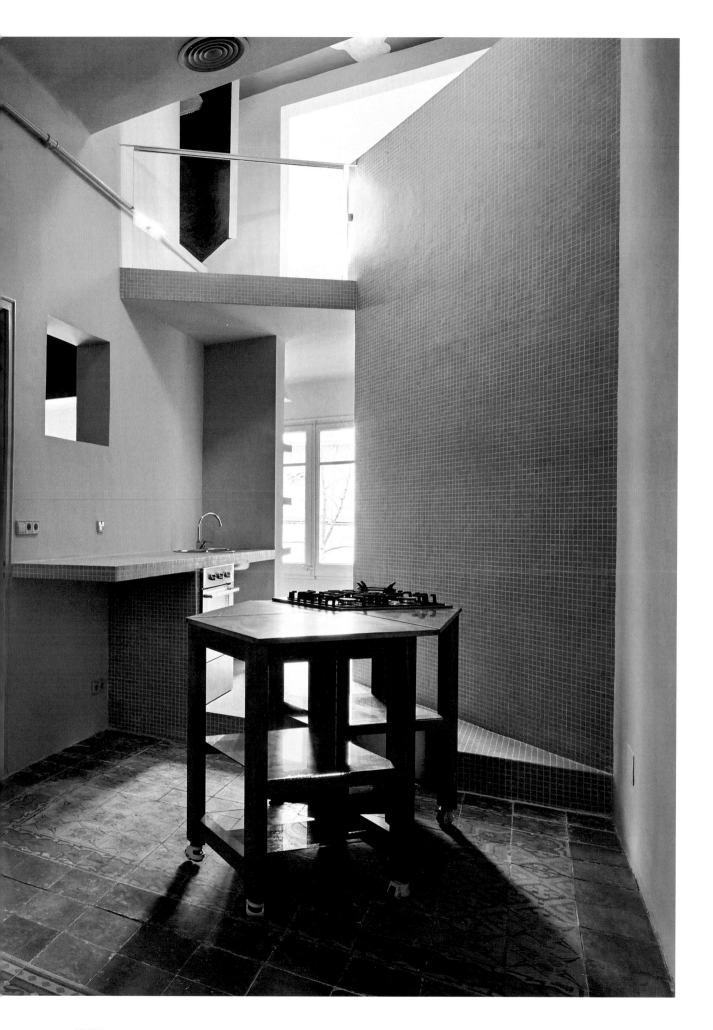

Casa Horta

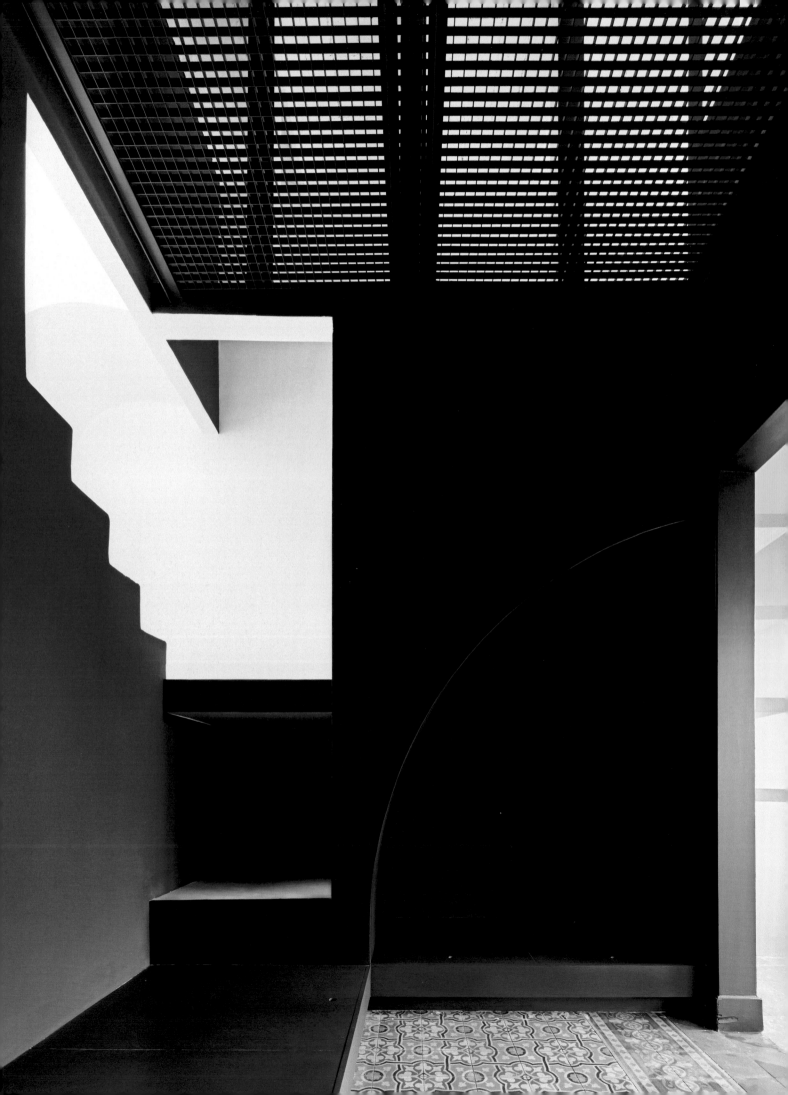

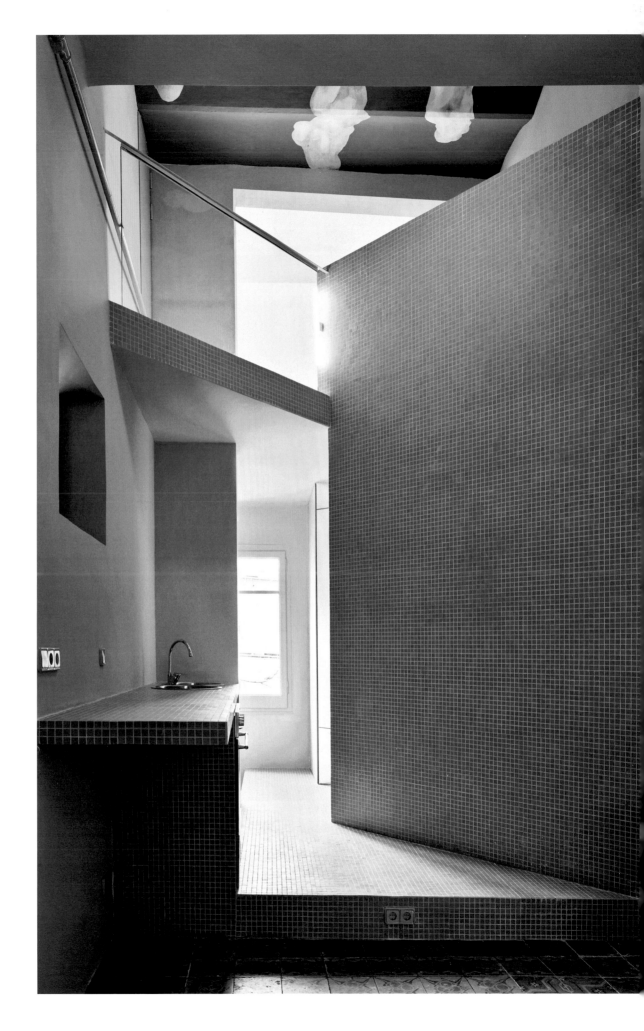

Casa Horta

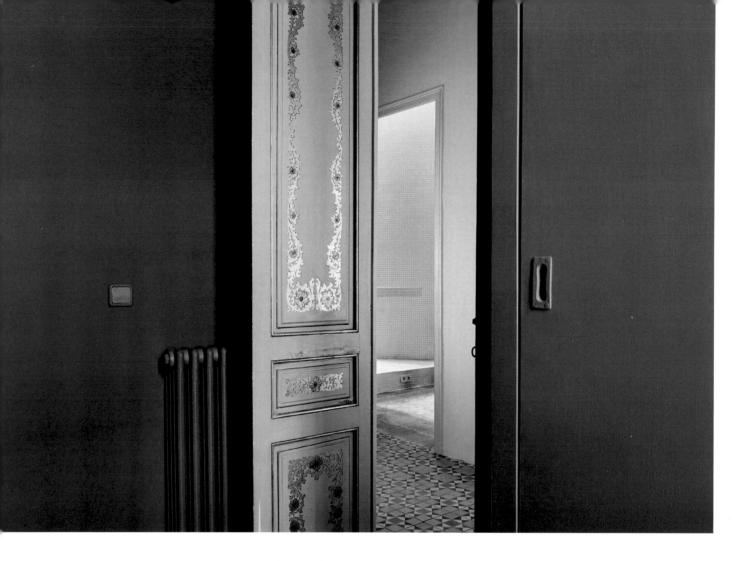

This three-story, 1,700-sq.-ft. (160-m²) home in Barcelona is the result of a renovation of an historic property. Santomà approached it in an intuitive way, beginning by opening the existing walls and implementing a new layout that doesn't rely on strict architectural planning. A saturated color palette covers most of the home, but here and there, a few period details, such as the original tile floors and gold-painted doors, can still be spotted.

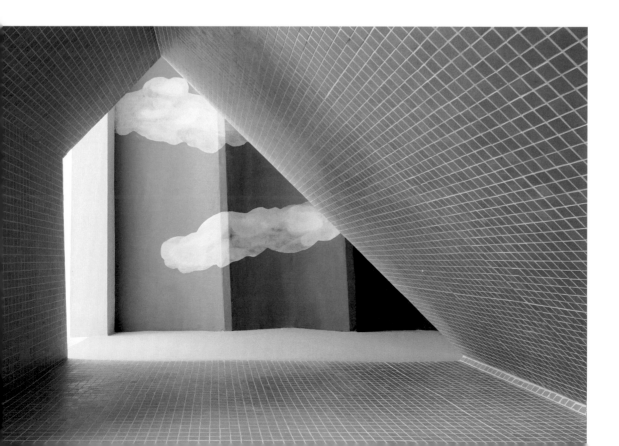

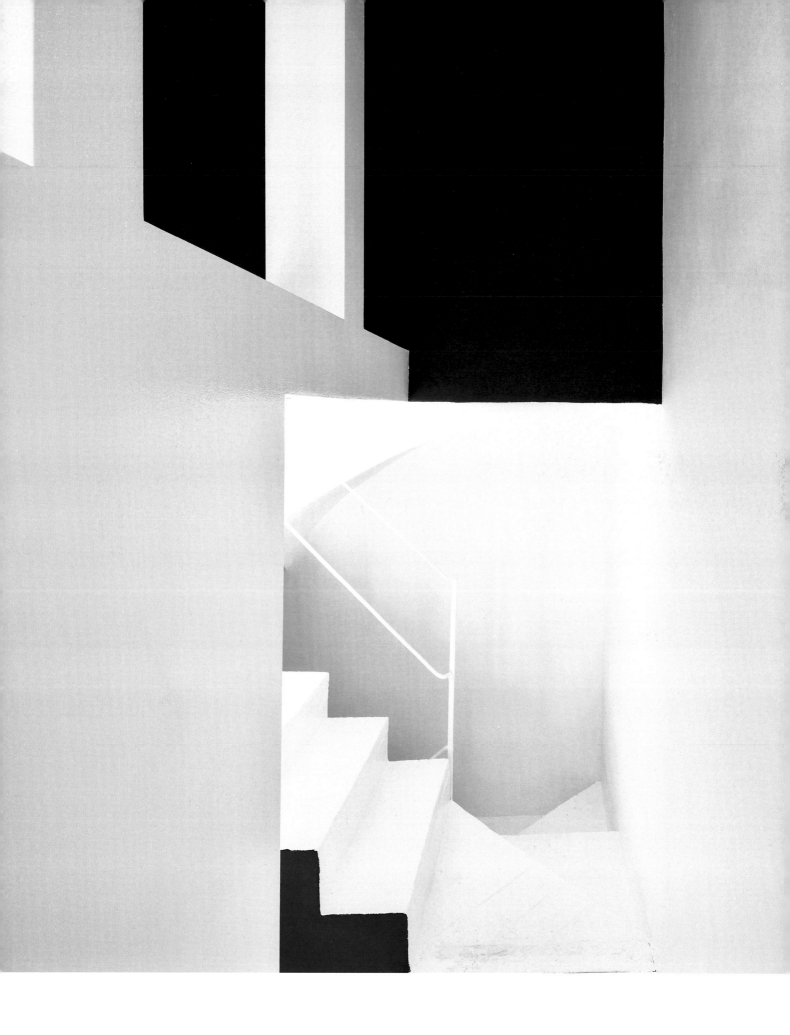

Casa Horta

Multitudes of Marble in a Midcentury Milan Flat

Teorema Milanese

Marcante Testa

Milan, Italy

The canvas for this residential refurb was a high-end Milanese apartment from the 1960s. The task: reimagine a typical apartment in an atypical way. The result: an open, light-filled space brimming with the colors and textures of the city itself. Consider the use of marble: multiple types of the precious rock, supplied by Catella—a firm favored by Gio Ponti—articulate the movement from one space to the next. A dusty color palette, the same you'll see coating the facades of many magnificent Milanese buildings, makes up a blush-colored rug here, a pistachio console table there. Together, it all feels rooted in a sense of place, and yet there are several surprises to be found. Between the marble, color palette, and the period details, the home's greatest strength is the way it ties together the modern and the historic. The furniture selection blends the twentieth century and the contemporary. To the architects, this was a deliberate move, to "reconcile modernity with tradition," and to display a sense of irony. As ever, this design duo from Turin doesn't take itself too seriously.

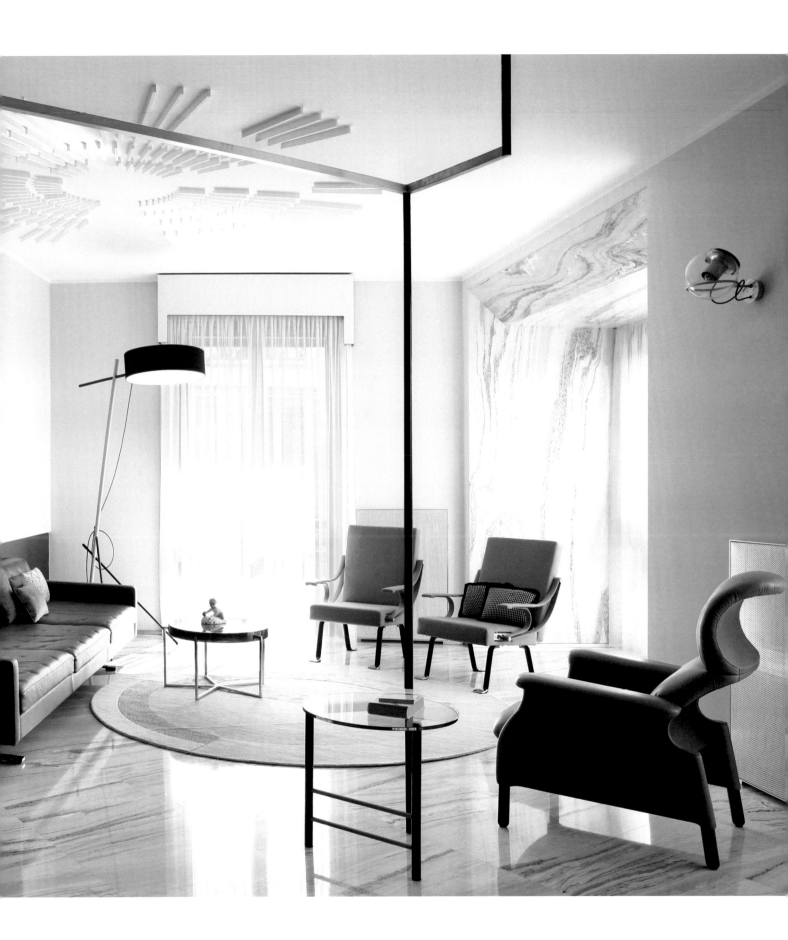

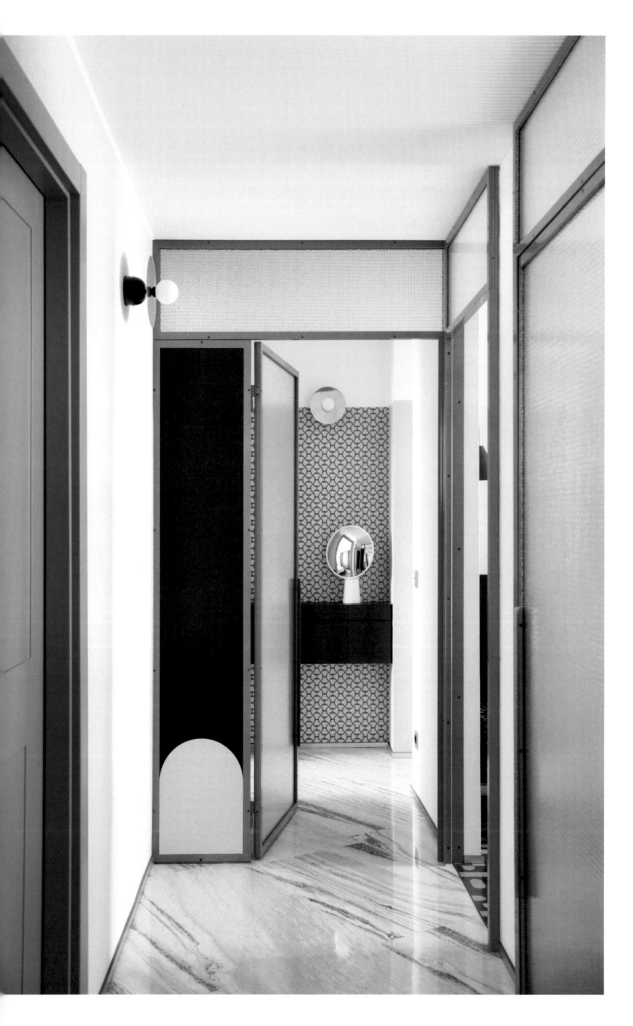

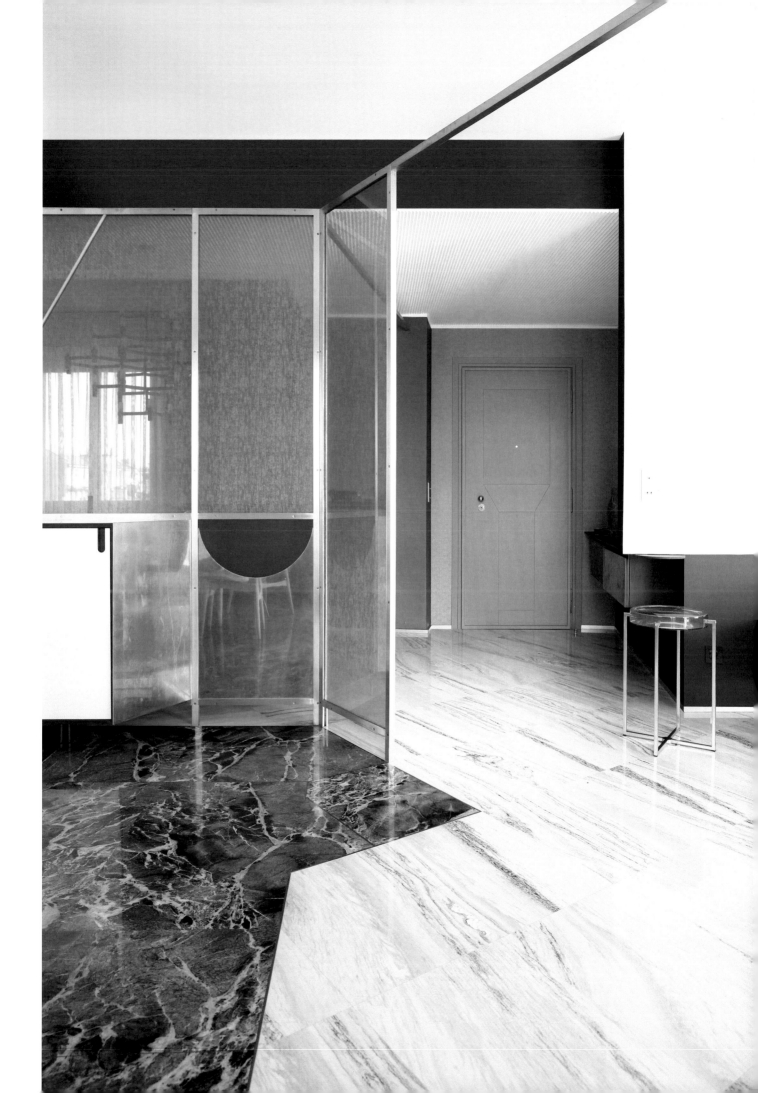

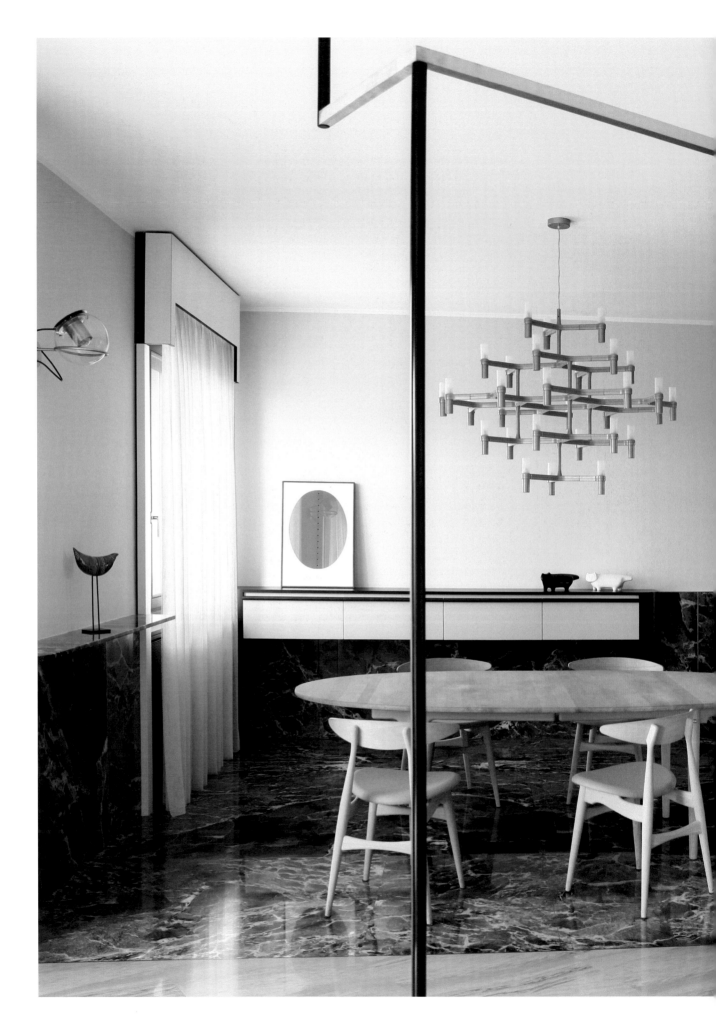

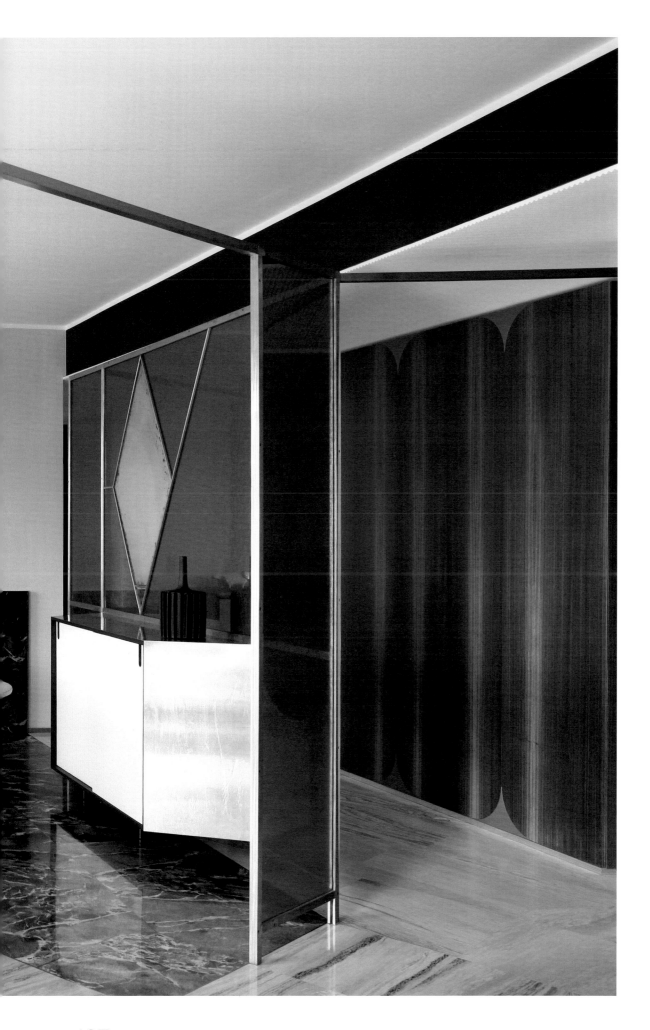

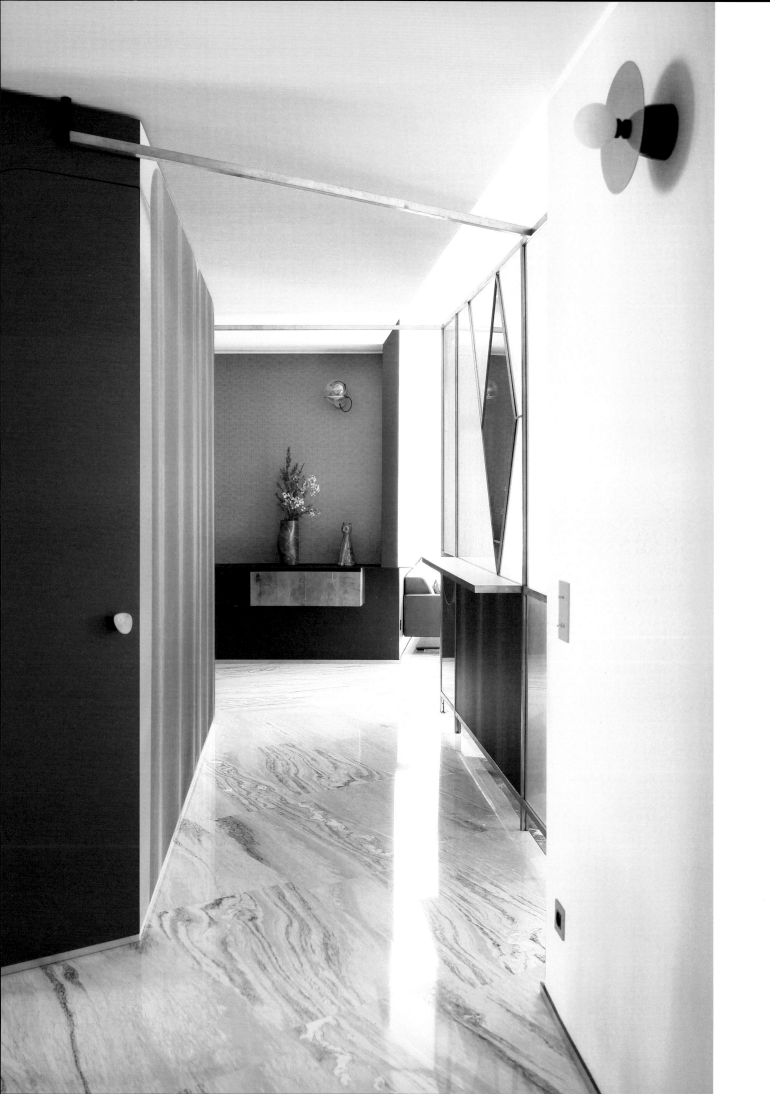

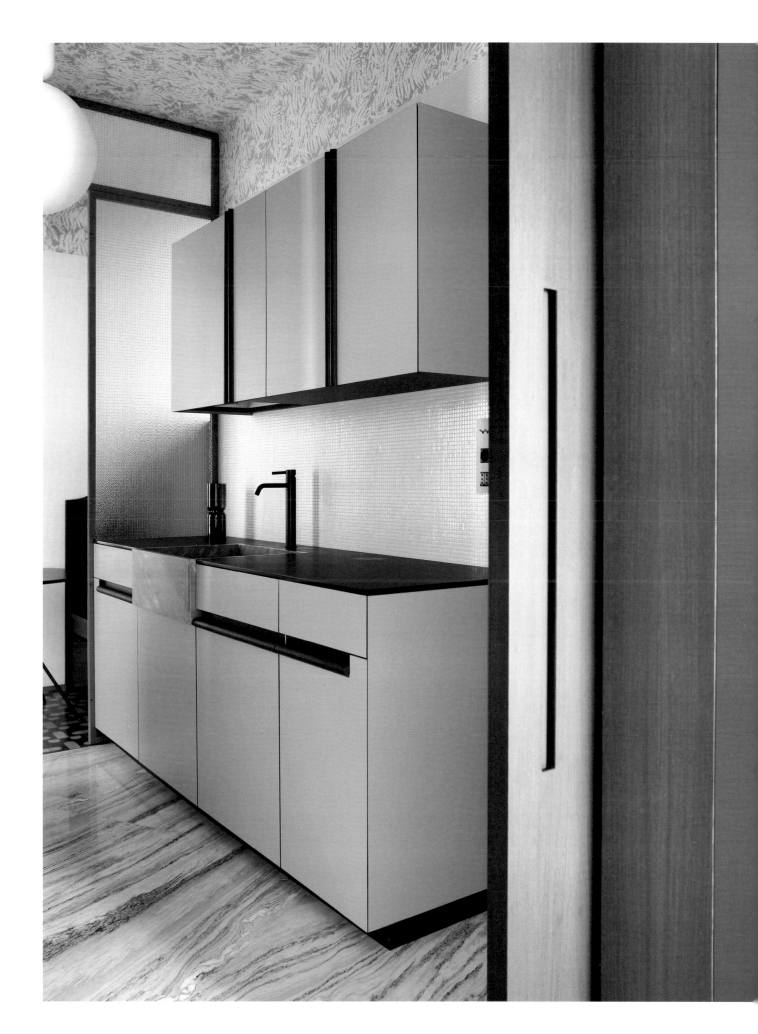

Teorema Milanese

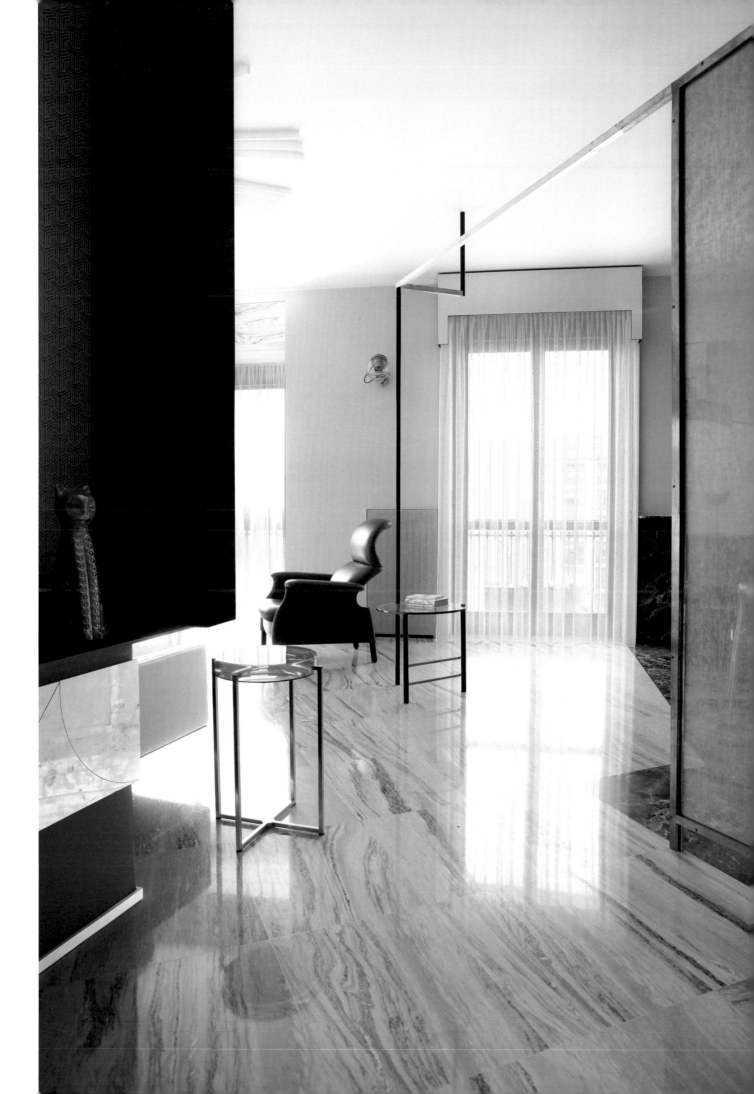

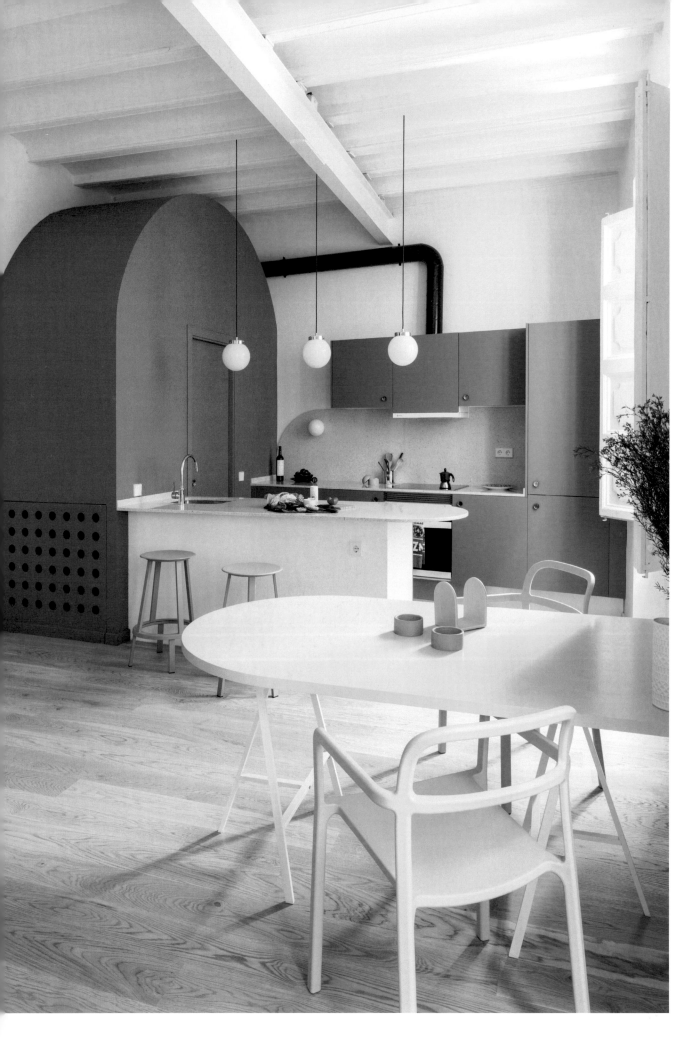

A Powder Room in Pretty Pastels

Apartment in Born

Colombo and Serboli Architecture

Barcelona, Spain

This apartment is located in one of Barcelona's oldest neighborhoods in a building that dates back to the thirteenth century. But unless you look closely at the period details on the shutters or the Catalan vaults in the ceiling, the space doesn't give away its age. Instead, poppy contemporary features are the result of a rigorous refurb, where the brief was to turn the old property into a vibrant flat for a fashion professional. The new space, which was reconfigured into a more open-plan apartment, is focused around a bright kitchen and living area. A rounded peninsula offers an informal eating area adjacent to a bright-coral, arch-shaped volume concealing a powder room. It was the client's wish to include a guest bathroom in the new layout, and the architects decided this would be the apartment's defining focal point. The arc motif appears again and again: in the kitchen back-splash, the terrazzo-like quartz kitchen island, and the dining table.

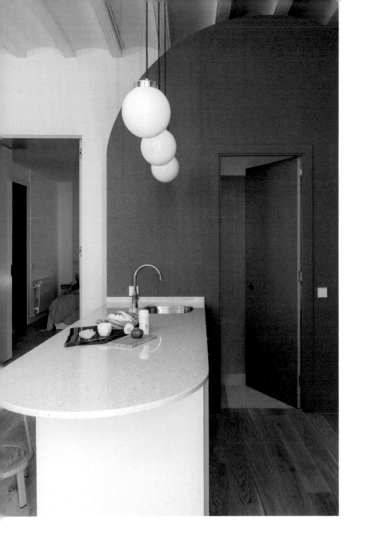
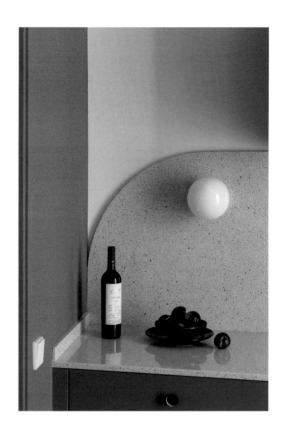
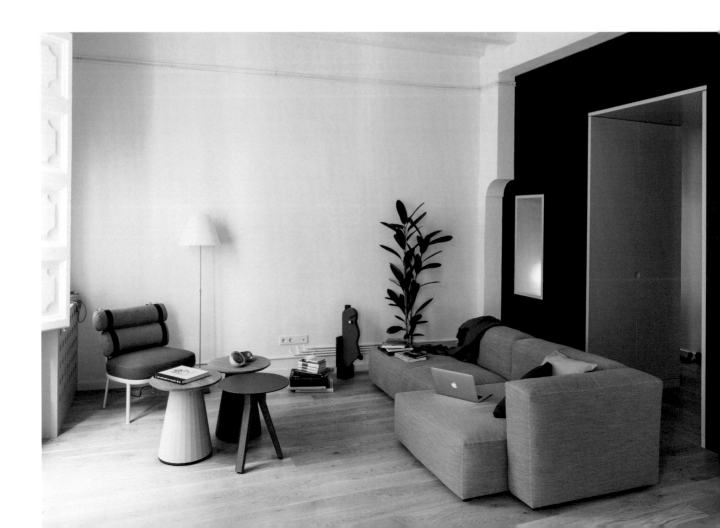

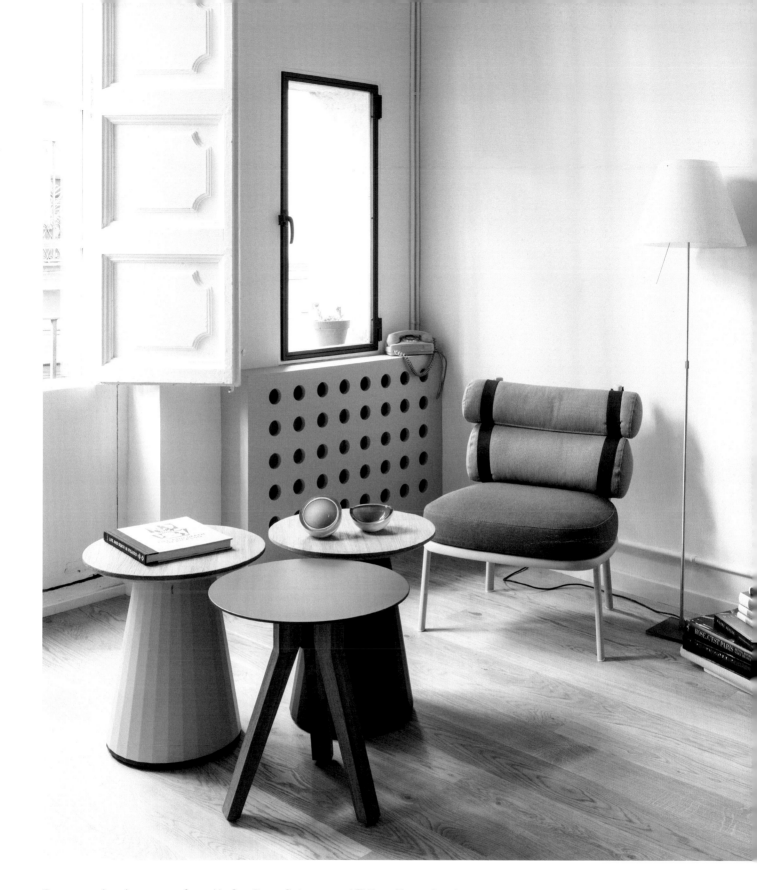

Curves and archways are found in furniture, fixtures, and fittings throughout the home, formulated especially well in the enclosed powder room and kitchen peninsula, pictured above left. In the living room, a sofa by Hay is paired with Kettal's Roll Club Chair by Patricia Urquiola and a trio of side tables, also from Kettal.

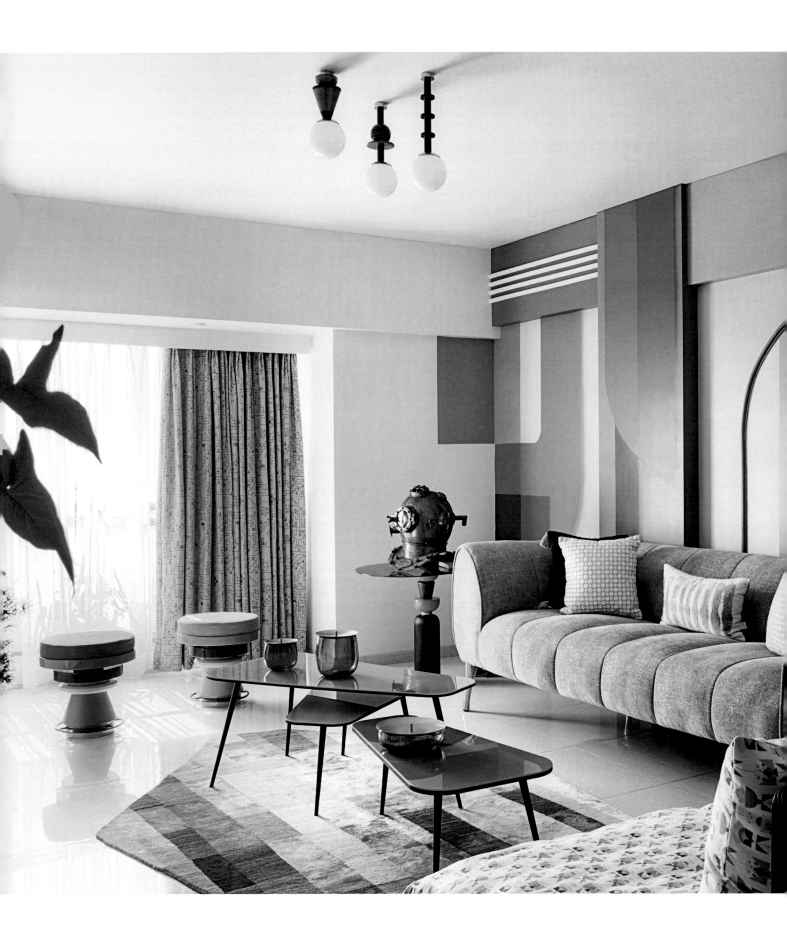

A Little Dash of Memphis in Mumbai

Quirk Box

Baldiwala Edge

Mumbai, India

In some respects, the design of this home was a long time coming. The brief itself came from a young client who wanted their home to reflect their personal aesthetic: bright, cheerful, bursting with color. But to the architects, the brief represented the opportune moment—one they'd been hoping for—to recreate the magic and dynamism of the Memphis movement, a process they liken to "being a kid in a candy store." Behind the sofa, the living room is anchored by a feature wall that is positioned to set the tone but not dominate the space. Nearby, a chaise longue is upholstered in a fabric by Indian textile artist Nikita Shah. The hanging lights also reference Memphis, but with an Indian spin: the Channapatna lights are named after the town in which they were made, which is better known for its toy production. In the den, curves and arches are met by a contrasting color scheme of blue and yellow. In the bedroom, the palette is more muted, but in keeping with the rest of the home, every surface is nonetheless covered in color.

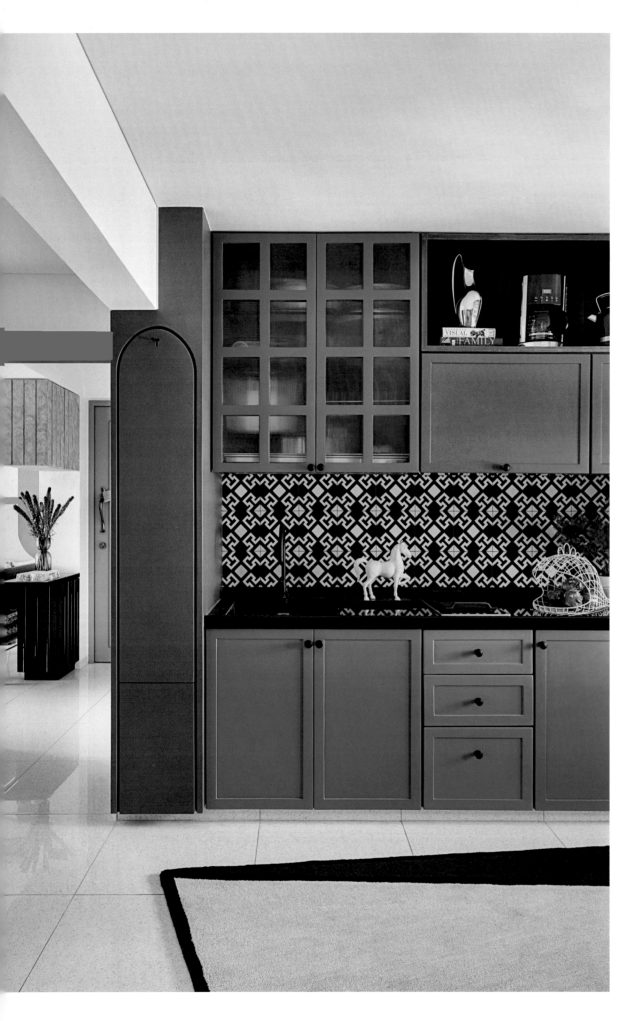

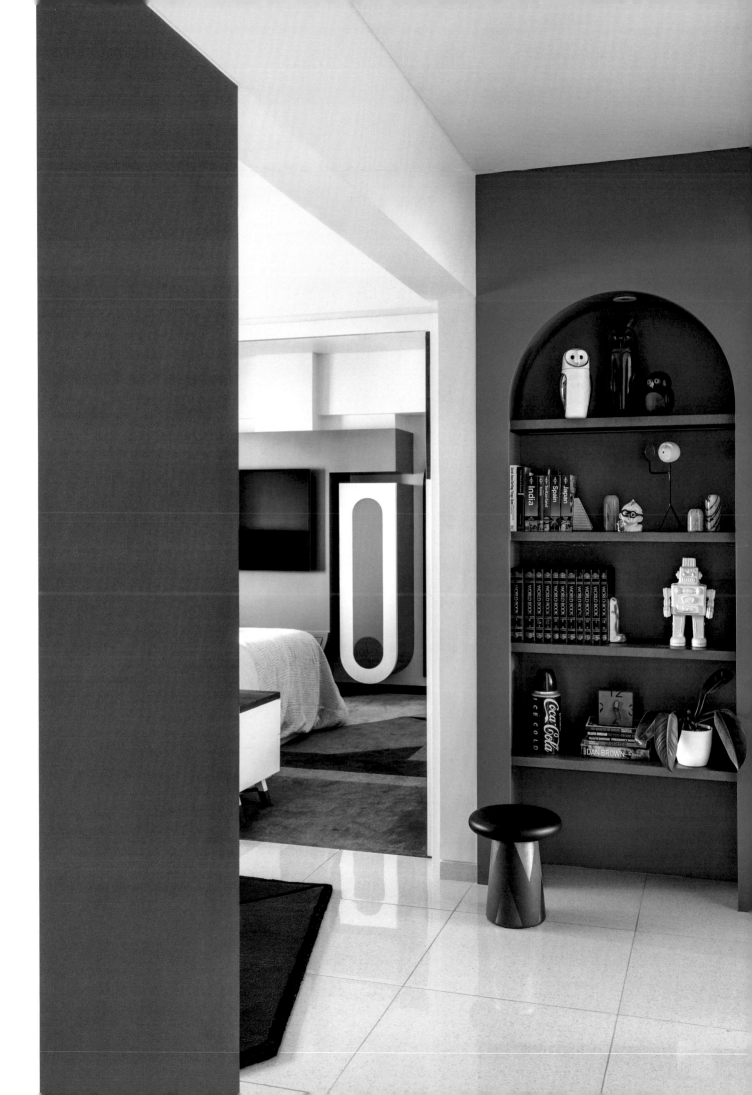

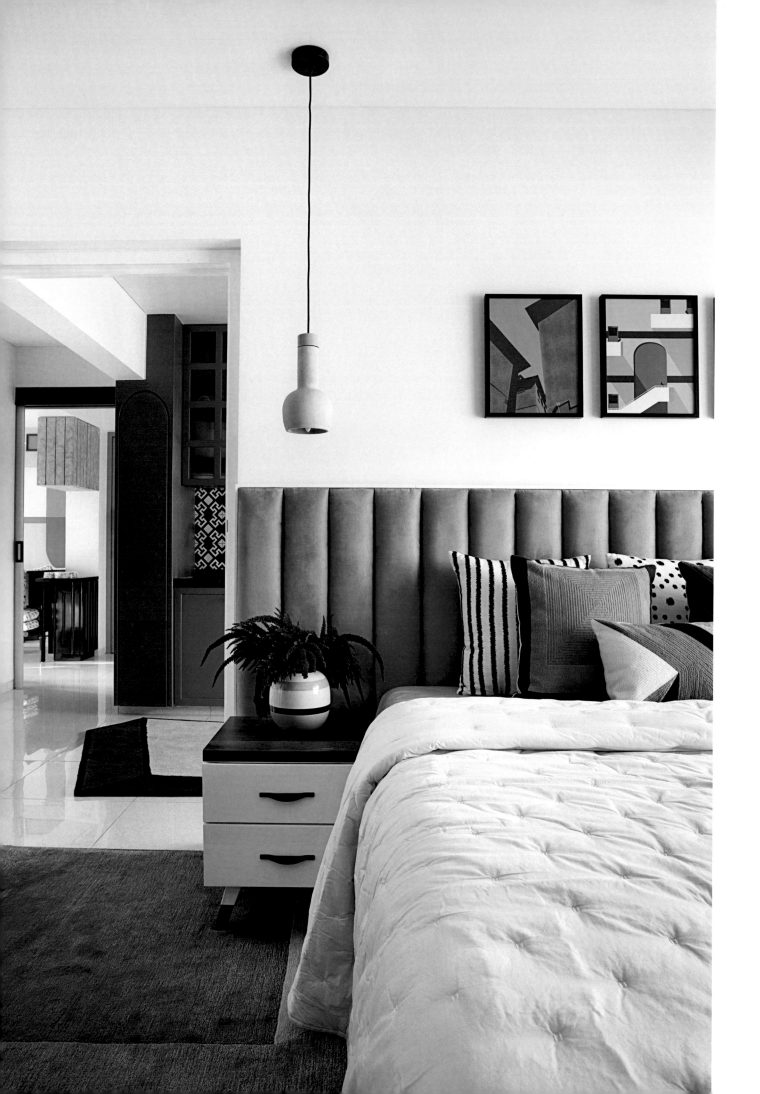

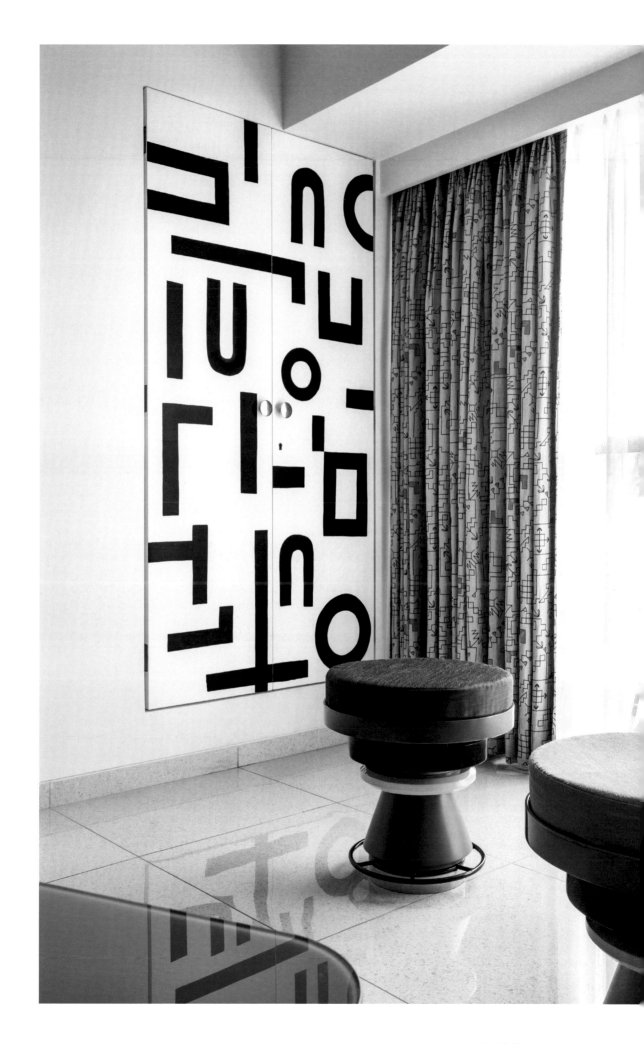

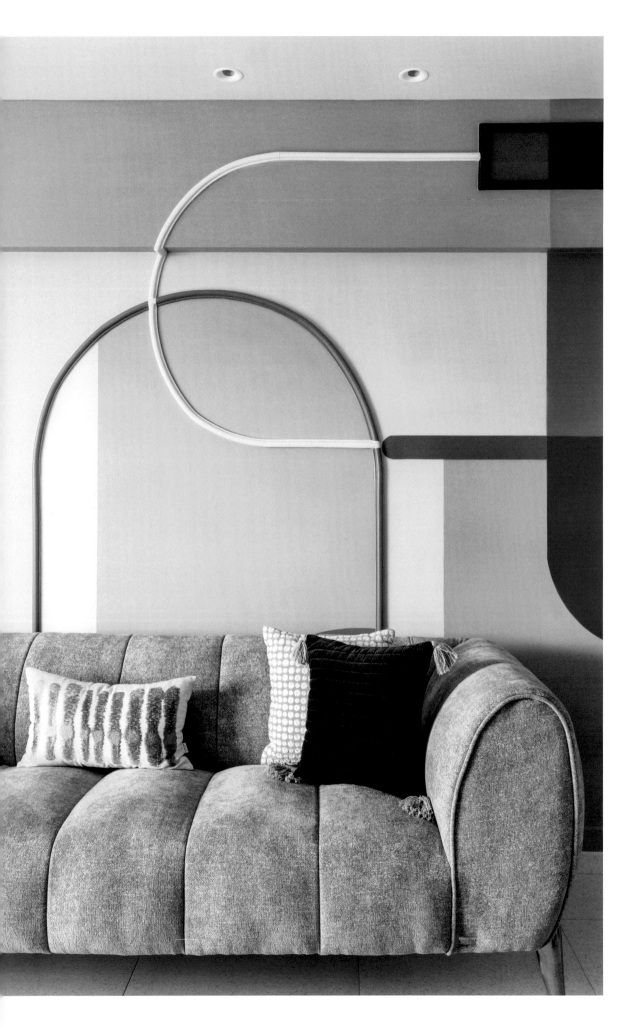

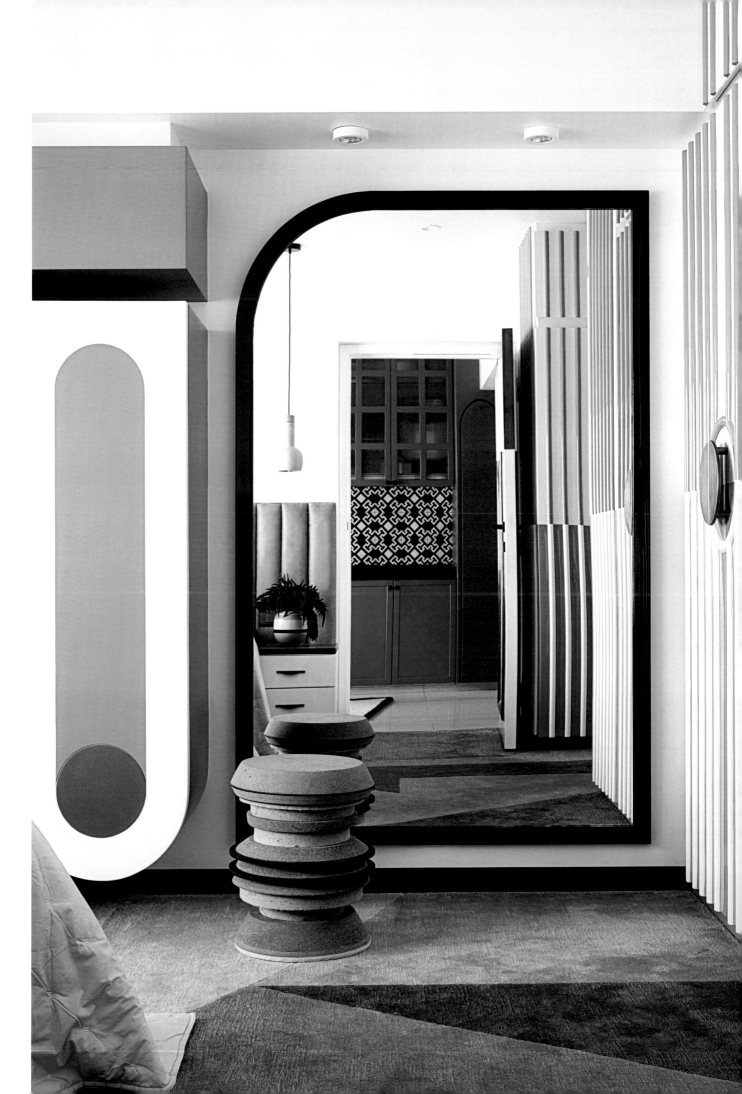

Organic Shapes, *Chunky Furniture,* and Pleasing Proportions

At the Uchronia showroom and home of its founder, Julien Sebban, a sofa by **Gaetano Pesce** is paired with a set of coffee tables and a prototype chair for a Japanese restaurant, both by **Uchronia.**

Ballooning sofas, chubby chairs, and all things puffy—a trend that's been on the rise since the late aughts can actually be traced back much further than that. In the 1940s, Finn Juhl's Pelican Chair was lambasted as looking like a "tired walrus." But something must have stuck, because those same oversized proportions have resurfaced repeatedly, especially in the 1970s and 1980s with the Memphis movement and the work of Gaetano Pesce. Nowadays, chunky furniture livens up living and dining rooms alike, their pillowy forms inviting bums to seats and smiles to faces.

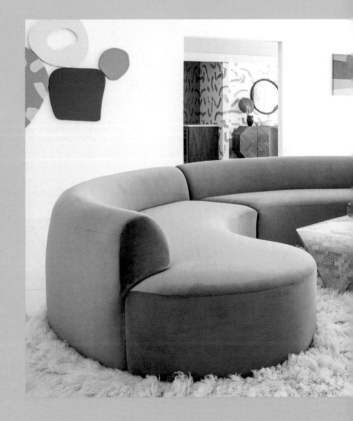

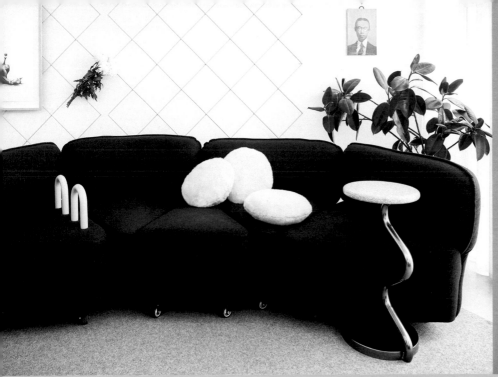

In this interior by **Sibling Architecture,** the modular sofa is not only inviting but also serves a specific function. Each segment has wheels and can easily be moved to make room for wheelchair users.

German designer **Swantje Hinrichsen's** former studio is filled with a smattering of joyful objects in a spectrum of pastel colors. Here a chunky lilac sofa is matched with a bright Bold Stool by **Moustache.**

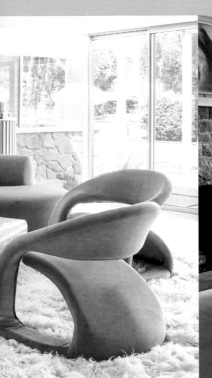

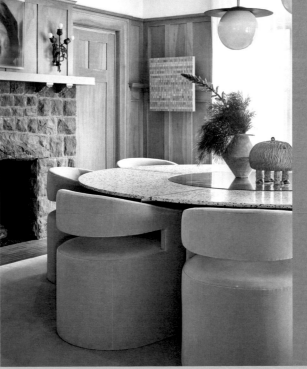

The coral-colored Chubby Sectional Sofa from **ModShop** upholds the home's 1970s vibe, not least of all in its placement atop a shaggy flokati rug scored on Etsy. The vintage blue Jaymar chairs are from **Chairish.**

The dining chairs at this Los Angeles residence are by **A. Rudin,** upholstered with Dedar cotton velvet. Their chunky silhouettes are teamed with a bespoke terrazzo-topped dining table.

A canary-yellow wall provides a perfect backdrop for the Balloon Sofa by Chinese furniture startup **ZaoZuo** at this Beijing residence designed by **MDDM Studio.**

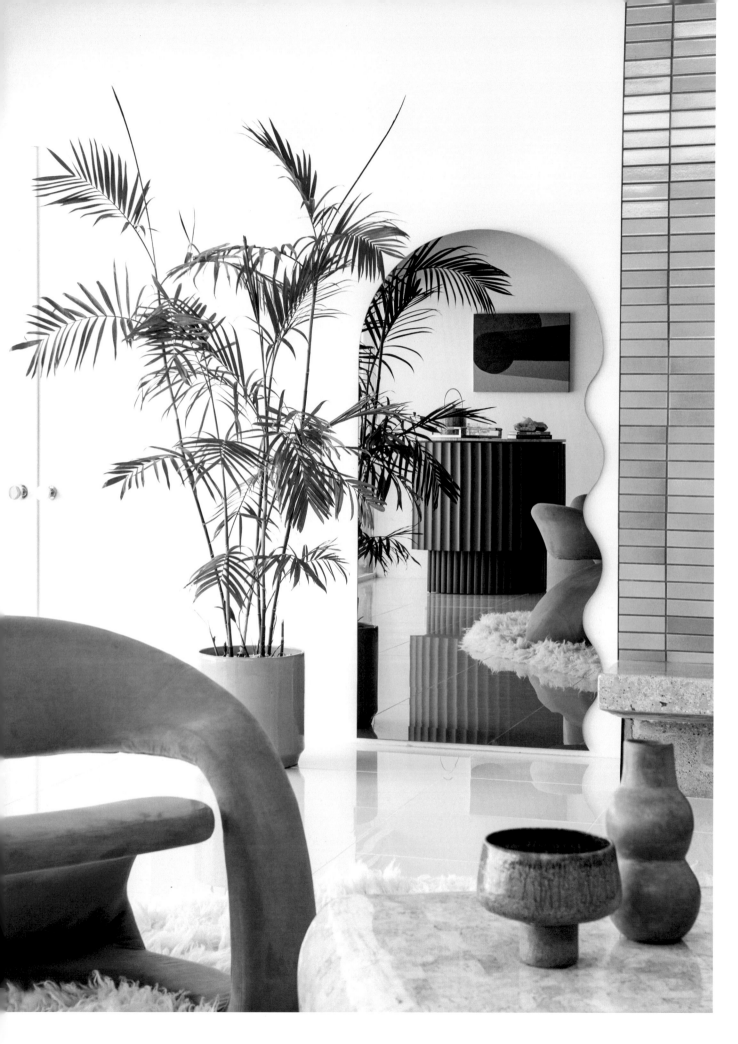

A Midcentury Refurb in Sunny California

Marrow Midcentury

Bells + Whistles

Rancho Mirage, CA, USA

There is no one single theme in this Californian dream home, but rather, the merging of several. Consider the living room, where, according to the designers, "surreal silhouettes and abstracting colors balance playful tendencies with a dreamlike sensibility." Or the second bedroom, "a Dalí-esque space-age dream." Filling a home with a multitude of imaginative themes is not easy to pull off, but even less so when it's not a blank canvas. The Marrow Midcentury home was designed by Donald Wexler as part of Thunderbird North, an enclave of homes designed by modernist architects William F. Cody, Donald Wexler, and Richard Harrison. The designers admit that working with an architecturally significant home can have a paralyzing effect. But the brief was clear: juxtapose the clean, sleek lines of Wexler's architecture against bold colors and organic shapes. The tidiest encapsulation of this, perhaps, is in the back garden: an angular, hexagonal pool filled with inviting murals by artist Alex Proba.

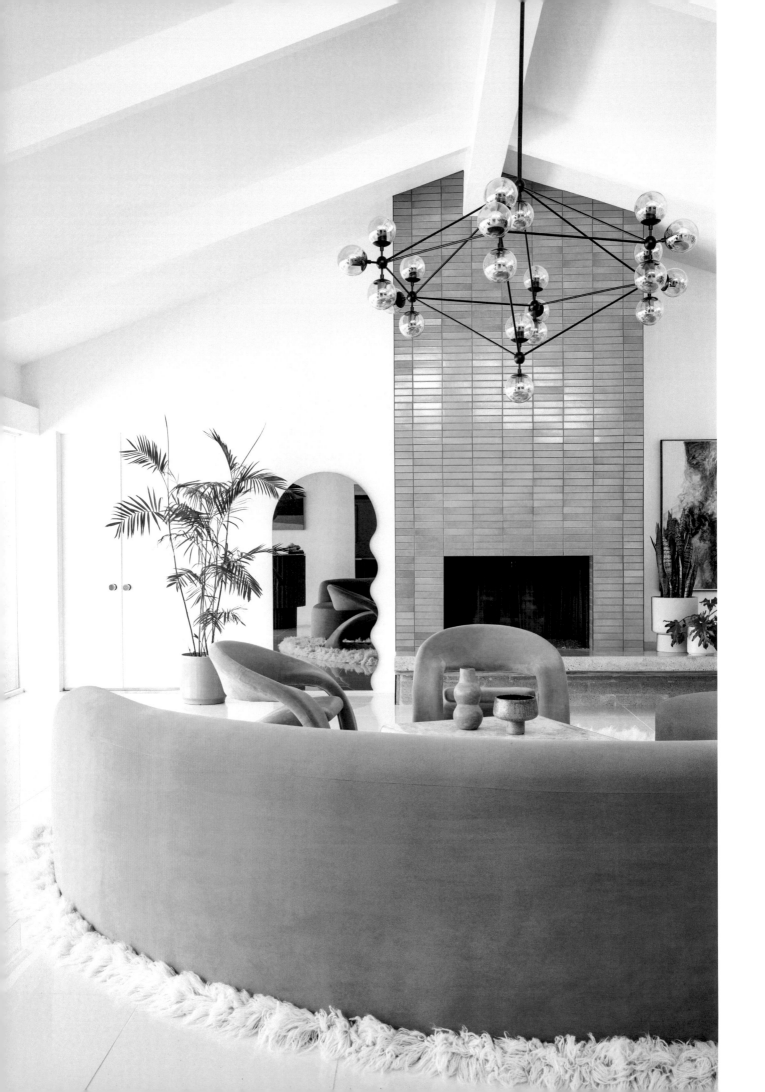

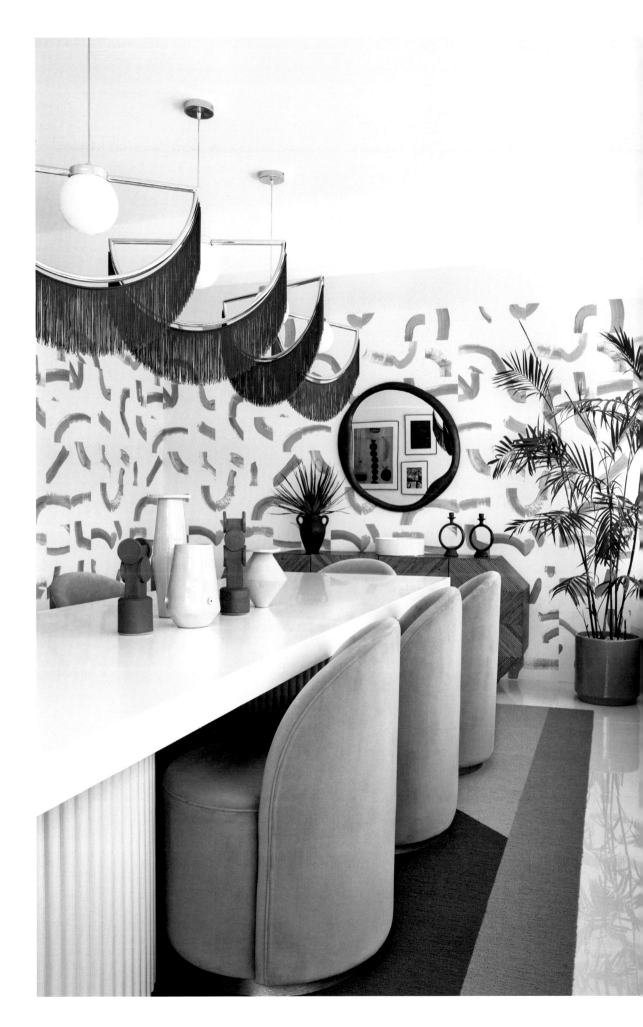

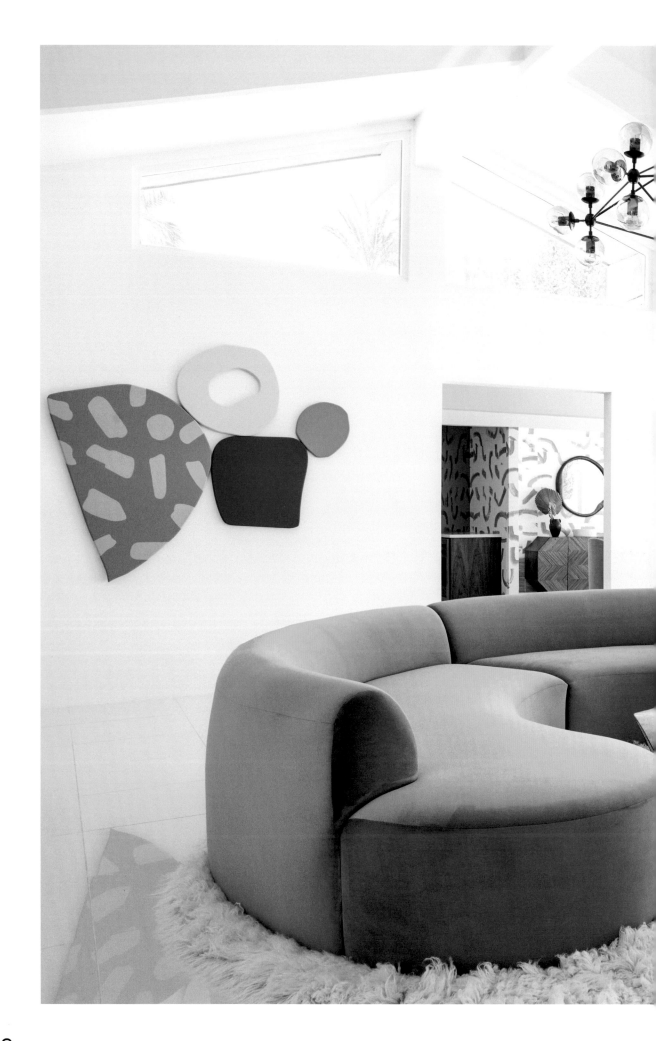

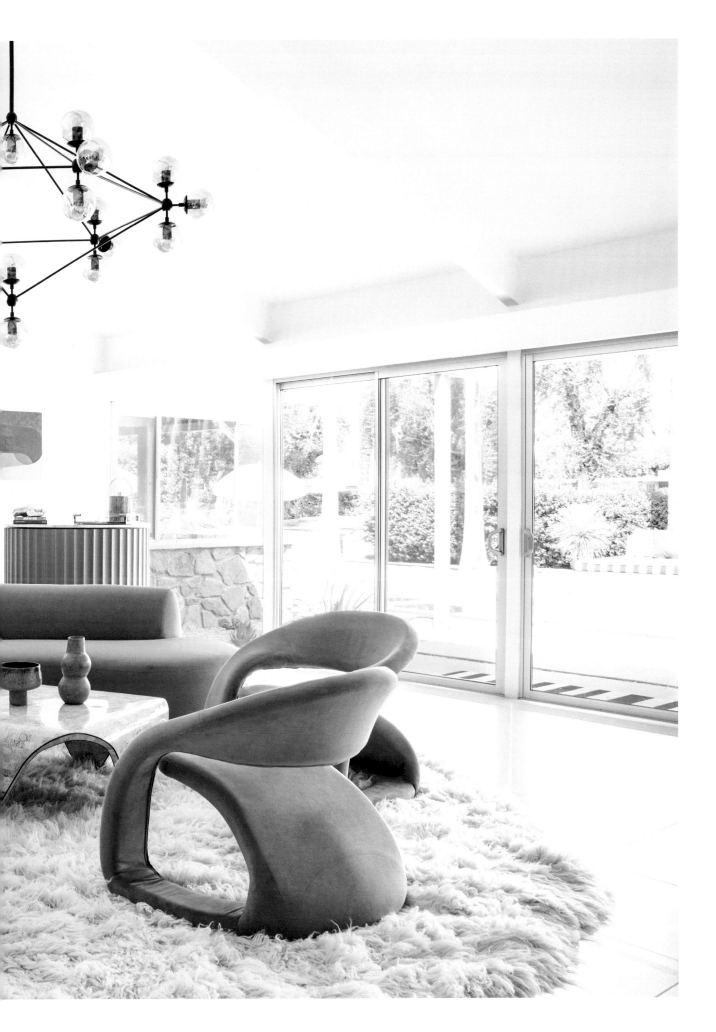

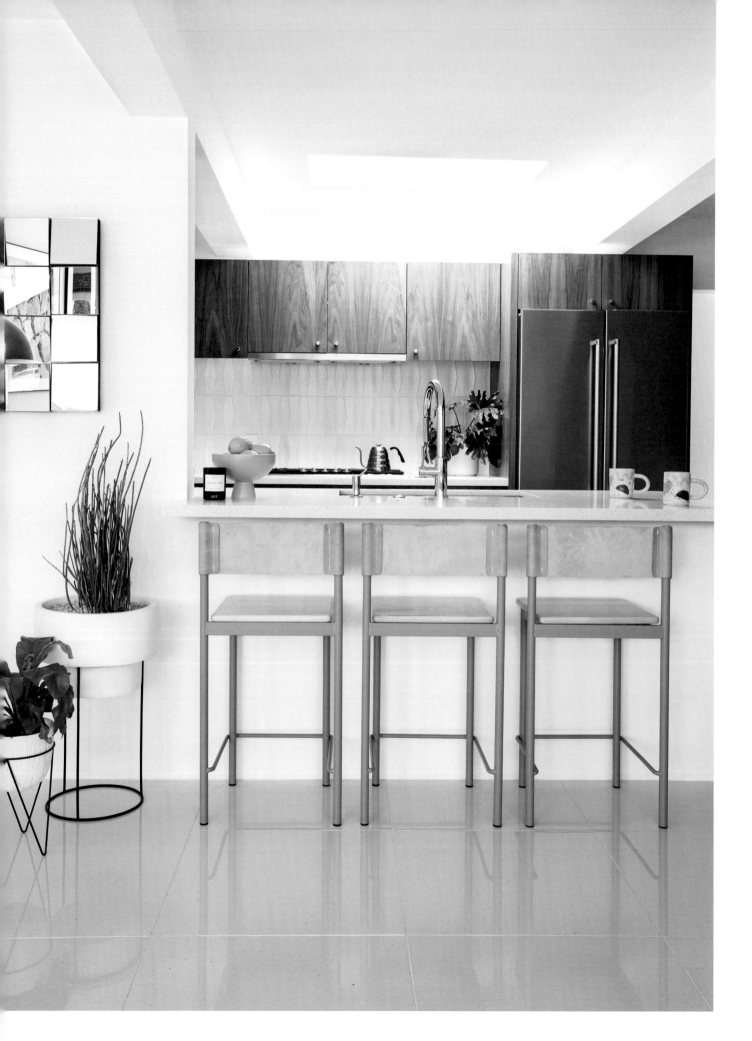

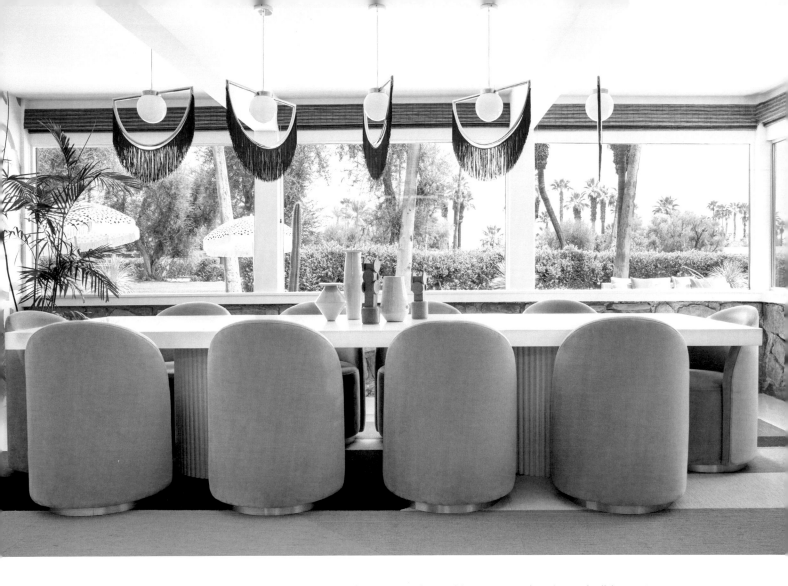

Until they found this home from 1957, the residents were planning to build a custom house from scratch. The dining chairs seen above are from ModShop, and the fringed lighting is from Manfredi Style. The disco ball hanging over the cactus garden was installed at the request of the residents' daughter.

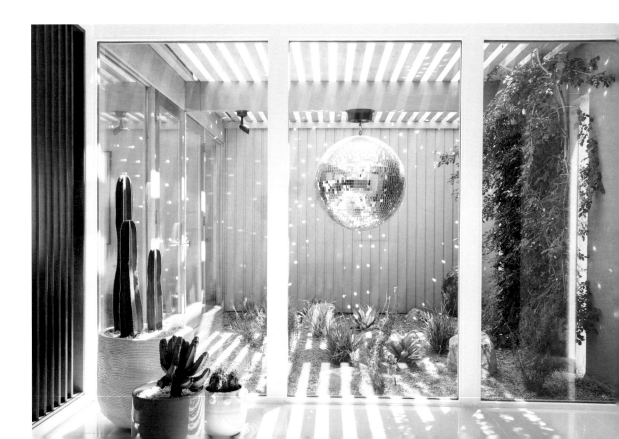

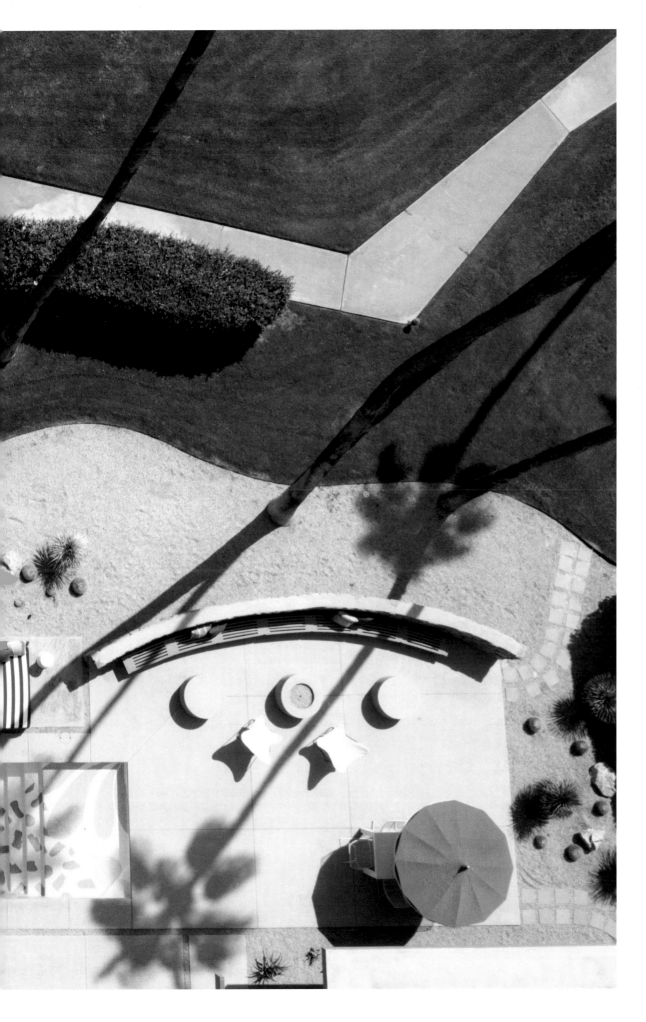

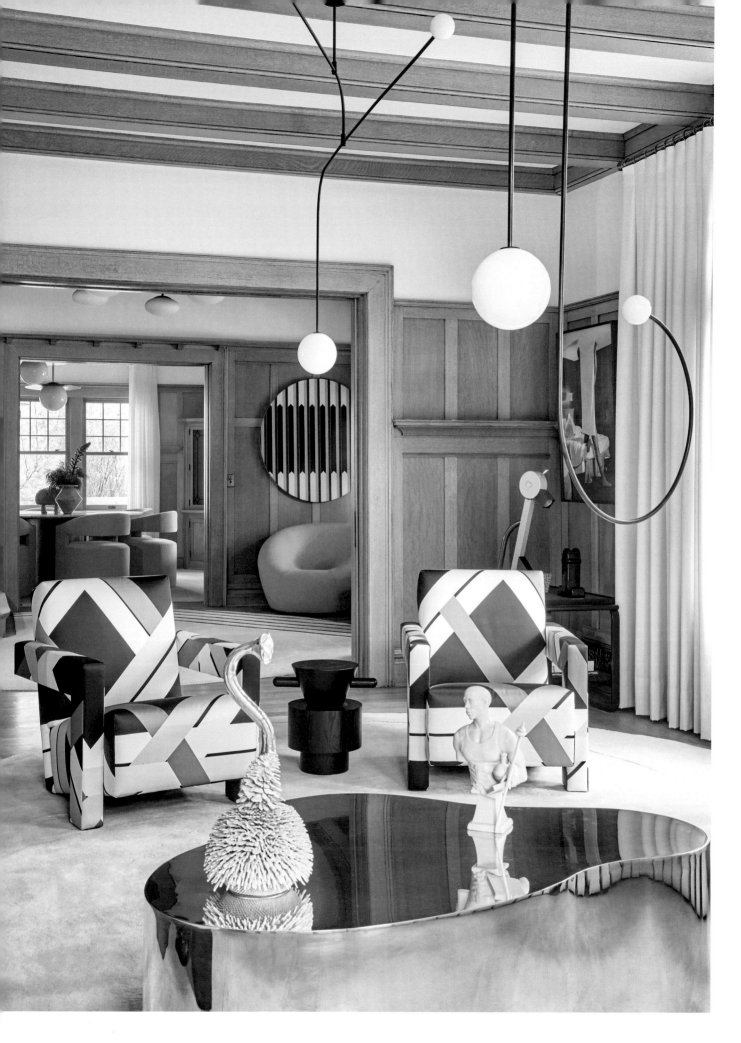

California Sunshine on the Inside and Out

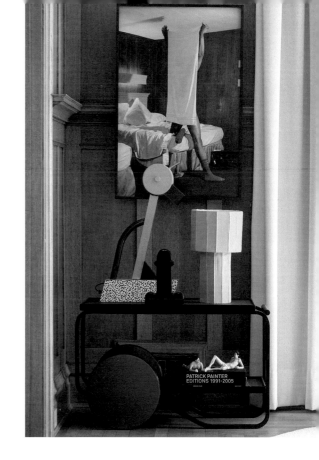

Cummings Estate

Ghislaine Viñas
and Chet Callahan

Los Angeles, CA, USA

At 120 years old, Cummings Estate is among the oldest residences in the Los Feliz area of Los Angeles. But despite its age, not every aspect of it was worth saving. The style is, according to the architect, "quasi-craftsman," with Spanish influences and elements from other styles. As a whole, there were a few poor choices that the architect, who now lives in the home with his husband and their two sons, felt didn't need to be maintained. On the bright side, a number of the building's details, including the original woodwork, were intact enough for the interior designer, Ghislaine Viñas, to integrate them into the home's overall narrative. The result playfully clashes old and new, particularly with a two-story, glass and terrazzo addition. Each room tells its own tale, articulated through colorful accents, chunky furniture, and an especially impressive art collection. Viñas's own furniture designs can be seen throughout the home, notably a mint breakfast table with a perforated base and scalloped console.

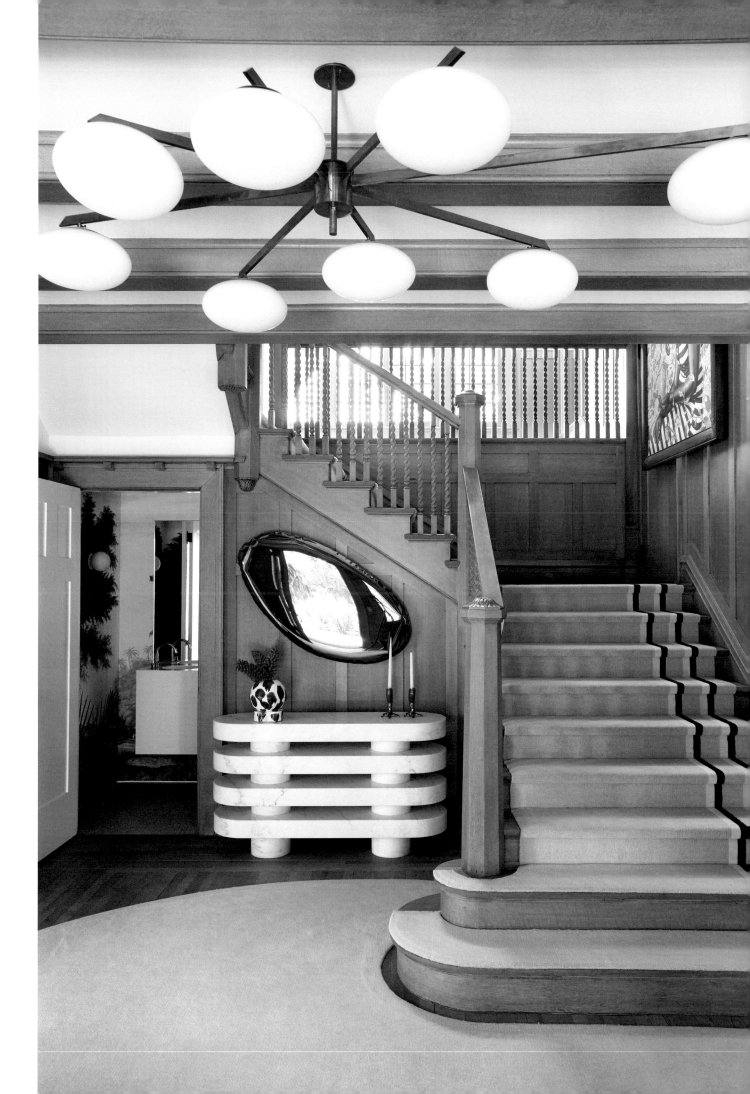

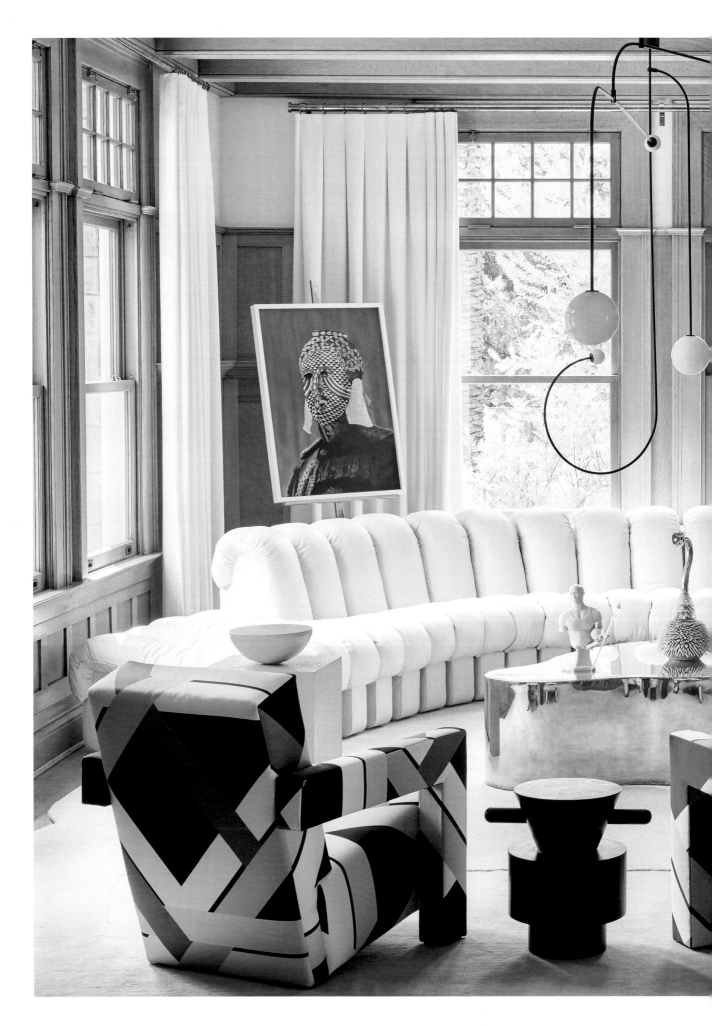

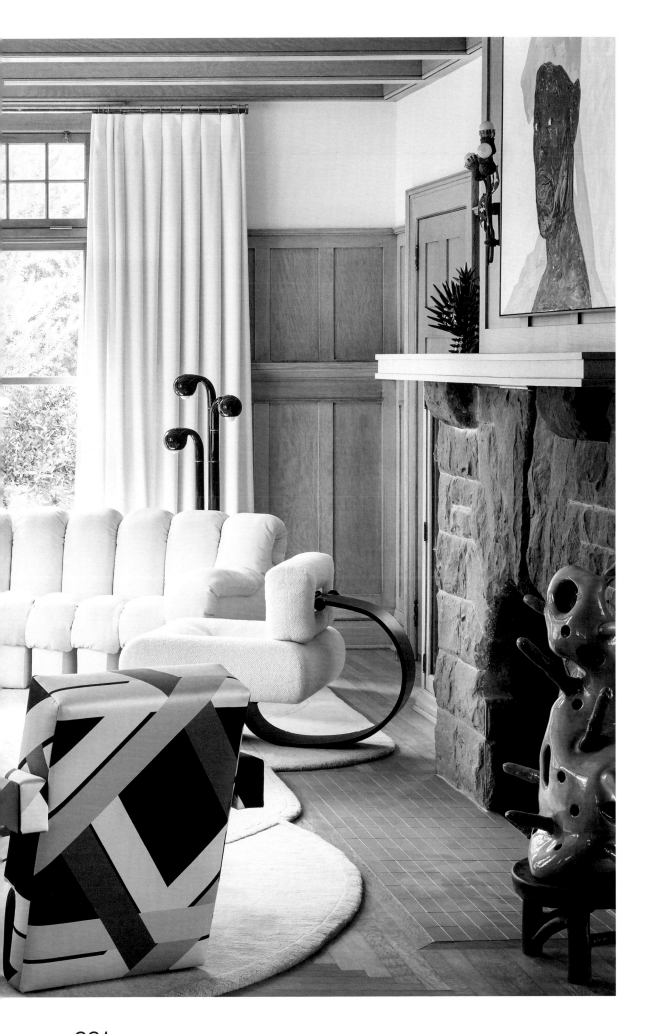

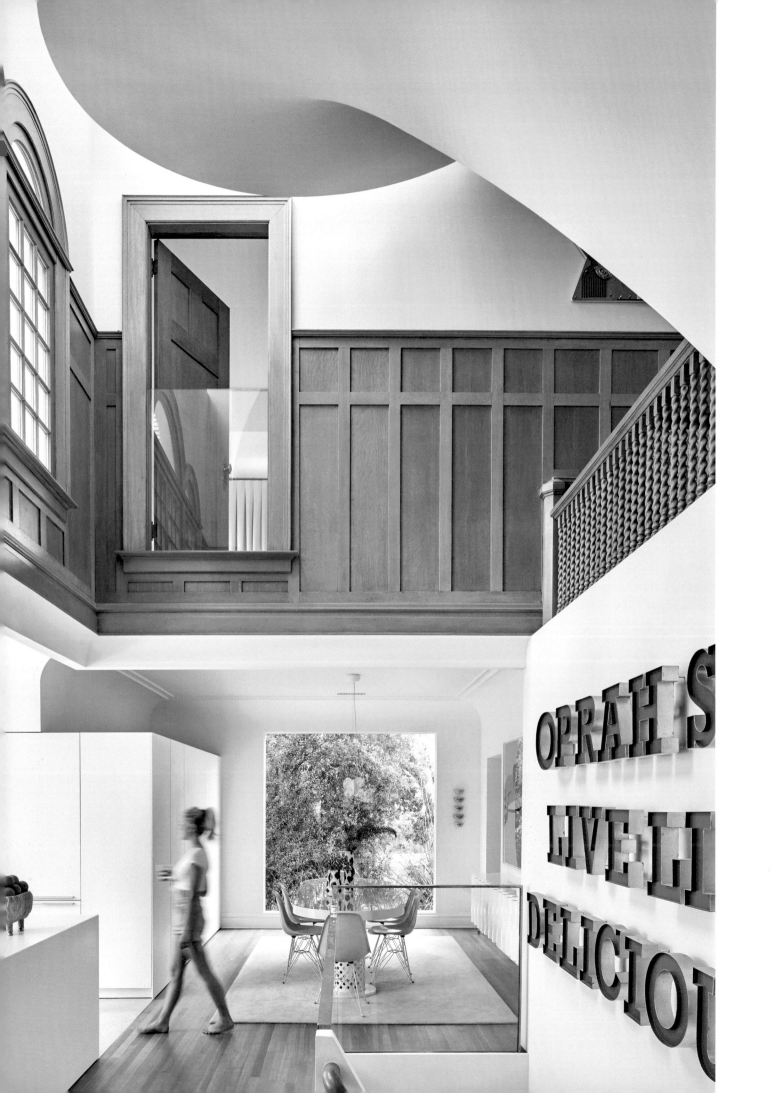

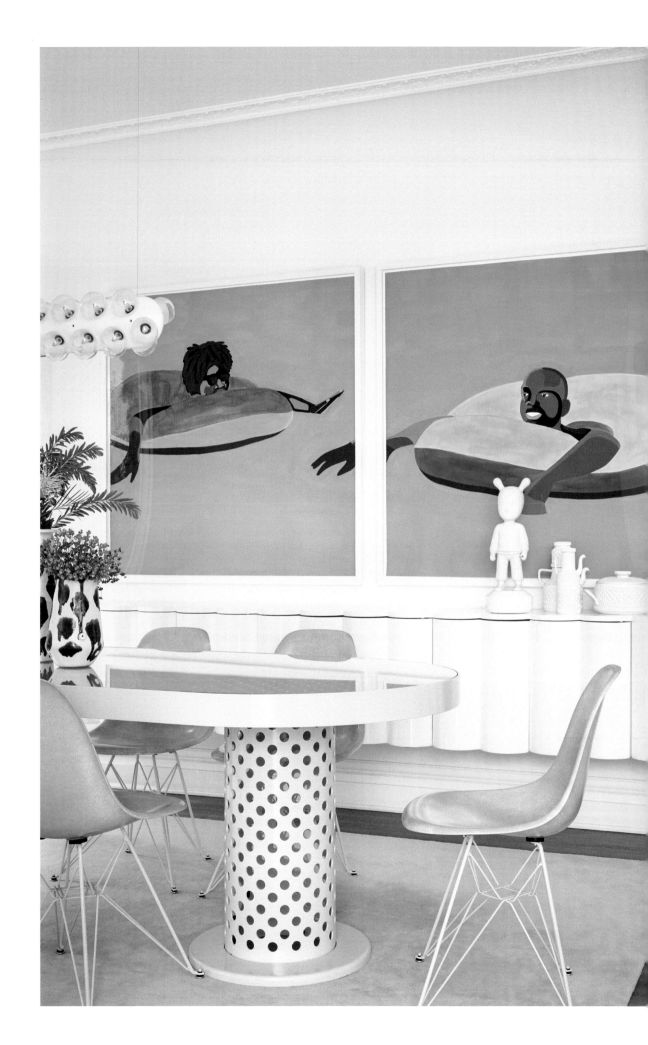

223

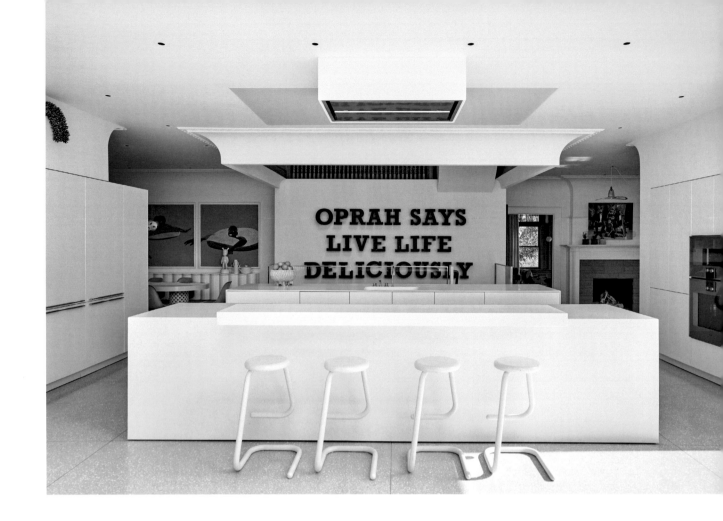

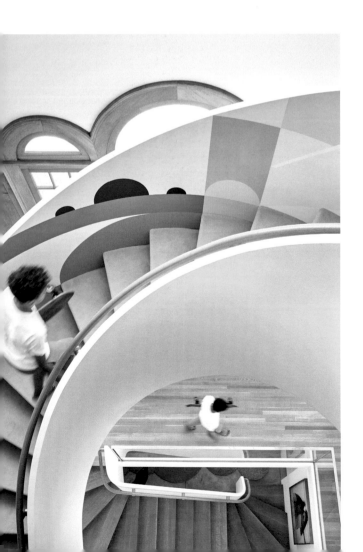

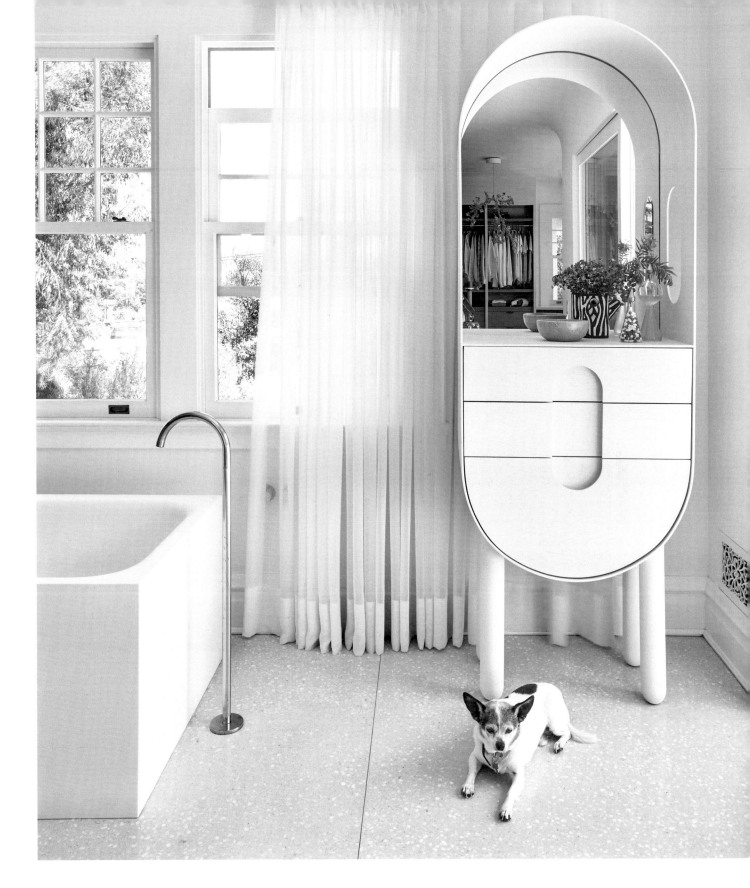

This home takes Murphy's Law and flips it on its head: anything that can be joyful, will be joyful. That's especially true for the winding staircase, which was painted with bright patterns by artist Adrian Kay Wong. In the kitchen, an uplifting artwork by Brett Murray sets a positive mantra, while playful words also illuminate the tropical powder room.

An Exuberant Home Full of Period Details

Nob Hill Home

Jonathan Adler

San Francisco, CA, USA

A bright blue bust of a giraffe, geometric color-block trays, and a porcelain vase shaped like a hand holding an ice-cream cone are just some of the many pieces that prove Jonathan Adler is no stranger to exuberant design. But as bountiful as his products might be, he tends to stay away from decorating. This home in San Francisco, paired with two wonderful clients, won him over. He was entrusted to transform a 1915 house into a fun and unexpected home that reflects the clients' jovial spirit. Adler's first move was to coat the home in a crisp layer of white paint. The result: period details feel strikingly modern, and Adler's vibrant furniture choices—from his own designs to designer pieces by Gio Ponti, Verner Panton, and Jindrich Halabala—pop against the white backdrop. Splashes of color articulate the space: patterned curtains are paired with a mossy green carpet and midnight-blue sofa in the sitting room, while a bold blue stairway stands out beside a round, pink settee. Adler's interior decoration projects may be few and far between, but they certainly are worth the wait.

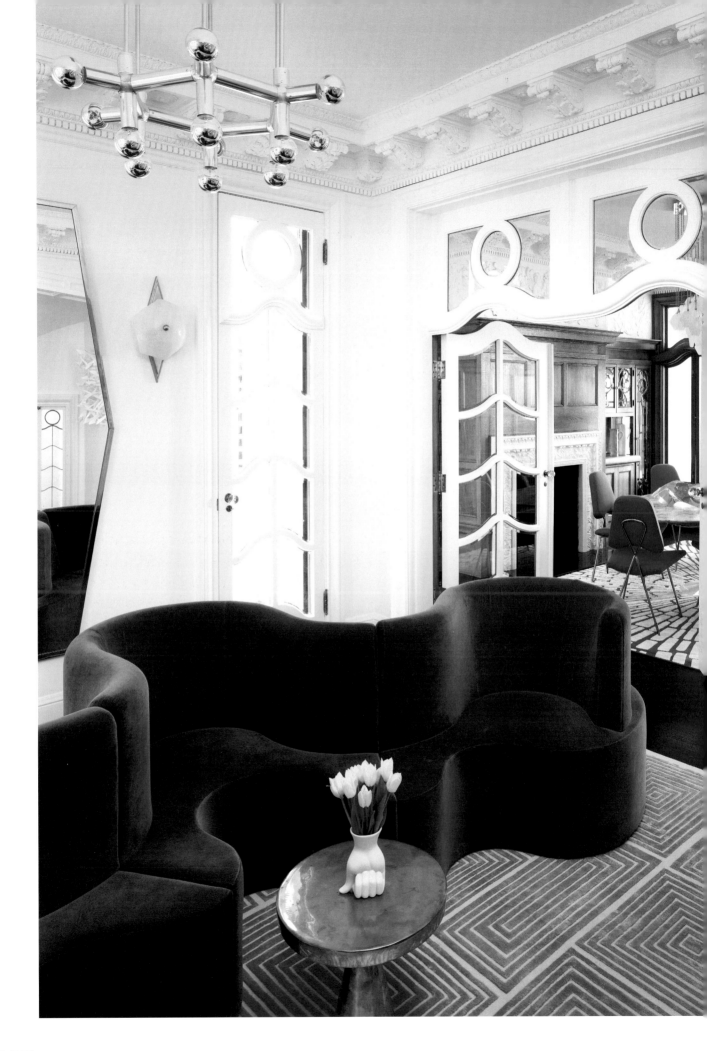

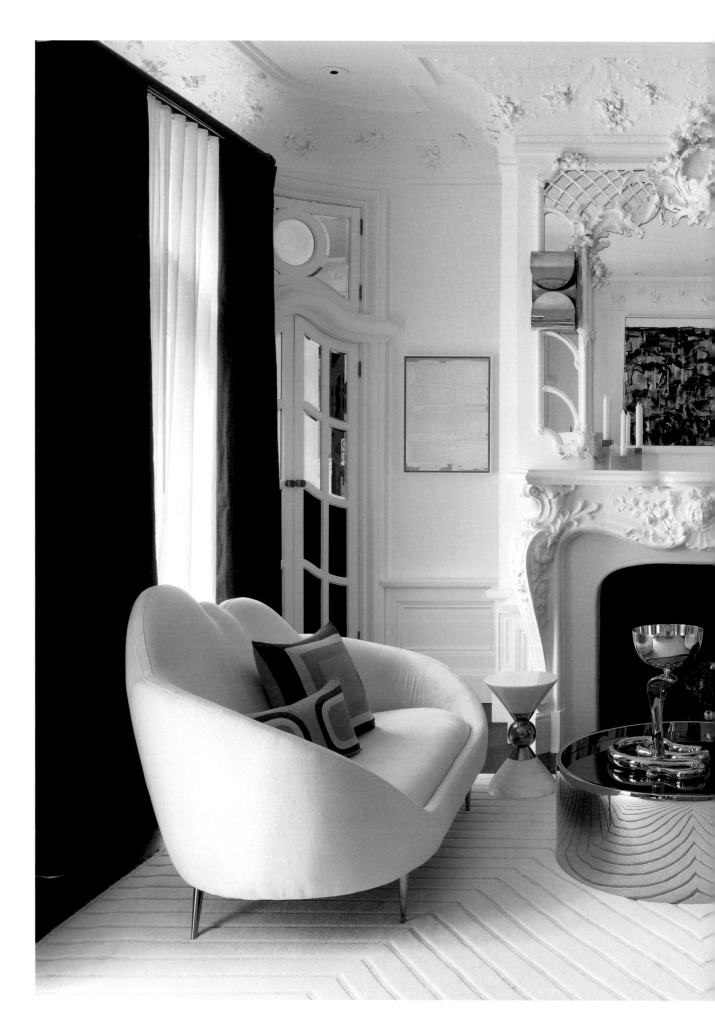

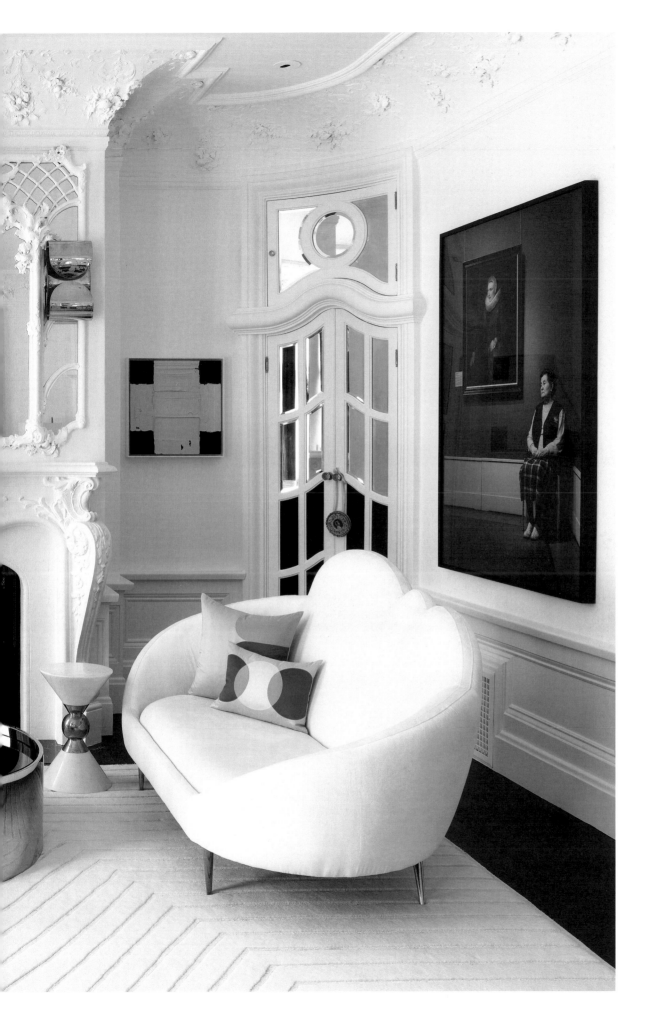

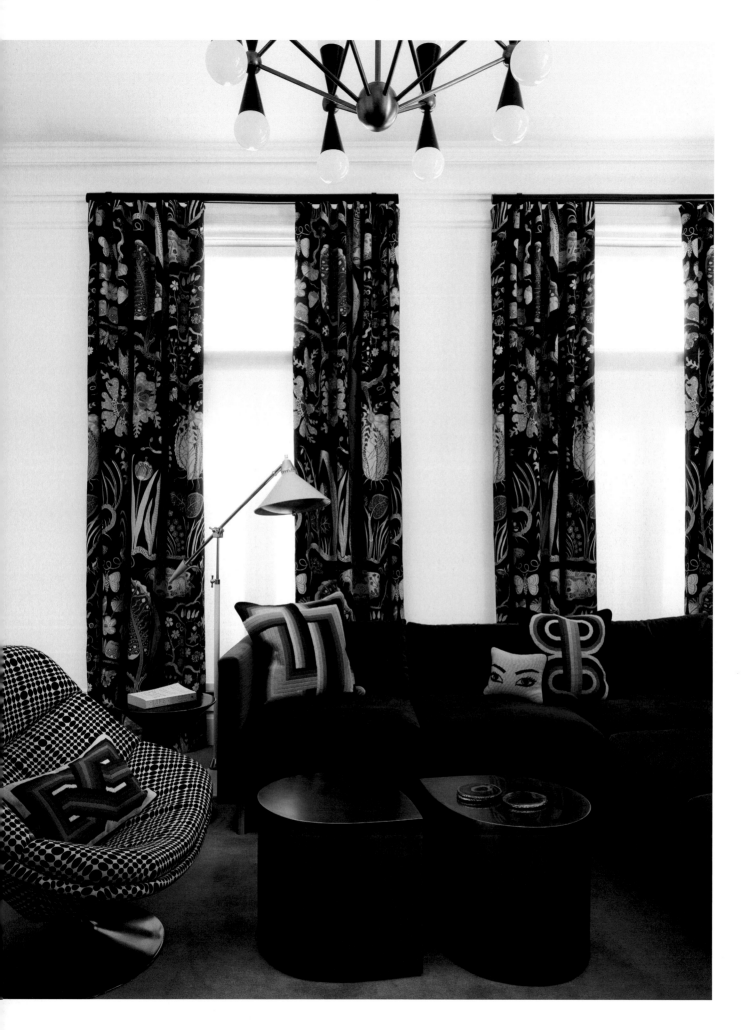

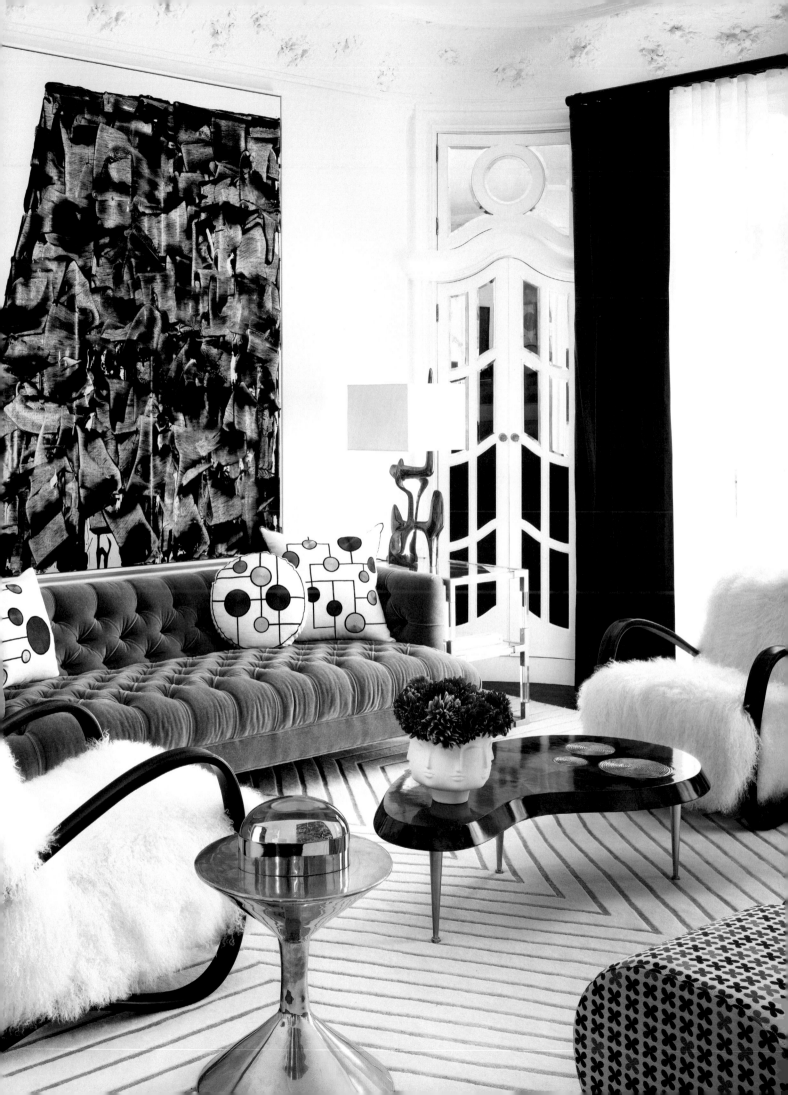

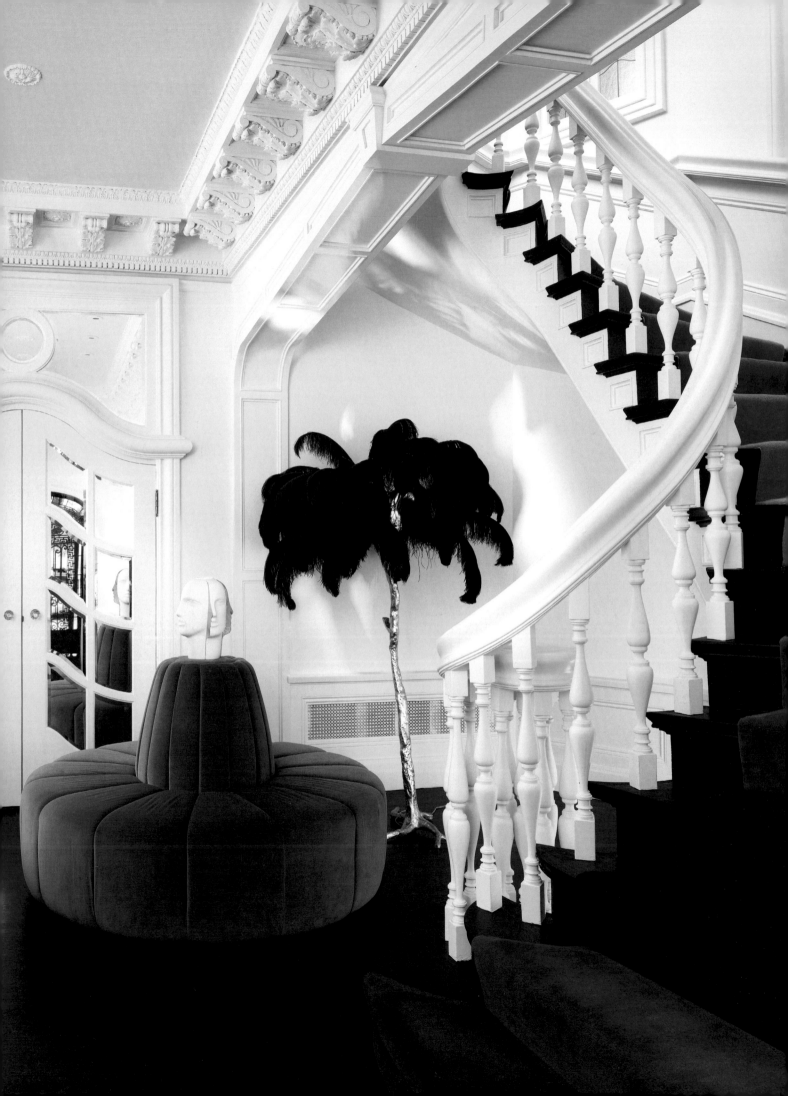

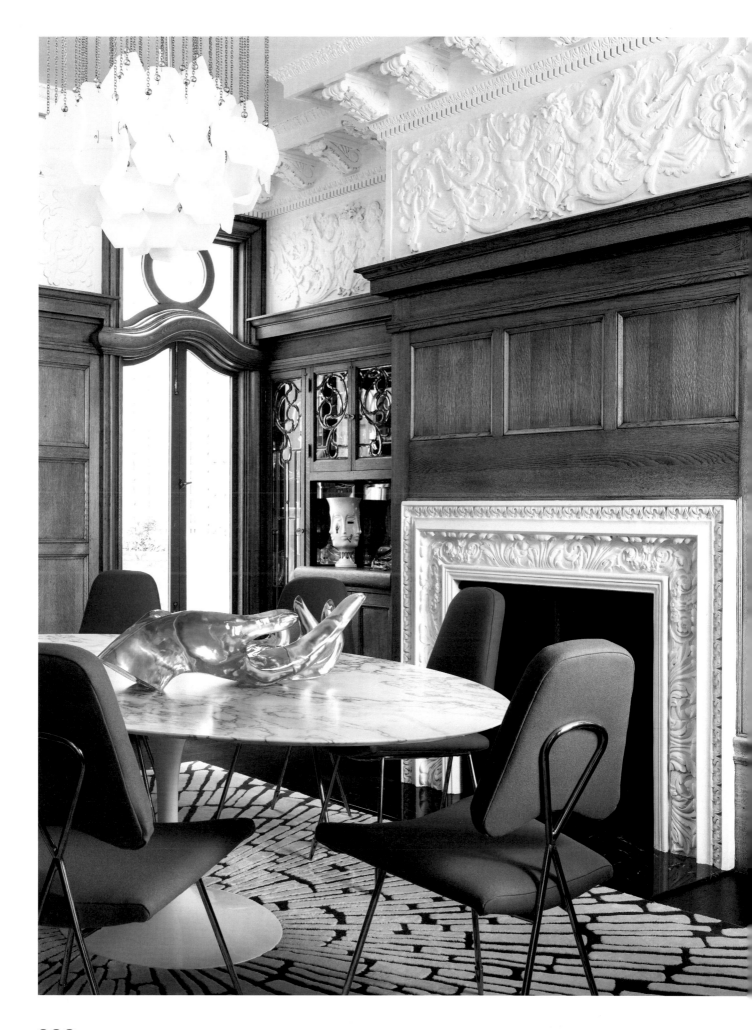

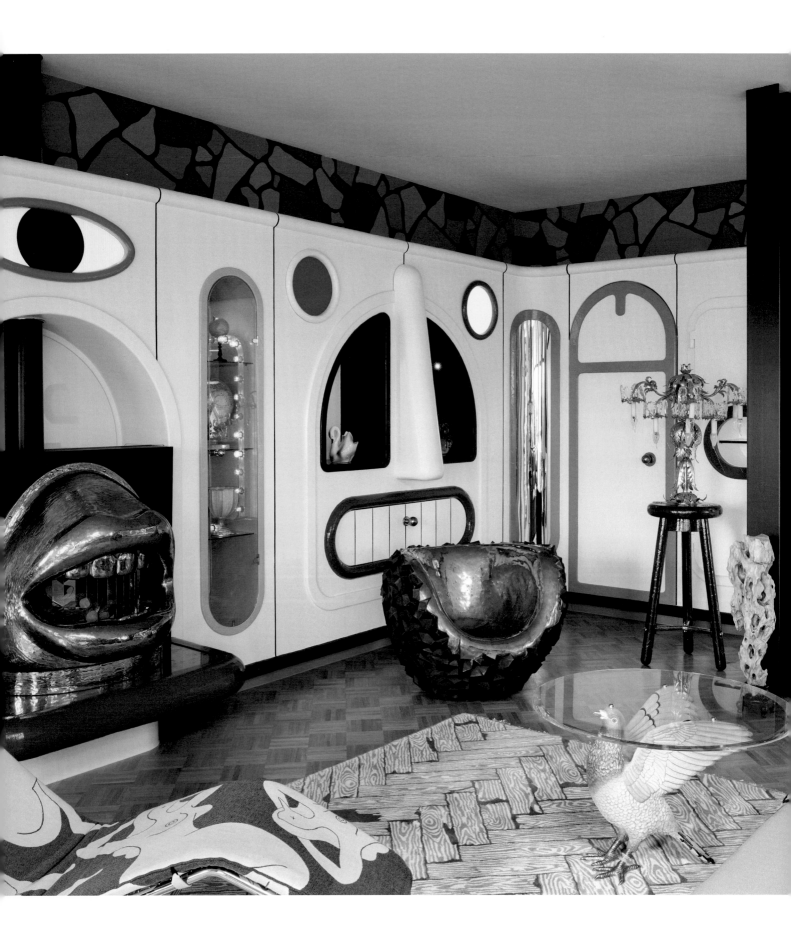

Chaos and Perfection in Equal Measure

Rolf Snoeren's Penthouse

Studio Job

Amsterdam, Netherlands

Few words do justice to the work of Studio Job, whose design pieces include a lamp in the shape of a seductively reclining banana and a hamburger-shaped chair. "Extraordinary" is one. "Bonkers" is another. So when founder Job Smeets was enlisted to design a penthouse for his friend, the avant-garde fashion designer Rolf Snoeren of Viktor & Rolf, the result could only be a perfectly executed chaos. The wall storage has faces; the fireplace has teeth. There are naked ladies lounging on a chaise longue (the upholstery is a custom-made fabric by Piet Parra), there's a mirror in the shape of a frying pan, and a porcelain axe on the wall. There is art absolutely everywhere. This apartment, with its kaleidoscopic rugs and its crazy-paving wallpaper, is what happens when a designer like Smeets has carte blanche. Smeets was quoted by *Architectural Digest* in reference to this penthouse, claiming "not everybody needs to live in a modernist white box." Not everybody needs to grow up either, and this apartment is all the proof we need.

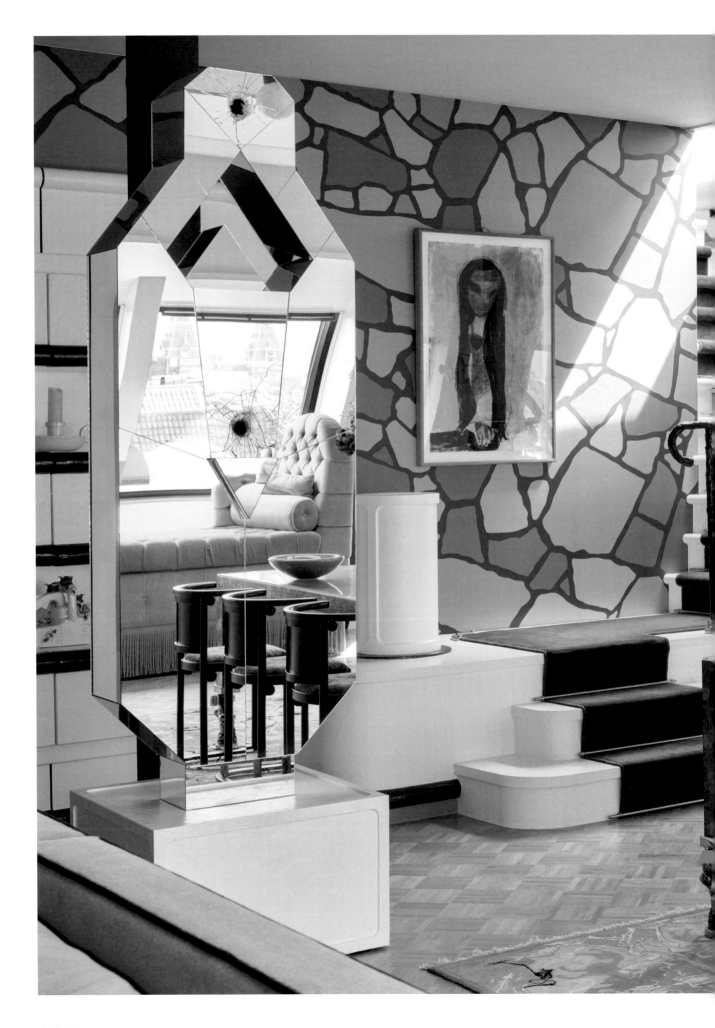

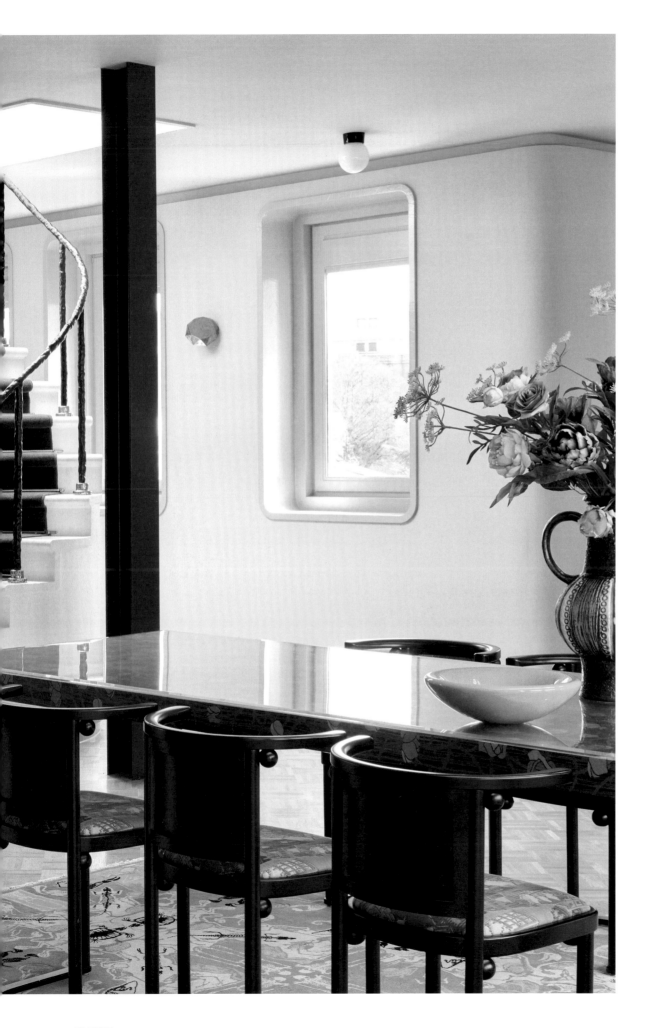

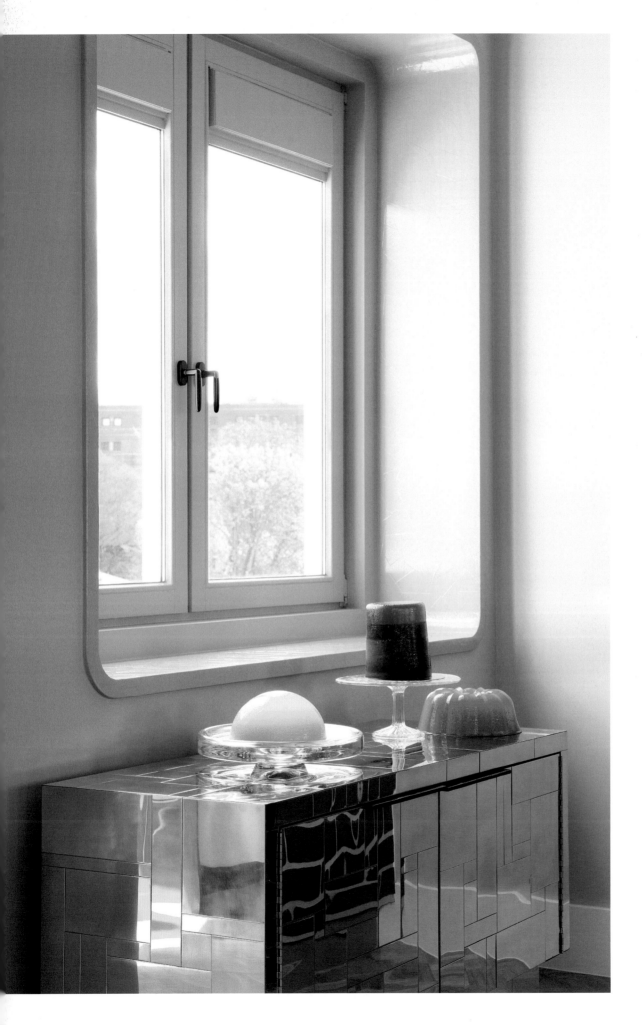

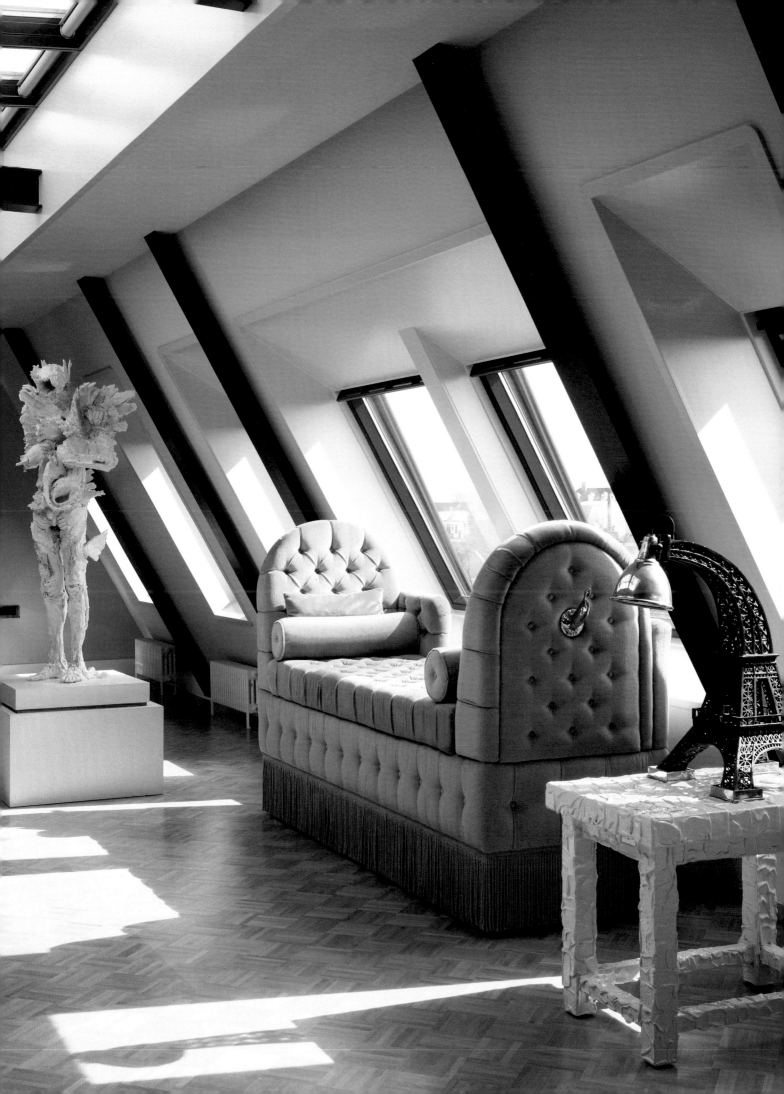

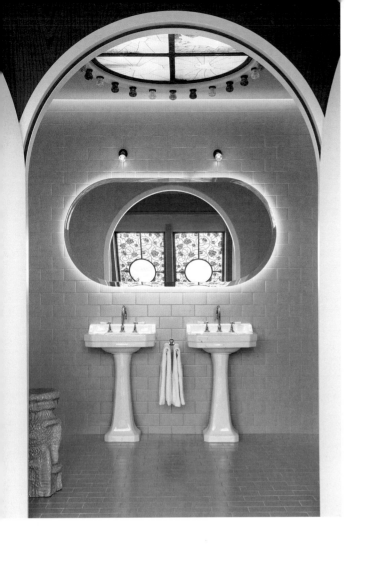

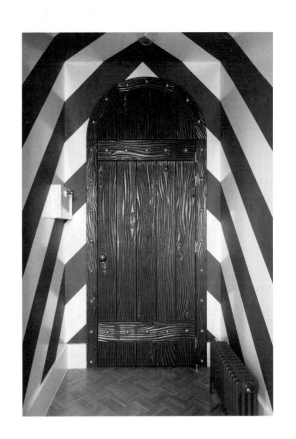

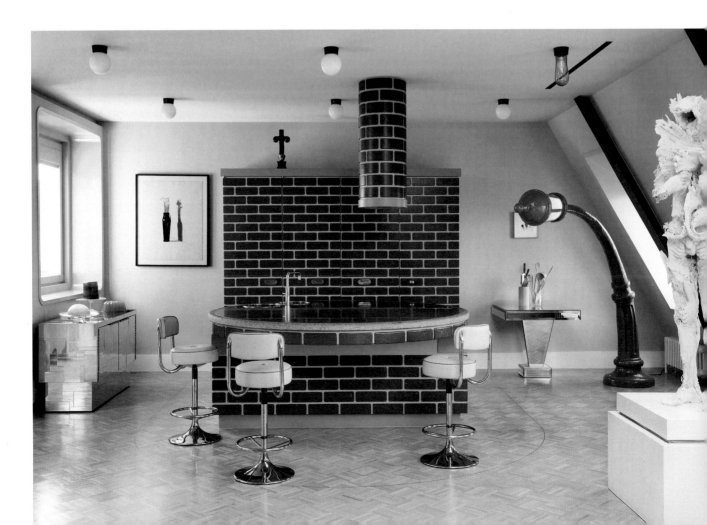

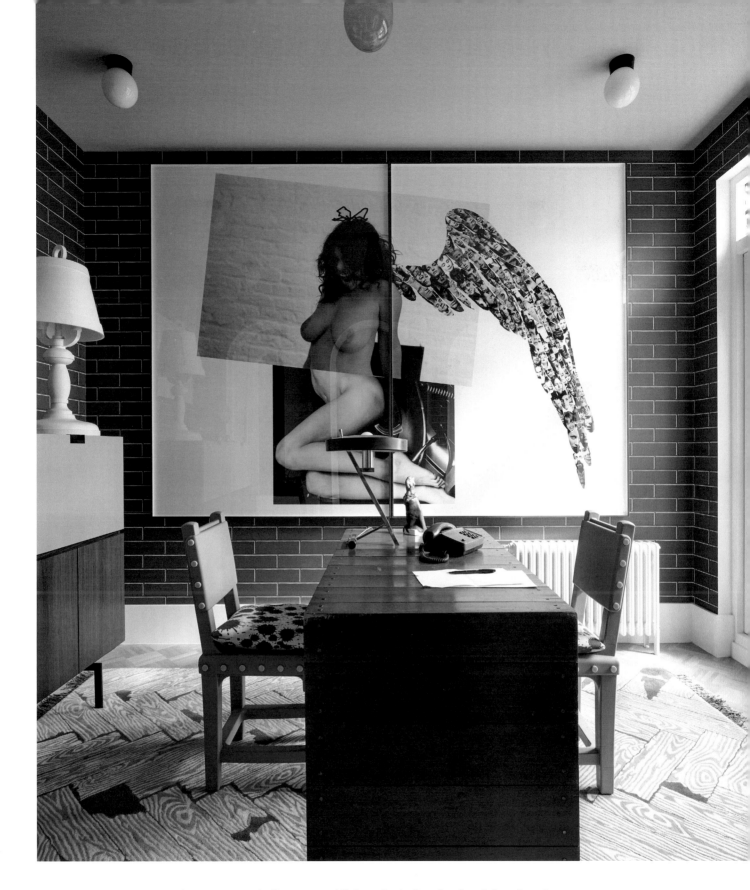

The home includes several custom-made fixtures and fixings, including the ring-light mirror in the bathroom (above left). In the kitchen, seen on the left, an artwork by David Hockney hangs beside brick-style kitchen cupboards, its cartoonish quality echoed by the toy-like entrance to the apartment. In the home office, pictured right, an artwork by Inez van Lamsweerde and Vinoodh Matadin hangs above a vintage desk.

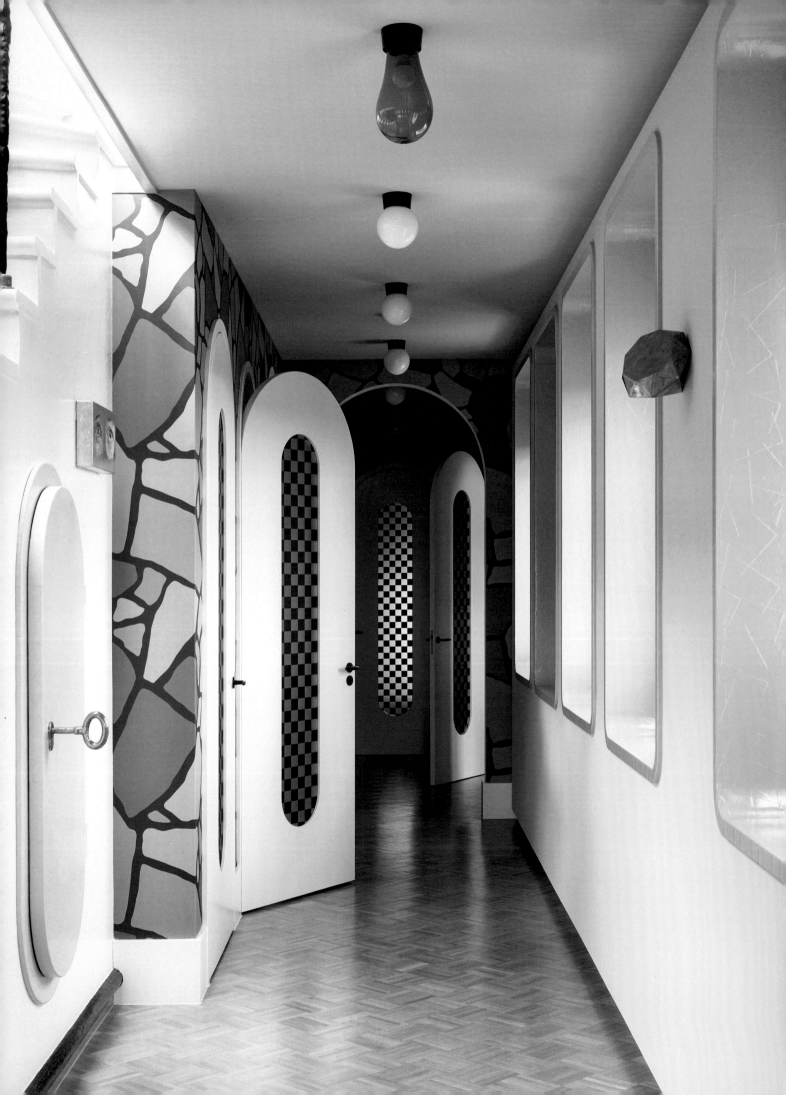

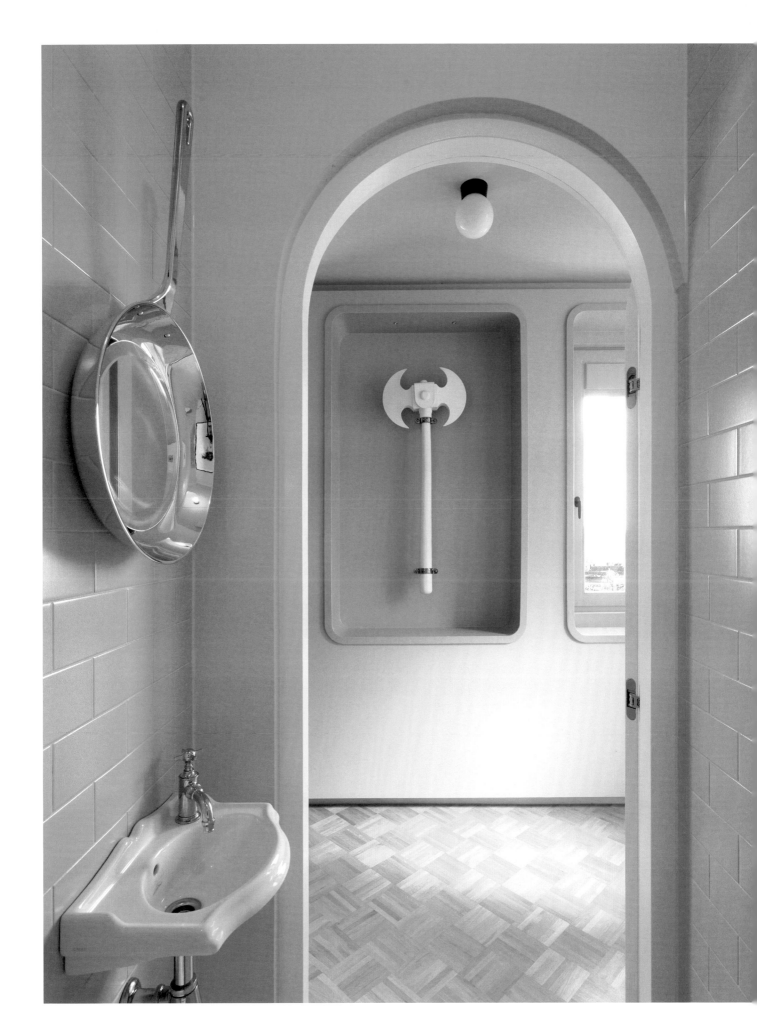

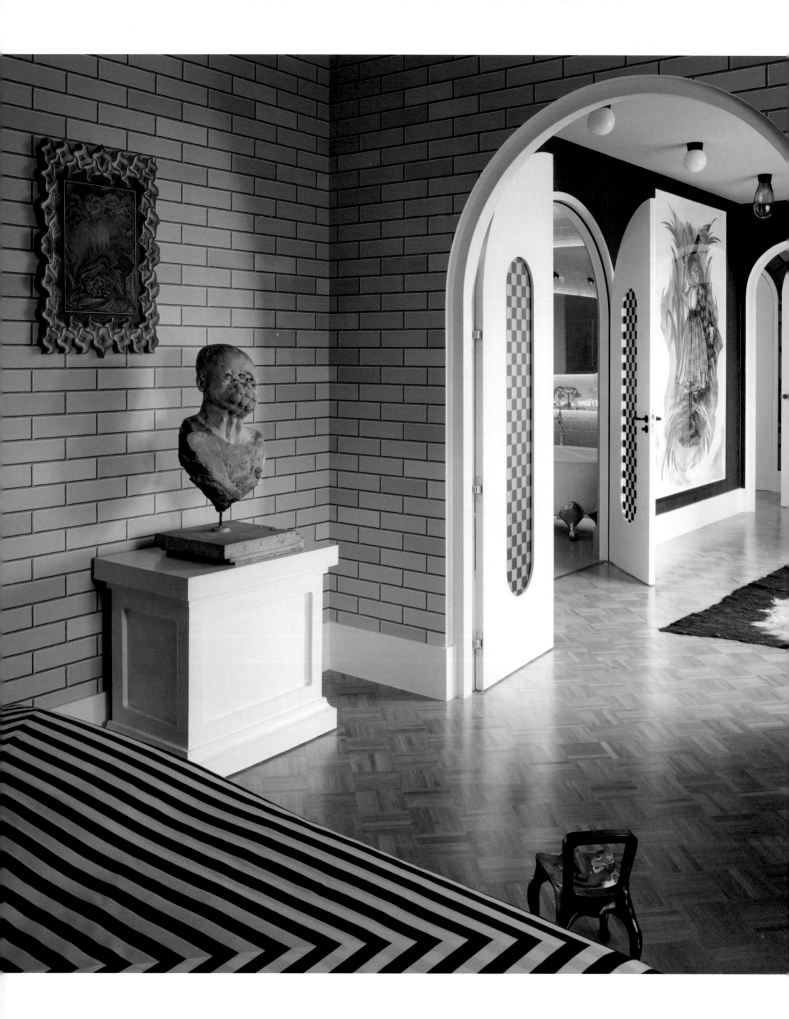

Rolf Snoeren's Penthouse

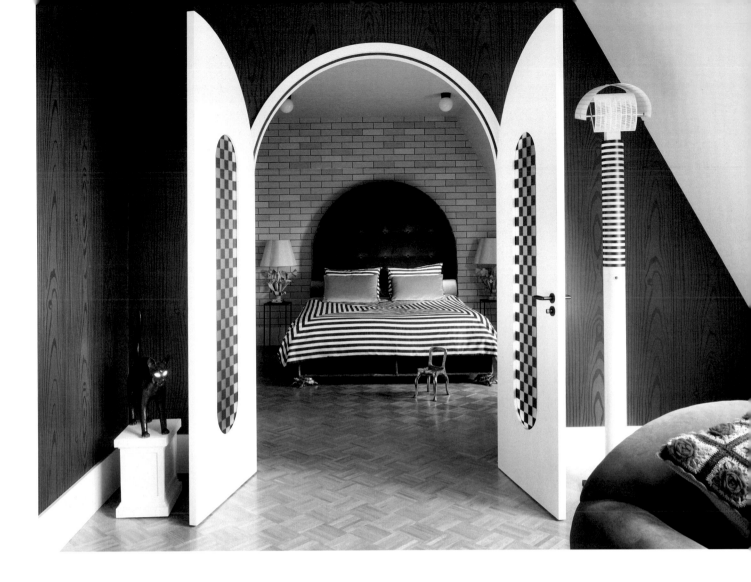

Arches frame the doorways throughout the home, as seen on this spread. The bed is a custom-made Treca de Paris, with bronze-turtle feet by Studio Job. The miniature bronze chair at the foot of the bed is also by Studio Job, as is the faux-wood wallpaper seen in both images on the right.

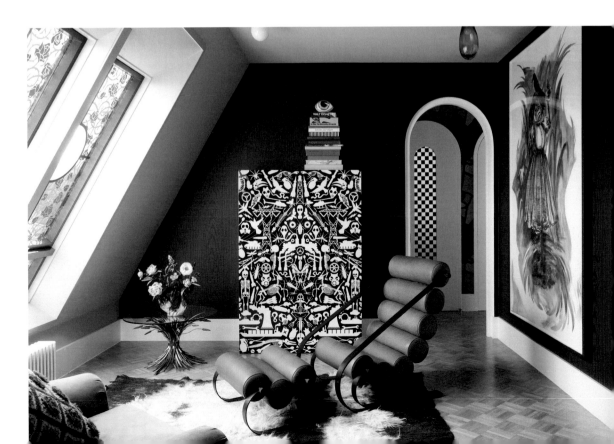

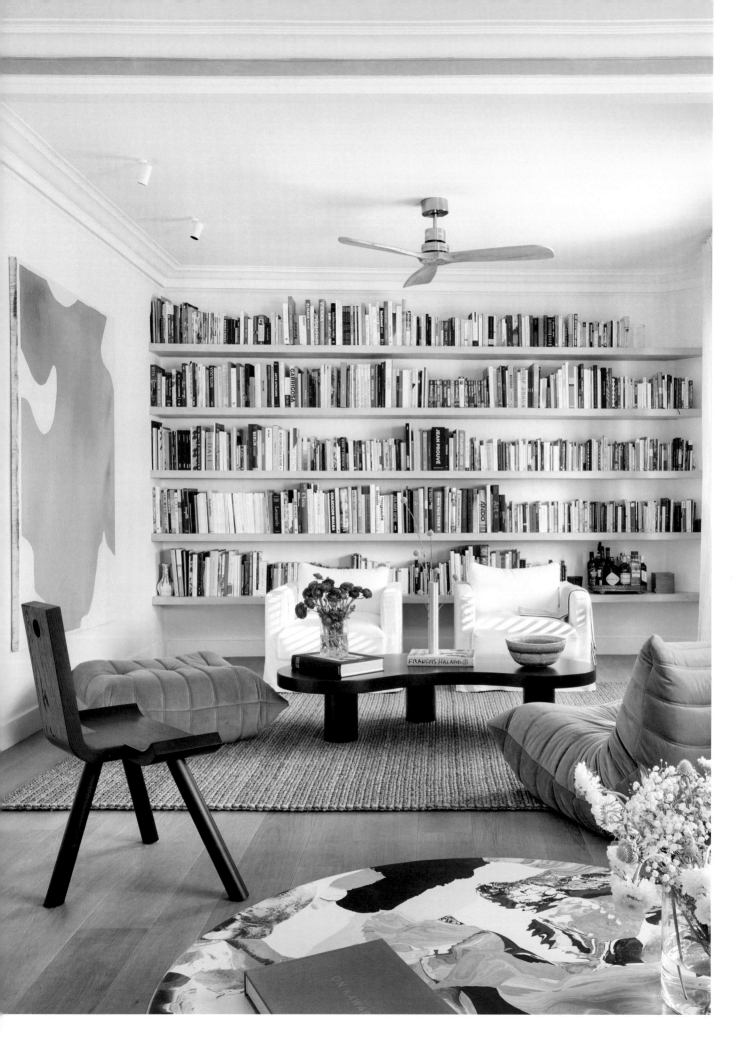

Clever Moments in Forgotten Spaces

Rossellón

John Brown Projects

Barcelona, Spain

In most apartments, the molding that articulates the space between wall and ceiling is just that—a molding and nothing more. But in the home of Juan Moreno Lopéz-Calull, founder of interior design consultancy John Brown Projects, they're a series of moments, painted in a deep and ever-changing palette. The same goes for the thresholds, especially the angular, slate-black plane that frames the doorway between the living space and home office, the latter filled with the many wondrous items he's collected over time. A Platner armchair in polished nickel stands beneath a gallery wall of moody photography and vibrant artworks. In fact, the home is full of art: the back of his apartment door is covered in a mural of the female form, painted on an impulse by Lopéz-Calull's friend, the artist Sandra Modrego. The corridor itself is treated as a gallery, with floor-to-ceiling tapestries, sculptures, coffee-table books, and a chair by Spanish designer Adolfo Abejón.

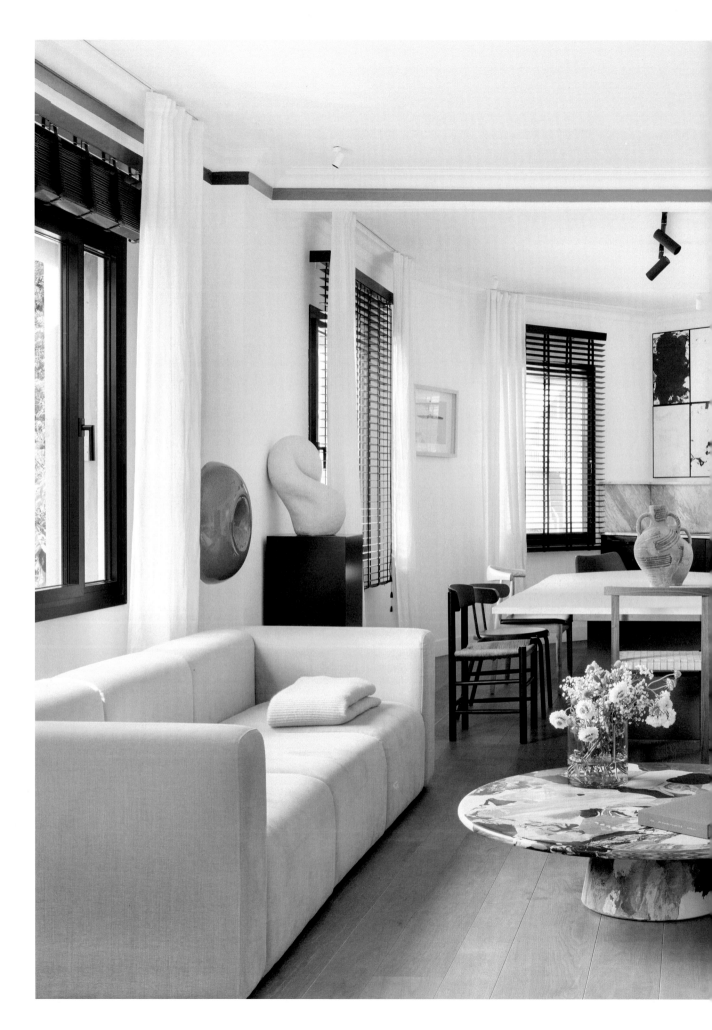

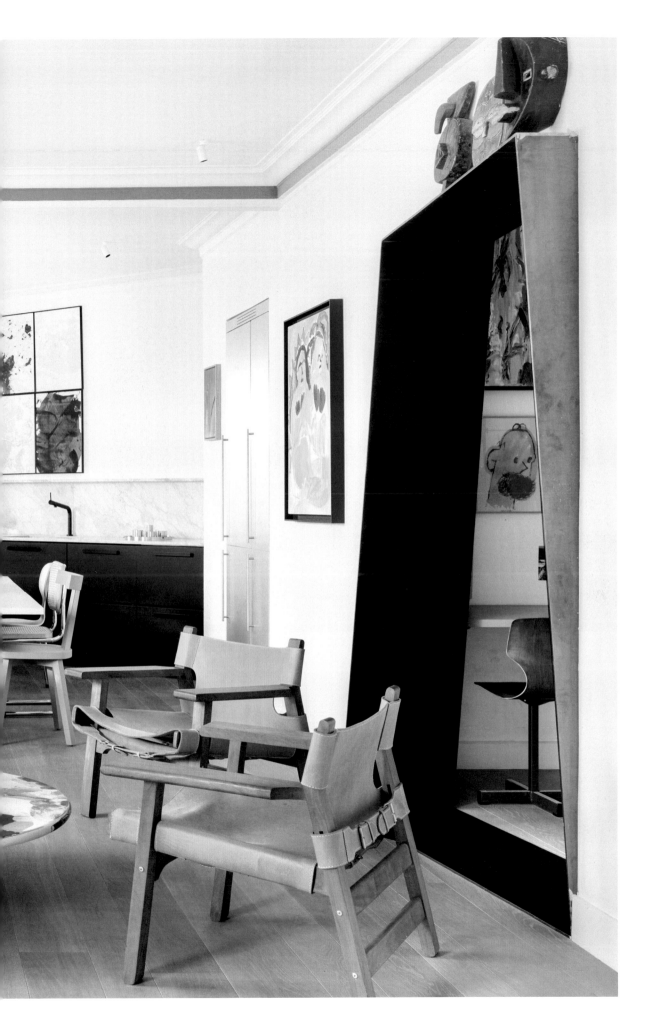

249

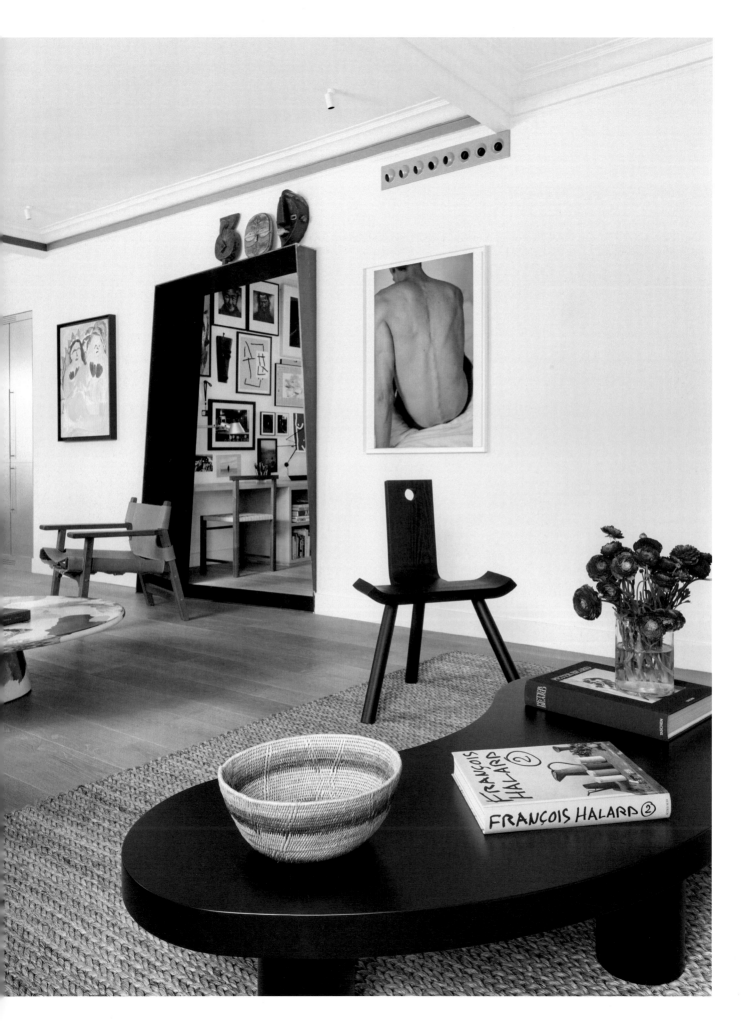

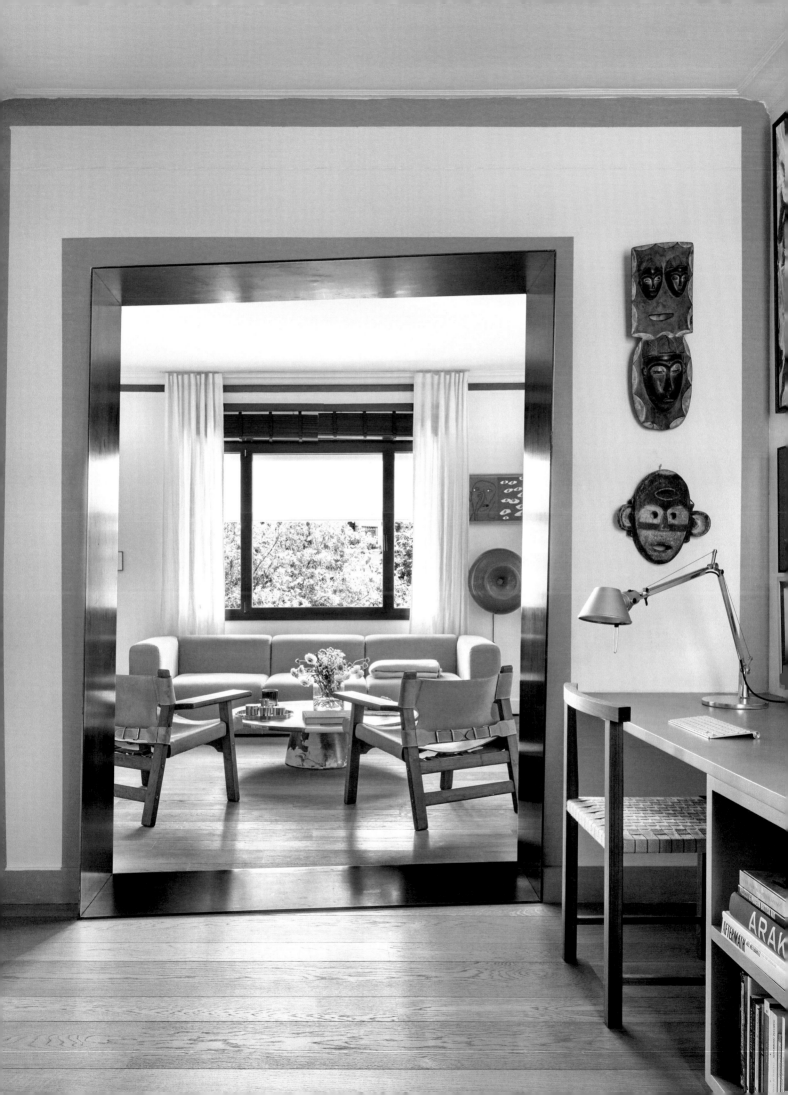

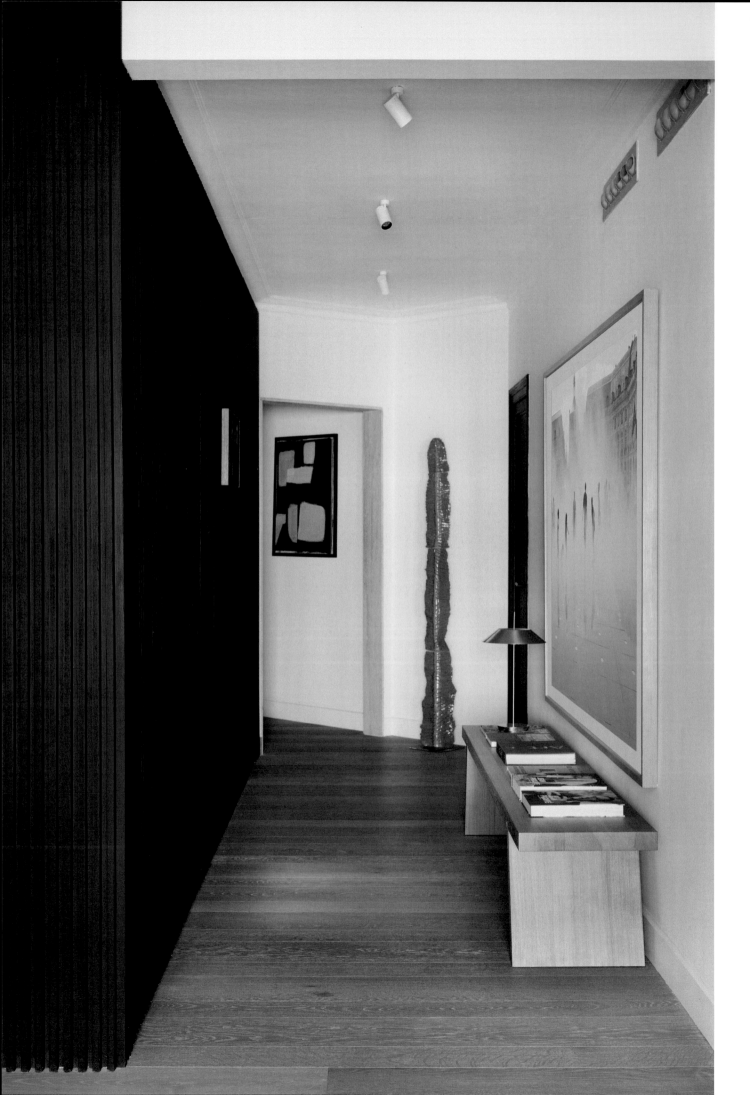

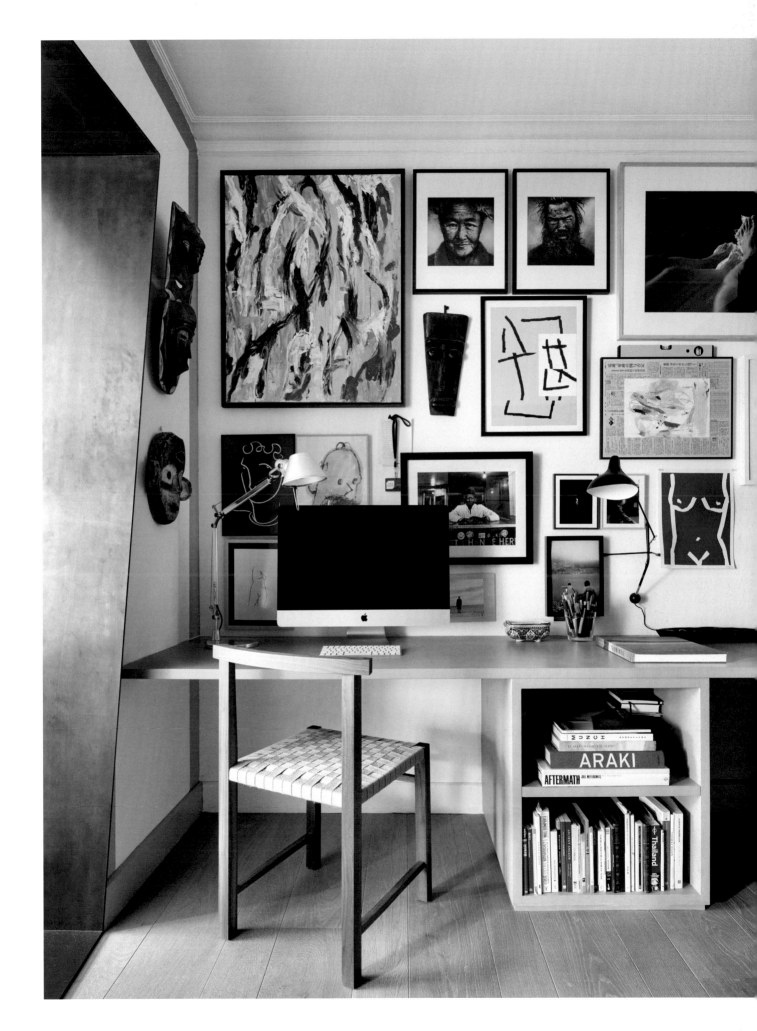

253 Rossellón

Jonathan Adler
jonathanadler.com

Nob Hill Home
San Francisco, CA, USA
Photography: Jose Manuel Alorda
pp. 6, 155 bottom right, 226–233

Baldiwala Edge
baldiwalaedge.com

Quirk Box
Mumbai, India
Photography: Talib Chitalwala
@talib_chitalwala
Stylist: Samir Wadekar
pp. 9, 40 bottom, 135 top right,
167 top right, 196–203

Bells + Whistles
bw.design

Marrow Midcentury
Rancho Mirage, CA, USA
Photography: Madeline Toll
pp. 41 top left + bottom right,
87 bottom right, 154 top,
204 bottom, 206–215

Bureau
bureau.ac

Origin Float Experience
Geneva, Switzerland
Photography:
Dylan Perrenoud
pp. 76–79

CAN
can-site.co.uk

Mountain View
London, U. K.
Photography:
Jim Stephenson
pp. 10–17, 101 top left

Axel Chay
axelchay.com

Casa Calada
Marseille, France
Photography: Valerio Geraci
for The Socialite Family
pp. 86 top left, 120–125

CHZON
chzon.com

Il Palazzo Experimental
Venice, Italy
Photography: Karel Balas
pp. 101 top right, 135 bottom left,
142–149, 167 bottom right

**Colombo and
Serboli Architecture**
colomboserboli.com

Apartment in Born
Barcelona, Spain
Photography: Roberto Ruiz
pp. 192–195

Mariana de Delás
marianadelas.com

Palma Hideaway
Palma de Mallorca, Spain
Photography: José Hevia
pp. 69 top left and
bottom right, 80–85

Matrioshka Attic
Madrid, Spain
Photography:
Imagen Subliminal
p. 69 top right

**Mariana de Delás
and Marcos Duffo**
marianadelas.com

Raval Hideaway
Barcelona, Spain
Photography: José Hevia
pp. 18–23

**Ellen Van Dusen and
Van Dusen Architects**
dusendusen.com

Ellen Van Dusen's Brooklyn Home
New York City, NY, USA
Photography: Max Burkhalter
pp. 69 bottom left, 126–133

Dvekati
dvekati.ru

Slow Wine Bar
Moscow, Russia
Photography:
Polina Poludkina
pp. 24–31

Gundry + Ducker
gundryducker.com

White Rabbit House
London, U. K.
Photography:
Andrew Meredith
pp. 101 bottom right,
108–111, 134 top

Swantje Hinrichsen

Photography:
Swantje Hinrichsen
p. 205 top right

John Brown Projects
johnbrownprojects.com

Roussellón
Barcelona, Spain
Photography: Eugeni Pons
pp. 101 bottom left, 246–253

KC Design Studio
kcstudio.com.tw

Cats' Pink House
Miaoli, Taiwan
Photography: Hey! Cheese
pp. 100 bottom, 112–119

Masquespacio
masquespacio.com

Bun Burgers
Turin, Italy
Photography: Gregory Abbate
pp. 70–75, 135 top left,
167 bottom left

MDDM Studio
mddm-studio.com

House P
Beijing, China
Photography: Courtesy
of MDDM Studio
pp. 100 top left, 102–107,
205 bottom right

HOUSE OF JOY

Playful Homes and
Cheerful Living

This book was conceived, edited,
and designed by gestalten.

Edited by Robert Klanten, Elli Stühler,
and Rosie Flanagan

Texts by Elli Stühler

Editorial Management by
Sam Stevenson and Arndt Jasper

Design, layout, and cover by
Stefan Morgner

Photo Editor: Valentina Marinai

Typefaces: Beatrice by
Lucas Sharp with Connor Davenport
and Kia Tasbihgou, Degular by
James Edmondson

Cover image by Claire Esparros
Backcover image by Madeline Toll

Printed by Printer Trento s. r. l.,
Trento, Italy
Made in Europe

Published by gestalten, Berlin 2022
ISBN 978-3-96704-038-8

For more information, and to order books, please
visit www.gestalten.com

Bibliographic information published by the
Deutsche Nationalbibliothek.
The Deutsche Nationalbibliothek lists this
publication in the Deutsche Nationalbibliografie;
detailed bibliographic data is available online at
www.dnb.de

None of the content in this book was published in
exchange for payment by commercial parties or
designers; the inclusion of all work is based solely
on its artistic merit.

This book was printed on paper certified according
to the standards of the FSC®.